WOMEN SHAPING ART

WOMEN SHAPING ART

Profiles of Power

Judy K. Collischan Van Wagner

PRAEGER SPECIAL STUDIES • PRAEGER SCIENTIFIC

New York • Philadelphia • Eastbourne, UK
Toronto • Hong Kong • Tokyo • Sydney

Library of Congress Cataloging in Publication Data

Van Wagner, Judy K. Collischan.
 Women shaping art.

 Bibliography: p.
 Includes index.
 1. Women art critics—United States—Interviews.
 2. Women art dealers—United States—Interviews.
 I. Title.
 N7482.5.V36 1984 709'.2'2 [B] 84-4794
 ISBN 0-03-070757-9 (alk. paper)

Published and Distributed by the
Praeger Publishers Division
(ISBN Prefix 0-275)
of Greenwood Press, Inc.,
Westport, Connecticut

Published in 1984 by Praeger Publishers
CBS Educational and Professional Publishing,
a Division of CBS Inc.
521 Fifth Avenue, New York, NY 10175 USA

456789 052 9876545321

Printed in the United States of America
on acid-free paper

*For my Mother, Olive Amanda Sundberg Collischan,
and my Father, Michael J. Collischan,
with love*

Acknowledgments

Foremost and primarily, I wish to thank my husband, Robert Grey Van Wagner, for his editorial work in preparing this manuscript for publication, for aiding me with the research, and most importantly for his unwavering support.

Also, I am grateful to all of the women I interviewed for their cooperation and help. I am thankful to Joan Harrison for her photographic work.

Lastly, I would like to acknowledge my son, Brien Grey Van Wagner, for the particular support that only he could give me.

Contents

WOMEN SHAPING ART

Introduction

A phenomenon of the last 50 years in the American art world is the considerable number of women who have played instrumental roles in shaping the course of contemporary art through their careers as art critics and dealers. Choices of artists and styles made by women in these influential positions have affected the course of recent art. My purpose is not to diminish contributions made by men in similar positions or to compare male and female accomplishments in these areas, but to call attention to successful and pivotal women in two arts professions and to consider their impact on emergent artists and stylistic trends.

A great deal of emphasis has been placed correctly upon artists and their focal place in art. The notion of artists as the sole movers of creative activity is undeniably accurate; however on a more realistic level it is also, and some would even argue that it is primarily, through the efforts of gallery dealers and critics that artists' work becomes known and preeminent over that of their peers.

In Europe during the late nineteenth and early twentieth centuries, it was Durand-Ruel who began to introduce and support contemporary artists on a personal as well as a commercial level. He attempted to market work by Impressionist and Post-Impressionist artists to an unsympathetic public. Later Daniel-Henry Kahnweiler did the same for Cubist artists, and Ambroise Vollard assisted Cézanne, Gauguin, Maillol, Matisse, Picasso, and Redon, among others. Essentially, it was men who dealt with current art in Europe, while American male art dealers showed work by European masters. During the period around World War II, however, American women rose to prominence because of their support of indigent, avant-garde artists who were experimenting with new forms and ideas. Among these pioneering women was Edith Halpert, whose Downtown Gallery, established in 1926, became a mecca for young artists such as Arthur Dove, Marsden Hartley, and Charles Sheeler. Halpert's concept of American art was holistic as she viewed twentieth-century art as heir to earlier folk traditions. She championed contemporary native art and artists at a time when European old masters dominated American eyes, minds, and pocketbooks. Peggy Guggenheim's short-lived Art of This Century Gallery, which opened in 1942, provided an arena for the introduction of painters whose work was later to be termed "Abstract Expressionist." Later, or in 1953, Martha Jackson began showing artists important to the beginnings of Pop and assemblage groupings, including Jim Dine, the Gutai, Jasper Johns, Louise Nevelson, and Claes Oldenburg. There were also other women, namely Rose Fried, Ellie Poindexter, Anita Reuben, Bertha Schaefer, Eleanor Ward,

and Catherine Viviano, who operated galleries important to the propagation of a modernist art. Without the efforts of these women of determined vision and confident taste, the history of modernism, indeed the very concept would have been different or perhaps would not have existed at all. It would be fruitless to speculate about the fate of Demuth, Johns, Pollock, Reinhardt, or Scheeler had not these women asserted themselves, their tastes, and beliefs in a surfacing American art. The facts are that Halpert, Guggenheim, and others did launch the cause of American modernism.

Women working as art critics was also an American development of the twentieth century. Prior to and during the time Halpert and Guggenheim were running galleries, women critics such as Elizabeth Luther Cary, Emily Genauer, Elizabeth McCausland, and Aline Bernstein Saarinen were writing about new American art and shaping its course in this century.

To a large extent, art history has been a story of men and of artists. Little attention has been paid to the patron/patroness, benefactor/benefactress, the philanthropist or the partisan. These persons have been considered only as subsidiary to the male creator figures and generally have thought of themselves as functionaries performing secondary roles. Of course, their association with the artist has brought them degrees of fame and immortality, but their province has been relegated to a more passive status. The artist has always needed physical and intellectual sustenance, and thereby the patron has possessed the power of his own taste, knowledge, and judgment. Even those artists who were independently wealthy have required some sanction from another person. This is an area requiring further study, because without such knowledge a void exists regarding social motivations and influences in art. This book attempts to rectify the neglect of the significant contributions of both women and the confrère in art.

THE SELECTION PROCESS

In establishing guidelines and limits for the subject, I decided to choose only living women, so that I might meet and talk with them personally. Interviews, varying in time and intensity, were conducted with each individual presented in the book. The interview format certainly had artificial aspects: there were limits in the degree to which the querist could become acquainted with her subject or the amount of information the questioner could glean within such a qualified framework. Nevertheless as a female historian interested in modern and contemporary art, I felt the inadequacy of research based upon written information and the value of personal contact and oral commentaries and observations. For-

tunately, all the persons I contacted were willing to be interviewed with the sole exception of Barbara Rose. I deeply regretted not being able to include Ms. Rose and her work, because I felt that she had been an important force in today's art world.

Second, I have chosen to consider only critics and dealers who are operating within the context of a gallery although there is a need for a concerted assessment of the contributions of various curators, such as Juliana Force at the Whitney Museum, Ellen Johnson working outside of New York City at Oberlin College in Ohio, Dorothy Miller in the Museum of Modern Art, Hilla Rebay at the Guggenheim, and Marcia Tucker, a relative newcomer who is showing new art at the New Museum in New York City.

Among living critics and dealers there were a number of choices. Inevitably, a few people might feel that additional or other people should have been selected, and admittedly my decisions were subjective to the extent that I judged the importance of the contribution made and being made by each woman, thereby including some and omitting others. An arbitrary factor was somewhat amplified because certain excluded people possessed greater experience and fame, while others included are relatively new to the scene. I felt that it was necessary to consider women of vast and wide knowledge as well as newcomers who had already become influential and whose future seemed auspicious. In all instances, I not only researched individuals, but repeatedly visited their galleries or followed their written work for a period of time in order to determine whether or not I felt that their work had been important and was propitious with regard to the future. Because of spatial limitations, I was not able to include a number of other significant individuals, such as Terry Dintenfass, Rosa Esman, Miani Johnson, Kay Larson, Ellen Lubell, Kim Levin, Kathryn Markel, Roberta Smith, Bernice Steinbaum, and Barbara Toll.

My aim in writing about each person is not only to discuss their factual accomplishments, but also to convey some sense of character, primarily through excerpted portions of their conversations with me. I would like to answer both the questions of *what* these women have done and *who* they are. Toward this purpose, I have developed a portrait-essay format that fulfills my intention to discuss their work and specific contribution while delineating the particular personality and character of each woman. At times, events, decisions, or beliefs revelant to these women provoke elaborations on general issues and problems affecting the art world. The portrait-essays are arranged in chronological order according to the year each woman entered her chosen profession on an independent basis.

My stipulations provided a loose time framework. Roughly speaking, it was the period prior to and shortly after World War II that a flux

of women began to approach the art field as gallery dealers and writers. Undoubtedly this had something to do with the general entry of women into professional areas during this era. The war also prompted a greater awareness of European avant-garde work as a number of artists fled to the United States—a great influence was the presence of Piet Mondrian in New York City and the appearance of Surrealist artists and the theorist André Breton. The International Style dominated new architectural theory while in the sphere of popular culture were Norman Rockwell's covers on the *Saturday Evening Post,* big bands, the singing stylisms of Frank Sinatra, and the beginnings of television broadcasting. Within this diverse milieu, Emily Genauer wrote for the *New York World-Telegram,* Marian Willard ran her east-side gallery, Katharine Kuh campaigned for modern art in Chicago, Antoinette Kraushaar assumed the directorship of her father's gallery, and Betty Parsons opened her own exhibition space.

During the space age decade of the 1950s, the Korean War occurred, segregation issues arose, and a building boom produced inner-city glass and steel rectangles and a mushrooming suburbia. On the West Coast, Jack Kerouac wrote *On the Road;* in New York City, playwrights took their work to the newly evolving off-Broadway scene; the Museum of Modern Art sent 80 pictures representing "The New American Painting" to Europe, and the performing arts found a home at the recently erected Lincoln Center. Within this context, Grace Borgenicht was persuaded to open a gallery, Dore Ashton began writing on art, Virginia Zabriskie managed to purchase a gallery, and Kuh became art critic for the *Saturday Review.*

The 1960s brought us the double-sided Kennedy era of youthful aspirations and grievous tragedy in the form of the deaths of major social and political figures such as John F. Kennedy, Robert Kennedy, and Martin Luther King. It was the confused era of the Vietnam War and its unpopularity with large portions of the American people, especially members of college and university communities. Protests became commonplace and radical groups, such as the Yippies and Black Panthers led activist factions. In art there was also a move away from the establishment in terms of artists taking their work out of galleries and museums into the wider context of open minds, land, air, and sidewalks. This was the time of earth art, sky works, street works, and other purportedly antiobject trends such as Conceptual Art. In such indeterminate and perilous times, Paula Cooper entered the gallery business, Grace Glueck's articles began appearing in the *New York Times,* Lucy Lippard took up the banner of "difficult" art, and Cindy Nemser launched a career as critic.

In the 1970s, Americans enthusiastically embraced the populist proposals of Jimmy Carter and then about-faced to welcome the right-

wing conservatism of the first president with thespian background. This decade of art was dubbed "pluralist" by art critics. Partially as a result of the women's movement, these years were marked by a return of interest in various modes of realism, narrative art, and pieced or collage work of materials usually associated with women's work. Galleries flourished, and several new dealers of varied tastes and aesthetics entered the fold such as Ileana Sonnabend who moved her operation to New York City from Paris, Holly Solomon, Monique Knowlton, Pam Adler, and Barbara Gladstone. Among younger critics appearing on the scene was April Kingsley.

As a result of my study, various generalizations could be posited with regard to similarities and differences among the backgrounds, approaches, and concerns of these women regarding diverse issues with which they have been involved or that arose as a result of their work.

Among resemblances was the extraordinary energy demonstrated by these women. No matter what their age or attitude, they planned, moved, and expanded within their particular modes of operation. At the age of 65, Borgenicht shifted her dealership to its current Fifth Avenue space, and she was followed in 1981 by Kraushaar who had been in the business over 40 years. In the year of her seventy-fifth birthday, Parsons opened a second space. Ashton and Lippard were working on new books (underscore the plural) and Genauer was writing her memoirs, while Kuh sought a publisher for a chronicle of her career. In my "portrait" of each woman, I attempted through insertions of parts of the interviews, to convey some sense of the tremendous vitality I observed upon talking with each one and which was evident in their accomplishments.

Many of them had undertaken more than one project. Zabriskie recently opened a third gallery in Paris. Kingsley was involved in curating exhibitions as well as writing about art and Lippard not only curated shows but contributed an enormous amount of time to organizational work for political causes.

For the most part the attitude of each toward her vocation was genuinely positive, with the exception of Nemser who did become both disillusioned with the art world and interested in writing fictional pieces. The younger critics, in particular, tended to be more cynical toward or dissatisfied with the market aspect inherent in the current art situation, however they were enthusiastic about their own particular course as it might affect that system. Most of them were not trained as, nor did they ever want to become artists. Of course, Parsons was an exception here along with Borgenicht who at one time was an aspiring painter, and Lucy Lippard did design conceptual pieces and performances and was interested in drawing cartoons.

On the whole, the dealers lacked business experience when they opened galleries. However, familiarity with these affairs was quickly as-

similated "on the job." I also felt, in talking with members of this profession, a great sense of camaraderie and good will toward one another. They inevitably spoke about each other with respect and/or genuine warmth. In fact, several specifically remarked on a sense of fraternity among gallery owners.

Focusing on the critics, one might say that they were all interested in writing per se and that generally it was a case of that ambition coming before an interest in art. Kuh and Kingsley would be exceptions here in that prior to beginning careers as critics, the latter was a curator and the former served both as a gallery dealer and a curator.

Generally, all of the persons interviewed were devoted to their particular careers, however both dealers and critics frequently and happily crossed lines into curatorial work. Kuh had the most varied career considering her early work as a dealer, followed by curatorial work for the Chicago Art Institute, acting as an art consultant, buyer for a bank, and writer of art criticism.

On a more personal level, many of these women were born and raised in New York City or its environs, or they moved to this city as it was a predominant center for the arts. To mention an extreme example of this circumstance, Parsons was raised on the site now occupied by Rockefeller Center!

All of these people, directly or indirectly expressed interest in the educational value of their profession. Dealers were particularly concerned with this function. Among critics, Kuh and Genauer were especially involed with their role as educators and with the task of audience development.

On the whole, these women were interested in the art contemporaneous to their lifetime, and in abstract, if not nonobjective, work by young Americans. Kuh was somewhat of an exception in that at an early date, she courageously supported modernist art by young Europeans.

One rationale presented for the entry of a number of women into careers as critics and dealers was that these particular jobs offered them the opportunity to fulfill traditional female roles of supporter and nurturer, while men dominated the creator-producer realm. From a sociological standpoint, women were taught to think of themselves in a secondary light. For whatever reasons, it was argued that women in art chose to support young Americans because they were predisposed to bear or sustain. In actuality, it was probably the most practical course. New art by Americans was readily available at reasonable cost and with less effort. It should be pointed out that there was some contradiction in casting women as subordinate while criticizing the dealers and the critics for their ascendent control and/or manipulation of the art market. Perhaps the fact that women were involved was not immediately considered in these complaints, or possibly in this case, women were powerful enough to be resented.

A final commonality was a rejection of mainstream art. Parsons's association with Abstract Expressionism came after the fact of her choices. She picked the artists (after Peggy Guggenheim had shown work by some of them), and Clement Greenberg connected them with theory. Certainly her taste did not correspond to the dominant artistic fashions of the 1940s. Likewise, the other women considered herein prided themselves on the diverse and eclectic nature of their preferences. They did not particularly wish to be identified with a single style. Indeed they rejected the concept of trends. Solomon was somewhat unique within the group in that she was particularly concerned with introducing the so-called "new wave" style as it was applied to work by various European artists.

The tendency toward independency in taste was directly related to the freedom enjoyed by these individuals in their chosen occupations. The critics might be more tempted to write about a certain kind of art or artist in order to get their work published, but certainly the life of free-lancing, which all of these individuals were involved with to varying degrees, offered considerable latitude. All of them felt a great amount of leeway in choice of subject, whether they wrote regularly for a newspaper or less often for a specialized magazine. Dealers, of course, unless they wished to follow a certain market trend, could choose work that suited their personal concept of art. Generally speaking, each of these women selected a course that allowed them to enjoy relative immunity from routine, restriction, and repression.

Differences among these women were primarily singular in nature. In background there was considerable variety. Already mentioned were early careers as artists. Other former occupations represented by persons in the group were model, secretary, actress, nurse, stenographer, architectural historian, and elementary school teacher. A good part of the reason for such varied backgrounds was that there were and still are no training programs for dealers or critics. As one gallery owner put it, to become a dealer, all one had to do was want to be one.

A primary divergence of opinion within this assemblage of persons concerned the relative substance or even the very existence of the women's movement. Reactions ranged from a complete denial of its presence—"What women's movement?" to a lack of support for or belief in it, to people who proclaimed its significance and acknowledged its profound influence on their respective professional developments. Age was a factor here in that older women tended to deny the impact of recent feminist efforts. However, these individuals readily pointed with pride to their own accomplishments as members of the female sex.

Finally, within the broad category of new American art, there were great divergencies in aesthetic judgment among these women and dissimilarities in the approach of each to her profession. For example, one championed sculpture, while another preferred painting; some favored

art with figurative references and others chose completely nonobjective art. There were dealers who stressed the business aspect of their jobs and those who placed greater value on their associations with artists. In their relationships with artists, a few preferred formalized contractual arrangements, while most were content with verbal agreements.

A division in art criticism occurred between those who were published systematically in a newspaper and those who free-lanced on an irregular basis. For younger critics there existed fewer newspaper outlets for their talents than there were 30 years ago. Moreover, the value of the efforts of those who chose at whatever time to write for newspapers was questioned. There were those who felt that the daily and weekly confrontation with art and art writing prohibited time for reflection and synthesis, hence such writings became mere reportage. However, it might also be argued that articles produced as a result of longer periods of thought and gestation sometimes became centered on the writer's idea into which she fitted works by various artists, and that the more immediate writing-publication situation was closer to the actual pulse of the scene. It seemed obvious that there should be room for both approaches without undue denigration of one or the other. Another schism existed between critics who prided themselves on their catholic taste and younger individuals who were associated with a specific type of art. Recently, in keeping with overall societal tendencies there was a move toward specialization. Thus, a particular critic became known as a supporter of, say Super Realism, and would usually write mostly about that style.

ANNOTATIONS

It is important to keep in mind that dealers are businesswomen who are interested in making profits. Some emphasize this aspect more than others, but the fact is that their very existence and that of their artists is dependent upon sales and promotion. For this reason, it is often the dealers who are blamed for making money and being successful at what they do.

Generally and understandably, artists feel—and have felt, over the course of approximately the last 50 years—that they do not have the time or the inclination to meet with collectors, sell their work, set-up exhibitions, see to the publishing of cards and catalogues, etc. It can be argued that the dealer's cut of the price of an individual art work is too much, that the artist should receive more dividends. Dealers respond that their expenses are high, and certainly Manhattan rentals alone have reached astronomical proportions. Gallery owners can also reasonably maintain that the bigger and better known they become, the greater the market and price they can garner for the artist. Finally, as businesswomen, a motivation for entering into a marketplace career, is a desire for success

measured in terms of monetary gain. The question is how else and in what other ways can art reach an audience? Art considered as a means of expression requires an appreciative respondent. If artists decide to communicate only with themselves in making art, they must find a place to store or hang their creations, and they have to search for some other means of livelihood. Former *Times* critic Hilton Kramer has expressed his amazement over the fact that people generally do not realize that art is sold like "bushels of potatoes" or any other commodity. There is no doubt that the general public views, and has been encouraged to think of art as some kind of mystical, pure, and sacred fruit of the artist-shaman. However, it is not only the commercial character of art that is fundamental here, but the circumstance that art, unlike most other modern human enterprises is based on the one-of-a-kind concept. Individual objects are marketed under the rubric of art, however, unlike potatoes sold by the pound, great care is taken to distinguish the originality and uniqueness of eack work of art. It is this modern myth of personality that fosters commercial exploitation. The "system" that is often spoken of with great disdain and contempt has evolved as artists have become cognizant of their work in relation to themselves rather than connected or belonging to a larger belief or faith. Thus, as the Renaissance person emerges from the anonymous devotee of Middle Age religion, so art becomes less an act of faith and a gift of God and more an action of man and a "gift" to whoever buys it. The spiritual aura of art is retained as it slips into another mode of expression and reason for being. Therefore, it is not the relatively new phenomenon of art dealers that can be totally blamed for merchandizing art. The process has been emerging since the Renaissance and is an intrinsic part of our prized individual identity and enterprise.

In spite of the negative criticism that is leveled at dealers and critics in general, it is true that as individuals they experience an amount of fame. America's obsessive development of the cult of personality into the manufacture of the mythical star concept has dusted these professions. Certainly dealers are crucial figures in that it is largely their taste that determines which artists' works will be shown, sold, and brought to the attention of the public. (In this connection, note that almost all of the dealers say they depend primarily upon artists already in their gallery to recommend fellow artists.) Critics also are elevated to stardom, and their influence in the promotion of artists and the creation of aesthetics or styles is considerable. However, critics cannot actually show the art work to the public, and today, more often than not, a critic's work is geared to whatever is shown in galleries or alternate spaces where people can go to see it for themselves. First the artists—and perhaps one can point to Andy Warhol as the original artist-star—and now critics, dealers, and museum people are affected with the contemporaneous tendency to popularize and aggrandize.

Another issue germane to a book on women art critics and dealers, and one that will certainly be raised by contemporary feminists, is why didn't these women deliberately choose other women's work to write about and to show. A few do, but most respond that they are interested in quality not gender. More than likely, they operate along the same established lines as their male colleagues. Certainly within the last decade there is a greater concern for women artists and their work. New "herstories" of art show that for centuries a number of women have indeed worked as artists. Critics who began to write in the 1960s and 1970s, such as Lippard, Nemser, and Kingsley are (or have been in Nemser's case) most sympathetic toward and active in supporting women artists.

Finally, an important issue is that of the number of women in what some would term support or auxiliary stations. In reality these positions are of primary importance in establishing the course of art in the United States. It is and has been acceptable for women to become involved with the arts as long as it is some genteel occupation or preoccupation suitable for the weaker, fairer sex. A new position for women critics and dealers is one of influence and power.

Significant is the fact that criticism and art dealing are professions that still elude blacks, Hispanics, and other minorities, male or female. Recently, these minorities are beginning to occupy administrative posts in a few alternate spaces, but there are no, or very few Hispanic or black dealers or critics. White women taking care of accepted art is part of the scheme of things conceived by a society dominated by a white, patriarchal structure of priorities and systems.

In general, working with new art exists on the fringe regions of respectability. Certain types of art and a particular female race are endowed by Western civilization with exceptionally high character as long as they do not disturb or accede to the more assertive and influential positions and ideas being held by men. White women tending traditional art is a highly esteemed combination, while women, blacks, or Hispanics promoting avant-garde art (minority art is indeed new to the scene) is a situation that provokes censure and objection. Nevertheless, women (and hopefully blacks and Hispanics will also) ignore established strictures to excel at these tasks in the sense of changing and molding the art of our time. One wonders whether or not change in art has been and can only be accomplished by women (or minority groups) as an interruption of the status quo.

Whatever the social, political, or personal aspects responsible for the presence of women in art writing and dealing, they are excelling in these positions. Their impact is awesome in terms of the people they sponsor and have believed in, and the resultant dominance they possess via the important part "their" artists have had and do play in the directions of American art of the past half century and in the future.

1
Emily Genauer

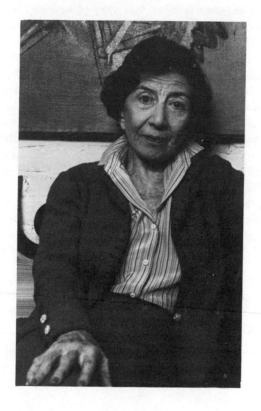

Photo by Joan Harrison, New York.

Emily Genauer is a New Yorker and possesses all the spunky, straight-forwardness that has been ascribed to this city's indigenous inhabitants. To some she may seem noble, rather grand, but what may appear to be a lofty manner is often her way of teasing. She does in fact possess a subtly clever, straight-faced wit, and she does have every reason to be proud. Not the least among her many achievements is a Pulitzer Prize awarded her in 1974 for Distinguished Criticism, the only one that has been awarded in art.

Genauer's background was somewhat conducive to her choice of career. She always wanted to be a writer, and she had some early contacts with art. Outside of his association with the real-estate business, her father dabbled in painting and sculpture and wove rugs. She recalled that he visited museums and took classes at the National Academy, where she too eventually enrolled as a sculpture student. "I had a wonderful feel for things. I loved sculpture, but it didn't take me long, being a good critic, to realize that I was not going to get anywhere."[1] With pride she pointed to her mother as a member of the Milch family who owned one of the first galleries in New York City to handle American art.

When asked for the date at which she began writing, she answered,

> My dear, I started writing. . .I have clippings and medals that I got when I was in the fourth grade! I was born and brought up on Staten Island, and there was a paper called the *Staten Island Advance*. There still is. They used to give prizes each year, and I have a pack of medals with red, white, and blue ribbons. . .you'd think I'd won a war! They were things like "Why It's Great to Be a Girl Scout," you know, or "Why We Must Be Careful" for Fire Prevention Week. I was practically a little baby, but they always got published, they got the prize, and so I very early on knew that I was going to be a writer.

She emphasized the fact that she was employed as a newspaperwoman at the tender age of 18 ("I was a baby!") before she finished her second year at the Columbia University School of Journalism. By special arrangements made at the suggestion of the dean, her classes were scheduled so that she might take a job with the *New York World* in 1929. She worked for this paper for two years as a staff and art feature writer. Among influences on her career, Genauer credited Walter Pitkin, Sr., one of her instructors at Columbia, for teaching her how to write a feature story. "He taught me to look out that window and do you a feature story!"

In 1932, and for the next 17 years, she was employed as an art critic and editor for the *New York World Telegram*, which had purchased her first

employer. Initially, the new management decided that they could not employ several people, including Genauer. However, in a matter of months, she got a call.

> Roy Howard called me and said, "We have been looking like crazy for an art critic, not because we care that much for an art critic, but we don't get Bergdorf-Goodman and we don't get J. Thorp. We don't get any of the chic shops, because we don't have art on the page. Are you interested in coming to talk to us?" I said, "Sure," and it turned out they were down to three people. The three they were interviewing were Alfred Frankfurter, who was editor-in-chief of *Art News* at that time; Maria Monis, who was somewhat acquainted with the art world though much more familiar with music, and me. I was the only one of the three he found—I was *by far* the youngest—who not only knew how to sit down at a desk in a newspaper office and write a good, fast story against deadline, but who was at home in the art world.

Thus, her career as art critic was officially launched.

Early on in this paper and in free-lance articles, Genauer wrote about American art. In 1936, for the early College Art Association journal, *Parnassus*, she wrote a piece entitled, "New Horizons in American Art," in which she favorably reviewed a Museum of Modern Art exhibit of works by artists employed by the Federal Art Project.[2] In it, she remarked on the importance of this program, the exhibition, and the rise of young artists under the W.P.A. Approximately six months later in the same periodical, she wrote on Charles Biederman, Paul Cadmus, Arshile Gorky, Carl Holty, and Louis Shanker in "Young Painters in the East."[3] Her choices were both adventuresome and sensitive for the 1930s when an influential critic like Royal Cortissoz campaigned against the very concept of modernism. Others such as Howard Devree and Herbert Read wrote on European art and Forbes Watson was concerned with nineteenth-century or more conservative modes of twentieth-century American art. These artists did go on to establish names as artists, especially Gorky whose development provided a presageful bridge between European Surrealism and American Abstract Expressionism. The lesser-known artist, Biederman chose to leave New York City for a small town in Minnesota. Nevertheless, through exhibits at the Walker Art Center in Minneapolis and within the last few years at the Grace Borgenicht Gallery, his Constructivist sculpture has reached an increasingly wide audience. Thus, at an early date, Genauer was writing about programs and new work by young artists who were to become recognized as part of the American avant-garde.

It might come as a surprise to some to learn that in the 1930s, there was a magazine called *Independent Woman* (later entitled *National Business Woman*), in which Genauer published an article on the Paris Exposition

of 1937.[4] This piece exemplified her early interest in design, particularly as it affected home interiors. Today, she expressed pride at having been one of a very few early supporters of Art Deco. In 1939 she wrote a book, *Modern Interiors*, which emphasized the desirability of linking art with industry.[5] Primarily, her inspiration was the tasteful exhibits presented at the European international expositions. She was not, however, interested in writing household decoration columns. There was some pressure put on her by editors at the *Telegram* to dispense home decorating advice, but she remembered responding in her typically spirited manner.

> I told them that I would never do that. Instead I wrote on the homes of well-known collectors, but after about six months, I said, "I won't even do that for you anymore. Not because of my wishes, but I think it's unfair to your readers. I think you must have a couple hundred thousand readers who want to know how to put up decals in their kitchens. So take it off my page! Put it on the woman's page, and let me run a straight art section," which they did.

Genauer stressed the fact that the art world was different in earlier years from what it is now. For example, she recited the names of 13 art critics writing for newspapers in New York City in the 1930s. Certainly this was a healthy situation in terms of employment for critics, general coverage of exhibitions, and quality of art criticism. For whatever reason, newspapers seemed to consider an art column as a part of their production, and as a result several points of view were published on a regular basis.

This is, of course, in contrast to the present situation. Among city newspapers, only two, the *New York Times* and the *Village Voice* employ art critics. Escalating printing costs and a correspondent industry move toward corporate structure has allowed for a few rather than many enterprises. The number of newspapers has dwindled, and some of the survivors have not been interested in giving up nor have they experienced any pressure to relinquish space for an art column.

At her job with the *Telegram* and in articles published elsewhere, Genauer lost no time in becoming an outspoken and thereby, controversial figure. As early as 1940, in her article published in *Art Digest*, she criticized the Metropolitan Museum of Art for not purchasing American art.[6] At this date and for several years hence this institution and others of its status were interested only in purchasing work by European masters. Four years later, an article with the classic title, "Fur-Lined Museum," appeared in *Harper's* magazine. In it, she took to task the Museum of Modern Art for failing to exhibit American art. Her words, written almost 40 years ago, seemed a prophetic echo of the exact sentiments expressed repeatedly by some artists and critics today. She wrote:

The central task of such an institution, a task even more important than that of showing Sure Things effectively, is to aid, promote and celebrate the best contemporary art, both foreign and native: to be a force steadily and surely working to foster and encourage the ablest living artists and to bring them the backing of the general public. In this task the Museum of Modern Art has failed.[7]

She claimed that prior to publication, she had called all the members of the museum's board and that each expressed dismay over the activities of Albert H. Barr, Jr. (Barr was director of the museum from 1929 to 1943 and director of research from 1944 to 1946.) Her account is probably true, because Barr was "retired" a year before Genauer's story came out. Genauer also remembered a particular instance in which she felt Barr and other museum personnel had gotten out of line.

They had gone mad for the Sunday painter, and at one point they made a big thing of a bootblack's chair. Alfred Barr had gone in somewhere to get his shoes shined, and he found a bootblack's chair that had been twisted with tinsel and had bows on it. He was so touched—genuinely touched by a little old Italian who had done it that he brought it up to the Museum of Modern Art. I was *very* upset.

Years later she praised Barr's contributions and good taste, but remained critical of what she termed his tendency to favor certain artists. Generally, she felt that Barr was one of the most remarkable men she knew and credited him for what she termed his "grace" in writing to her, even after the *Harper's* piece, whenever she did an article he liked.

Another flash of her independent courage erupted into a piece entitled "Public Be Damned; Art Popularity Polls," appearing in the *Art Digest* in 1946.[8] Here she decried emphasis on the general opinions reflective of what she termed the "unlettered taste" of the public. Indeed, one thing that she emphasized throughout her career was the need for education in the arts.

In the 1950s, she wrote a piece for *House and Garden* called "Your Children and Art," in which she pointed to the value of educating children as a future audience for art.[9] In fact, she literally put her views into practice. In 1940, she gave birth to a daughter, Constance Lee, in whom she carefully inculcated an interest in visiting museums. She told the story of one family visit:

We walked into one of the galleries on a Sunday afternoon, and the guard gave us a broad smile. You know they're always very cross types. I said to my husband, "I can't imagine what's happened. The guard has smiled at us," and my daughter looked up and said, "He didn't smile at you, he smiled at me." And I said, "How come? Do you know

him?'' She said, ''I take the kids over here from Bentley School at lunch-
time.'' So she used to walk three or four kids over each day. She had
her own little lecture tours.

In 1953, Genauer wrote an article in *Art Digest*, criticizing the notion of
federal sponsorship of the arts and suggesting that art commissions be
decided by panels of experts.[10] During the next decade, she was invited
to participate in a panel sponsored by the Council for Basic Education
on ''What Should Be Taught in Art, Music and Literature?''[11] Her con-
tribution evolved about the theme of building a knowledgeable and ap-
preciative audience for the arts. Finally, as late as 1967, she published
''Coming to Terms with the New Art,'' a kind of ''how to'' compendium
for understanding modern art.[12]

In accordance with her pedagogical aims, a high point in the early
part of Genauer's career was the publication of *Best of Art* in 1948.[13] The
book was accompanied by an exhibition at the Riverside Museum and
both consisted of a work by each of 50 artists, most of whom were
Americans. Actually, as Genauer explained it, the book and exhibit were
to be annual affairs, and the title should have been something like, ''Best
of the Year.'' The publisher chose what she felt was a pretentious title
while the author was in Europe. A novel promotional device was con-
ceived that not only illustrated the importance of Genauer and her book
but something of the relative enthusiasm for art at that time. As she
described it, city department store windows in New York, ''beginning
with Macy's and crossing to McCreery's'' contained not only copies of
the book but a painting that was reproduced in the book.

This volume, as Genauer stated in the introduction, represented her
campaign to span the ''gulf between artist and public.'' She wrote about
work by painters that had some impact on her over the past year. Also
among her introductory comments, she made some generalizations
regarding her choices. These overviews reveal something about the type
of art Genauer supported at that time. The overall characteristics she saw
in the group as a whole were a concern with the world and with a
vocabulary reliant on symbolism to express social concerns. Her gener-
alities were manifested in work she chose by artists such as Eugene Ber-
man, Philip Evergood, Stephen Greene, Philip Guston, Yasuo
Kuniyoshi, Jack Levine, Loren MacIver, Matta, and Abraham Rattner.
One of the most abstract creations in the book was a painting by Irene
Rice Pereira, a highly inventive and still underrated artist, whom
Genauer supported and befriended for many years. In fact, she might
have added to her characterizations that the majority of her choices ex-
emplified varying degrees of abstraction.

The book came out when Abstract Expressionist artists were emerg-
ing in terms of attention from other critics. Genauer, unlike other peo-

ple considered in this book, never responded to Abstract Expressionism with great enthusiasm.

> It took me a long, long time to be moved by a Jackson Pollock, because I knew him during that early phase when he was a bad representational painter. But he changed the face of painting in the twentieth century and *that* makes him important. And so I have to tell you right off, I think Jackson Pollock is one of the most important painters that lived in my lifetime whether I liked what he did or not.

Her reaction to Abstract Expressionism was based on her general preference for intelligible regularity in art. For example, in 1951 she attempted to ascertain what to her was an "unmistakable American accent," in an article titled, "Is There an American Style in Art?" published in *House Beautiful*.[14] She saw the American manner expressed in, "...clean, pared down compositions which, perhaps unconsciously, are a reflection of our national love affair with brisk efficiency, bright machinery and progress in technology." American Expressionist work she termed "gloomier," and she urged her readers to see more art in order to educate themselves so that artists might be caused, "...to turn away from the involved and undecipherable private symbolism which has characterized too much of modern art." Ten years later in an editorial first printed in *Art in America,* she capsulized her aesthetic predilections. In this piece called "Purpose of Art in Our Time," she proposed,

> The first, the basis, the without-which-nothing purpose of a work of art, is that it stake out in a way unique with its creator, an area of order in a world that today, as always, is a terrifying chaos.[15]

She went on to state that she did not find that order in Abstract Expressionist work such as that of Pollock.

> I agree completely on the incalculable importance of the defiant individual expression in the face of our time's mechanization and anonymity particularly as we feel it in America. But such an expression however valuable, is not necessarily esthetic. It cannot alone make for a work of art.

Although she was not particularly interested in Abstract Expressionism, she was on friendly terms with and received letters from a number of the designated proponents. Furthermore, she never charged these artists with a lack of or questioned their sincerity. "I never knew an artist who tried to fool the public except for realistic, academic ones who didn't know any better." Her disagreement with Abstract Expressionism was based on her own taste for a more objective order in art. After an auc-

tion in 1965, she wrote a lead *Tribune* article, "The Night the Bubble Burst," in which she rather triumphantly proclaimed the demise of Abstract Expressionism.[16]

It was not only Abstract Expressionism that Genauer doubted. At least one realist artist did not meet with her approval. About Edward Hopper, she remarked, "He's a great realist, but a *dull* one!" And to her, Jean Dubuffet's work was of "...the most unimaginative, the most pedestrian, the most unacceptable sort."[17] On the other hand, she wrote sympathetically about art in which she found that sense of order that satisfied her. For example, she endorsed Alfred Mauer and submitted a moving account published in the *Tribune* on her meeting with John Marin at the age of 81.[18] An article of 1953 reflected her great love of and admiration for the work of Cézanne whom she called a "master of nature" while admiring him as a formalist pioneer.[19]

The 1950s proved to be a difficult period for artists and writers as the public was swept away with a wave of antileftist hysteria led by Joseph McCarthy. Even before this "McCarthy era," another congressman, Republican Representative George A. Dondero of Michigan took it upon himself to accuse Genauer of having been "very kindly" toward "left-wing, so-called artists."[20] Probably as a result of his attacks the *Telegram*, for which Genauer had worked for 17 years, saw fit to dismiss her. She recalled that the reason given was that they were no longer in need of an art page. A number of people in the art world came to her defense, including Alfred H. Barr, Jr., whom she had attacked five years earlier and Alfred M. Frankfurter whom she had competed against to get this job. Two months later, "Still Life with Red Herring" appeared in *Harper's* magazine.[21] Genauer counterattacked in this piece about an exhibition at St. Alban's Naval Hospital on Long Island. Dondero had called this exhibit subversive because of its "communist" modern art, and Genauer took this opportunity to expose his meanness camouflaged by the mantle of a false, opportunistic patriotism.

During this decade, Genauer's work had not only been published in the *Tribune*, in art and women's magazines, but she had branched out into writing about visual aspects of the theater. Her work on topics such as set design was published regularly in *Theatre Arts* magazine in 1951. Among her colleagues at the newspaper were Judith Crist who wrote on film and Walter Kerr who served as theater critic. Whenever, and the occasions were infrequent, Genauer crossed from visual arts into other areas there did not appear to be any objections from her distinguished colleagues.

Today, there is less flexibility. Most newspaper and free-lance critics write only within their particular area. Indeed many have specialized interests within the art field. For example, one may be associated with a certain aspect of realism, while another writes on artists associated with

purely formalistic elements. This type of concentration is particularly peculiar to criticism written during and since the 1960s.

It should be pointed out that Genauer's pieces for the *Tribune* and those published elsewhere were not strictly a reporter's reviews. Even when a review was the premise, it often became a springboard for thoughtful exposition on a larger concept. For example, in a *Tribune* article, "Art and Artists: New Galleries," she wrote, "For unlike the public, or critics, or museum directors, young artists don't see a picture as a picture. It is important only if it is a door leading to new aesthetic adventures."[22] The catalogue essay written for an exhibition of work by Robert Motherwell at the Museum of Modern Art provoked a piece called "The Myth of American Provincialism," in which she upbraided Frank O'Hara for writing about America's isolationist position in the 1930s and 1940s.[23] Again, on the occasion of an exhibition of three centuries of American painting at the Metropolitan Museum, she admitted that we should be modest about our artistic heritage of the eighteenth and nineteenth centuries, but again staunchly defended creative activity of the third and fourth decades of this century.[24] A series of exhibitions in ten New York City galleries, "Seven Decades, 1895–1965: Cross Currents in Modern Art" brought forth a *Tribune* column, "Isms and Schisms, A Survey of Seven Decades," in which she maintained that no one period had been dominated by a single style, that "isms" did coexist. She defined an "ism" as "the result of tensions between past art and present artists" and "between present artists and their own time," and continued, "What is insufficiently understood is that the rebellion, conscious or unconscious, esthetic or social, which gives birth to new art isms, is itself born out of tradition."[25] For another 1960s' piece prompted by an exhibit of work by Marcel Duchamp at Cordier and Eckstrom, she came up with the title, "Duchamp—Pop's Granddada," a caption worthy of today's weekly newspapers. In this article she expressed her own rather dubious view of this widely acknowledged figure in art.

> Perhaps the greatest "accident" of his career, the one thing that could not have been predicted, was that the arch rebel of the twentieth century, the symbol of nihilism, the man who didn't stop his rebellion with his art, but made his whole life an act of rejection of traditional esthetic values, emerges at the end as the greatest spokesman for tradition, for thought, for belief, for clarity.... But *was* it an accident? Is Duchamp, even now, putting us on?[26]

Indeed this sampling of her essays prompted by specific shows illustrated both the fact that she certainly transcended the role of journalistic reviewer and that she wrote on a wide range of artists and ideas.

Two particular and incidental observations, the first made in 1951 in

Theatre Arts and the other in a *Tribune* piece, attested to her astute and actually prophetic awareness of the New York art scene. She wrote that, ''New York is the art center of America because of its commercial galleries, not its museums,'' referring to resultant stimulation offered to artists;[27] and at the beginning of a new fall season in 1965, she worried about ''...our current approach, our cultivation of art as fad, our indifference to anything not 'in'....''[28] The consequence of galleries and the fashionable aspect of art were then and are today indisputably influential factors in the art world.

Concerning specific artists and events of the 1960s, she wrote supportively about people ranging from Alberto Giacometti to Bruce Conners, from Donald Judd to Lucas Samaras and Len Lye, and she proclaimed an ism of her own in a title, ''Now It's Pubism,'' for a story on shows of nudes.[29] Genauer did ''keep up'' in terms of writing about a range of artists who were important during this decade. There was, however, a generational difference between her and the artists she wrote about after 1960. Illustrating this point was an anecdotal story Genauer told of seeing a little boy, six or seven years old, holding the hand of a woman in a museum. The woman approached Genauer and asked if she would look at some of her son's work in order to advise her as to whether or not she should encourage him in art. When Genauer agreed, she was shown ''little flower drawings'' by the child who grew up to be an artist. In the 1960s, this man became well known in the art world as Ellsworth Kelly.

Among all of the feature stories, columns, and articles that she produced over the years, it was the editorials that she wrote for the newspaper that pleased her the most. An excellent example involved the Metropolitan Museum's purchase of Rembrandt's *Aristotle Contemplating the Bust of Homer* for over 2 million dollars. A skeptical editor asked her to decide the paper's position as to whether or not the painting was worth that amount.

> Whoo, that was a toughie! Editorials had to be short, and they're unsigned, but I had a brilliant idea. I looked around the city room and saw our science editor. I went over and said, ''Earl, will you tell me what you can do with $2,300,000 in the space program.'' He said, ''Let me make some telephone calls.'' In five minutes he was at my desk, and he said, ''You could buy the compass on the needle of the spacecraft.'' So I wrote an editorial which I'm very proud of saying, ''Yes, it was worth it, yes.''

This particular incident and resultant sample not only demonstrated Genauer's clever resourcefulness in coming up with a ''good story,'' but the unyielding manner in which she stood by her beliefs in art.

After the demise of the *Tribune* in 1967, she continued to write a syn-

dicated column for *Newsday* for a year, and then distributed it herself for a short time. In the 1970s her book on Rufino Tamayo was published, and she wrote a thoughtful article for *Newsweek*, "Leonardo and the Stain," in which she related Leonardo's ability to see something in a stain to contemporary artists' discernment of value and beauty in castoff objects and junk.[30] Generally, in the 1970s she persisted in her loyalist role in relation to contemporary art via a somewhat reduced output.

During the course of her career, Genauer received many prizes. In retrospect, she claimed that the New York Newspaper Women's Club retired their annual award after she won it six times. However, a highlight of her professional life was certainly winning the Pulitzer Prize upon the completion of over 40 years as a critic. After it was awarded her, she reflected: "Total, continuing immersion in the world of creativity is the most effective antidote I can find to the incircling, overwhelming corruption of our time. In comparison with what goes in politics, the maneuverings of dealers, collectors, museums are child's play."[31]

Genauer claimed to have viewed 500 exhibitions a year over the course of her long career. She wrote for general interest periodicals, specialized arts magazines, and for newspapers. She did not consider herself a mere reporter of arts events, but a person of knowledge and position to pass judgments on what she saw of art. She prided herself on her "catholic taste" rather than on her association with any particular individual or group. She pointed to the fact that no one ever told her what to write or like, and she's particularly pleased with her friendships and correspondence from such diverse artists as Marc Chagall, Louise Nevelson, Mark Rothko, and David Smith. If there was a specificity regarding her associations in and with art, it was her resolute advocacy of American art. Throughout the story of her professional life figured the indomitable will of a highly independent woman.

Her response to the question of a women's movement was that there was no such thing. However, her own free spirit would seem to ally her with those who believed in a women's movement. She married her husband, whom she met in an art gallery, against her parents' wishes after having known him only a month. She said that she felt if the marriage hadn't worked out, divorce was common enough to dispell any problems of social disapproval. When she married, she kept her own name and said that "everyone did" at that time. Furthermore, she insisted that at an earlier date, "Women in this country *ran* the art world," and pointed to Elizabeth Luther Cary, Juliana Force, Edith Halpert, Antoinette Kraushaar, Dorothy Paris, Gisela Richter, Aline Bernstein Saarinen, and Catharine Viviano to illustrate her contention. On a personal level, she called Louise Nevelson a close friend and reflected that she could more easily become friendly with women artists.

In answer to a question on chauvinism, she replied in terms of

American art and its relationship to a European counterpart. Neverthe-
less, she recalled with amusement, a story about one encounter with a
male artist.

> I had two tickets to the ballet, my husband was called out of town, and
> I did not feel I could let that ticket go to waste, so I went through a cata-
> logue trying to recall some artist who had worked with ballet themes
> and who might be interested in attending. The first name I came on was
> a *very* well-known artist who had done a series of good ballet pieces.
> I called him and I said, "This is Emily Genauer. How are you? Blah,
> blah, blah," and then I said, "Look, I have two tickets for the ballet to-
> night at the Metropolitan Opera. It's the first performance of the Rus-
> sian ballet in this country. My husband can't accompany me, because
> he's been called away on business. If it would interest and please you,
> perhaps you'd like to come with me." He hesitated for a moment, and
> then he said, "Can we have dinner first?" And I said, "No, thank you.
> I'm having dinner at home with my child, but I'll meet you outside of
> the opera." He was there and had a wonderful time. When we left the
> opera, he said to me, "Your house or mine?" I looked at him as if he
> were mad and said, "Come on, you're pulling my leg." He said, "No,
> but I'd like to." So I said, "You've got to be kidding. Don't you believe
> what I told you? I got your name out of the last Whitney catalogue. You
> were represented by a ballet picture, and I remembered you did ballet
> pictures, so I asked you to come with me." And he said, "Well, I'm
> sorry if I hurt your feelings, but you are attractive and I thought per-
> haps we ought to be better friends." I replied, "Perhaps you're right,
> but I'm not sure anymore." So he said, "Would you have a cup of cof-
> fee with me?" and I did, he took me home and that was that.

Genauer is indeed, a small, dark attractive woman with a full, clear
voice. Her residence is a relatively modest but spacious townhouse on
the upper east side of Manhattan. Within the modernist, straight lines
and airy spaces of the architectural structure is rather heavy, ornately
decorated pieces of furniture, and of course, works of art. Her self-
sufficient attitude is apparent as she talks about a collection that she has
purchased rather than accepted as gifts unless the particular piece was
relatively small in scale or intimate in nature. There is an early David
Smith sculpture for which she paid $250, and other three-dimensional
pieces by Henry Moore and Nevelson, plus paintings by Larry Rivers,
a Ben Shahn sketch, drawings by Reuben Nakian and Pereira, and a
piece by Chagall. Her collection is reflective of her taste for art by Ameri-
cans that is abstract but retains figurative connotations.

In a number of articles spanning her career, Genauer reflected on
and analyzed the function of her profession. In a piece entitled "Criti-
cal Look at the Art Critic" written for *House and Garden* in 1957, she
posited her position on her profession.

I point out that the art critic is not a shopping guide, that he exercises not economic power but influence. A cross between torchbearer and teacher, he sees his function as helping to create a large and sympathetic popular interest in, and understanding of, art at a time when the public has more leisure to look and more money to spend but is confronted with an art grown so bewilderingly complex as to seem utterly removed from common experience. Criticism, though never written for artists, becomes, I add, an important service to them anyway. By helping to develop a sympathetic climate for the artist's work, it makes it possible for him to function as a part of society rather than as an embittered exile whose art is likely to become almost definitely obscure to the public which has ignored it.[32]

She concluded this article with a reiteration of her recurring and consistent emphasis on education in the arts. "Most of all, the critic must understand that the purpose of all his criticism is not to direct the artist in his production or to affect his economic welfare, but modestly to give his readers enough information and insight so they may develop their own knowledge and enjoyment of art." In 1965, she wrote a piece in the *Tribune* in response to an analysis of the critic's position written by Harold Rosenberg. She called it "Critics' Anxieties" and in it she stated:

We are craftsmen (although sometimes, in our more wildly ambitious and wistful moments we fantasize ourselves as functioning closer to the areas of creativity than some of those responsible for what we have to look at). And our greatest anxiety is to be interesting, to treat seriously, passionately, even evangelically, with a serious subject and yet not be pontifical: to write with dignity and knowledge, and yet with lightness; to make clear, without using definitions that will seem offensive to some readers things which will be unfamiliar to others; to be able, without sounding like revivalists, to communicate our own excitement to an audience which may not yet share it, and to bring to readers who do something more than the latest news and gossip.[33]

In the mid-1960s, she reiterated her view of the critic's educational function in terms of her/his selections of artists as individuals or in groups.

Have critics' and juries' choices no value, then? Sure they have, but only as the subjective selection of people who have looked at more art than the general public, find a particular group of artists or works most stimulating at a given moment and are able to explain why, with sufficient clarity for readers to be able to check the verdict against their own reaction. The aim is not to expand the critic's ego or investment but the reader's and viewer's experience.[34]

Of course in the above quotes and other instances, she was careful to explain her contentions to her readers. She also literally attempted to

educate her readers through verbal descriptions and interpretations of individual works. She guided her reader to new understanding and insight throughout her book, *Best in Art*. One example is found in her discussion of a painting, *For Internal Use Only* by Stuart Davis.

> In the looking one can find one's own visual adventures and pleasures, pleasures which find their psychological atmosphere in the "New York immediacy" of Davis's initial and intuitive concept but stem from his rational and conscious development of every line, dot and area in his picture. One can relish Davis's skill in always maintaining his pictorial equilibrium, so that where color "recedes" in one passage it is brought right back in another; in his adeptness in never permitting the color movement to stretch so far that a "hole" develops in the composition. One can savor the subtle balance Davis establishes between complex pattern in one section of the canvas and flat color areas in another (as, for instance, between the white area figured with vaguely Chinese motifs in the upper left-hand portion of the canvas and the bold, red area, traversed with two broad blue bands, at the right). One can enjoy the deftness with which the artist directs the spectator right through every part of his picture, much as if it were a picture-puzzle maze with no blind alleys at all, only pauses for pleasure in its structural complexities.[35]

Genauer, like other critics of her generation, could not be judged on a contemporary basis or in terms of her affiliation with a particular style or group of artists. She did not champion certain groupings or theories such as that of Abstract Expressionism, nor did she feel compelled to associate herself with some category. She must be considered in terms of her milieu and in this sense her contribution was a major one in view of her support for American art of an abstract nature and because of her continuing efforts to increase the numbers of an appreciative audience for the arts. She did this in her own inimitable and lively manner that attracted readers to her columns and articles and did thereby further the interests of American art.

2
Marian Willard

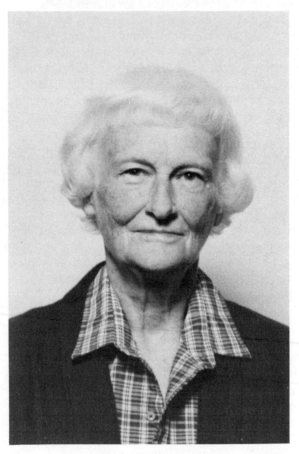

Photo: Courtesy of Marian Willard.

When Marian Willard opened her gallery 46 years ago, it was with a quite definite and unique concept of art in mind. She had been inspired by the dual experiences of lectures on psychology by Karl Jung and of paintings by Paul Klee. Essentially, she believed that Klee's work embodied the theories of Jung and that the art possessed a content particularly appropriate for the twentieth century. Later she came to feel that oriental philosophy and religion, particularly Zen Buddhism, offered insight applicable to the modern era. During the course of her career as a gallery dealer, she was attracted to abstract art that she perceived as having a deeper-than-surface meaning.

Her view of art was almost exactly opposed to the popularly accepted, objective theory of art developed by Clement Greenberg. Over the years from the 1930s through the 1960s, her more intuitive ideas about art were neglected in favor of a view of art as a matter of confrontation with an object possessing particular material characteristics. It really wasn't until the art object was "dematerialized" and intellectualized via Conceptual Art beginning in the late 1960s and rejuvenated with emotional values during the course of the women's movement that content apart from the visually apprehended physical nature of the object made a respectable reentry into critical definitions of art.

Actually, some artists along the way, such as those of the Abstract Expressionist grouping thought of their art as having universal, subconscious meaning, but like those of Willard, their views were all but overlooked in favor of the more tangible notion involving formal criteria of judgment in art. The precepts of Greenberg and others were rooted in the objecthood of art, rather than any kind of immaterial, spiritual value. As such, Greenbergian ideas were no more valid than other approaches to art, but they certainly were more pervasive in the art community. Because of the overwhelming influence of Greenberg, opposing views such as that of Marian Willard were largely overlooked. A subjective view of art such as that held by Willard should be reevaluated on its own terms and her contribution granted long overdue recognition.

Willard's background was not especially conducive to establishing a life in art. She was born on April 20, 1904, to parents who were not particularly interested in art or in their daughter becoming involved with it. Her father was a real-estate agent and her mother a housewife. She remembered that they gave her a twenty-first birthday party and told her to buy herself a present. Her choice, a print by Picasso from his Blue Period was the object of ridicule from both friends and family members. She did, however, recall one incident of passing interest in modernist

art shown by her grandmother. She recollected with amusement the astonishment she felt when her grandmother was attracted to a broken blind that had been appropriated for some assemblage work put together around Christmas time at an early Willard Gallery. "Here's this old-fashioned lady who was living in the lap of luxury and calling sculpture 'statuary,' taken by this blind!"[1] This particular instance of interest was the exception rather than the rule when it came to her family's appreciation of abstract art. Willard did not enroll in college, but attended Chapin School in New York City where she had a few courses in art history. Later, accompanied by a friend, she traveled to Italy where she began to independently see and study art. The term self-educated could be well applied to Willard, because she certainly devised and directed her own curriculum and its content.

As early as the late 1920s she had independently begun to associate the theories of Carl Jung with art. In 1935, she took it upon herself to travel to Zurich and there attended lectures by Jung for a summer. She was the guest of Carola and Sigfried Giedion in whose home she read in the afternoons after having attended Jung's morning sessions. She recalled with amusement her disagreements with the Giedions who were steeped in a Freudian viewpoint. She returned two years later for the same purpose and also went to see Paul Klee because of her admiration for his work. Aided by $1,000 her mother had given her to help with the trip, she bought six paintings from Klee. Within this period, she also bought a small sketch from Henry Moore during a stay in England. She felt that Moore was another artist whose work embodied Jungian ideas or the more psychological significance she was searching for in art.

Artists' work, particularly that of Klee, appealed to her as it personified the theories of Jung or as she put it, "...taking the unconscious into the conscious and coming out with a different kind of symbol, something for our day." Her association of psychological thought with American contemporary art was quite unique. In Europe, Surrealism had become a potent force, but by and large, American artists were involved with representational art involving native or regional themes and content. In spite of the singularity of her ideas, Willard tenaciously held to her interest in the interconnecting relationships between art and a universal significance.

In 1936, she decided to open the East River Gallery at 358 East Fifty-seventh Street on the basis of a rather novel concept. She established a rental gallery where people might borrow art work and later, should they decide to keep it, could apply rental fees to the cost of the piece. Although this enterprise was not particularly lucrative, it did put her in touch with artists and others interested in the arts. Within a short time, she began to think about working with particular artists in the context of the accepted gallery-artist relationship. In 1938, she joined J. B. Neu-

man in his gallery on Madison Avenue in order to learn more about the gallery business. Two years later, with the aid of a $7,000 trust fund established for her by her parents, she opened a tiny gallery space at 32 East Fifty-seventh Street and called it the Willard Gallery. At this time, she was unmarried and 36 years of age. She recalled this period in the late 1930s as one of limited public interest in art. The most positive factor was the Works Progress Administration's tremendous influence in terms of support of artists and their works.

Naturally, when she opened her gallery, she chose to show Klee's work. She was not the first to exhibit his work in America, but certainly in the late 1930s it was a bold move. To her, Paul Klee's inner vision paralleled Jung's interest in a human subconscious. His theories of images and symbols common to a "collective unconscious" related to Klee's "inner voice" that conveyed "ultimate mysteries" dependent upon his own receptivity to intuitive, subliminal signals. Klee's work had a spiritual, symbolic feeling that seemed psychological in its import. Klee's own statement, "Today we reveal the reality that is behind visual things," reflected a northern European cultural tradition and appeared to coincide with Jung's belief in the symbol-making activity of the human unconscious.[2]

Willard's interest in abstract visual forms was directly related to her apprehension of content in them. To her, abstract forms were relevent to basic elements of human existence. She accepted abstraction not as a deviation from reality but as symbols for the very essence of life. Mere description of reality was not as meaningful or relevant as signs for a deeper, less apparent being. Thus, at an early date, she supported abstract art as it represented a more absolute and universal significance rather than as a part of an evolutionary process in the course of modern art.

David Smith's abstract sculpture also constituted one of the first shows at the East River Gallery. She recalled, "I was working with David Smith from the very beginning, and we sold practically nothing of his work. But I believed in him all the way up and down the line. Later in the fifties his things got enormously big, and I could't handle his work at that point. At the time, he was casting aside all his relations and friends, and I was among them." Smith's eventual place in contemporary sculpture proved to be substantive, but her view of his importance differed from that of critics who saw his work in terms of its visible apprehension as form. It should be noted that when Smith was showing his work in Willard's galleries, he was working primarily with imagery abstracted from nature but still related as organic shapes. This early phase involved Surrealist influences, and the resultant sense of content was undoubtedly what attracted Willard to his work. It was she who brought the work of this distinguished artist to public attention, and subsequently, Smith became respected as America's premier sculptor.

The work constituting other early exhibits at Willard's gallery also tended away from visual description toward abstract forms possessive of a more symbolic potential. One such show consisted of work by Lionel Feininger, which Willard had been introduced to by his son. Feininger at the time was still living in Europe, and she exhibited his work here. His position in art at this point was also one leading from representational to abstract art. In addition, she showed paintings by a woman, Loren MacIver, during these early years when the artist was concerned with mystical, poetical symbols for natural or man-made phenomena.

Other artists whose work she handled were Richard Pousette-Dart and Vieria da Silva. Paintings by both of these artists exhibited Willard's preference for work of an insubstantial image and subliminal meaning. Among the several artists who interested her, Pousette-Dart became within the last year, the subject of critical attention and acclaim particularly as his work consisted on nonobjective form and an immaterial content.

In 1940, Willard met her prospective husband, Dan Johnson, who went into the gallery business with her and two years later they were married. When they began to raise a family, they shared child-care responsibilities in terms of alternately staying where they lived in the country and later supervising children in an apartment adjoining the gallery.

In the 1940s, Willard took on work by Mark Tobey and Morris Graves, who in her words, ''. . . were on the West Coast which is as far as you can go before you get to the Orient.'' Paintings by these two artists were based on an intuitive recognition akin to the subjective, mystical aspects of Eastern religious thought. She began to spend a great deal of time in her ''second home'' in Seattle, Washington. Eventually, she also showed work by sculptor Philip McCracken. These artists, particularly Tobey and Graves, were concerned with the metaphysical sources and implications of their work and the paintings of each possessed a spiritual content and aura.

Although she was not particularly concerned with the novelty of showing artists outside of New York City, it was nevertheless unusual at that time, and still would be exceptional, to show work from out-of-towners. Even since the ''New York School'' became celebrated for the establishment of American preeminence in art, these two factors, namely New York City and leadership in the arts became synonymous. Artists who lived and worked in ''the city'' automatically partook of some of the mystique of superiority. Practical reasons for dealers based in New York to show work by indigenous artists involved the cost factor for shipping and the fact that greater contact with the artist could be maintained by the dealer. Recently, more gallery owners have shown work by artists living outside New York, but certainly, Willard was a pioneer in her early support for West Coast artists.

As Willard developed her gallery business, she also cultivated her own view of American abstract art. As she put it, "If you're searching for something, and you have a particular area in which your interest lies, I think you automatically turn to things, or things sort of come to your attention and develop, and slowly, if you don't force it too much, they become cohesive." Her approach itself was intuitive. The key element in Willard's thinking was her alert but passive pursuit of knowledge in a manner that seemed related to Eastern thought.

Willard was primarily concerned with the import or expression available through a use of artistic form. In her own words, she was interested in "...what struck me as having that kind of content or meaning or whatever you want to call it. This was what I was looking for, and you don't often find it, but once in awhile you do." Although her words did not express the exact essence she sought, they conveyed her more relaxed and less forced program foreign to the assertiveness of Western enterprise. Hers was not a defined theory but an attitude based on a belief in art that contained a meaning germane to human existence. Willard was not nearly as interested in selecting an incumbently important artist or an emerging form of expression as she was in discovering work that to her had a more universal meaning and larger significance.

Her affiliations with oriental philosophies were not only directly concerned with art work she showed in her gallery. In 1959, she became affiliated with the Asia Society and chairperson of the programming committee that organized and sponsored exhibitions of Eastern art in New York. In the early 1940s she met Alan Watts who shared her interest in linking art and content which was the thesis of his book, *The Spirit of Zen; A Way of Life, Work and Art in the Far East*, published in 1958. They became good friends, and she remained his supporter until the time of his death.

In 1962, Stuart Preston wrote in the *New York Times* a review of the twelfth anniversary of a Willard gallery. He characterized her taste for work as "...exhibiting an interest in complex, poetic, semi-abstract, usually small scale, leaning toward esoteric interpretations of nature or of intellectual themes."[3] He went on to observe that she preferred art without figures and that in general, it had a "slightly inhuman" quality. Apparently, Preston associated "inhuman" with a departure from representational art and a concern with intangible facets of reality. When read these excerpts from Preston's piece, Willard expressed her general agreement with Preston's description. Preston's summary was reflective of several reasons which when combined, contributed to a lack of attention paid to her more philosophical aesthetic. Until recently, American mainstream art and society in general during the second half of this century displayed great enthusiasm for large-scale productions and art as an object composed of certain recognizable formal factors rather than as a reflection of content that was at once undefinable and immaterial.

As she resolutely pursued what might seem to be a specific or particularized course but what actually embodied a quite indefinite and expansive content, other dealers were attentive to issues of form, degrees of abstraction, and speculation on the avant-garde nature of the art they showed as it might be acclaimed in future judgments. Her artists and her aesthetic were extraordinary during a time of successively fashionable "isms." Among her colleagues, Willard's approach was unique in terms of her notion of a relationship between American abstract art and a kind of psycho-philosophical meaning.

In spite of her long and illustrious career, she remained relatively unknown. Her view of art was different from the widespread acceptance of formalist doctrine. Problems of visibility and opticality pertinent to Greenbergian thinking did not impress Willard. A more universal, archetypal content found in visual forms or symbols interested Willard, and it didn't matter to her whether she found it in New York or Washington. Reflecting upon this situation, Willard said,

> The fact that Tobey and Graves were not members of the New York School was a great detriment in the advancement of their causes because they were *ignored* by the press and by the people who were promoting the New York School. They didn't come down and fraternize, because they didn't belong here, and I think it kept these artists from getting a lot of recognition that I feel they deserved.

Willard's ideas had little chance for recognition as they were concerned with a subconscious meaning in art rather than externally apprehended criteria.

In spite of her stance outside the main currents of modern art, Willard did establish a successful dealership. However, in 1974, the youngest of her two daughters, Miani Johnson, expressed an interest in entering the business, and her mother was "delighted" to turn over the reins.

Today, Willard is a tall, long-limbed blonde with clear, bright eyes. Her dress, manner, and bearing are direct and simple, dignified, and elegant. Presently, she only spends approximately one day a week in the gallery. She feels that her daughter, who has chosen to show work by such successful and well-known artists as Ralph Humphrey, Lois Lane, Kenneth Price, Judith Shea, and Mia Westerlund is doing a good job in a new art world in which she is less comfortable.

> It's much more of a business-like affair than it was. In the old days you could count on a handful of people who might be interested in what you had, and then you'd find the gallery next door had the same handful interested in what they were showing. There were interesting collections being formed then of artists, in depth, let's say. Now I think it's more a sample of this, and a sample of that. You know, this busi-

ness of being *au courant* with what's happening and maybe not as personally involved. I remember some collectors would come in year after year and ask to see the recent work of an artist in whom they were interested. You built up a clientele that way.

The situation Willard described would not seem conducive to her deeply felt, subjective approach. Perhaps it could even be said that at no time within the modern period of trends and styles would Willard's highly original course have found an enthusiastic reception. Nevertheless, she supported some highly important artists. Moreover, her contribution consisted of just that singular course in searching for art with content corresponding to her independent sensibility and view of art.

3
Katharine Kuh

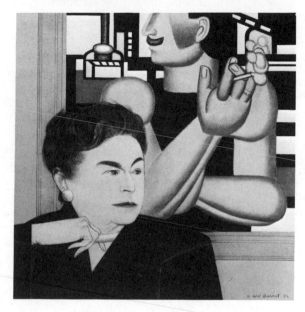

Courtesy of Will Barnet: Photo by Otto E. Nelson, New York.

As a gallery owner, museum curator, art consultant, and art critic, Katharine Kuh supported modernist art of American and European origin. Her interests have ranged from Western art (both past and present) and American Indian art of the northwest coast to Pre-Columbian art of Latin America and Far Eastern Indian art, particularly that connected with the Buddhist religion. During the course of her long, illustrious career, Kuh befriended many prominent artists and others associated with the art world. Her influence has been dependent upon her discriminating taste for modernist art that has resulted in pioneering exhibitions and articles as well as additions to important collections.

Her home is an upper east side Manhattan apartment that is somewhat sparsely furnished. The space seems adapted equally for living and for exhibiting Kuh's art collection which consists of work by Arthur B. Davies, Hans Hofmann, Wassily Kandinsky, Paul Klee, Willem de Kooning, Gaston Lachaise, Fernand Léger, Lenore Tawney, and some examples of Alaskan Indian art. Most of the objects are gifts from artists, except paintings by Kandinsky, Klee, and Miró. It is appropriate that her living quarters contain the art to which she has devoted her life.

The Kandinsky, a landscape painted in 1909, was purchased for five dollars (!) at an auction of the Arthur Jerome Eddy collection in Chicago around 1937.[1] At this sale, she bought a total of ten oil paintings for $110 and sold nine to help support the gallery she had opened in this city. Borrowing money from her friend Daniel Cotton Rich, who had accompanied her to the event, she bought two Kandinskys from a skeptical auctioneer who referred to them as "Timpanskys"; a large, early Man Ray that she later gave to the Whitney Museum; a Gabriel Münter; and four Jawlenskys. These pictures were among the first purchased by Kuh who was later to choose work for the Chicago Art Institute, for the collection of the First National Bank of Chicago, and for several other institutions, such as the University of Southern Illinois and the Crocker National Bank in San Francisco. Throughout her career, she has shown an unerring eye for quality work. Her influential and distinctive choices have become part of public and private institutions for the pleasure and edification of large audiences.

Kuh's first interest in art was aroused as a child of ten years when she was afflicted with polio. Her father had collected prints of old-master works and felt that a suitable preoccupation for his stricken daughter was to catalogue his collection. Years later, while attending Vassar where she majored in economics Kuh heard about a new, young professor who was teaching art history. Subsequently, she enrolled in Alfred Barr's course in Italian Renaissance art. Barr left shortly thereafter, eventually to begin his distinguished work at the Museum of Modern Art, and Kuh went on to the University of Chicago where she received a master's degree in art history. Unsatiated, in 1929, she enrolled in a Ph.D. program at

New York University. In order to finance her education, she helped write bills for the American Association for Labor Legislation. This full-time employment allowed her to take only those courses offered at night. She continued this until 1930 when she met and married George Kuh. When this marriage was dissolved, she entered the professional art world by opening a gallery in Chicago in 1936.

Although not particularly supportive of contemporary feminist concerns, she did remark about her career, "Everything I think I've done has been women's lib, before women's lib." Certainly her pursuit of a graduate education in art history and her decision to open an art gallery were bold steps for a young woman during the second and third decades of this century. As her circumstances would have it, the conventional and accepted institution of marriage proved unworkable and prompted her untraditional solo venture into a business of her own. Upset about the divorce, Kuh consulted a psychiatrist. According to her the crux of their interchange came when he asked her, " 'Now that you're free, what is the one thing that you want to do most? What do you really want to do?' I said, 'I want to start a *modern* art gallery in Chicago.' He said, 'Do it!' " In addition to the psychiatrist's advice she received full endorsements from her family. They continued to pay medical bills connected with a back condition resulting from her childhood disease, but they did not give her financial aid to open the gallery. Much more important to her was their "tremendous moral support." In particular, Kuh cited her mother: "She was a great believer in my doing things. She encouraged me in this kind of thing." The decision to open a modern art gallery within the context of a conservative and even hostile Chicago environment was undoubtedly an act of courage, and the venture did not prove easy or even eventually acceptable. Nevertheless, until America entered the war, Kuh doggedly maintained her modernist outpost in mid-America.

She earned the monthly rental fee of $50 for her establishment located on Michigan Avenue in the Diana Court Building by teaching classes in art history at the back of the gallery. During the summers from 1938 through 1940, she pursued a pedagogical career as a visiting professor at the University School of Fine Arts in San Miguel de Allende, Mexico. At this early stage, Kuh succeeded in combining her love of art history with a business enterprise. Her enthusiasm and interest made up for a lack of staff. "I didn't have a secretary, I did everything. I addressed the envelopes. I brought my lunch from my little apartment. It was a great adventure!" She added that she was constantly attacked by newspaper critics, and in the course of one modernist show a few ultraconservative individuals smashed a window of the gallery.

The fare Kuh offered in her gallery was extraordinarily avant-garde for the depression era in Chicago. Each year she exhibited Paul Klee's

work which she called "closest to my heart," and she had shows by Léger, Kandinksy, and Miró. There was no problem making contacts and arrangements with these artists by mail. "They were dying for outlets." She gave Josef Albers his first show in the United States and among young Americans, she exhibited work by Chicagoan Ivan Albright, Charles Biederman, and Stuart Davis when they were little known. According to Kuh, at this time Davis "...was near to starving. I couldn't sell a picture, and it made him mad, but I tried."

Not only did she exhibit art unique for that time and place, but she herself did not exactly fit into the extant art world. She remembered a New York dealer, Karl Nierendorf who handled Klee's work, coming to her gallery.

> I was not a very auspicious looking dealer. I was young and sitting there with my hair down. He said, "Oh, I was looking for Mrs. Kuh," and I said, "I'm Mrs. Kuh." "Oh, don't tell me that," he said, "No wonder you don't sell anything. My heavens, you've got to look like a dealer, dress up, fix your hair. You've got to look like an entrepreneur." I never did.

Kuh did not conform personally or professionally to the art world of the 1930s. Her aims and goals reached far into the future.

Mostly, Kuh waited for out-of-town visitors to her gallery. "There was no one who would show Klee in Chicago. Who would exhibit Kandinsky's work? It was unheard of. They showed French Impressionists in Chicago, and that was considered *very*, very advanced." She had only two customers who bought Klee's work. One was a noted architect Mies van der Rohe—"...in that fine, deep voice of his, he'd say 'wunderbar' " and the other was Claire Zeisler, a since highly acclaimed weaver.

In 1942, she closed the gallery because she was no longer able to keep in touch with European artists during the war.

> After I closed it, I didn't have a job right away, and people said, "Oh, you ought to be more socially conscious. Stop this art business. They need you to work at the public venereal disease clinic." So I went there, attended three weeks of classes and just hated it. I was supposed to start working with prostitutes, but they fired me. I was too curious, too concerned.

Temporarily out of work, Kuh was shortly thereafter offered a job at the Chicago Art Institute in the public relations office. "So then I went to the Art Institute, but I never had the freedom, I never had that *alive* feeling of freedom that I had when I had my own gallery."

In 1945, she was appointed editor of the *Bulletin of the Art Institute* and director of the Gallery of Art Interpretation. In her position as editor, Kuh wrote essays on the Mexican printmaker Posada in 1944 and on Marc Chagall and Gaston Lachaise the next year. These pieces were

written in connection with institute acquisitions. The Gallery of Art Interpretation was the unique and innovative "brainchild" of Kuh and Rich, then director of the institute. Mies van der Rohe designed the gallery without fee, and in her piece, "Seeing is Believing" for the Art Institute periodical, she described the purpose of the gallery as "showing rather than telling."[2] The intent was literally to assist people in developing an understanding of art via abbreviated, but explanatory wall captions couched in nontechnical language. "It was the only one of its kind in the world," according to Kuh, and it attracted national attention in terms of an article in *Newsweek*, appropriately titled, "Interpreter Kuh."[3] This piece was prompted by a gallery display in connection with a huge Cézanne show put on by the institute and the Metropolitan Museum in 1952.

Her book, *Art Has Many Faces, The Nature of Art Presented Visually*, published in 1951 by Harper, was an outgrowth of her work in directing the gallery. The aim behind both endeavors was to cultivate more knowledgeable viewers. In the first two chapters, she discussed the variety present in nature and art and multiple approaches applicable to any subject matter treated in art. In subsequent sections, Kuh explained the artist's use of form and materials. In this first part of the book, she chose visual examples from all periods of art history. The following synopsis of factors she had discerned as influential on twentieth-century art were illuminated by illustrations of modern art and included topics such as: "The Machine," "War," "Psychoanalytic Thought," and "The City." Toward the end of the book, she stated her belief in Klee, Piet Mondrian, and Pablo Picasso as the "three most significant artists of the first half of this century."[4]

In 1953, she was appointed curator of modern painting and sculpture and four years later she became curator of all painting and sculpture. At this point, she closed the Gallery of Art Interpretation because of her extensive curatorial duties and responsibilities. In these positions of authority, she managed to make several important additions to the institute's permanent collections. She added six Picassos, numerous Légers, a large Matisse, Picabia, a large, late Monet, de Kooning's "Excavation," a Pollock, a large Rothko, several sculptures by David Smith, a three-dimensional work by Matisse, and a *Balzac* by Rodin. She knew Katherine Drier, a collector of experimental art and was instrumental in arranging a gift (a sculpture by Brancusi) from her estate to the institute in 1955. Undoubtedly, she made some outstanding acquisitions for the institute, but not without considerable dissension and resistance from trustees who were dubious about and unfamiliar with the value of modern art. A case in point involved a saga of her adventures that she tells in connection with obtaining a large painting by Picabia.

> Around 1950, I went to Europe to buy paintings, and while I was there, I went to a couple of galleries and in one I saw an unstretched Picabia.

It was big—huge. It was on the floor, unstretched and not in the best possible condition, but it was a *marvelous* painting. I asked the price and they said it was $5,000. So I cabled back to Chicago. They replied that they didn't want it, even though $5,000 was all they were asking for it. When I got back, I said I wouldn't go on another trip to Europe unless there was an agreement that I could buy anything up to $10,000 without going through the trustee committee. I had given up the Picabia, but I told the dealer that I loved it and thought it was a disgrace that we hadn't bought it—and that I thought it was a bargain...which it was.

So then I came back home and forgot about it until one day I got a letter from Fritz Glarner. He wrote, "We've never met, but I've heard you're a great admirer of a painting by Picabia. I now have it—it's in my hands. Would you still be interested?" I wrote back and said, "Yes, I'm coming to New York, and if it isn't sold, I *certainly* would be interested." In his small studio, the painting which was no longer unstretched, filled the whole wall at the end of the room. I said, "Ah! It's even better than I remember!" He said, "I have to tell you the price is doubled. It's $10,000 now." So I went back and pleaded with our people, and they turned it down. They wouldn't buy it. So that was the end of that for a while.

Then I was doing an exhibition of work by Léger, and there was a collector here in New York who had some rather fascinating watercolors by Léger. I arranged to see them and borrowed two of the very best ones. At this point, he said, "Mrs. Kuh, I know all about you and the Picabia painting. Would you like it?" He now owned it and was not able to put the large painting in an appropriate place, and he didn't want to give it up. He said, "Because you really are fond of it, I'd like to lend it to you." So I said to Dan Rich, "You don't have to ask those idiots about this do you?" He said he didn't and after about ten years during which the painting was on loan to the museum, I wrote the man and asked if there was any chance he'd give it to us. He did, and that's how we got it, but even then the committee accepted it less than enthusiastically.

Having to answer to trustees made her feel restricted and unhappy and a year after Rich left, she resigned.

In the course of her 17-year tenure, Kuh was involved in a variety of innovative activities, some related to and others accomplished outside of her work at the institute. In the latter vein was a trip to Alaska in 1946 for the purpose of conducting a survey of Indian totemic carvings for the United States Office of Indian Affairs. During the course of this trip and four others to this region, plus considerable travel in the Southwest and Latin America, Kuh developed American Indian art as a special area of expertise. In 1947, she and Frederick Sweet organized the pioneering "Abstract and Surrealist American Art" show, and two years later, she initiated an exhibit of the Walter Arensberg Collection of work by avant-

garde artists, such as Marcel Duchamp and Picabia. The exhibit lead to an article, "Four Versions of Nude Descending A Staircase" published in the *Magazine of Art*. Her approach to a controversial subject was both informative and supportive. She wrote that this series of paintings had been made the "victim of absurd negative publicity" and attempted to convey some sense of its "psychological content." At this early time and before America's enthusiastic embrace of Duchamp's work, Kuh wrote, "Probably no artist since Leonardo has been so concerned with philosophical and technological experiments."[5]

In "Chicago's New Collectors," published in *Art Digest* in 1952, Kuh pointed to a lack of support for Chicago artists and of the Chicago Art Institute.[6] In this piece and others she was critical of the art-going public, particularly in terms of their reception of modern art. Nevertheless, she wrote a highly supportive article on Midwestern art and artists, "The Midwest—Spearhead, Chicago" that appeared in a 1954 issue of *Art in America*.[7] In this piece, Kuh denied the presence of regionalist tendencies and extolled a new and indigenous Expressionist style she found at the time in work by artists such as Byron Burford, Rudy Pozzati, and Harold Tovish.

Kuh had shown work by Léger in her own gallery and had become good friends with this artist. She was his early supporter, and as a result the midwest was offered a look at Léger's work in advance of his recognition in other parts of the country. In 1953, she organized a large retrospective exhibition of the artist's work at the institute, an early if not the first comprehensive showing of Léger's work in America. Subsequently, the exhibit traveled to both coasts via the San Francisco Museum of Art and the Museum of Modern Art in New York City. In an article for *Arts and Architecture* and in the catalogue for the show, Kuh expressed her view of Léger as, "...one of the great protagonists of twentieth century life, a man so steeped in the world around him that his art cannot be separated from contemporary vision."[8] In keeping with her educational aims at the institute, she directed her essay toward students of art and laymen.

An honor accorded her in 1956 was an invitation to organize the American section of the Venice Biennale International Exhibition. She chose the theme, "American Artists Paint the City," and included Lyonel Feininger, Edward Hopper, Franz Kline, Willem de Kooning, Jackson Pollock, and Mark Tobey among others.

After she had left the institute in 1959, another friend, James Thrall Soby recommended her for a position as critic with the *Saturday Review*. As a writer for this magazine, Kuh's essays reached an extensive section of the American public for the next 18 years. Her national reputation was secured and she subsequently accepted numerous offers for lectures, teaching jobs, curatorial work, and consultation. Among her early arti-

cles was "Grandma Moses" of 1960 on the occasion of Moses's one hundredth birthday. Considering her readership, Kuh boldly questioned the prestige of this particular artist beloved by the American public. She wrote, "Too often we tend to romanticize the mediocre art of colorful people, identifying it with their more notable accomplishments."[9] When asked about this piece, she commented, "I thought she was just a nice, old lady, but a terrible artist. And of course, Norman (Cousins) was horrified, because he loved her." In another piece, she expressed her negative view of the work of Andrew Wyeth.[10] "Norman was horrified about Wyeth too, but he published anything I wrote. Some of the readers were furious!"

Also of 1960, was an interview with Mark Tobey for *Saturday Review* and another with Lipchitz for *Art News* in 1961.[11] Other interviews with artists constituted her book, *The Artist's Voice: Talks with Seventeen Artists* that Harper published in 1962.[12] Some of the others she talked with were Albers, Albright, Duchamp, Hofmann, Lipchitz, Alexander Calder, Naum Gabo, Franz Kline, Isamu Noguchi, Georgia O'Keefe, and David Smith. In the latter instance, Kuh pursued her earlier interest in this artist. Other pieces she did for *Saturday Review* included "Art in America in 1962, A Balance Sheet," in which she expressed her doubts about some contemporaneous art which she found lacking in "content and meaning" and her disapproval of certain museum operations.[13] Her own experience with her gallery and at the institute caused her to disapprove of influential trustees as decision makers, administrators who were more concerned with business operations than aesthetic choices and of exorbitant prices paid for certain works of art. She prided herself on knowing how and when to buy, and throughout her life remained critical of anyone who had not cultivated her art-market savvy.

Her expertise as a buyer was recognized by Gaylord Freeman of the First National Bank of Chicago when he invited her to become art consultant for the bank in 1968. Her first reaction was negative. In fact, she told him that at that point she wanted to spend the rest of her life enjoying what she did, "And, frankly, teaching you kindergarten is not something I would enjoy."[14] She did, however, eventually agree to work for the bank, assembling a collection of some 2,300 pieces by 1979. Her work with the bank pioneered the area of corporate consultation. As it turned out, she "loved, absolutely loved, working for the bank. They gave me freedom. I didn't have to bicker all the time about money, about what was modern and what wasn't modern, and they sent me all over the world." On these trips she made purchases for the bank's main collection and for branches. In addition, she wrote on art that she found in various parts of the world for *Saturday Review*. For example, "Mystifying Maya" concerning the art of Mexico appeared in 1969. In this article she concluded her observations with, "In Yucatan, what we do not

know is as engrossing as what we do know."[15] The year before she wrote on the art of Ireland,[16] in 1966 she examined the art of Israel,[17] as well as returning to her previous interest in American Indian art,[18] and in 1963 Russian art was the topic of another thorough examination of this facet of the cultural heritage of another nation.[19]

In 1964, she was invited to organize what she called the "Hudson River Show" for the New York State Council on the Arts.[20] The exhibit occupied the state pavilion at the New York World's Fair. This monumental undertaking involved research into and selection of work representing American art of the Hudson River region from the eighteenth and nineteenth centuries. Kuh chose 50 paintings, almost all of which were illustrated in the catalogue and accompanied by short descriptive and historical notes. Her insight into this area was exemplified by her contention that a great deal of this early American art was characterized by "an unlikely combination of austere realism and romantic moralism," and concluded her essay with this observation:

These early artists were faced with the constant struggle between a yearning for self-discovery and a traditional dependence on Europe. Not unexpectedly, the very men whose work today seems strongest were often the ones who struck out on their own, impressed by the glories of their homeland.[21]

Throughout her journalistic and curatorial careers, Kuh was concerned with an overall or comprehensive view of modern art as well as its individual manifestations. A case in point was her book, *Break-up; The Core of Modern Art* in which she characterized art of our century by a "consistent emphasis on break-up."[22] Her urge to synthesize could be traced back to her pedagogical involvement with the Gallery of Art Interpretation as well as her own beliefs about an appropriate approach to art. Early on in this volume, she pointed to Cubist dissolution of form in depicting modern life, to Surrealist "break-up of chronology" and to Abstract Expressionism with which "everything is shattered." In subsequent chapters she dealt with the break-up of color by Impressionist painters, break-up of pigment by certain artists such as Francis Bacon and Vincent Van Gogh, break-up of form in work by Cézanne and in the development of collage, break-up of content exemplified by the oeuvre of Klee, break-up of space by Robert Delaunay and others, and the break-up of design and surface by Kandinsky, Tobey, and Abstract Expressionist artists. Kuh's unique view of the sources, processes, and developments of art added another dimension to understanding the modern era.

Kuh's approach to writing reflected her own broad view of art. Her examination of art and artists was not narrowly confined in terms of artists, styles, or critical means. At times she displayed her tremendous

feeling for art as in a piece on Clyfford Still for *Vogue* magazine in 1970.

> Still deals with painted imponderables. Space becomes a yawning void in which volumes sweep upward with such tense velocity as to exaggerate the boundless areas they move through. This invented geography of the mind is an interrelated experience. No one element lives alone. No colour, no brushstroke, no void, no surface detail is separate from the whole.[23]

Most often she attempted to place artists from various periods within the larger context of their societal or cultural milieu. This was evident in the various divisions of her book, *Break-Up* and in another volume appropriately titled, *The Open Eye: In Pursuit of Art,* appearing in 1971. The latter epitomized her ecompassing view. An opening section called "People," included essays on such diverse personages as Duchamp, Rembrandt, Wyeth, Ivan Albright, Walter Arensberg, Alfred Barr, Eugene Delacroix, Laszlo Moholy-Nagy, and Mies van der Rohe. Though varied, her choices reflected the sophisticated and intrepid taste of an expert who was not interested in specializations or categories. A second part of the book, "Places" dealt with the even wider context of her concerns with the arts of other cultures. Perhaps the final division, however, was the broadest in terms of subject matter. One essay title alone, namely, "The Open Eye," was indicative of her expansive position.

There were also other articles that rounded off her wide-ranging concerns in modern art. A romantic apprehension of art appeared in "Maturity and A Touch of Madness" in which she wrote, "To be an authentic Expressionist, regardless of period, demands maturity plus a touch of madness."[24] "New Breeds in Art" constituted her expression of disapproval regarding certain aspects of the contemporary art world.

> Last but not least baneful in the new hierarchy is a modern coalition between critic, artist, and dealer. What does this mean? It means that John Doe, influential writer on present-day art, publishes a number of laudatory articles on an artist he admires, whereupon certain dealers in America and abroad rush to show this man's work. But what perhaps is not so clear is the business relationship between John Doe, the dealers and the artist in question. What are we to believe if critics, who are theoretically impartial, join organized combines that demand not their business acumen alone but the virtuosity of their pens? The critic thus assumes a dubious role behind the scenes; he turns into a manipulator of public taste who himself materially benefits from his own words more as entrepreneur than as writer. That such an unannounced Janus figure wields power is indisputable.
>
> If the boundaries dividing painting and sculpture are no longer visible, neither are the boundaries defining other peripheries of art. Critics become businessmen who, as advisers to artists and dealers, emerge as

leading personalities in an already overpersonalized field. The scene is absorbing, cynical, and open to any taker. Euphemistically we might call it exciting; realistically we must call it depressing. Again the final watchword is—beware.[25]

Although she devoted her life to art and was generally highly positive about and supportive of all creative endeavors, she was also well aware of less-positive features of the art world.

A series of subsequent articles provide additional insight into her broad interests. In 1972, for the *New York Times,* she wrote on "The Vision of Hilla Rebay," influential curator at the Guggenheim Museum.[26] A *Saturday Review* issue of 1974 carried her piece, "Beyond Function and Form" dealing with what she termed architecture that transcended "...both art and function to become valid philosophical experiences on their own terms." A Buddhist shrine, Gothic cathedrals, the "Falling Water" house by Frank Lloyd Wright, Hagia Sophia, a Japanese temple, and Mies van der Rohe's Crown Hall at the Illinois Institute of Technology were to her exemplary of "...designs that neither borrow from the past nor mirror the present but concentrate on universal ideas in architectural terms."[27] In a continuation of her interest in purchasing art, she wrote, "Guide for the Guileless Bidder" in which she advised readers, "One last suggestion: The best way to find bargains at auction is to buy works that are out of fashion."[28] In a perceptive piece on an exhibition of work by Edgar Degas, whom she termed "The Reluctant Impressionist," she sagaciously observed, "Technically, he was not an Impressionist; psychologically he was."[29] Thus, within a five-year period, this multitalented woman wrote on such multifarious topics as a curator, architecture, buying art, and a French Impressionist painter.

Kuh's association with the *Saturday Review* ended in 1977. She weathered several publications difficulties including the interim formation of *World Magazine* in her apartment. In 1979, she left her position as art consultant for the bank and began writing a yet unpublished book, *Past Encounters, Present Memories* based in part on what she termed her greatest contribution to modern art, her supportive friendships with numerous artists, such as: Marcel Duchamp, Ellen Lanyon, Fernand Léger, Seymour Lipton, Carlos Merida, Isamu Noguchi, Man Ray, Theodore Roszak, Mark Rothko, David Smith, Hedda Sterne, Lenore Tawney, and Mies van der Rohe.

Kuh has been called "salty," "outspoken," and "a dauntless peregrinator" because of her criticism of any situation that seemed less than her high standards for art. She was openly critical of certain movements and developments in contemporary art. For example, she was never an advocate of Pop art, and at times artists also drew her reproving comments. On work by Ellsworth Kelly, she wrote for a 1973 *Saturday Review:*

At worst Kelly is an optical trickster, at best a subtle architectural painter. No one understands scale, proportion, and saturated color more astutely. Yet is this enough? On first sight his compositions are dazzling, but on second view there is little left to ponder. Metamorphosing into brilliant designs, they become adjuncts to architecture rather than paintings to be explored on their own terms; or could it be their terms are too slender?[30]

Collectors were the focus of a piece in the *Review* in which she delineated differences she discerned between recent and past art worlds.

The "new collectors" are not unlike the art they collect—brash, expansive, and temporarily effective. Time was (and not so long ago) when their predecessors acquired paintings and sculpture for pleasure and rarely for monetary gain or social prestige. As a rule the earlier devotee kept the works he bought and, with passing years, often came to identify with and appreciate them more intensely. For him familiarity bred neither satiety nor dreams of aggrandizement. Today, however, one scarcely knows where to draw the line between collector and dealer, between self-publicizer and connoisseur.[31]

As early as 1960, in a *Review* piece, "Can Modern Art Survive Its Friends?," Kuh expressed her dismay over the emergent art scene.

Originally we hoped better trained, unbiased eyes would embrace fresh ways of seeing a dynamic, changing world. What we did not seek was a periphery of novelty, noise and news. Today it is not uncommon to hear successful young artists referred to as "hot this year" or, in a darker vein, as "done for" or "finished" if, following one or two annual exhibitions, easily recognizable new styles do not emerge.[32]

She went on to complain about escalating prices in art, the number of artists following in the wake of American Abstract Expressionism with diluted, derived paintings and the increased inducement for change or new developments.

With the relentless pressure for new styles and techniques, a successful artist must also compete with himself, with his own reputation. Often faced with obsolescence before he has reached his prime, he is tempted to deny himself thoughtful gestation periods in order to remain in the public eye.[33]

Kuh's motivation and purpose as she served in various capacities, was in her own recent words, to form a "...connection between art and the public, to help the public understand what the artist is trying to do." Twenty years earlier she held the same position.

Sympathetic relationships with living artists, far from jeopardizing a critic's integrity, clarify it, unless he totally mistakes his role. For to my mind he is not an all-powerful judge but ideally an anonymous voice acting as liaison between the public and the artist.[34]

She concluded,

If an art critic is neither a reporter who faithfully describes what he sees, nor a historian who masters scholarly facts in relation to their chronological evolution, what then is he? What is his function? This, of course, depends in part on the publication he represents, but at best he is that much-needed and rarely found phenomenon, the man with no axe to grind who knows his subject well enough to interpret it to the layman with intensity. This man needs none of the fancy pseudo-technical jargon which often compensates for lack of knowledge and sensibility. It is for him neither to damn nor to promote. He has the unique opportunity of explaining and interpreting art to a public he guides rather than leads. Obviously, he must select and reject, but one can only hope that rejection does not dominate his thinking. Paradoxically, his work becomes creative only in so far as it willingly remains subservient to the far more creative forces which are its raison d'etre.[35]

Kuh's multiple contributions are enhanced by the fact of her entries into several professions at times and places indifferent to the development of careers by women. When questioned about feminist issues, Kuh said she had not felt discrimination directed against her as a woman. Actually her own observation regarding her liberated choices and directions before liberation became sexually related, best exemplified the freedom dear to her professional initiatives. The high value she placed upon independency of action and thought caused her to steer an intrepid course in all of her endeavors. Admittedly, her goal was not explicitly advancement in terms of her sex, but indirectly her actions can be seen as serving that purpose. Her life has been devoted to furthering and expanding people's knowledge, understanding, and appreciation of art, a task she approached with exquisite taste, sensitivity, and consummate knowledge.

4

Antoinette Kraushaar

Photo: Courtesy of Antoinette Kraushaar.

Among New York art dealers, Antoinette Kraushaar is a grand dame, a woman who has been involved in the business of showing and selling American art for over half a century. As an inheritor of a family enterprise, she carried on a tradition begun by her uncle and father of exhibiting new work by artists of this country. Her father, in particular, championed the renegade "Eight" group of artists who shocked a contemporaneous public with both the commoness of their urban subject matter and the informality of their painting technique. Even in the early 1940s when Antoinette Kraushaar took over management of the gallery, European old-master work was still the overwhelming preference of male gallery owners. It was Kraushaar and other women such as Edith Halpert, Betty Parsons, and Marian Willard who proceeded to exhibit avant-garde work by indigenous artists. Since Kraushaar's initial involvement with the gallery occurred in 1946, her career spanned the period from an early era of disinterest in native art to recent years of almost total immersion and interest in the contemporary art of local artists. Through her efforts, the Kraushaar belief in the importance of modernist work survived and flourished in this century. In fact the Kraushaar vision and that of a tiny band of women materialized into the dominant status presently enjoyed by America in the art world.

Charles Kraushaar established the gallery in 1885; about five years later his younger brother and Antoinette's father, John entered the enterprise as comanager. In the early years of the gallery's existence, European as well as American art was exhibited. Subsequently, in 1917, John Kraushaar became acquainted with a number of young artists who called themselves "The Eight" and who were popularly referred to as the "Ash Can School" because of what appeared to audiences in those days as lowly subject matter. At least as shocking to early twentieth-century viewers was the obvious evidence of spontaneous and loose application of paint. Of this group of painters, John Kraushaar gave first exhibitions to John Sloan and George Luks. He was also highly supportive of sculptor Gaston Lachaise and showed work by William Glackens and Ernest Lawson. At a time when the small group of extant galleries in America were concentrating on European old-master works and Impressionist painting was considered highly advanced, Kraushaar devoted a great deal of energy to the support of young, unknown artists who were concerned with a uniquely localized subject matter that did not at that time even qualify for the European category of genre painting. Furthermore, the rebellious attitude of these artists and the aura of infamy that surrounded them set the stage for later enactments in American art.

After "The Eight," art often reflected artists' interests in indigenous subjects and in new approaches to painting. For example, the so-called Precisionist artists painted aspects of our cities and countryside. In the 1950s, Abstract Expressionists pushed the act of painting beyond any consideration of representation and thereby provoked art audiences to reactions of anger and disbelief. Later, Pop artists' choice of mundane, urban American subject matter again aggravated and dismayed viewers. During the twentieth century, a significant aspect of art resided in a newly recognized capacity to expand into unprecedented areas. Artists persistently sought unknown frontiers. In so doing, they subverted an accepted aesthetic and were perceived as radicals.

Looking back in time, American artists' interest in humble subjects could be traced to the trompe l'oeil school of William Harnett or John Peto. However, in terms of painting technique and contemporary subjects, "The Eight" forged a new territory in terms of representational art. Also, the radicalness of their stance distinguished these artists from their predecessors. In view of their place among past and future historical developments, the contribution of "The Eight" group played a significant role in establishing the peculiarly and persistently modernist character of American art.

A crucial factor to the eventual prominence and acceptance of "The Eight" and subsequent developments in this country was the presence of sympathetic dealers who supported and promoted these artists' work. John Kraushaar provided the necessary link between artist and public facilitating the eventual high recognition accorded to this group. Eventually, Antoinette Kraushaar and an increasing number of women chose to endorse advance movements in art.

When her Uncle Charles died in 1917, Antoinette Kraushaar went into the business with her father, because "There was no one else available in the family."[1] In retrospect she speculated, "I don't think my father ever thought a woman in the gallery was going to be a permanent thing, but he accepted it." Prior to becoming involved in the business, she had been connected with it on several different levels. Her earliest memories were of childhood trips into the gallery to view parades on Fifth Avenue when the family home and gallery were located on that thoroughfare. As she grew older, she became more conscious of the art and artists that formed a part of her everyday environment. When she was just out of grammar school, Luks painted her portrait and sometime later, Lachaise did a sculptural representation of her. When her father was still handling European art, she made a number of summer trips with him to that continent where they talked to artists and dealers and visited galleries and museums. She also did some reading on art. In spite of her early contacts with the art world, she claimed that her entry into the profession was via family necessity rather than an act of deliberate

choice on her part. "I don't think anybody thought of me as a career woman, since I had moved easily into a family business. I went into it because I was a stenographer, a real stenographer, not just playing at it. That was how I got started in it." Kraushaar's adamant modesty about her assumption of a dealership paralleled her view of her experience in art. In spite of her innumerable, direct encounters with art, Kraushaar insisted, "I *still* don't think I have an education in art such as you would get if you went to college." As an afterthought she added, "but I have seen a lot of pictures."

No matter how propitious her entry into the art world was, Kraushaar became a successful dealer in her own right. As a woman whose involvement in her career encompassed half a century, she experienced many changes in terms of the place of art in a modern society, the position or status of artists and their relationship to commercial art galleries. Her memories extended back to depression years when sales were lean and the Kraushaar Gallery lost contacts with European artists. She referred to this period as "a long siege" lasting until almost the time of the Second World War when affairs began to pick up a bit. She noted that years ago, "Art was something for a few rich people. The museums existed and showed their pictures. They didn't do anything like the publicity or the propaganda that they do now." She also remembered the existence of several newspapers employing critics who reviewed almost every show put on in New York's museums or galleries. Within the last 40 years, Kraushaar witnessed the growing efforts of art institutions and businesses to reach wider audiences by employing sophisticated promotional methods in advertising their products and programs.

Kraushaar's reminiscences also included the difficulties once inherent in selling women artists' work.

> There was a time when you very, very carefully didn't say the first name for awhile. You'd simply speak of the artist as Smith. It always amused me, because at some point or the other, I was also careful that I *did* say the name. And sometimes I lost sales at that point.

Although Kraushaar did choose to show women in her gallery, it was with reservations based in part on circumstances of an earlier milieu when women were less likely to opt for a career.

> I recognize the problems in taking on young women as artists. If they get married and have children, there may be a considerable gap in their work. Not all women can cope with the difficulties of doing two things. Even now women who have jobs and are married and have children have double work. I know that they're a greater risk because quite often they stop for ten or fifteen years and don't pick it up again.

Throughout the course of her career, Kraushaar gave serious thought to taking on a woman because of problems she might encounter with them. She did, however, acknowledge a change over the years to the choice of today's women for careers rather than or in addition to marriage and possibly a family.

Over the years, Kraushaar also noticed differences between men and women collectors.

> I find that men are less conscious, or have been less conscious of how an art work will look in their home and what their friends might think of it. A woman who is in her home all day, has luncheons and people coming in and out, is much more vulnerable to criticism. People are very frank in criticizing another's pictures, whereas it's considered terribly rude to say, ''Your curtains are hideous.'' Women find that more trying, and I don't blame them.

Kraushaar's stance concerning sexual considerations in art are based on her years of experience in the business, and while her views cannot be considered those of a hard-core feminist, she is certainly sympathetic to the plight of women both as collector and as artist.

Another recollection involved the relationship of the artist to their gallery. Years ago, the arrangement between artist and dealer was highly informal in nature.

> In the earlier days, when I came into the gallery, it wasn't even an understanding between an artist and one gallery. The artist would take some things here and leave a few there. He might have had a show with more than one gallery. It would be a very casual arrangement on consignment. Often artists would sell from their own studios. They would have a list of prices that were *often* governed by size. If a dealer wanted to come in and buy, he would get a break in price.

According to Kraushaar, a particularly unusual practice was that of another woman dealer, Emily Francis, who devoted her gallery space to giving artists first shows. After an initial exposure, if they were unsuccessful in getting another gallery to show their work, she might give them a second show. Francis's idea was to assist artists in becoming established at least at the initial stages.

Like many other dealers today, Kraushaar still does not utilize a formal contract in her relationships with artists. ''We have an understanding that they will work entirely through us. If there are reasons for doing something special outside the gallery, we discuss it and work it out.'' Obviously Kraushaar's casual contractual agreements have been successful for her. Undoubtedly, her longstanding success as a dealer commands respect from artists who entrust their work and career to her.

In terms of her own guidance of the Kraushaar Gallery, she cites her father as the greatest influence on her career, and indeed the artists she has chosen to associate with the gallery generally work in styles that might be best generally described as romantic realism. In part her taste is revealed by her reaction to a remembrance of an exhibition held at the Metropolitan Museum based on their curator's request of certain artists to choose another artist whom they had admired 20 years earlier. Had she been asked, Kraushaar says she would have selected Rembrandt. This preference indicates her predilection for painterly renditions of recognizable subject matter. Among her choices of artists whose work in this vein she has shown in the gallery are: John Heliker, William Kienbusch, John Koch, James Lechay, Elsie Mansville, Karl Schrag, and Jane Wasey.

Although the Kraushaar Gallery is best known for its artists working in what now is considered to be a traditional type of realism, she has shown work by some artists working in an abstract manner. However, she never became involved with artists of the Abstract Expressionist group primarily because she inherited from her father a stable of artists working in a different mode, and perhaps as a result of his legacy the work of the action painters did not appeal to her. The Kraushaar hallmark has been exhibitions of painterly representations by American artists. This does not mean that two-dimensional work is her only interest. Sculpture has always had a place in the establishment, and in spite of the gallery's reputation for quality work by native artists, Kraushaar asserts, "that doesn't say I won't do a show outside of our specialty if I'm intrigued by it. After all, there's no board of regents to object."

Certainly, no one objected when she recognized the talents of abstract sculptor George Rickey and gave him his first three shows in the 1950s. At that time, Rickey had worked through a fascination with work by Alexander Calder to a lasting interest in Constructivist ideas. When Kraushaar showed his work, he had already begun to utilize pendular motion and was involved with mechanics and machines as they might serve an aesthetic function. Today, he is one of the most highly recognized of American sculptors.

Her particular operation includes not only showing work by living Americans, but managing the extended artistic affairs of deceased individuals. In addition to the approximately 25 artists currently affiliated with the Kraushaar Gallery, she also handles the estates of over a dozen people such as Glackens, Robert Laurent, Sloan, and Marguerite Zorach. In her capacity as estate executor, Kraushaar sometimes buys at art auctions and on private bases. She distinguishes her work as an "agent" for living artists from her activities as a "dealer" on the art market.

The number of individuals served by Kraushaar is substantial, and a great deal of skill and organization is required to maintain all of her

various art-connected endeavors. She is well respected by her colleagues for her business knowledge, prowess, and standards. Grace Borgenicht calls her "a model," and Monique Knowlton refers to her as, "a fascinating woman, full of knowledge and one of the few ladies." She is admired not only for her ability in gallery affairs, but also for her above-board method of doing business. Her special qualities involve a combination of diligence, astuteness, experience, and grace.

5
Betty Parsons

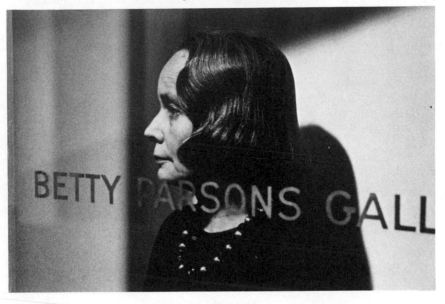

Photo by Alexander Liberman, New York.

Although she is best known for exhibiting work by artists associated with the Abstract Expressionist movement, Betty Parsons was never personally interested in categories. "I can't stand isms or fashions or trends or anything like that. I can't stand them! (said with vehemence). Pay no attention to them. No, because that's awful to me. Artists being influenced by the moment...it's a selling point."[1] After she had shown work by Pollock, Rothko, Stamos, Tomlin, and others, it was critic Clement Greenberg who developed a theory that grouped them. Parsons never picked "Abstract Expressionism" per se; she chose artists' works that attracted her, and in actuality, her selections were not limited to this mode.

During the course of her long career, she exhibited work by hundreds of artists. Among diverse and unrelated persons to whom she offered shows as manager of the Wakefield Gallery between 1940 and 1944 were Walter Murch (1941), Alfonso Ossorio (1941), Joseph Cornell (1942), Wolfgang Schultz-Wols (1943), Theodoros Stamos (1943), Saul Steinberg (1943), Hedda Sterne (1943), and Adolph Gottlieb (1944). As director of a contemporary section of the Mortimer Brandt Gallery between 1944 and 1946, she showed art by individuals such as: John Graham (1945), Stanley W. Hayter (1945), Louis Shanker (1945), Hans Hofmann (1946), Ad Reinhardt (1946), and Mark Rothko (1946). In her own gallery, established in 1946, she displayed work by Seymour Lipton (1947), Clyfford Still (1947), Ossip Zadkine (1947), Maude Morgan (1948), Jackson Pollock (1948), Richard Pousette-Dart (1948), Marie Menken (1949), Buffie Johnson (1950), Barnett Newmann (1950), Anne Ryan (1950), Bradley Walker Tomlin (1950), Lee Krasner (1951), Robert Rauschenberg (1951), Kenzo Okada (1953), Lyman Kipp (1954), Richard Lindner (1954), Ellsworth Kelly (1956), Jack Youngerman (1958), Alexander Liberman (1960), Eduardo Paolozzi (1960), Chyrssa (1961), Agnes Martin (1961), Robert Murray (1965), and Richard Tuttle (1965). Section Eleven, an annex to her main gallery was the showcase for: Agnes Martin (1958), Leon Polk Smith (1958), Paul Feeley (1959), and Ruth Vollmer (1960). In several instances she showed work by these artists for several years. Some negative stories suggested that several artists left the Parsons Gallery for more lucrative stables. In fact, when they left, their reputations were on the rise, a factor usually related to increased sales. On the other hand, a number of reputable artists, such as Okada, Reinhardt, Steinberg, and Sterne stayed with her for some 20 years. Between 1941 and 1968, she exhibited the work of Feeley six times; Kipp, seven; Lieberman, six; Murch, ten; Okada, seven; Pousette-Dart, eleven; Rothko,

six; Stamos, ten; Sterne, fourteen; and Youngerman, six. As Lawrence Campbell wrote in *Art News* in 1973, "No gallery anywhere has equalled her record."[2]

How did one person accomplish such a feat? In an oft-quoted statement, she credited her success to "a great love for the unfamiliar." Certainly her choices did not conform to things she could have seen in other galleries at the time. Nor was her taste limited to work in what was later termed an Abstract Expressionist vein. She was instrumental in showing artists associated with Color Field on Minimalist groupings, such as Ellsworth Kelly, Agnes Martin, Leon Polk Smith, and Jack Youngerman. Although she was intrigued primarily with abstract work, there were notable exceptions represented by the paintings of Richard Lindner and Walter Murch.

She claimed her interest was in "the higher dimensions, a reach of the spirit, something more to do with the spiritual rather than the physical world." An inner realm was her general focus whether it was paintings by Kelly, Lindner, Martin, or Pollock. In response to a question on her criterion for selection, she searched her purse for a scrap of paper and read from it a quotation from a favorite writer, Willa Cather: "What was any art but an effort to make a shape, a mold to which to imprison for a moment, the shining, elusive element which is life itself."

Parsons not only recognized the aesthetical merit of art by young artists, she also realized that this new work needed a special physical environment. Through repeated redesigns of her gallery by Calvert Coggeshall and Tony Smith, she was able to show small works by Ryan or Steinberg, as well as the large paintings associated with Abstract Expressionism and color field. In addition, she laid claim to having conceived of a white-walled space within which paintings were hung without ornate gold frames. In general, the atmosphere of her gallery was not formal or commercially-oriented. Artists used to "hang out" there, and at one time, she sponsored poetry readings and artists' performances. As Alloway pointed out, the feeling of her place was more akin to a cooperative gallery.[3] A sense of informality, freedom, and lack of contrivance pervaded her exhibiting environment, encouraging a healthy and lively give-and-take among artists and others interested in art.

Who was Betty Parsons? In time she literally became a legend. In 1981, she was awarded the Mayor's Award of Honor for Arts and Culture. "I had to go to Gracie Mansion. It was an eeennooooorrrmous occasion, and I had to make a speech. It was packed with people. I was terrified." She also received the Brandeis award of $3,000, and honorary degrees from Rhode Island School of Design, Parsons School of Design, and Long Island University at Southampton. Before she died, she remarked, "I'm getting a lot of honors. I'm 81, so it's high time!"

Born in New York City on January 31, 1900, her childhood home was

located on the present site of Rockefeller Center. As the daughter of upper-class parents, her youth was molded according to a somewhat prescribed pattern. She attended the Chapin School, Miss Randall McKeever's Finishing School, and made her debut in 1919. The next year, she was properly married to Schuyler Livingston Parsons, but in an entirely unexpected and improper manner, she divorced him shortly thereafter. Her aristocratic family was dismayed at the idea of divorce, but she went ahead and at this point began to chart a course incomprehensible to them. "I'm a complete sport in my family." To statements that her blue-blooded background helped her obtain clients as a gallery owner, she countered, "No. They didn't give a damn about art. None of those people did. All they cared about was crystal, flowers and food." She went to Paris where the divorce decree was granted and stayed there for ten years living on the Left Bank. She decided to become an artist and made the acquaintance of many creative individuals who graced Paris in the 1920s, such as: Alexander Calder, Hart Crane, Harry Crosby, Max Jacob, Gerald and Sara Murphy, Isamu Noguchi, Man Ray, and Tristan Tzara. Sculpture was her primary interest, and she studied for six years with Antoine Bourdelle. One of her classmates was Alberto Giacometti, but they never became friends. Later she chose Ossip Zadkine as her teacher, and during the summers she studied watercolor in Brittany with an English painter, Arthur Lindsey. In 1927, she had her first solo show of watercolors in Paris. This auspicious start, however, was marred by the stock market crash that affected the financial standing of her father and her ex-husband, and eventually cut off her financial resources and ended her stay in France.

Returning to America in 1933, she went to California where she gave art lessons, painted portraits, worked in a liquor store dispensing advice on French wines, and continued her study of sculpture under Alexander Archipenko. In a peripheral way, she became involved with the film world, meeting Marlene Dietrich and playing tennis with Greta Garbo. (Her physical resemblance to Garbo has been noted, along with her low, husky voice which was akin to that of Dietrich.) After her return to New York City, she had a show of her work at the Midtown Gallery in 1936. Subsequently, she worked on a commission basis in a gallery in the Wakefield Bookshop where she first showed a number of artists who were to become well known and influential among a new American avant-garde.

In the early 1940s, Parsons struggled to establish a gallery of her own, and for a short time her course intersected that of Peggy Guggenheim. In 1942, Guggenheim had opened her Art of This Century Gallery on West Fifty-seventh Street in New York where she showed work by Pollock and other incipient Abstract Expressionists. The same year, Parsons moved to the Mortimer Brandt Gallery. Four years later, when

Brandt moved elsewhere, she opened her own gallery at 15 East Fifty-seventh Street with $5,500 of her own money and that of a few friends. Guggenheim closed her gallery in 1947, leaving Newmann, Pollock, Rothko, and Still without representation. Parsons had already shown Hofmann, Reinhardt, and Rothko at the Brandt Gallery and, when they approached her, she decided to take them all on.

As early as 1944, she had met Newman, who was later to become her "guide." Some critics have credited Newman with developing Parsons's reputation as a dealer. She admitted that he introduced her to some people, but in answer to a question as to whether or not it was her decision to show these artists, she reacted: "It certainly was. I was paying the bills." Newman was particularly helpful in the organization of an exhibit of Northwest Coast and Alaskan Indian paintings as the inaugural show in her gallery. This marked one of the first attempts to show Indian work in an aesthetical context rather than as anthropological data. However, in general consideration of Newman's influence on Parsons, it should be noted that prior to knowing him, she had met and shown work by several artists, such as Cornell, Gottlieb, Murch, Ossorio, Stamos, Steinberg, Sterne, and Wols. Furthermore, she showed many artists outside of the Abstract Expressionist group; for example, those of the subsequent and so-called color field school. Her prophetic sensibility and role cannot and should not be diminished or minimized. In terms of more recent trends, she even organized a "Pattern Art" exhibit in 1966, prefiguring the "pattern and decoration" grouping of the 1970s.

Between 1940 and 1946, she introduced approximately 250 new artists. At this time, there were only a few other galleries exhibiting any art by young artists. In 1936, Marian Willard had begun her business, Kraushaar took over her father's operation about this time, Peggy Guggenheim opened in 1942, and in 1945 Charles Egan and Samuel Kootz entered the profession. Noteworthy is the fact that the Kraushaar, Parsons, and Willard establishments successfully survived over an ensuing period of almost 40 years. In 1958, Parsons opened an annex to her gallery that she called Section Eleven, where she showed young artists such as Martin and Vollmer until 1961.

Her first gallery on East Fifth-seventh Street was located between those of Brandt and Kootz. After they left, Sidney Janis moved in to the space adjacent to Parsons and eventually rented the entire floor. After a bitter struggle with him, she moved to 24 West Fifty-seventh Street in 1963. Her gallery remained at this location for the next 20 years, or a year after her death. In 1962, she met and employed Jock Truman who stayed with her for many years. Later, he claimed that it was his plan to encourage Parsons to become the "star" that she was quickly turning into so that he could take over management of the gallery.[4] In actuality, she did become an important art world figure, but always remained a part

of the day-to-day operations of her establishment. Truman's statement should not be misconstrued as mere opportunism given his extended association with and loyalty to Parsons. Indeed, he shared a joint venture undertaken with her in 1975 for the purpose of showing drawings and works on paper. The opening of the Parsons-Truman Gallery occurred when Parsons was 75 years old, and Grace Glueck reported in the *Times* that she danced until 2 A.M. on the occasion of her birthday.[5]

In addition to dancing, Parsons enjoyed and was proficient at tennis until the last few years of her life. Even at 80, she looked and acted at least 20 years younger than her age, and her blue eyes remained clear. Undoubtedly her strong physical condition allowed her to live at a pace that accommodated an astonishing number of activities in one day. For example, in one morning she met Truman at her warehouse, returned to the gallery to critique an artist's work, spoke with an interviewer, answered telephone calls, set up a luncheon appointment, met one of the artists represented by her gallery and was thinking out loud about an engagement she'd accepted to speak at a memorial service for Tony Smith. In her aphoristic manner of speaking, she observed, "Although David Smith holds down walls, Tony Smith holds down the horizon."

Her active life also afforded time for poetry writing, meditative exercises, and the pursuit of a personal career as an artist. During the last year of her life, she observed, "I'm becoming very successful!" Since the late 1930s, she exhibited her watercolors in New York, and within the next decade she began to paint abstract pictures. As for influences from artists in her gallery, she claimed, "I have no recall. When I'm sitting in front of a painting, it's exactly as though I'd never seen anything, any picture in my life." Critics pointed to primitive qualities in her work and one could speculate on whether or not early exhibitions of Pre-Columbian and Northwest Coast Indian art might have affected her work. Regardless of the source, there is a kind of totemic feeling to her sculptures consisting of materials found on the beach and elsewhere. Her work as a whole was often affected by places where she lived or to which she traveled. In later years, she worked on weekends and during the summer at her studio-house on Long Island. This structure and an adjacent guesthouse was designed by Tony Smith. In this habitat, her guests were treated to the products of yet another of Parson's skills as a French cordon bleu cook.

On the whole, her work seemed to parallel her own capacity for wit and whimsy. An intelligent naiveté contributed a sense of personality to her paintings and sculpture. Among artists who interested her were Fra Angelico, René Magritte, Henri Matisse, and Joseph M. W. Turner. This group might seem somewhat disparate; however, such a selection was typical of her disinterest and even disdain for groupings, historical or otherwise. Undoubtedly, the emotional qualities present in the work

of all of these artists attracted her. Specifically appealing would have been the innocence and wonder found in the paintings of Renaissance artist Fra Angelico; the sense of incongruity in pictures by the Surrealist, Magritte; the decorative design qualities found in Matisse's work; and the overwhelming sense of drama characterizing Turner's paintings. Her own work as an artist as well as her dealings as a gallery owner have never been governed by fashion, fad, or trend.

Three hundred examples from her large collection of art was exhibited at Finch College in the 1960s. Her accumulation consisted of a potpourri of styles and periods augmented by gifts and purchases from the artists exhibited in her gallery. Included among these items were a number of primitive objects, a de Kooning that she bought from Egan, a drawing given to her by Arshile Gorky, a Motherwell purchased from a client, and a Cornell that she bought from a stranger. Also represented are Carl Andre, Donald Judd, Murch, Newman, Okada, Pollock, Pousette-Dart, Reinhardt, Rothko, Ryan, Frank Stella, Still, Tomlin, Richard Tuttle, and Youngerman.

Did she make any mistakes during the course of her illustrious career? She later regretted her choice not to show work by Jasper Johns who wanted to show at her gallery in the late 1950s. In general, she was not interested in Pop Art, partially on the basis that to her it was too literary. She did, however, show "Conceptual" pieces like the mail art of Ray Johnson. To her, Conceptual Art had "more feeling to it. It had a kind of a dream in it."

Unlike the practice of most other galleries, Parsons simply gave $400 in cash to an artist who was having a show, and he or she was free to spend it in any manner. As a result, the Parsons Gallery exhibitions were not found advertised in large, color formats in art magazines. She did not emphasize the more commercial aspects of gallery ownership. She steered a firm course focusing primarily on art itself rather than the cultivation of movements or personalities. Business affairs were necessary but peripheral responsibilities to her. She was quoted as saying, "Most dealers love the money, I love the painting."[6]

Parsons was somewhat at odds with the contemporary art world because of her lack of interest in the name or reputation of the artist. "I've always said, look at the work, not the name."[7] Thus, on the occasion of anniversary exhibitions, she hung work by the well-known artist next to that by a less famous individual. She said, "It's the money that makes the big names. They're not necessarily the best artists. Very often the worst artists sell better than the best. There's no consistency in that."

Another quite distinctive aspect of Parsons's gallery career was that she always showed work by women. She exhibited work by seven women in one-person shows from 1940 to 1944 at the Wakefield Gallery, and before the impact of the women's movement or up to the late 1960s

she had introduced art by approximately 30 more women in solo exhibitions. In spite of her extensive experience as a dealer and as a juror, she maintained that she could not distinguish a distinctive male from a female imagery. She noted that at times in her experience male artists seemed to gravitate toward and have more confidence in a male dealer. Concerning collectors, she felt that appreciation for art could vary depending upon sex. She cited Marjorie Phillips as more "responsive to the creative" than her spouse, Duncan. With a slight smile and gleam in her eye, she told me, "Women are more sensitive than men, anyway."

Parsons felt that her most substantial contribution to art was her unwavering search for quality in art. "I've always shown the creative world. I've never shown anything that was cliché, repetitive or influenced. I've kept a very high level or standard." Her approach to art never ceased to be romantic, idealistic, and fresh. At the age of 81, she summed up her career with an enthusiastic reading of the following poem:

> From earth to sky
> The quivering hand of man
> Will fly
> To open doors
> and lead the way (she energetically raised her right arm)
> to other shores.

6

Dore Ashton

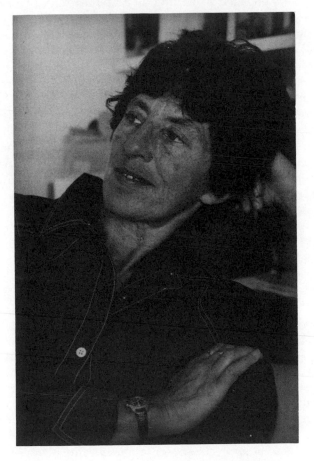

Photo by Mercedes Tejada, New York.

It is the belles-lettres tradition that Dore Ashton wishes to belong as a writer who is engaged in writing as a fine-art form. To her, authors included in this literary category are "people who write essays...people who are moved by something. It could be one painting or an experience. Occasional writing."[1] Historically, this literary bent is most closely associated with nineteenth-century romantic tendencies. It is literature that may be about art, but that is also in itself a work of art; writing that is based on inspiration or a spontaneous feeling evoked by what might have been a coincidental circumstance that triggered the artist-writer's sensibilities. This type of writing is quite different from the judgmental position associated with the profession of criticism and from the journalistic view of the person who writes to meet a weekly or monthly deadline. Even though Ashton has been employed as an art critic for journals and newspapers, she would prefer to be thought of as an "authoress, or just plain writer," thereby disassociating herself from an occupational role and emphasizing the more fortuitous or intuitive aspects of her endeavors.

As might be expected of a person with her belletristic affections, Ashton professes admiration for Charles Baudelaire and his impassioned contributions as a writer on many topics, including art. She also respects certain authors on specific topics, such as Gaston Bachelaer on Albrecht Dürer and Pierre Schneider on Henri Matisse. In a wider context she cites, "...Harold Rosenberg, not so much for his visual acuity as for his cultural assessments." Like Baudelaire, her approach to art as well as writing is decidedly romantic in character; and in the manner she ascribes to Rosenberg, Ashton has continually sought to place art within a wider social context.

Born in New Jersey, the daughter of a physician and a journalist, she credits her mother, who wrote for a newspaper, with instilling in her children a "...real appreciation for language. She always corrected us and still does. If I say, 'I wanna visit you.' she says, 'want to'." During her childhood, Ashton painted, won prizes in art and attended art school. As an adult, she continued to paint watercolors in the summer but spent more energy on writing about art. By the time she was about 12 years old, Ashton found New York City's Museum of Modern Art which she called "...a very important event in my life." Although her parents were not themselves inclined toward the visual arts, they were sympathetic to their daughter's talents and interests. At the University of Wisconsin she studied literature, and while pursuing a master's degree in art history at Harvard University, she decided that she wanted

to do magazine writing on contemporary art. Her mentors were opposed to her intentions, but she went ahead and succeeded in publishing a couple of articles in New York. Subsequently, she moved to this city, and "I just decided that's what I was going to do and fought my way in."

Actually, her entry was not extended over a prolonged period. Within a year of her graduation from Harvard or in 1951, she became an associate editor of *Art Digest*, a position she held for three years. During this time, she wrote several articles on printmaking, including a discussion of graphic art by Jacques Villon. Her work was also published in *Arts and Architecture*, including a piece on Jose de Rivera in 1952. She set an early course that encompassed various artistic media and styles devoted to the creation of abstract art. When she left *Art Digest*, her position was taken over by Hilton Kramer.

She married artist Adja Yunkers in 1953 and subsequently gave birth to two daughters. In 1955, she was offered a post as associate art critic with the *New York Times*. At the age of 27, she obtained the job, "...which every woman my age would have been thrilled to death about." However, shortly after her employment commenced, her husband received a Guggenheim grant to work in Europe. She was faced with a "...terrible decision on whether or not to give up this irreplaceable opportunity." She did, in fact, relinquish her position to accompany her husband to Europe. However, an older critic assumed the *Times* position, reserving it until she returned to this country.

From 1955 to 1960, she not only wrote for the *Times*, but published several pieces on English and European as well as American creative activity in arts magazines. During this period her writings reflected her avid interest in art of a lyrical nature. In an article appearing in a 1955 issue of *Arts Digest*, she described Afro as "...a painter of sentiment."[2] "Notes from France and Spain," printed two years later in *Arts and Architecture*, contained her observation that, "There is no question, though, that the dominating current in Paris, as in New York, is unqualifiedly romantic."[3] Her early and dogged faith in an art overtly charged with emotion was climaxed within this decade in an article of 1957 on Mark Rothko. In this piece, Ashton's expression of her response to the artist's work was also reflective of her own predilections in art.

> Rothko's bursts of emotion are broader than the eye can see. They are made for the inner-eye. His works command silence. It is possible to stand rapt before a work of art but impossible to spell out rapture.[4]

Often, Ashton's particular approach to her task was highly poetic, inspired by her experience of the work. In a clear parallel to beliefs, she advocated the nineteenth-century notion of an inspired encounter with art. In keeping with this subjective attitude was the consideration by

American painters of the 1950s that their work possessed universal implications. Correspondingly, Ashton viewed a work of art as reflective of a spiritual essence beyond mere formal manipulation. She concluded the Rothko piece with, "It is cowardly to 'live' through the painter's act alone. The only glory is in going beyond the gesture."[5] It was essentially on the point of objective meaning and analysis of art that Ashton parted company with the Greenbergian approach to artists classified as Abstract Expressionist. Her position was firmly based upon what she perceived to be the temper of art as an heroic act that overruled reason.

Ashton's interest in the spirit reflected and inherent in art was articulated many times in several of her articles on Rothko and is the context for her forthcoming book, *About Rothko*. In 1977, she wrote in *Arts* magazine, "His adventure—for it was certainly an adventure of a high spiritual order—was to go beyond the world of substances to a world, literally, of values."[6] As reflected in her writing on Rothko alone, over a period of 20 years, she obviously sustained and expanded upon her conviction of an eternal import beyond the temporal characteristics of art. It was this sense of a sublime enterprise that attracted her in art, rather than formalist elements and categorization in terms of stylistic characteristics. She saw Rothko as, ". . . son of what Nietzche called a scholarly and tormented generation, the miracles of color and light were creations of man in all his self-generated moods."[7] Her view of art was based on essences rather than surfaces, on feeling or a meaning beyond form. Instead of analyzing Rothko's choice or use of color and a resultant sense of light, she termed these factors "miracles."[8] The term, "abstraction," to her did not refer to manipulation of forms. In reference to work by Rothko, she wrote about ". . . those abstract values we call tragedy, irony, higher, better."[9] Apropos to her own position as well as that of the artist, she referred to this artist's "religious enterprise" in an article appropriately titled, "Rothko's Passion," published in *Art International* in 1979.[10] Her sympathetic perception of the artist as a tormented soul, somehow purified through struggle, inner conflict, and perpetual quest for ultimate experiential fulfillment was embodied in her assessment that:

> Rothko's overwhelming desire was to be ravished. What he yearned to possess was some vision of ineluctable beauty that would "tear away," as the word ravish suggests, the uncertainties with which he wrestled until the end.[11]

Ashton's own pursuit of illumination beyond the fact of physical presence was also apparent in other writings. On Joan Miró in 1964 for *Craft Horizons*, she wrote, "Art affirms. It affirms even as it hints at the terrors of existence and symbolizes the dark, unfathomable strain in

man.''[12] She saw the contribution of Marcel Duchamp in terms of intuition, irony and myth in her article on him for *XX^e Siecle* in 1965. The latter aspect was part of the romantic tradition to which she chose to belong, and she defined myth as ''...the product of imaginative activity as opposed to history.''[13] To her, art as well as myth could not be assessed by so-called modernist values, particularly those dependent upon an art-for-art's sake aesthetic. In a 1959 piece on de Kooning, published in *Arts and Architecture*, she refuted a critic's suggestion that this artist's work is ''paintings about painting,''[14] and 17 years later writing in *Arts*, she maintained that de Kooning and his contemporaries thought of ''...painting as the action of their ethical existence'' in which they expressed a ''...full emotional response'' to life.[15] Summarizing her position, she found de Kooning's work to be ''...an embodiment of the deeper structures that underlie our life-long gesturing.''[16]

The work of Philip Guston also attracted her and satisfied her feelings about the nature and purpose of art and artist. In her book, *Philip Guston*, published in 1960, she wrote, ''The artist must be prepared to live in a state of perpetual uncertainty, pursuing his elusive truth....''[17] She saw Guston like Rothko, as a representative of a particular bent in art.

> Guston shares what is perhaps a tragic destiny with the painters of his generation. They have abandoned mimetic concepts. They can no longer believe that descriptive records of visual impressions are adequate. Once upon a time painters longed to reproduce life. Now, they long to create it. The painter, and poet as well, is cast today in the role of demigod. His profound desire is to discern the mysteries behind what is visible and known, and express his discoveries—a desire painters in other periods may have had but never dared hope could be realized.[18]

Her *Studio* article of 1965, entitled ''Philip Guston, the Painter as Metaphysician,'' expressed her belief that, ''The vital painter in our century cannot subsist merely describing the surfaces of visible things. He must move beyond external nature.''[19] Again, the spiritual or religious aspect she associated with art emerged in her observation:

> Many are the priests. Few are the theologians. Many are the painters who make pictures unquestioningly working on established assumptions but never reflecting. Few are the painters, who, like the theologians, search for the meanings behind the rituals.[20]

As a protagonist for emotional feeling and universal content, her stance is at odds with many critics of contemporary art. Some would find her opinion, rooted as it is in nineteenth-century romanticism, inappropriate to the current art scene. However, at a time when names have

become more important than issues and some art enjoys a season in vogue rather than representing a lifetime commitment, it is fortifying and essential that someone inquire as she has as to, "When will we attempt a philosophy which supports the highest abstraction, and searches for the underlying symbolic meanings in contemporary art?"[21]

As might be expected, Ashton's view of modern art is not based upon a sense of linear progression, and she disputes those who would employ a deterministic approach to contemporary art. After delivering lectures in the 1960s, she was asked, "Where is art going?" Her response reflected a belief in flux rather than a recognizable end or goal. At the time, she answered, "Art is constantly coming and going, changing its emphasis and breeding with the immediate past in many ways." She does not accept the contemporaneous notion of the new or novel as anything more than another ripple in the larger sea of human creativity. Once her attitude is understood, it is easy to accept her declaration, "I don't care about being the first," and her assertion that, "I follow artists over a period of years." It is indeed refreshing to recognize her viewpoint amidst constant scurrying to achieve "number one" status, to "arrive" before anyone else and to change allegiances with every passing enthusiasm. The race to be unprecedented supports repeated efforts to name new trends, fashions, and modes in art whether or not they actually have any substantial basis. Ashton sees art as possessive of universal traits and essences that have and will continue to exist regardless of endless variations.

This is not to say that Ashton is uninterested in new art. Recently, she wrote an article (*Arts*, 1980) and a catalogue essay on work by Christopher Wilmarth, who was also the subject of a piece written for *Arts* in 1971. "Art USA 1962" and a piece on the Maeght Foundation published in *Studio* and a 1970 issue of *Arts*, respectively, contained compendiums of her taste in the 1960s including commentary on work by Bruce Conner, Edward Kienholz, Franz Kline, Richard Lindner, Joan Mitchell, Louise Nevelson, Robert Rauschenberg, George Sugarman, and Miriam Schapiro. In 1959, she wrote favorably on the Gutai group's appearance at the Martha Jackson Gallery. She has been keenly aware of what she calls a tendency to be "exclusive," a state that she wishes to avoid. She reflected that ". . .my lack of sympathy for certain of the foremost painters in the middle and late 1960s led me to sometimes feel, 'Oh, my God, maybe I'm just out of it.' But, of course, now everything has come back. Now young people call me up and say, 'I'd like you to come and see my show. I think you'll like it!'. . .and you know just what they mean." Specifically, painting per se, has reemerged as a vital vehicle for the artist, and Ashton has written about several of these individuals, including Paul Rotterdam (*Arts*, 1982), Jake Berthot (*Arts*, 1982) and John Walker (*Flash Art*, 1981) whose work has been enthusiastically received

in the 1980s. In actuality, because she does not think of art in terms of successive movements, her position cannot go "out of style." She stands for more lasting values.

It must be noted, however, that there have been popular art movements that Ashton openly opposed. She did not like Pop art. She termed it "chic" and fashionable and claimed that there was "...no art in Pop art." In a 1959 issue of *Arts and Architecture*, she warned against reduction and serial systems in painting, "...reduction is a puritanical and often tyrannical tenet which carried to its extreme leads to all sorts of abuses. It leads above all to self-impelled repetition to obsessive signature-making."[22] Indeed, she found wanting a number of 1960s' art movements. In 1970, she wrote in *Arts*, "...the history of the past decade is an almost illegible text of exclamation points...."[23] When asked about the art of the 1970s, such as pattern painting and European Expressionism of the 1980s, she commented, "It's just more exclamation points. I'm not very sympathetic to the engineering of movements. It's the expression of a very temporary ambition."

On the other hand, she consistently championed abstract or art that extended beyond particular temporary forms. The title of a 1970 *Arts* piece was "Young Abstract Painters: Right On!" expressing in a phrase her exact and continuing sentiments. Her first manuscript for a book, *Abstract Art Before Columbus*, published by the Emmerich Gallery in 1957, was concerned with the art of Pre-Columbian cultures. In this case, it was the nonrepresentational nature of this art as it reflected larger, timeless realities that attracted her.

> He (the Pre-Columbian artist) wishes to express truths that are non-discursive, out of the range of verbal communication. He feels that his perceptions and intuitions of natural law can be stated only in terms of abstraction.
> Since abstraction transcends time, and even place; since it is the only common language which survives centuries, it is normal, even noble, that the modern artist—like the artists of all time—seeks to carry his temporal feelings into the transcendent permanence attaching to abstract form.[24]

The Unknown Shore: A View of Contemporary Art, which she called her "first important book," was written in 1962, and was reflective of her vision of art as a striving toward an unfathomable horizon or goal. Significantly, insofar as her own sources may be identified, she concluded this book with a quotation from Goethe.

> To produce a form or an image is to fix time. The painter who expresses infinity finally is the one who can express its opposite; who can, on the

same canvas, give the finite measure of human experience and an intimation of its infinite measure.

The painter suffers the riddles of the cosmos intensely. He tries in his medium to lessen their chaotic pressure. Today's painters question the universe with as much sober passion, as much desire to "see" ideal unity, as any artist in the past.

The contemporary artist sees himself in a tragic situation, a troubled man in a world whose mystery he can never satisfactorily penetrate. But he is not alone in history. Even so solid a figure as Goethe knew what it meant to follow a destiny in which the unforeseen lured him onward:

"One wonders how a man can bear to live another forty years in a world that even when he was young seemed to him void of meaning.

"The answer to part of the riddle is: because we each have something peculiarly our own that we mean to develop by letting it take its course. This strange thing cheats us from day to day, and so we grow old without knowing how or why...."[25]

In reviewing this book Graham Reynolds lauded her "...gift for communicating the experiences engendered by works of art...."[26] Abstract art to Ashton was never merely formal manipulation but form, material, and image organized in a manner designed to reflect a more perfectly profound state of being. Her observations about a specific work of art did not consist of formalist analysis but an attempt to illuminate which would parallel the effect of the art object itself. For example, in a 1971 Arts, she wrote this about a painting by Richard Diebenkorn:

"Ocean Park #45"; The "purist" Diebenkorn I have ever seen, a quite constructivist approach to rectilinear forms. But not really, not really: that orange bar across the top reminds me of his other cues. All the forms pend from it. Pending is the nature of the painting—a field of grass green hung like a vernal rug, and falling, falling, because Diebenkorn strokes it downwards. Its neighboring blue vertical plane is falling also. Yet wait: that slender interstice in the green plane with its hint of a charcoal line has riven the plane, made a recessive space. And in the delicate whitish vertical at the right border, there is a half-stated line which once perceived becomes the insistent focus of the painting. In that wavering line which goes midway up the canvas lies the life of the painting.[27]

In a kind of soliloquy, she beckoned the reader to perceive the painting on its own terms. She did not instruct, analyze, or describe; she conjured up her experience of seeing this work of art. Another example of this technique was embodied in her book on Guston, Yes But...: A Critical Study of Philip Guston, published in 1976. In this volume, she expressed her encounter with one of his works.

A painting such as "Voyage" is not as gracious even in emotional tone. The dense balls of rose, ocher, and orange are massed into an almost impermeable sphere, where nests and pockets are unaccountably congealed to form a convex surface related to the earlier "To B.W.T." As if to make their incongruous union more emphatic, Guston leaves the four edges of the canvas white, and only lightly, scores the surrounding space with neutrals, terracottas and washes of blue. Fibrous lines waver uncertainly interlocking matrix in the center. The whole throbbing surface can be read in several sequences (for instance, there is a group of forms that seem like stepping stones to infinity, reading from bottom right to upper left), and yet the impression is finally one of mass displacing the encroaching space.[28]

Pervasive in her writing on contemporary or historical art was the unspoken assumption that the art work could be best known through direct contact. On Bonnard for *Studio* magazine in 1972, she wrote, "The only summing-up about Bonnard that there can be lies in the experience of looking at Bonnards."[29] Ashton's considerable talents as a writer conveyed a sense of the experiential factor crucial to her aesthetical beliefs.

Ashton's interest in abstract painting did not preclude response to a number of other styles and media. On two occasions, in 1964 and 1969, she wrote in article and book form on work by Richard Lindner. Also of 1964 was her manuscript for *Rauschenberg's Dante*, an essay written for this modern artist's illustrations for the Renaissance poet's work, and completed within the same 12 months was her contribution to a book dealing with another medium entitled *The Mosaics of Jeanne Reynal*. In the course of this year, she wrote articles on Al Held, Robert Motherwell (whose work was also the subject of a piece published in *Flash Art* in 1980), and James Rosati for *Studio* magazine. Three-dimensional art was her concern in *Modern American Sculpture* published in 1968 and *Pol Bury* of 1971, written at a publisher's request. Samaras, whose work she referred to as "an educated obsession" (*Studio* 1973), fascinated her, and she considered Dubuffet in terms of his influence on Claes Oldenburg (another artist whom she admired) and the "anti-culture" of the 1960s (*Arts*, 1969).[30] About sculpture by Picasso, she astutely observed that he exhibited a ". . . total lack of embarrassment when caught at play."[31] A comprehensive project she undertook for The Documents of 20th Century Art series was the editing of *Picasso on Art: A Selection of Views*, published in 1972 and consisting of various statements on art made by the artist over the years. An even more gargantuan task was her 1972 cultural guide, *New York*, which included historical, political, social, and cultural aspects of New York as a context for this city's art, particularly architecture.

Beyond her interest in various forms of art, Ashton has also been concerned with an even broader view of art as it was reflective of an overall cultural milieu. In 1959, for example, her book *Poets and the Past*

was published, again in connection with the Emmerich Gallery. For this volume, she invited a number of poets to respond in their particular creative manner to photographs of art works created centuries before their time. Later, or in 1981, for *Arts* magazine, she wrote on the relationship between Symbolist painting and literature ("From Symbol to Symbolism"). To her, the essences involved in creativity were not exclusively bound to time, place, or material. Ashton's concept of the past as pertinent to the present was again an issue germane to *A Reading of Modern Art* of 1969 and in periodical literature in which she related earlier to modern times. Exemplary was a piece in *Arts* magazine called, "Distance from 1926 to 1966." Of 1959, was her article for *Arts and Architecture* titled "New Realism" in which she compared the work of Samuel Beckett, Alain Robbe-Grillet, and Mark Tobey in terms of what she observed as their "additive surface detail."[32] In 1972, she wrote on the topic of concrete poetry for *Studio*, and a decade later for *Soho Weekly News*, she commented on Wassily Kandinsky's "multimedia opera," that he called *The Yellow Sound*, and noted Alfred Barr's interest in "...the total artistic life of the modern world—films, photographs, architectural models, industrial designs, theatre designs and documents of the history of modern dance, as well as painting and sculpture" in a memorial column written after his death.[33] A *Horizon* magazine issue of 1961 contained her piece, "About-Face in Poland," in which she linked social and political circumstances with the creation of art, and in her 1966 review of "Roots of Abstract Art in America" appearing in *Studio* magazine, she delineated the world situation between 1910 and 1930 as it affected art. Her position was clearly stated in Rosenberg's book on Gorky, in which she raised questions that revealed her concern with art as a part of a larger social context. Some of her questions were,

> Can art sustain itself for long when removed from external events and environments? Can the artist live within the confines of a canvas eliminating the third entity (the canvas, the world and the creator being the conventional trio). Can the man and the artist be separated? Can art continue to feed on art?[34]

Among her own books, *The New York School: A Cultural Reckoning*, written with the aid of a Guggenheim grant and published in 1973, was exemplary of her interest in a broad base for the consideration of art. This excellent treatise on a period with which she was personally familiar consisted of a discussion of art in terms of artists, their lives, and the spirit of a New Deal era in America. In connection with this volume, she was criticized for promoting the "myth" of the isolated artist; however, considering her thorough presentation of the "times" as well as creative activity, such comments were based on a quite narrow reading of her text. Certainly, she emphasized the creative act as an individual one, but she

has consistently emphasized the universal goals of the artist and his or her place within a social milieu.

Within the next decade, discussing an exhibition of the Costakas Collection of Russian art shown at the Guggenheim Museum, she remarked,

> There's a remarkable painting by Rodchenko which was done in 1943 at exactly the same time that Jackson Pollock began these kind of circular, wandering labyrinthian movements, and this is a circular, labyrinthian painting. Rodchenko could *not*, under any *circumstance*—after all in 1943, there's a big war on over there—have known anything about Pollock or even the Surrealists who inspired Pollock, but there is an unquestionable *zeitgeist*.[35]

Her conception of art history as a total cultural climate rather than isolated phenomena remained a major tenet in her discourses on art.

Over the years, Ashton found her all-encompassing view of art at odds with the approach of most academic art historians. She felt that they were unwilling to recognize overlappings and relationships in what she termed their "...materialistic view of cause and effect or action—reaction. I disagree with that plus their lack of allowance for the unaccountable, for genius in short. We know, or I know, that there is such a thing and that it does exist and somehow does act outside the framework of methodical art history." Several years earlier, or in 1968, she wrote in *Arts* magazine:

> No matter how often the critics intrude the argument of progress in the body of art works, it is always rejected, like the human heart in transplantations. No artificial transplant of aesthetic theory affects the vagarious course of painting and sculpture. The temperaments that were moved to go beyond the orthodox optical principles of perspective in the 16th century were propelled by their peculiar affection for fantasy and psychological ambiguity. Styles in the history of art constitute one history. But there is also a history of temperaments, and in that history, the affinities are legion. If "modernism" is a one-way course, hurtling to ultimate simplicity (and its own negation), modernism is only one chapter in a history of style. In the other history, the history of temperament, there are no one-way streets, and hosts of by-ways which are always well-travelled no matter where, no matter when.[36]

Since the year of this statement, she has served as professor of art history at Cooper Union where she teaches the subject "within its cultural matrix."

> When I speak about Matisse, it is within that certain period in which he functions. I try to inspire young people to look for a temperament at work there, to find what's true about his attitude toward the arts, to-

ward his art especially. My students have to read Mallarme when they study Matisse, or other poets he was concerned with, or Bergson, which gives them a dimension from which they can form their own cultured opinion.

In connection with her broad-based view of art, its history and underlying traits, Ashton has followed the development of some artists that interest her over a period of years. Thus, she has not been concerned with one particular stylistic phase, but in the total expression of a creative person. For example, on various occasions, she wrote on Rothko's work and followed Guston for approximately a 20-year period. In the late 1950s she knew many artists, listened to them, and participated in their discussions. "It was exhilarating." She thought of herself as "very close" to Guston and Rothko and knew Kline, Motherwell, and Schapiro. She found Duchamp interesting as an historical figure and knew him for many years. She first interviewed him for a radio program that she moderated in the early 1960s, and later (1966) in *Studio International*. More recently, she commented, "I always liked one thing about Marcel Duchamp, and that was his sense of language, and maybe he was a verbal artist more than anything else." She was also a long-term friend of Joseph Cornell about whom she wrote, *A Joseph Cornell Album* in 1974 after his death. This volume was intended as a collection or a kind of scrapbook of prose, poetry, and pictures. As such, it was perfectly apropos to and paralleled Cornell's own predilection for collection and display.

Ashton's long-term interests in artists, coupled with a capacious view of art, placed her at odds with the ephemeral, business aspects of modern art. As early as 1958, in *Arts and Architecture*, she complained that the "...whole psychology of the 'art world' has been conditioned by the world of commerce and industry...."[37] A review for *Artscanada* in 1974 contained her complaint that only new work appeared in galleries, "...in keeping with the world of fashion's notion of development, but hardly germane to the world of art."[38] Six years later in the same journal, she charted what she termed America's rise to fame and fall to provincialism in art during the period from 1950 to 1970. The eternal elements she found in art were incompatible with the faddist current that was prevalent in the recent art world's absorption in consumerism.

That a person of her obviously high standards and motivation should be criticized for her point of view and questioned about the strength of her personal integrity seems incomprehensible, but that's exactly what happened before Ashton left the *New York Times* in 1960. In a memorandum of that year to her, John Canaday insinuated that she had shown preference in terms of coverage to her artist friends. In her reply, Ashton denied any wrongdoing and asserted her belief in the necessity of a knowledge of artist as well as his or her work. As a result of this inci-

dent she left her position with the newspaper, and the International Association of Art Critics voted to censure Canaday for having treated a fellow critic in an unprofessional manner. At the time, Ashton decided that she had more important things to do than contend with Canaday. "You have to care an awful lot about the outside world, and I really didn't. I wrote a book and had a child. I was perfectly happy and never thought about it again, although it was an unpleasant experience." Within a four-year period after this unwarranted attack, she received the prestigious F. J. Maher Award for Art Criticism, a Graham Foundation grant, and a Guggenheim fellowship.

Within recent years, Ashton has received a grant from the National Endowment for the Humanities and has published two books, *American Art Since 1945* and *A Fable of Modern Art*. The latter volume seems related to her approach in *A Reading of Modern Art* in which she was concerned with art history as allegory or twentieth-century art as a number of symbols, each "a subject for reflection" and "a signal for commentary." In the preface to this volume, she wrote:

> The mission of the contemporary critic is often construed as a purgative activity aimed at ridding commentary of ornamental maunderings. The modern critic is, with some justice, wary of poetic flights that depart from the work of art and travel great distances on their own momentum. But in the passionate effort to deal with essences, or things in themselves, much modern criticism has deleted a whole realm of experience.
>
> The trouble with the purist or isolationist critical approach is not that it is in itself improper, but rather that it is arbitrarily limited. The first effort of the critic should be to see the unique quality inherent in a work, the quality that immediately attracts the receiver and moves him. But the critic must also remember that other action of a work of art: its expansiveness. If it moves us, it can move us emotionally, morally, psychologically, intellectually, historically, depending on a host of subtle considerations.
>
> It seems to me that twentieth-century art must be considered in a double perspective. The individual work must be seen for its uniqueness, its inherent character—in other words *in itself,* lying wrapped in its own ambience like the moth in the cocoon. And it must be seen in its other capacity as a vital germ that incites the mind to allegorize.[39]

American Art Since 1945, appearing in 1982, seemed to be almost a sequel to the *New York School*. In numbered chapters, Ashton traced the development of American art as she saw and experienced it. Typically, Ashton presented art and artists within the context of their cultural milieu, including contemporaneous literature, philosophy, and criticism. An important contribution made by this book and one that distinguishes it from others of its ilk is Ashton's pervasive consideration of the nature

of American art or what constitutes an art of this country. Early on she describes American artists of the 1950s as having assumed, "...an adversary stance in relation to a prosperous but largely uncultured American society."[40] In what would seem to be her own continuing credo, she attributed to artists a reaction to the resistance provoked by modernist forms. "Philistine attacks quickened their resolve to sort out issues of social commitment, esthetic independence, art and its relations with society as a whole, and art as a transcendent force." In ensuing chapters of this book, Ashton discussed work of women, especially those she associated with Abstract Expressionism and in particular, that of Helen Frankenthaler. However, her relegation of the feminist movement to a single small paragraph at the end of the book was a quite pointed denial of actual circumstances.

Regarding the 1960s, Ashton did not see any notable shifts in the strata of cultural circumstances.

> No matter how enthusiastically artists had banded together in common causes, no matter how much street theater or public exhibitions were subsidized by the government, the same old elite seemed to control culture. In the face of such powers, many artists who had temporarily engaged themselves in the fight for cultural change returned disheartened to their studios and their solitary ideological battles.[41]

Not unexpectedly, she observed that in the 1970s there was "The increasing perception that, despite all the radical departures from traditional means, painting was still a viable expressive means...."[42] Commenting on recent developments in art, she noted, "...uncomfortable parallels between works of art and the objects purveyed to a docile consumer society."[43] Her summary of a situation she found wanting because of a rampant consumerism and negative corporate involvement in art, evolved around her own insistence upon a comprehensive and deep-seated ethical basis for art. In conclusion, she warned, "...American art, with all its diversity, or, as commentators like to say, its pluralism, is on the threshold of crisis—not economic but moral."

Over the years, Ashton, a lively, petite woman with large, bright brown eyes, has been involved in a number of political groups or causes, such as the civil rights movement. She belonged to CORE, worked with the poor, and participated in the anti-Vietnam War movement. She has remained active in PEN, a writer's organization dedicated to the betterment of author's rights. Over the years, she has written on a number of women artists, including Frankenthaler, Mitchell, and Schapiro but, according to her, never because they were women. She said, "I'm more interested in the well-being of working-class women, poor women, than I am in the fortunes of my own middle class. What I'm really interested in is social justice, and I include everybody in that, not just women."

Given these views, it is not surprising that she has not become involved in feminist groups. When it comes to her writing, Ashton is less concerned with its effect upon other people. She says, "I'm a person that writes about art, or whatever else that I write about—more or less first for myself and then for whomever is interested. I don't do it to illuminate other people, but to illuminate myself first." The few people whom she does admire and wishes to have as readers are other writers on art, such as Rudolph Arnheim, Andrew Forge, Fred Licht, Roger Shattuck, and Robert Winton. As an author firmly entrenched in the romantic tradition it is, of course, expected that she should wish to examine her own human experience in relation to history—past and present—and to various cultural factors. Hers is an experiential approach to what she sees as an ongoing quest for fleeting gleams of precious creative insight into the phenomenon of human existence. In some ways quixotical, her concern for an art of feeling and emotion has never wavered, and in a manner indicative of her romanticism, she spoke of "...fighting off the philistines, the encroachment of the mass media. I still do believe that's a great fight."

7
Grace Borgenicht

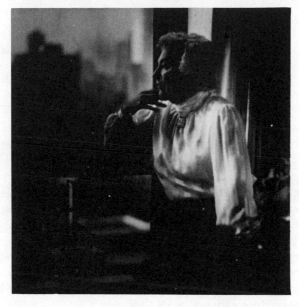

Photo by Warren Brandt, New York.

As part of an unpublished autobiographical statement, Grace Borgenicht wrote:

> Though there have been thin times in my business life, I have never needed financial success and therefore have been left freer to follow my tastes and enjoy warm personal involvement with my artists. For them I am happy to be, at times, psychiatrist, business manager, marriage counselor, and as my artist husband, Warren Brandt, complains to me— "Four children is one thing—but twenty-four!"[1]

There are two symptomatic factors in this presentation germane to a consideration of Borgenicht's position as a gallery dealer; namely, the presence of financial resources that have facilitated her lack of a personally felt need for financial success and her benevolent personality and association with artists.

Tastefully dressed in muted tones and soft-spoken, Borgenicht expresses her pride in the fact that most of the artists whom she has shown in her gallery have stayed with her during the course of their mutually satisfying and intertwining careers. She said, "They believed in me, they thought I was honest and they knew I was doing my best. I had a good rapport, a very close rapport with the artists."[2]

Borgenicht was born in New York City in 1915, the daughter of a shirt manufacturer who became prosperous after he entered the oil business. As a child, she was interested in art, particularly painting and continued to follow her artistic inclinations with the full approval of her parents. In compliance with her mother's wishes, she looked for a college close to home and chose Barnard. During the course of her interview there with a dean, she inquired about the study of art. The answer was "This is not the place for any girl who wants to study painting or cooking." This academic administrator's reply reflected an attitude toward art and women that has not changed much over the years. This dean undoubtedly meant to emphasize what she felt were the rigors of a higher educational program which did not allow dabbling in what she considered frivolous activities. Her intention was part of the institutional commitment of a prestigious women's college toward what they considered to be a substantive academic program, and this curriculum did not allow by omission the traditional associations of art and homemaking with the female gender. Thus, young Grace Lubell wound up at an experimental school called New College at Columbia University where she took advantage of an opportunity to live and study in Europe. For one year, 1934, she resided in Paris where she studied painting with Andre

Lhote and then printmaking in Stanley Hayter's Atelier 17. She received a master's degree in art education and embarked on a teaching career only to relinquish it in order to marry Jack Borgenicht, a manufacturer of children's clothing. Subsequently, and "For years, I was mother, housekeeper, 'gentleman' farmer and painter of watercolors."

In spite of her involvement in housewifery, Borgenicht did take the time to continue her career as a painter and had her first one-woman show in 1947 at the Laurel Gallery, a small establishment on East Fifty-seventh Street. In a review of her show in *Art Digest*, Judith Kaye Reed described her as a "fluent watercolorist" using a "rich palette."[3] Her subject matter was industrial scenery, still lifes, and portraits. A reviewer writing in *Art News* about a second show, described her as an "expert technician" who created a sense of "moody picturesqueness" in pictures of mines and blast furnaces near Scranton, Pennsylvania.[4] On the occasion of her third exhibit, there were written references to her "romantic approach to native themes" and experiments with sand, sawdust, and other materials.[5] Perhaps the apex of her career as an artist came in 1955 when her work was shown at the Martha Jackson Gallery. In *Art Digest*, Martica Sawin extolled Borgenicht's "...elegance and a preference for the formal and contrived over the random and immediate,"[6] and Parker Tyler, covering for *Art News*, termed hers an "impressionistic" method "consisting of a use of blotted lines and spatterings."[7] Borgenicht's work was accepted into the Whitney Annual exhibition and the Brooklyn International Watercolor show. Thus, by the late 1940s and early to mid-1950s, she had launched what seemed to be an incipiently successful career as an artist.

In the course of her affiliation with the Laurel Gallery, she met Milton Avery, Jimmy Ernst, Stanley William Hayter, and Gabor Peterdi. To her, this was a time when "...the existing art world opened its doors. It seemed like there was a whole new world out there I hadn't known about." She became friendly with gallery owner Chris Ritter, and decided to invest some of her husband's money in the business. Resultantly, she became active in gallery affairs, but by this time she had two children. "I thought, well, some day when the children grow up I might do something about a gallery, but as it happened, I couldn't wait." During the course of her association with this gallery, she and Ritter decided to put out the Laurel Portfolios of prints designed to both promote and sell artists' works. She recalled with dismay one Avery portfolio of five etchings that they couldn't sell for $25, but that later brought $7,000 at Parke Bernet. In spite of her interest in this venture, she retired after a short time and withdrew her support in order to bear and care for her youngest daughter, Lois. Not long after, Ritter sold the Laurel Gallery, and Ernst and Peterdi approached her about starting another gallery. At first she told them she didn't know enough about being a dealer, "but the prevailed, so I opened a gallery."

In 1951, with financial support from her husband, she established her own place at 65 East Fifty-seventh Street. Immediately, Ernst, Peterdi, and Avery chose to show their work in her space. In 1952, Jose de Rivera joined up, and soon she introduced the work of Leonard Baskin, Charles Biederman (whose work had been shown in New York over 40 years earlier) Edward Corbet, Gertrude Greene, Roy Gussow, Hans Hokanson, Reuben Kadish, and Wolf Kahn. Also, at early stages of their respective careers, she exhibited work by Ilya Bolotowsky, Paul Burlin, and Ralston Crawford. Subsequently, these artists received and continue to be recognized for their creative contributions. About this turn of events, Borgenicht observed:

> Both Jose de Rivera and Ilya Bolotowsky came to my gallery when I first started. I believed wholeheartedly in their work, but it took a long time to convince the public of their excellence and importance. Today, de Rivera's work is in major museums throughout the country, his commissions are priced at $100,000, and my long years of faith have been rewarded. Bolotowsky has had a retrospective at the Guggenheim Museum in New York and at the National Collection of Fine Arts in Washington, D.C., after many years of neglect.

After their deaths, she also received the estates of Stuart Davis and Max Beckmann, the only European in her group.

Although most of her artists have remained with the gallery, there have been exceptions. For example, before his death and after 30 years, Bolotowsky decided to move to Joan Washburn's gallery. Over the years, Borgenicht never bound an artist to the gallery in terms of formal arrangements.

> I've never had a contract with an artist. I feel that if a gallery isn't pleasing an artist and isn't doing what the artist thinks it should be doing, there's no point in being together. Contracts can always be broken if anyone wants to. I feel there should be a mutual parting of ways. It happened with Leonard Baskin. I gave him his first one-man exhibit and showed his work for about fifteen, sixteen years. Then he was made offers with guarantees that I've never given an artist. I bought his work when he needed money, but I never gave him guarantees. So I said, "If they can give you a guarantee, go ahead." It was a mutual parting of good will and no bad feelings.

In general, however, her associations and relationships with artists have been amicable and lasting and, oftentimes, she has helped her artists out of financial problems by buying work. When Burlin needed an eye operation, for example, she bought a painting. Perhaps one reason for her good relations with artists is that she has not taken advantage of them.

There are galleries that buy young artists' work at low prices and then make money from it. I've never done that. People have said to me, "If you know you've got a sure hit, why don't you buy out the show first and then make some profits?" And I've said, "Well, I really want the artists to make the money." That's always been my policy.

Upon occasion, she has purchased work by artists showing in her gallery as well as that of other individuals, and in the process she has amassed a sizable collection. She owns work by Burlin, de Rivera, Ernst, Hokanson, and Kadish, as well as that by Peter Agostino, Adolph Gottlieb, Willem de Kooning, Ibram Lassaw, Fernand Léger, and Piet Mondrian. Her current husband, a painter of realistic still life, prefers nineteenth and twentieth-century French masters, so they also own watercolors by Paul Cézanne, oils by Edgar Degas, Auguste Rodin sculpture, and drawings by Pierre Bonnard, Henri Matisse, and Edouard Vuillard. On the whole, graphic work dominates their acquisitions.

Borgenicht's taste has been described as inclined toward "elegant" objects that in a general way corresponds to the earlier descriptions of her own paintings. A notable exception, however, is the work of German Expressionist, Max Beckmann.

I've always shown what I've liked. I've tried not to get on bandwagons. I never show Op, and I never showed Pop. I never showed the "movement" sort of thing, and that's why the group is varied. It goes from pure forms, like those of José de Rivera and David Lee Brown to Max Beckmann and Paul Burlin whose work is Expressionist. Wolf Kahn is an Impressionist. You can't pin me down. I really show what I like, what I'd like to buy myself and what I feel I can believe in.

There is a variety of styles present among artists shown in her gallery, but there also seems to be a prevalent sense of refinement, clarity, and dignity that entails the artist's interpretation of a natural or figurative theme.

Regardless of who or what she exhibited, her contribution, like other women of her generation, was her choice to show work by young Americans in her gallery. She recalled that,

In the fifties and sixties, the museums in this country didn't want to show Americans and Europeans wouldn't think of showing Americans. That's why I really opened my gallery. I wanted to do something for American art, because I realized that no one was pushing it. There were a handful of galleries showing American art.

During these early years, it was difficult to convince people, particularly collectors, of the value of work by Americans.

I lost money for five years, and after that I broke even. It took a great deal of faith in myself, my own strong likes and dislikes and faith in the artists I took on. Since then I've been making money, and each year it seems to be more which is amazing to me.

Although she had no business experience when she opened her gallery, Borgenicht found that she did like the sales aspect of the job. In retrospect, she tentatively credited her aptitude to an inheritance from her father who was at one time a salesman. In a modest manner, she did not overrate her abilities except to affirm the continuing success of her dealership over an almost 30-year period.

In the course of her years in business, she lived through several changes; namely, the rise in popularity of American art in this country and in Europe and the development of what to her was a new type of art collector.

Collectors are very smart these days. They follow the market. They go to all the galleries, they go to artists' studios, and they find people. There's a whole breed of collectors who are very serious about it. They know prices, they know artists, they know everything.

She included in this group the speculative collector who has demonstrated an eagerness ''...to try new things. I think they're afraid that they might miss the boat. They've seen what happened to the Abstract Expressionists and to other artists.'' In addition, she has seen a great rise in prices for some artists. ''Once I sold an Avery for $1,000, now I can sell it for $300,000.'' Certainly, over the past quarter century, like the status of American art and the number of collectors, the prices of art have increased dramatically, the market has broadened, and art has been deemed a valuable commodity and investment.

In recent years, one difficulty Borgenicht has found in her line of work is selling work by artists who are working in traditional modes. ''It's very hard to create excitement for a person who's 'just' been painting. If you don't do anything splashy or spectacular, and if you don't go with fashions, it's difficult to simply keep up representation of a good artist.'' This has been a complaint Borgenicht has expressed more than once in recent years. In 1977, she told Barnaby Conrad,

It's hard to get publicity for artists who just paint and don't protect themselves outrageously. The average critic won't write about a painter who is just good, there has to be something ''newsy'' involved. Even the museums seem bound to show ''name artists'' to attract people.[8]

Her problem in this regard, is one that has concerned and affected other dealers. In art, as in all other aspects of contemporary society, there has

been a tendency to force change-for-change's sake, an effort that often results in producing a "new" product that is merely warmed-up old material. Borgenicht has squarely faced the issue of going out of style in terms of her taste, and her selections have proven to have longevity. In some cases, she has been in the favored position of reaping the benefits from increased sales values on work that has withstood the test of fashion. In certain instances, she may be somewhat limited in terms of those artists working in conventional modes, but there are also those printed forums and their critics who favor her aesthetic. Borgenicht's continuing and increasing success has stood as one convincing testimonial to the validity of her choices as a dealer.

Since the late 1970s, Borgenicht has given increasing responsibility for finding new talent to her youngest daughter, Lois, who is vice president of the gallery, and to other members of her staff. Lois Borgenicht has followed in her mother's footsteps in simultaneously pursuing careers a painter and as a dealer. Her daughter and others on Borgenicht's staff have chosen work by a number of younger artists new to the public. Specifically, young employees are allowed to spend a great deal of time looking at slides and going to artists' studios. Their "discoveries" are shown in small exhibits in a subsidiary gallery space. The final decision in these matters is Grace Borgenicht's, but she says she tries to "go along. It may not be what I would buy myself, but I feel there is a whole new market out there. It's changed so rapidly. There are collectors buying these new things. I wouldn't buy, but they do." Along with the perogative to bring in new artists, members of her staff also have their own correspondent clientele.

Borgenicht's life has been and is one of an active, effective person. In reference to her female colleagues of earlier years, she says, "You know, we were very liberated, and we didn't have to wait for 'Women's Lib'. We just wanted to do it and did it. Sometimes I've said, 'I wish I weren't so liberated'. I wouldn't mind somebody taking care of me." Her first husband was a "casualty" of the first few lean years of her trade, and she remarried twice. As she succinctly states, "Being a businesswoman has been a recognized part of my life." As is her custom, she rises early and walks to work. In fact, when in 1980, she moved her gallery from Madison Avenue at Seventy-ninth Street to its present location at Fifth Avenue and Fifty-seventh, she sold her townhouse on Ninety-fifth Street and moved into a downtown apartment so that she might continue to walk to her gallery. She moved her gallery to Fifth Avenue because she felt there was more traffic in the Fifty-seventh Street area. The space had been a fur factory. "When I took it, I just closed my eyes, because it was so horrible. It was a complete wreck of a place. We had to do a complete demolition and then start to build. We put a lot of money into renovation." At the time, her husband said to her, "At

your age, you're signing a ten-year lease for a million dollars?'' Her answer, as quoted by Grace Glueck in a 1981 *Times* piece was, ''I'm a gambler. And besides, was I going to spend the rest of my life doing— needlepoint?''[9]

As a woman who was one of the pioneers in developing a career as a dealer, she has had only a few role models. People she has admired include Adelyn Breeskin, whom she called a ''model of a scholar and a wonderful museum person.'' She notes similarities in their lives in that they both had daughters, were divorced, and both are still active. She also calls ''Miss Kraushaar's,'' a ''model of an excellent gallery'' and has received encouragement from her continued vitality.

Borgenicht sees the gallery dealer as a kind of median between artist and public. The artist must be encouraged financially and morally, while the public is instructed and informed about cultural matters. Artists must have the opportunity to experiment as the critical faculties of prospective viewers are brought within range of unprecedented work. She considers the gallery a place of education, but adds, ''It must be a profit-making venture, however, if artists are to be free to create without resorting to outside means of support. The problem of creative artists and their society has always existed. . . .'' Indeed, Borgenicht operated within the space of this schism for the many years of her successful career as a dealer, and she continues to encourage the development of new art by living artists as well as to promote the work she has continued to believe in over the years.

8
Virginia Zabriskie

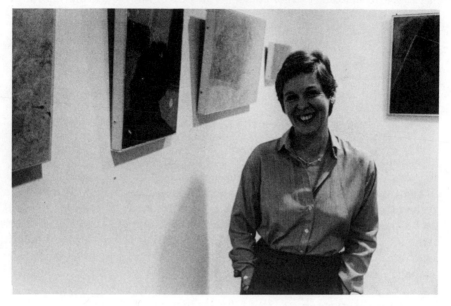

Photo by Doug Magee, New York.

The Zabriskie Gallery sign appears not one, but three times—at 724 Fifth Avenue and 521 West Fifty-seventh Street in New York City and 29 rue Aubry le Boucher, Paris, France. Virginia Zabriskie has, as she says, a "big business" which grosses close to 2 million dollars a year in what she calls "my middle range" as compared to the total receipts of other prominent galleries.[1] Her successful operation is even more unique in light of the fact that she has chosen to handle sculpture and photography rather than the more acceptable and saleable medium of painting.

Born on Manhattan's West Side, Virginia Marshall attended public school and the High School of Music and Art. She was attracted to art as a child, but "...my capacity to criticize grew faster than my ability to paint." Her parents were not interested in art or, as she puts it, "Not a picture on the wall." Nevertheless, she pursued her inclinations, receiving a bachelor's degree in art history from New York University and a master's degree from the New York University Institute of Fine Arts. Her thesis was on Jacques Villon, Marcel Duchamp, and Raymond Duchamp, and even as a graduate student, she began to exercise her managerial abilities via the establishment of an organization called Art Research Associates. With the assistance of a friend, Betty Morrison, she initiated this service that utilized the abilities of other graduate students in offering research skills and experience to prospective clients. Encouraged by Walter Pach to pursue her studies in art history, she spent a year in postgraduate study of art history at the Ecole du Louvre. Shortly after her return to the United States, she married George Zabriskie, but didn't give up her interests in art.

In 1954, she paid one dollar to assume the lease of a gallery established by Marvin Korman, a fellow student from the Institute. The Korman Gallery occupied a small space on the second floor of 835 Madison Avenue. At the time she didn't have to work, but the gallery presented an opportunity to pursue both her art and business interests. A $1,000 inheritance left to her by her grandmother aided Zabriskie in offsetting her expenses. In retrospect, she is proud of the fact that she did not then or later borrow money or rely upon backers.

With the Korman Gallery came several young artists; namely, Pat Adams, Tom George, Clinton Hill, and Lester Johnson, whose work she has continued to show over the years. In 1957, she entered a partnership with Robert Schoelkopf who eventually became tired of being called "Mr. Zabriskie" and subsequently established his own gallery. During her first year in business, the gallery did quite well, grossing $6,000. Twenty-five years later, she was aiming at her first million.

"You've got to remember that you are a retail store," she said about the function of a gallery. "You must bring attention to and make money for your artists. There is only one reason that an artist comes to you." Upon occasion, an artist has approached her and said, "Mrs. Zabriskie, I don't care if my work is sold," and she has told these individuals, "First, I'm here to sell. You've come here to be represented and to have your work sold. In order to sell it, I must extend your reputation, give you more visibility, and do as much for you as I can as a dealer." Zabriskie possesses a firm but flexible approach to her job. "My primary obligation is to my artists, and that means selling, creating visibility, and understanding what he or she wants. In some cases, visibility may be more important than sales to a person, so I would push that end for the artist." Zabriskie understands, of course, that often these two factors are dependent upon one another. In general, she runs a no-nonsense operation in a clear course toward the realization of her responsibilities as she sees them.

Zabriskie is emphatically direct about the importance of the retail aspect of her career. She has said, "Ninety-five percent is business, and anybody who thinks it isn't doesn't know how to run a gallery." In spite of the great importance she places on sales, it is somewhat surprising to learn that she personally does not do much selling. "It's probably one of the reasons my gallery has grown to the size that it has. I'm not very patient, and if I sell I usually teach. So a lot of that has been delegated to people who are with me, who are close to me, and who enjoy it."

Zabriskie thinks of herself primarily as an administrator, a position that provides her with much satisfaction. "I think from the beginning I have been interested in the managerial end of running a gallery." The growth of her operation, however, has curtailed some activities she enjoyed in earlier years. "At the beginning, I loved designing catalogues and I loved installing an exhibition. Until seven years ago, no one ever installed an exhibition except me." Indeed the administration of her enterprise has grown over a period of 30 years. In 1966, she moved her gallery to 699 Madison Avenue, and after five years to 29 West Fifty-seventh Street. Ten years later she took over a new space at 724 Fifth Avenue. In 1977, she inaugurated a small space for shows of photography in Paris, and within the next three years she opened the doors of a large space for sculpture at 521 West Fifty-seventh Street. On the whole, she spends more of her time in Paris "... because that gallery needs me more than the ones in this country."

Zabriskie feels that her auspicious beginnings in the gallery world and her continuing prosperity are due to her ability to "... take advantage of a situation when it presents itself." Exemplary is her Paris gallery set up where she found an interest in and a dearth of opportunities to view shows of photography. In this instance, she was able to capitalize on a specific need as it coincided with her own intentions. At

the outset of her career, she had no intention of retaining the dealership.

> The fact that I'm still in it thirty years later is amazing to me. I absolutely love it, but there was a time when I thought, "Well, when I get to be forty, maybe I'd like to work for the United Nations." I thought about doing something else, because my skills had other possible applications.

Zabriskie realized that her interest in art was at least equaled by her considerable talent for running a business.

In addition, her will to succeed has been an important factor in her life and work. To her, "...success is a wonderful thing. Just being successful is about the nicest thing that can happen to anybody, especially after having set out in life not having any fantasies about being somebody or anybody in particular." Her natural assets, including ambition, discipline, and a willingness to work hard could have served her well in other professions.

> I think I set out to prove myself. Whether I would have done as well in a bank or at teaching, I don't know. I rather think so, but maybe not quite as well. I've been able to make money, which for women in our time is a really new frontier. I think we've seen women entering areas where they are successful, whether it's business or whatever.

Zabriskie's point is well taken and certainly in the art world a number of women have risen to prominence as dealers both in monetary and aesthetical terms.

With regard to showing work by women artists in her gallery, she said, "I never made a point of not showing women, and I think there have been galleries that have deliberately not shown certain people for particular reasons. It never occurred to me." She has not considered herself to be overtly involved in political matters; however, in 1982, she sponsored a show and sale of work in support of efforts to pass the Equal Rights Amendment. Among the artists she has represented, she pointed to Mary Frank as the only one attentive to political matters. In spite of her own marginal involvement with the women's rights movement, she reflected:

> When I get to be a really nice, little old lady and people say to me, "What changes have you seen in your lifetime?," I think I'll say feminism over nuclear energy. I would say racism and feminism are the two big things that I've seen change in my lifetime.

Thus, even though she has not cared to become actively engaged in public affairs, she expressed quite a deep concern for social and human issues.

In consideration of dealers' affairs and problems, Zabriskie speculated on the respective motivations of women and men in the art world. "I think women are as interested as men in money, and that men are as interested in art as they are money." Contrary to popular belief, Zabriskie felt that "getting ahead" and being rich was a part of women's ambition as well as that of men. Furthermore, she viewed men as concerned with cultural elements, an area often associated with the female sex. Regarding her own position, she has said that, "A gallery is a business." And she has been highly conscious of financial considerations and their consequences.

> What people have a hard time understanding is that a writer's agent can work on a ten-percent commission because he or she can handle forty people with a telephone. An art dealer running an exhibition gallery has more in common with a publisher. I have all the costs of publishing, including a staff. I am only able to do ten or twelve shows a year, and I have high overhead. Therefore, there is a greater commission.

In 1981, Zabriskie figured that her overhead was $40,000 per month, including all expenses such as rent, catalogues, and openings. When she first opened her gallery, she charged all the artists $100, and later for the total cost of their exhibitions. "In the last fifteen years—I mean, I probably buy their clothes!" She saw serious repercussions arising from this situation.

> Unfortunately, one of the problems for all of us is that we can no longer serve the younger artist in the way I could when I was younger and paid a rent of $185 a month. The economics of running a gallery today are staggering, absolutely staggering. You can't search out younger artists. You are very dependent upon established names.

Certainly this is a problem for the younger, "unknown" artist, and one that undoubtedly affects the course of contemporary art. That is, the amount of new artists and work to be shown in established galleries tends to be governed by financial concerns. Hopefully, this state of affairs will not stifle experimentation. Zabriskie has attempted to do her part in introducing work by scheduling a group show each year that will introduce someone to the gallery-going public. In addition, she has used her West Side space for invitational exhibitions that may include work by a new artist.

Zabriskie is quite formal about her arrangements and agreements with artists. She utilizes "letters" as contracts. "A letter is also a contract. I do not believe, as many dealers do, in shaking hands. I run a business, and I believe that both parties should know what their obligations are to one another." Likewise, she recommends that artists em-

ploy counsel and that they should not simply leave their work in a gallery hoping the dealer will sell it.

> I am for artists being more business-like. They're dealing with establishments that are businesses, and artists can no longer treat galleries otherwise. Any other attitude is a hangover from those days when nobody sold anything anyway. An artist can no longer operate that way.

In general, Zabriskie prefers to keep her associations with artists friendly but on a professional level. She does not believe in buying work by artists represented by her gallery, out of concern for entering into competition with her clients. She has, however, purchased work when artists have needed money or encouragement.

> I remember the first painting I ever bought. Lester Johnson, whose work I showed, came to me and said, "My children need shoes," and they really did. The work wasn't selling and he had no money. I said, "Lester, I'm never going to buy a pair of shoes, but I'm going to try to buy a painting."

In actuality, Zabriskie is not particularly acquisitive and is quite philosophical about the possession of work. "Art is something that goes beyond us. If you buy a picture, you are a custodian, and that picture will go back into the public domain very quickly. You're taking charge of it, watching over it for a very short period of time."

In spite of Zabriskie's avowed belief in a dealership as a business, she has not selected the most expedient or lucrative course in terms of work shown in her gallery. She has chosen the difficult task of selling sculpture. "I love sculpture! I've always found painting in some ways more abstract than the reality that exists somehow in sculpture." In addition to artists she took in when she bought the Korman Gallery, she has contracted the following sculptors: Mary Frank, Ann Healy, Ibram Lassaw, Theodore Roszak, Kenneth Snelson, Richard Stankiewicz, and Athena Tacha. Stankiewicz had his first show in her gallery in 1972 after a seven-year absence from the New York exhibition circuit. She handles several estates, including those of sculptors Alexander Archipenko, Saul Baizerman, and William Zorach. Painters' estates under her management are those of George Ault, Albert Gallatin, Yasuo Kuniyoshi, Kenneth Hayes Miller, Katherine Schmidt, and Abraham Walkowitz.

During the course of her career, Zabriskie has not been involved in showing art connected with movements. Likewise, the artists she has chosen have not been particularly identified with any fashionable label. For example, the work of Mary Frank has defied categorization. Although she has been considered a major artist for several years, her highly personal work has escaped particular groupings. Frank has also

successfully challenged prejudices about clay as a craft medium. The lyrical, poetical, rather ethereal grace that marks Frank's work seems to define qualities that have attracted Zabriskie. In addition, she seems to have some predisposition for work that has some connection to nature and mythology like that present in the work of Roszak. On the other hand, she has also shown the nonobjective works of Snelson that possess a spiritual quality more relative to urban or city life. Zabriskie has shown particular fondness for welded metal as exemplified by her choices of Lassaw, Roszak, and Stankiewicz, artists whose work possess more of an historical rather than a contemporary feeling. The "heavy metal" aesthetic of some Minimalist or post-Minimalist work is outside of her purview. Generally, she has chosen work that is in some way related to a human scale and that possesses a personal, often quite incorporeal essence.

Zabriskie has not excluded painting from her interests, and the painters that she does represent share an interest in the abstract possibilities of their medium. Certainly, abstraction is a term that might be applied to all of Zabriskie's choices but, as she puts it, "What other kind of art is there?" Her question assumes the human element inherent in creative activity as opposed to that of nature. Art, for her, is something innately civilized and subjective.

Although she has shown a preference for abstraction and for sculpture, Zabriskie is not a proponent of any one cause, style, or "ism" in art. She believes that it is wiser to "Concentrate on artists, not movements." She has, however, expressed some regret for not having caught onto some of the various enthusiasms she has seen possess her profession over the years.

> When I entered the business, people I most admired, like Pollock, de Kooning, and Kline, had found their way into other galleries. So, rather than choose second rank Abstract Expressionists, I chose other people and styles, and I seem to have followed that pattern. I have managed to miss every movement that ever took place in the art world. I missed Op, I missed Pop, I missed Minimal art. I never had those artists. Today, I don't have the Baroque art of people like Julian Schnabel. I may be admired for this by some people, but I find it sort of lacking in me.

Nevertheless, and in spite of her own assessment, Zabriskie has accomplished a sizable feat considering her financial success regardless of the fact that few galleries other than hers have specialized in three-dimensional art. Her problems and expenses with transportation are greater, and historically and at present, painting occupies a higher position in the minds of the public and the prospective collector. Zabriskie has undoubtedly assisted in elevating the relative status of sculpture in contemporary art.

Another of her distinctive contributions is her interest in and support of photography since the late 1970s. She has not only shown the work of individual photographers but has originated numerous important historical and group exhibitions. Among nineteenth-century artists whose work she exhibits are: Eugene Atget, Felice Beato, William Henry Jackson, Eadweard Muybridge, Nadar, and Timothy O'Sullivan. Her extensive list of photographers who have worked in this century includes: Bernice Abbott, Diane Arbus, Eugene J. Bellocq, Constantin Brancusi, Brassai, Harry Callahan, Henri Cartier-Bresson, Walker Evans, Mark Feldstein, Robert Frank, Lee Friedlander, Ralph Eugene Meatyard, Joel Meyerowitz, Duane Michaels, Man Ray, Charles Sheeler, Aaron Siskind, Alfred Stieglitz, Paul Strand, Weegee, Edward Weston, and Minor White. She held the first public exhibition of Atget's photographs of Paris and the surrounding area taken before World War I. Other important historic and contemporary photographs were exhibited in precursive shows, such as: "Sculpture: A Photographer's Vision," "Urban Focus," "France Between the Wars: 1925–1940," "French Fashion Photography, 1900–1975," "French Photography: 1945–1980," "Alfred Stieglitz and An American Place, 1929–1946," and "Nineteenth Century French Photography, c. 1845–1875." Via Zabriskie Editions, she has published photographic posters of work by Ansel Adams, Callahan, Friedlander, Stieglitz, and Strand, among others, and she has organized circulating shows of work by Feldstein, Meyerowitz, Stieglitz, Strand, and Weegee in America and abroad. She has also been concerned with combined shows of sculpture and photographs, for example that of Kenneth Snelson in 1981, or in showing the photographs of sculptors, such as Michael Singer.

Her gallery in Paris, located near Centre Georges Pompidou (Beauborg), has been devoted primarily to exhibits of photography, although she has shown other media, including small sculpture there. Between 1977 and 1981, Galerie Zabriskie sponsored the first major European shows of work by Aaron Siskind, Evans, Friedlander, and Meyerowitz. Work by Callahan was shown after a 20-year interval, and Abbott returned to Paris on the occasion of her eighty-first birthday to celebrate an exhibition of her work entitled, "Personalities of the 1920's" in the gallery. Zabriskie claims a dominant influence on the introduction of photography in Europe and its acceptance by the European public. Her love of photography is expressed in her own words,

> At forty-five years of age, I opened a gallery and began to learn things. Suddenly, I started to think about photography and its relationship to the other arts. I think some of my most original thinking has been in the field of photography. Within the first year, I recognized that I looked at photography in a manner different from the other arts. You don't look at it formally as you do painting or sculpture, and often you don't even

hang it on a wall. It's an intimate, in-depth experience. There's no such thing as a single photograph. You've got to know a photographer's work in depth. It would be like reading one chapter of Proust and not the whole book. It's more of a literary experience and draws upon intelligence other than the visual.

Zabriskie's self-designated "misses" in terms of choosing fashionable artists and movements have actually proven to be a source of her strength as she has concentrated on sculpture and photography, media that have increased in status and value over the past two decades.

In 1977, she began publication of a newsletter sent to art afficionados in Europe and the United States. This vehicle was extended in 1981 to cover all exhibitions and to replace show announcements. It is a gazette that offers information on all shows at Zabriskie's galleries, including biographical information on the artist, critical reviews and excerpts from critical writings, and updates on "her" artists' activities. Zabriskie's gallery is unique in its dissemination of such extensive information about gallery artists and events. It serves not only public relations purposes, but educational aims.

Zabriskie is an attractive woman with large eyes and soft features. She has been married and divorced twice while pursuing her career. Her devotion to her profession is perhaps best summarized in her own words:

> Everything I do is involved with looking. If I have an hour free, I'll go to a museum. My life has been so totally enriched, not by my personal success, but by art itself. It's just been fantastic. Can you imagine being a dentist and enjoying it after hours? I mean, I live it! That's been its richness, and that's true of anybody who works in it. I think we're all blessed.

There's no question about Zabriskie's interest in and involvement with her vocation. Among her colleagues, she admires Antoinette Kraushaar because of the older woman's energy, activity, and continuing vitality in terms of her gallery's operation. "This is the thing that gives her her kicks, and it gives me my kicks. I mean, I have much more fun going to work than going to the beach. It's the place where I feel most at home, most at ease."

9
Lucy Lippard

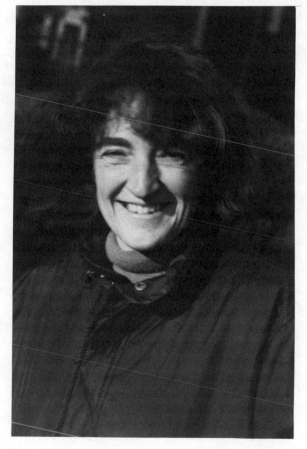

Photo by Jerry Kearns, New York.

During her entire professional career, Lucy Lippard has taken a radical and activist view of art and the art world. Her unswerving bent has been toward an art and content that is centered on other than traditional aesthetic concerns. For about three years, beginning in 1965, she wrote about art that has been called "Minimalist." During the mid to late 1960s, her reputation was firmly established by these writings and others on Pop Art. Subsequently, she supported women's art and that of a more specifically political bent. A superficially formed opinion might find her interests to be rather disparate and varied, but in fact, there is an underlying focus to the art causes championed by Lippard. Perhaps the most consistent and pervasive factor is her rejection of the status quo or orthodox doctrine of any kind combined with her inclinations toward art that does more than occupy space in a museum. In her own words, she is a "writer, activist, critic," and she has repeatedly used her advantaged position as an educated, well-informed person to call attention to and support unorthodox social as well as artistic issues.[1]

As a child, Lippard wanted to become a writer, and in spite of her quite well-to-do background, she set an early course toward combining her literary talents with powerfully felt concerns about our society. Her father was dean of the Yale University Medical School, a profession that combined academic with human values. Both parents were "Sunday painters," providing Lippard with a quite gentile home that encouraged both her educational and cultural development. Her undergraduate experiences involved two factors that seem to have set directions for her future. She attended Smith College, a well-known Ivy League school and spent her junior year in Paris. These quite respectable experiences were at least partially countered by her work after graduation in a Mexican village with the American Field Service Committee. Eventually, she disagreed with her parents on certain issues, and they called her an "anti-snob, snob," an epithet that was undoubtedly in part defensive, but one that could be retrospectively viewed as a reference to her leadership role in calling for changes in art and the art world as a whole.

In 1958, she went to work for a gallery, and somewhat precociously asked the then editor of *Arts* magazine, Hilton Kramer, for a job. He turned her down, but she did manage to acquire employment as researcher in the Museum of Modern Art's library. At this institution she met artists Dan Flavin and Robert Ryman both employed as guards, and night watchman Sol LeWitt. In order to increase her salary, she pursued a degree in art history at New York University's Institute of Fine Arts and took a trip to Florence, Italy, in connection with a course taught by

H. W. Janson. Just as her earlier education entailed conventional and unconventional facets, she continued to pursue traditional course work in and with certain bastions of art history while personally associating herself with artists who were soon to become leaders of the avant-garde in art.

Lippard returned from Italy in 1961 to marry Ryman and to support herself and him through free-lance work as a writer. The next year they moved into a new loft and became friendly with neighbors Ray Donarski, Tom Doyle, Dan Graham, Eva Hesse, Robert and Sylvia Mangold, and Frank Viner. Also in 1962, her first article was published in the *Art Journal* on Jean Dubuffet and Max Ernst. It was a comparative study based on her master's thesis work at NYU. Noteworthy is the fact that early on in her career she was interested in Dubuffet, an anarchist and exponent of anticulture and in Dada-Max, an influential artist member of a dissident movement in art. Within the next two years, she was hired as a reviewer for *Artforum*, took over Max Kozloff's position as an editor for *Art International*, and had a son, Ethan Iphram.

By 1966, she had three books in print—she wrote notes for *The School of Paris*, coauthored by Alfred H. Barr, Jr., and James Thrall Soby and authored *The Graphic Work of Philip Evergood*. These two manuscripts, along with journal articles published from 1962 to 1966, were analytical and traditionally art historical in nature. The third book, *Pop Art* (still in print), brought her wide critical acclaim and stature as an art writer. The latter was a kind of amalgam of art historical and critical methodology and critical analysis. In her introduction, she placed this grouping within an historical context, and in her essay on "New York Pop" and its spinoffs, she dealt with the content she found in Pop forms. She acknowledged both the opposition to Pop and critics' views of it as a commercially-oriented boondoggle. Significantly, the most important issue to Lippard was the leveling possibility she saw in Pop.

> Pop chose to depict everything previously considered unworthy of notice, let alone of art: every level of advertising, magazine and newspaper illustration, Times Square jokes, tasteless bric-a-brac and gaudy furnishings, ordinary clothes and foods, film stars, pin-ups, cartoons. Nothing was sacred, and the cheaper and more despicable the better.[2]

Fifteen years later she again advocated popular art forms as vehicles expressive of political issues.

In 1965, she had begun to write formalist criticism and continued to do so for the next three years. In this context she wrote an early article, "The Third Stream" (1964), on what came to be better known as "Minimalism" in art, interviewed Frank Stella and Donald Judd (*Art News*, 1966) and wrote on "Rejective Art" for *Art International* (1965). In

the latter piece and in a number of this magazine's "New York Letters," she defined what she termed "Primary Structure," entailing her view of the essential and independent objecthood of works of art. *American Sculpture of the Sixties*, a catalogue for an exhibit at the Los Angeles County Museum in 1967, contained her essay regarding "painting as object," a discussion of recent combinations of traits usually ascribed to either painting or sculpture. She pointed to the work of Ronald Bladen, Dan Flavin, Donald Judd, Richard Smith, and Frank Stella as exemplary of expansions of ". . . the dimension and formal possibilities of painting, or wall-hung pieces."[3] "Rejective Art" was to Lippard intellectual and centered absolutely in the art object.

Central to the expansion and development of her theories were the essays, "Cult of the Direct and the Difficult," published in *Two Decades of American Painting* by the Museum of Modern Art in 1966 and "Eccentric Abstraction" in *Art International* of the same year. Lippard opened the first of these with an historic reference to "direct" and "concrete" as terms ". . . suggested as alternatives to the term 'Abstract Expressionist' by the artists themselves in a 1950 symposium. Both words imply a tough, no-nonsense ideal that has been a constant factor in American art for the past two decades."[4] She continued to quote artists such as Pousette-Dart, Ad Reinhardt, and Clyfford Still in support of her contention that a primary form provided an absolute experience that did not immediately please or satisfy viewers in the way that more conventional forms of art had been able to provide satisfaction. To Lippard, Reinhardt's "square, symmetrical black paintings," completed during the days of the New York School, had remained pertinent to contemporaneous art that represented the most essential of artistic properties.

Already, or within a two-year period, Lippard began to question a strictly formalist approach. In "Eccentric Abstraction," she considered alternatives to formalism. She wrote, ". . . where formalist painting tends to focus on specific formal problems, eccentric abstraction is more allied to the nonformal tradition devoted to opening up new areas of materials, shape, color and sensuous experience. It shares Pop Art's perversity and irreverence."[5] The last sentence reflected Lippard's own choices and direction as they have always been disrespectful of accepted norms or established criteria. Within the vein of "Eccentric Abstraction" she placed work by Alice Adams, Louise Bourgeois, Eva Hesse, Gary Kuehn, Bruce Nauman, Don Potts, Keith Sonnier, and Frank Viner. She included these artists in an exhibition of the same title and year in New York. This show was the first east coast exposure for Nauman. The exhibit and the article marked an important transition for Lippard from "primary structure" or an "intellectual approach" to a more aberrant context for art.[6] "Eccentric Abstraction," she wrote, was based on an ". . . absence of emotional interference and literary pictorial associations."[7] Her disdain for

a romantic approach inherent in her support of "difficult" or "rejectionist" art continued to pervade her identification of "Eccentric Abstraction." "The sensibility that gives rise to an eroticism of near inertia tends to be casual about erotic acts and stimulants, approaching them non-romantically."[8] Thus, her own thinking about contemporaneous art lead from a formal approach to one admitting deviation and sensuosity. "Eros Presumptive," published in *The Hudson Review* (1967), reiterated her view that the best erotica in the then current art was abstract and basically unemotional.[9]

Essentially, Lippard had acknowledged the validity of erratic form, but she did not give up her notion of the primacy of the art object. In fact, she attempted at this time to associate a critical writing style with that of the art object. In *The Hudson Review* of 1966–67, she wrote, "The new criticism is opposed to the 'review syndrome' that has plagued contemporary art writing with minutiae, poetry, fanciful journalism, social commentary, and explanations based on a vague premise of *Zeitgeist*."[10] The "new criticism" to her should parallel art in a kind of "stream of consciousness" manner; for instance, "...criticism on Olitski should be all mushy, and on Judd all straight and trim."[11]

However, by the late 1960s, Lippard realized that it was the nature of art as object that had enhanced its significance as a product. Undoubtedly, the development of her own skepticism with regard to art and the art world corresponded with a general mood of disenchantment that characterized the latter part of this decade, particularly among young people and within educational institutions or intellectual circles. She had become aligned with the Art Workers Coalition in an attempt to present organized resistance to inequities in the world as well as the art community. A seminal writing was "The Dilemma," published in *Arts* magazine in 1970. In this piece she wrote about the possibility of a relationship between art and society.

> We are all too aware that art itself is "irrelevant," and that compared to the world of slums, wars, prisons, the art world is a bed of roses. At the same time art is what we do or art is the focus of what we do. A mass exodus from art-making would hardly contribute to the world a great factor for change, but a world without art as the desire to make art or the need for some kind of art activity would be a hopeless world indeed. There is no reason why an artist has to "step out of art and into politics," as one man recently put it, to act as a human being with a conscience.[12]

She concluded this piece with speculations on art and artists' activities in the 1970s with one assertion, prophetic to her own future development. "The only sure thing is that artists will go on making art and some

of that art will not always be recognized as 'art'; some of it may even be called 'politics'."[13]

Coinciding with Lippard's increasing social concerns was her continuing support of what she had termed "difficult" art, that she associated with avant-garde art in terms of its content as opposed to its form. The introduction to her anthology of essays from the late 1960s entitled, *Changing, Essays in Art Criticism,* included her assertion that "...the so-called cult of the new is actually a cult of the difficult," and further that "Difficult art generates ideas and issues difficult to articulate,"[14] but she as critic was committed to their identification and espousal. New art that was also public art occupying a communal ground with viewers was the most problematic; however, she maintained that this art should be "stimulating" and "difficult" as well as "decorative" and "commanding" ("Beauty and the Bureaucracy," *The Hudson Review,* 1967–68). Her interests in provocative and challenging work were also part of her book, *Tony Smith,* published in 1972.

It is important to note that Lippard identified abstract form with content. She had found in the work of Ad Reinhardt, for example, an absolute meaning, not a mere consideration of the form of art. In the context of an article on Douglas Huebler for *Art News* in 1972, she wrote, "Art has always dealt with accenting and focussing the energy of life, no matter how far inside itself art may burrow."[15] Content in art was certainly an issue germane to her support of art by women and to her early approval of conceptual art. Both of these concerns were decidedly antiestablishment in terms of art that broke away from the strictures of a consumer-oriented market.

In the early 1970s, her involvement in women's art, conceptual art, and earthworks or art done on the earth itself were part and parcel of a search for a deeper meaning in art, particularly one that existed beyond its sales value. An important book for Lippard was *Six Years: The Dematerialization of the Art Object* published in 1973. The word "dematerialization" meant to her an emphasis on idea over the product function that had been associated with art. To her, conceptual art represented another antiestablishment possibility. Consistently, her efforts were decidedly subversive as they were directed toward challenging and changing conventionally accepted art images, content, and roles. During their respective times in the 1960s, Pop Art, Primary Structure, and Eccentric Abstraction were new and thereby destructive of accepted aesthetic norms and standards. Likewise, women's art, art on the land, and conceptual art were to Lippard connected with a social content rather than a cultural context. In the final analysis, Lippard conceives of art as something that is in the end humanizing, relevant to our more communal capabilities rather than to a class separation and consciousness.

An assessment of her work published in the mid-1970s concentrated

on "the ugly, the difficult" and the "rejective" components of her crit-
ical theory without examining the larger social context she had already
formulated for art.[16] Since 1970, Lippard has been concerned with three
basic issues that are interconnected. They are: 1) feminism and women's
art; 2) art found outside of traditional contexts, such as galleries or
museums; and 3) political art or that which has social impact or rele-
vance. Considered singly, each of these topics reveal Lippard's deep
commitment toward a more jointly held art. In the area of women's art,
she acted as a staunch feminist in writing numerous articles on issues
and work by specific individuals. Numerous articles on women appeared
consistently over the course of the 1970s. To name a few, she wrote on
Jo Baer (1972) for *Art News*, considered the work of Yvonne Rainer twice
for the *Feminist Art Journal* (1975) and *Art in America* (1977), and covered
Faith Ringgold in *Ms* magazine (1976). In *Artforum*, she published arti-
cles on Hanne Darboven (1973), Ree Morton (1973), Jackie Winsor (1976),
Louise Bourgeois (1975), and Rosemarie Castoro (1975). *Art in America*
was the forum for her work on Mary Miss (1974), Nancy Graves (1975),
Brenda Miller (1976), women's body art (1976), June Leaf (1978), and
Alice Adams (1979). Often, her consideration was the first major essay
on the artist put before an art audience. Forthcoming is a book, *Feminist
Art Since 1970*, a collaborative effort by Harmony Hammond, Elizabeth
Hess, and Lippard.

In addition to examinations of work by specific women, she also
wrote on topics of general import to women's art. Her 1971 essay for the
catalogue to her exhibition, "26 Contemporary Women Artists" at the
Aldrich Museum contained her assertion that there was a "latent differ-
ence in sensibility" between male and female artists. She also asserted
socially derived differences in "Sexual Politics, Art Style," published the
same year in *Art in America*. Here she stated about sexual bias:

> The roots of this discrimination can probably be traced to the fact that
> making art is considered a primary function, like running a business or
> a government, and women are conventionally relegated to the secon-
> dary, housekeeping activities such as writing about, exhibiting or car-
> ing for the art made by men.[17]

Indeed, more attention has been paid to the artist as opposed to critics,
dealers, or curators, perhaps because most of the artists were male.

A point central to Lippard's feminist stance was that women's art
was inherently distinguishable from that made by men. Adapted from
her catalogue essay accompanying a show, "Ten Artists" (who also hap-
pen to be women) curated for the Kenan Art Center in Lockport, New
York, was her essay, "Why Separate Women's Art?" which appeared
in *Art and Artists* in 1973. In this treatise she wrote, "...there is no ques-

tion that female experience, social and biological is different from that of the male. And if art comes from inside as it must, then the art must be different too." She went on to list some characteristics that she felt best applied to women's art and justified her separate identity of women's art by maintaining that gender as a grouping was no more arbitrary than any other. These two notions of a distinguishable female sensibility and the need for exhibitions devoted exclusively to women were two of the hottest issues in the women's art movement of the 1970s contested by both males and other females. At the forefront of an ongoing controversy, Lippard continued to defend her position on these matters and never wavered in her stand.[18]

At the root of Lippard's insistence upon exhibiting and defining women's art was her belief that it could alter established social practices including those of the art world. In 1976, she published "Projecting A Feminist Criticism" (Art Journal, 1976), excerpted from her then forthcoming book, From the Center: Feminist Essays on Women's Art. In this context, she presented some of the problems pertinent to the exhibition of work by women.

> The most valid objection to the notion of a "women's art" is the basic fear that an individual's art will not be seen with a free eye, or seen with equal concentration, or seen as one intended it, or seen at all, if preconceptions and categorizations overwhelm it. But it would be naive not to realize the extent to which this is already true in today's art world. I wince when I hear all the lovely variety of women's art lumped as a single entity. Nor do I think all art by women or all feminist art is good art. At the moment that's *not* even the point because I'm questioning what good art is anyway. While I hope that the mere presence of more women in the art establishment is changing its value slightly—simply because women are different from men—I worry that we will be absorbed and misled before we can fully develop a solid value structure of our own.[19]

With regard to writing about art, she projected her view that criticism as well as art should not be concerned merely with style, but with an extended content or meaning.

Not only did Lippard affect the women's movement, but it in turn influenced her and her work. In 1972, she wrote "Two Proposals; Lucy Lippard Presents the Ideas of Adrian Piper and Eleanor Antin" appearing in Art and Artists. At this point she tentatively gave up her expository function as critic to "present" ideas by two women artists. She stated that she wished to think of herself ". . . at the moment as a vehicle for art ideas rather than an interpreter or appreciative proxy."[20] In refusing to play an interpretive role, she claimed, "It seems enough to say I like this, see if you do; this interests me, see if it interests you."[21]

In a very literal manner, she began to emphasize a more personal response to art. This particularized approach was best represented by and manifested in her book, *Eva Hesse,* published in 1976. In this volume, she attempted to present a psychological as well as a formal reading of this artist's work. Interjected reactions based on her own friendship as well as those of others with the artist combined with a discussion of Hesse's work enabled Lippard to intertwine life and art, informal with formal circumstances.

Also of 1976 was *From the Center: Feminist Essays on Women's Art* in which she confirmed that her response to art on a more personal level had resulted from the influence of the women's movement as a whole and from her experience in writing on Hesse in particular. One of the essays included in this anthology, "Freelancing the Dragon," presented a kind of autobiography predictive of her later efforts to relate intimate experience to regularized objects or situations. Lippard's search for content outside of herself lead her also to look inward for a uniqueness that was also universally human. She also began to associate herself and other women as female with nature as being female. In 1977, she wrote "New Landscape Artists: Michelle Stuart, Helen De Mott, Yvonne Jacquette and Nancy Graves." The central point of the piece was that these artists had all ". . . rejected the kind of sterility that much recent abstraction has fallen into, and gone 'back to nature' for content."[22] Of the same year was her "Art Outdoors, In and Out of the Public Domain: A Slide Lecture" *(Studio),* a consideration of the frequent lack of relationship between outdoor art and a "mass" audience. The ultimate experience of this year, however, was her trip to England where she lived for a year among the prehistoric remains of Western civilization. The result was her book, *Overlay,* published in 1983.

In introducing this volume, she stated that it represented,

> an overlay of my concern with new art on my fascination with these very ancient sites. Later, a second level of that overlay emerged: the sensuous dialectic between nature and culture that is important to me as a socialist/cultural feminist, and the social messages from past to present about the meaning and function of art, exposed by the tensions between two such distant and disparate times.[23]

Underlying this text was Lippard's belief in a social function or content for art. "The social element of response, or exchange, is crucial even to the most formalized objects or performances."[24] Herein she argued for a meaning in the hermetic and mysterious nature of art of the 1960s, and a relationship between the numbers and geometric figures and sequences found in Minimalist and prehistoric forms. Citing a variety of ancient and contemporary sources ranging from the visual and literary arts to mathematics, astronomy, astrology, and archeology, she offered fascinat-

ing comparisons between art works separated by centuries, but perhaps, she argued, not by human experiences. An important artist to such considerations was Robert Smithson about whom she had written in 1973 ("Two," *Studio*). Through a complex series of associations ranging freely through time and space, Lippard compared the intentions and expressions of peoples throughout the history of human society. She linked ritual and performance via their formal and personal or religious components. Lastly, Lippard compared "human-made and natural formations" in her endorsement of art possessive of a "spiritual core" that "can respond to and change with social life."[25] This book was written in what she termed a "collage" style that demonstrated as a document of her own active and quick intelligence as well as her extended recommendation of a socially significant art.

Underlying Lippard's commitment to feminism, socialism, women's art, and art on the land was her advocacy of a politically effective art. This interest can be traced back to the late 1960s, when she objected to the firmly entrenched consumerism of the art world. For example, in her *Art News* report on "Vancouver" of 1968, she concluded:

Lack of influence here may also mean lack of restraint and of derivative thinking. It will be interesting to see whether places like Vancouver can live up to such hopeful predictions, can avoid the temptations that come with more galleries and more collectors and can help to produce a new decentralized art world that will "modernize" the System.[26]

During the same year in her piece on "Pulsa" written for *Artscanada*, she stated that "A true public art is one in which the art itself cannot be claimed by any private body—collector or institution."[27] Within the next year in this magazine, her review of an exhibition of work by Canadian artists was ended with a statement reflective of her disgust with the American art establishment.

As long as Canada has no strong critical or curatorial hierarchy and no one city overwhelms the others, it has a chance to deviate from the North American norm. Such an approach successfully precludes the "ambitions" demanded by formal critics. The use of such a word in fact recalls the status symbol a certain kind of high art and higher language has become in the United States. In one sense ambitions may mean the desire to extend art within the vertical confines of progress; in another it means on the make within the status quo.[28]

Her political engagement increased in the 1970s as she defended "The Judson Three" in *Art in America* (1972) on the occasion of the arrest of Jon Hendricks, Faith Ringgold, and Jean Toche in connection with

the New York district attorney's closing of "The People's Flag Show" in 1970 at the Judson Memorial Church. In her *Studio* series, "One" of 1973, she stated that "Political art is not art with political subject matter, but art with political effect,"[29] and in "Five" appearing in 1974, she compared events in Chile with a strike at the Museum of Modern Art. For "The Death of a Mural Movement," coauthored with Eva Cockcroft in the same year, she wrote about a Chilean popular revolutionary mural created, ". . .to condemn the Junta's repression of the arts and call attention to the atrocities taking place in Chile."[30] In an article, "The Pink Glass Swan: Upward and Downward Mobility in the Art World," she synthesized and summarized her position as a feminist and as a supporter of art as a force for social change. She wrote, ". . .art should be a consciousness-raiser; it partakes of and should fuse the private and the public spheres. It should be able to reintegrate the personal without being satisfied by the *merely* personal."[31]

"Pink Glass Swan" was published in 1977 in the first issue of *Heresies*, a collective that produces a quarterly feminist journal. Lippard was an original founder of this group and felt that articles written for this periodical best express her viewpoint. In "Pink Glass Swan" she outlined the course of her own interests in art and the manner in which they had been adopted by the art market.

> In the 1960s the choice of poverty, often excused as anti-consumerism, even infiltrated the esthetics of art. First there was Pop art, modeled on kitsch, on advertising and consumerism, and equally successful on its own level. (Women, incidentally, participated little in Pop art, partly because of its blatant sexism, sometimes presented as a parody of the image of woman in the media—partly because the subject matter was often "women's work", ennobled and acceptable only when the artists were men.) Then came Process Art—a rebellion against the "precious object", traditionally desired and bought by the rich. Here another kind of co-opulation took place, when temporary piles of dirt, oil, rags and filthy rubber began to grace carpeted living rooms. The Italian branch was even called *Arte Provera*. Then came the rise of a third-stream medium called "conceptual art" which offered "anti-objects" in the form of ideas—books or simple xeroxed texts and photographs with no inherent physical or monetary value (until they got on the market, that is). Conceptual art seemed politically viable because of its notion that the rise of ordinary, inexpensive, unbulky media would lead to a kind of socialization (or at least democratization) of art as opposed to gigantic canvases and huge chrome sculptures costing five figures and filling the world with more consumer fetishes.[32]

She admitted that she saw Conceptual Art as a way beyond the art market only to find that the commercial system easily and quickly absorbed this form of art. In opposition to an art inevitably the property of an up-

per class, she looked forward to the dissemination of art among a larger audience and the inclusion of common elements into art. In "Making Something Out of Nothing" (*Heresies*, 1978), she expressed her egalitarian goals.

> Visual consciousness raising, conceived as it is now with female imagery and, increasingly, with female process, still has a long way to go before our visions are sufficiently cleared to see *all* the arts of making as equal product of a creative impulse which is as socially determined as it is personally necessary, before the idea is no longer to make nothings into somethings, but to transform and give meaning to all things. In this utopian realm, Good Taste will not be standardized in museums, but will vary from place to place, from home to home.[33]

Two years later in "Some Propaganda for Propaganda" (*Heresies*, 1980), she argued that feminists must combat "patriarchal propaganda," and expressed her view that, "The greatest political contribution of feminism to the visual arts has been a necessary first step—the introduction and expansion of the notion of autobiography and narrative, ritual and performances, women's history and women's work as ways to retrieve content without giving up form."[34] In this format she called for a continuation of the women's contribution in terms of going beyond art-for-art's sake toward a more socialistic goal.

> My own preference is for an art that uses words and images so integrally interwoven that even narrative elements are not seen as "captions" and even realistic images are not seen as "illustrations". It makes us forget that words and images working together can create those sparks between daily life and the political world instead of hovering in a ghostly realm of their own, which is the predicament of the visual arts right now.[35]

In 1981, Lippard began to write monthly articles for the *Village Voice*. At the end of her first piece, she presented a listing, "...of the issues I expect to spend this year's columns investigating: outreach, activism, organization and collaboration; the degrees of effectiveness of oppositional art within the dominant culture; the relationship of high culture to media and mass culture...and how these are generating new art forms."[36] These were indeed the problems that absorbed her, and in subsequent pieces she found these concerns reflected in painted heads by Michael Glier, paintings objecting to nuclear exploitation by Karin Batten, Vanolyne Green's performance about her secretarial job. In this forum, she also covered Lorraine O'Grady's "invasion" of a New Museum opening, Mel Rosenthal's photographs from the South Bronx, "reconstruction art" proposals by Marc Blane, John Fekner's stenciled words on found surfaces, Stefan Eins's Fashion Moda enterprise, Justen

Ladda's *The Thing* (reported in her December 2, 1981, column and sub-
sequently discussed in other forums), art by the Spindleworkers (men-
tally handicapped adults), Margit Kramer's installation dealing with *Jean
Seberg/The FBI/The Media,* and Jean Toche and Jon Hendrichs of the
Guerilla Art Action Group, whom she referred to as "public educators,
satirists, heirs to Ad Reinhardt's unenviable role as 'conscience of the
art world. . . .' " To her the "progressive artists" were ". . .those with
an advanced social consciousness who are trying to integrate their im-
ages and their politics. . . ."[37] In "Mercenaries and Interrogations," a
commentary on an exhibition of work by Leon Golub, she commented:

> (This) show is an open statement that manages to be both formally im-
> pressive and intensely critical of the world it clarifies. It's the hardest
> hitting "realism" I've seen. The fact that its subject matter is overtly po-
> litical is one reason. The other is aesthetic and, as I keep muttering in
> these columns and elsewhere, the two are not mutually exclusive, much
> as the folks on the podium would like us to think they are. When aes-
> thetics and politics meet with equal strength, the result is a double
> whammy.[38]

Also of the 1980s were pieces written for other vehicles, such as her
acclamation of Judy Chicago's *Dinner Party* in *Art in America,* 1980. In
"Sex and Death and Shock and Schlock: A Long Review of the Times
Square Show" (*Artforum,* 1980), she called this exhibit a "cry of rage
against current art-worldliness" and declared that the most important
factor was that this show was concerned with ". . .art being about some-
thing other than art."[39] In *Seven Days* ("Real Estate and Real Art,"
1980), she applauded an impromptu exhibition, "The Real Estate Show"
held illegally on Manhattan's lower east side as a ". . .unique combina-
tion of art exhibition and guerrilla action" that protested ". . .the whole
notion of property in a capitalist society."[40] Of 1981 was "Hot Potatoes:
Art and Politics in 1980," published in *Block,* an English journal. She
completed this article with a question.

> What, then, can conscious artists and artworkers do in the coming de-
> cade to integrate our goals, to make our political opinions and our des-
> tinies fuse with our art? Any new kind of art practice is going to have
> to take place at least partially outside of the art world. And hard as it
> is to establish oneself in the art world, less circumscribed territories are
> all the more fraught with peril. Out there, most artists are neither wel-
> come nor effective, but in here is a potentially suffocating cocoon in
> which artists are deluded into feeling important for doing only what is
> expected of them. We continue to talk about "new forms" because the
> new has been the fertilizing fetish of the avant-garde since it detached
> itself from the infantry. But it may be that these new forms are only to
> be found buried in social energies not yet recognized as art.[41]

In 1984, her book, *Get the Message?: A Decade of Art for Social Change* will appear and constitute her major statement on this form of art.

Concurrent with her activities as writer and critic, Lippard has had an extensive record of involvement in organizational efforts. She has been among the leaders of the Art Worker's Coalition, the Ad Hoc Women Artists Committee, West-East Bag (a feminist group), Women's Art Registry, Printed Matter, Inc., the Heresies Publishing Collective, and PADD. She was instrumental in instituting Printed Matter, a store that sells artists' books on commission—objects that are not one-of-a-kind but produced and sold at minimal costs in small editions. She still curates art exhibits in the windows of this downtown, Manhattan establishment.

> It's organizing in the good, old-fashioned labor movement sense. It's alone you drop and united we stand. If you want to have any strength or power to do things, you have to involve other people. You can't do it by yourself. Of course, artists are trained not to think in this manner. Whether they're male or female, they're told in schools and deeply conditioned into the notion that they may have a miserable life, be all alone and not make money. But at least there's this giant ego that keeps them going. That's what society allows artists, and God forbid they ever get together with anybody to work for mutual causes, their own rights or anything.

Currently, she is an active member of an organization she helped to found; namely, Political Art Documentation/Distribution. Its aim as she states it is

> to try to figure out ways that artists can have an organized relationship to society and show that image making can be an important part of social life—that it doesn't have to be restricted to galleries, museums or the upper classes and to demonstrate that art can have a place in people's lives.

All of these endeavors involve the concept of networking, mutual aid or looking out to and for one another.

In addition to and as a part of her involvement with PADD, she has collaborated with artist, Jerry Kearns on statements, lectures, and slide presentations that deal with personal, political, and artistic material. Her individual presentations have combined slides, observations, statements, and readings from her fictional writings and have been concerned with her way of life, her concerns, and her work. These "slide lectures" consist of autobiographical and political statements aimed at addressing issues that transcend individual art works, personalities, and systems. Call it collage, for that is the way she describes her method of working. A technique of juxtaposition, free association, and rapid shifts in thought

also characterize her work as a fiction writer. Best known of this genre is her novel, *I See/You Mean* (Chrysalis, 1979).

Lippard's Soho loft space is quite sparsely furnished and plain except for clusters of political posters tacked on the walls, a semi-enclosed area crowded with books and papers which obviously serves as a work area, and a number of small art works, particularly posters, hung on other walls. The overall effect is one of an assemblage of diverse components. Glancing over this space, she says,

> I'm interested in a collage aesthetic. Take a look at this house. It's a collage in itself! I work that way, and I've found that a lot of women share my experience. For instance, I'm a great admirer of Athena Tacha, whom I think of as being very organized and structured. But she wrote about working in the same way I do, which is like type a few lines, then suddenly go and get the broccoli out, type some more and then think about something else. I often have my best ideas while I'm reading. I may be reading a book and all of a sudden an idea about something completely different will pop in. I don't know whether that's female or whether it's imposed by the kinds of lives we lead. I mean, what could be more Surreal than to be a feminist and a socialist in a capitalistic-patriarchal society? It's a collage in itself!

Some of the artists who have been concerned with political issues in their art and who have been supported by Lippard have already become "successful," and their work has been absorbed into the system that Lippard rejected some time ago. Lippard's early writing on Pop Art, Primary Structure or Minimalism, and Conceptual Art were generally inspired by her opposition to accepted norms in the art world. Subsequently, however, these groupings were highly acclaimed in the established art system. Certainly, it was not her wish to espouse "political art" in hopes that it would become a dominant trend exhibited and sold in art galleries, and perhaps the "system" cannot stomach art directed against it by artists committed to social and collective causes.

Lippard occupies the unusual position of writing about art and artists whom she doesn't want to promote in the usual sense. In a utopic situation, there would be no need for her to write, because activism would be unnecessary. Given the history of Western civilization, however, this evolvement of such an effort is highly unlikely. It does seem evident, however, that she, in consistently reacting against the status quo in art and other established societal strictures, has identified important tendencies in art over the past two decades. Although she has not been allied with a single style, she has associated herself with certain issues as they can affect art; namely, personal content, collective art or prehistoric civilizations, feminism, and political issues.

Her subsistence as a free-lance writer consists of employment as a regular columnist for the *Voice,* plus payment for articles in arts magazines. She works without pay for *Heresies,* Printed Matter, and health care workers' union district 1199. She says, "I make my living by writing for an elitist audience, these other things I do mainly for free." Concurrent with her writings on feminist and political concerns were two books, *Surrealists on Art* (1971) and *Dadas on Art* (1972). She also began work on a manuscript on Ad Reinhardt, a project partially funded by a Guggenheim Fellowship in 1968. This volume was published in 1981. At first, Surrealism, Dada, Reinhardt, and feminism might seem disparate issues, but they had in common varying degrees of political concerns and anarchical tendencies. About Reinhardt, she wrote, "He considered art a social responsibility and saw himself as an imperative force toward the formation of a type or class of American artist opposed to the current image."[42] Each artist or grouping of artists refuted the status quo even as Lippard continuously reacted against established art criteria. The "difficult" traits she found in art have always entailed that which did not fit into a commodity system. She has consistently taken part in activities outside of established orders. She views political art as that which exists beyond any system. "It certainly isn't a movement because it's people working with a value system, not a style." "New" to her is not a valid criteria because several years ago, ". . . it became very obvious that new was manipulated, new wasn't particularly new, new was used as some kind of evolutionary number to make money for certain people and to knock other people off the ladder."

Both in spite and because of her consistent and unwavering advocacy of "other" art or that which ignored the marketplace (at least in early stages), she has been and is a figure that must be reckoned with. The fact that she has written about so many artists and art work that has later been acclaimed by other people makes it risky for people who do not hold her view to ignore her. Indeed, she's been accorded several awards: the prestigious Frank Jewett Mather Award for Criticism, 1976; two National Endowment for the Arts grants, 1972 and 1976; and Moore College of Art awarded her an honorary DFA in 1972. She has been too important, too much at the forefront even though she disdains this position and the whole sense of hierarchy. The quixotic goals of her career have evolved about a search for alternatives and reforms. Her aim has been to overrule or at least change the context of art so that it might have greater relevancy to life. In her own words, she'd like to be remembered as, "A feminist and a progressive art critic—somebody who rejected the notion that art had nothing to do with life, or with social life. Somebody who was trying to socialize art."

10
Ileana Sonnabend

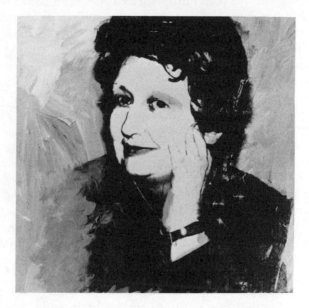

Courtesy of Ileana Sonnabend. Photo by Jon Abbott, New York.

A dealer who has accomplished significant work in terms of introducing avant-garde work to both European and American audiences is Ileana Sonnabend. After introducing Pop art to the European public in the 1960s, she continued to show other experimental art forms in America. Her name has long been connected with art "on the cutting edge," or with the most experimental developments. The important role she has played in recognizing important art, that is initially foreign to and difficult for even the trained viewer and that is later accepted as part of the "mainstream," has earned her the respect of fellow dealers. Many of her colleagues express admiration for her "eye" or for her sense of quality in new art. Her marriage to Leo Castelli was probably seminal to both of their careers in art. Castelli, of course, is a name that has international implications for art, while Sonnabend is somewhat lesser-known gallery. Part of the reason for the difference in reputation has to do with individual personalities and with the nature of the art world as it has been formulated within the last 20 years. In particular, greater emphasis has been placed upon promotion and sales of art work. Sonnabend's interests have continually veered away from acceptable modes toward new forms for which there is no established market.

Ileana Schapira was born in Rumania in 1914. Later her father changed their family name to Strate and, subsequently, she used both names. Her father was an industrialist and her mother a housewife who was "...very active politically. She was a Zionist in the early days. Also, she was active in social work, working with the children's hospital and such."[1] Her family was "vaguely" concerned with art, and her mother's second marriage was to the painter, John Graham, but generally family influence on her was not strong in terms of art. Ileana attended French and Romanian schools in Bucharest and was married at an early age when she was 18 to Leo Castelli. Together, they became interested in art. Leo opened a gallery in Paris in 1939. When they came to America two years later, they met a number of the Abstract Expressionist artists, such as Jackson Pollock and Franz Kline. In this country, Ileana studied child psychology, had a daughter, and took art courses at Columbia University. Over the 25 years of their marriage, Ileana and Leo Castelli became acquainted with a great number of European and American artists.

It would be somewhat difficult to distinguish her contribution from his regarding who met which artist first in the Pop grouping. Ileana preferred to be somewhat vague about these associations. Since it was Leo Castelli who successfully marketed both Pop art and artist, it would seem

appropriate that he should have received the accompanying recognition. A noteworthy factor, however, was Ileana's development after the dissolution of their marriage. She immediately sought and rapidly assumed a position of leadership as a dealer. She first struck out on her own to show work by young Americans in Italy. Then she returned and married Michael Sonnabend, and together they returned to Europe where she eventually opened a gallery in Paris to show Pop art. People have expressed their belief that her work in Europe was of value to Castelli in building the reputations of Pop artists, but Sonnabend was characteristically noncommital. "It always ricocheted back and forth. That he showed them here was helpful to me; that I showed them there was helpful to him."

Specifically, with regard to her contribution and role in relationship to that of Castelli, she described herself as his "assistant" and allowed that she "helped him set up the gallery." When asked whether or not she was instrumental in the selection of certain individuals, her reply was, "Well, I probably had more time to look around."

Whatever the relative importance of her role in discovering Pop artists, it was certainly she who brought this type of art to Europe. After her separation from Castelli, she made an initial trip abroad in 1960 with the intention of setting up a gallery of her own.

> Just at the time when we were separating, I had been to many studios and had stumbled upon Rosenquist. Of course, I knew Kline, and I was friendly with Andy, and just happened to know a lot of young artists whom I thought were very interesting. I left, and for a year was in Rome trying to make connections for these young artists to show in galleries there. I found it very difficult; the situation was different. There was so much male chauvinism there that I couldn't get anywhere. I was quite disgusted with the whole thing, so I left, remarried, and my husband and I thought that Paris might be a better place.

Michael Sonnabend was a scriptwriter who was interested in painting. His scripts were mostly for documentary films in art. At one time, he worked as a guide in Paris, a position that caused him to become acquainted with and interested in the visual arts. Subsequently, he studied fine arts at Columbia University. Thus, his interest in art complemented hers, and he was supportive of her efforts to exhibit American art in Europe.

> At that time, everybody was passing everybody in Europe. Wherever they were going, they were stopping in Paris, so it was geographically a good location. We started trying to get shows for these people (American artists) in local galleries, but nobody was interested. They said, "if you pay for the transportation, if you pay for the insurance, if you pay

for everything, then maybe you can have a show for three weeks." At that time, my husband said, "That's silly. If we have to pay for everything, why not open a gallery of our own, show the work, and see what the reactions are." So we started by renting space on a monthly basis because we never thought it would last, and we had a series of shows which I think were quite important for Europe at that time. We realized that there was a great deal of interest, so we decided to stay another year. We'd never really thought of opening a gallery and being dealers. We just wanted to present the work of these people, and then one thing led to another and we stayed. The gallery became so successful that we didn't consider closing it.

Actually, it was not until 1979 that she decided to close this space.

In point of fact, Sonnabend's assessment of her efforts in Paris was quite modest. She opened this gallery in November 1962 with a show of work by Jasper Johns, followed by one of Robert Rauschenberg's pieces, and subsequently exhibited the art of Jim Dine, Roy Lichtenstein, Claes Oldenburg, Robert Rosenquist, George Segal, Andy Warhol, and Tom Wesselman. It was the first European showing for all of these artists and, correspondingly, the initial opportunity offered the European public to view this emergent American art. Of course, this type of intercontinental exposure of so-called Pop artists helped to boost their reputations and thereby increased the value of their work. It also contributed to the establishment of America, particularly New York City, as an artistic center. In addition to the Pop artists, Larry Bell, Dan Flavin, Donald Judd, and Robert Morris, among others had first exhibitions in Sonnabend's Parisian gallery.

Her experiences as a dealer in Europe and America qualified her to compare the businesses as they existed in both settings.

Here, everything was open. In Europe, everything was secret. The sales were secret. There was a lot of competition between galleries. Much less now. But when I started there was tremendous competition for a small number of collectors because there were always only a few collectors there. So, even if you happened to be friendly with gallery people, and we were...we knew them all, they still attempted to take away sales. If you had a collector who wanted to buy something, and they got to know about it, they would try to dissuade him from buying from you. It was quite underhanded. Also, collectors didn't care to have it known at what prices they were buying because of tax laws. There were all kinds of considerations of that kind, so you had to be very secretive to the degree that one really couldn't keep records. That was one of the things that bothered me very much.

In 1967, she returned to America to open a second gallery that was established for the purpose of concentrating on Art Deco furniture and ob-

jects and exhibitions of photography. Noteworthy was Sonnabend's early and continued interest in contemporary photography. She continued to show "new" art only in Europe until 1971 when she opened a third gallery in the United States where she intended to exhibit work by "new people," or "interesting things that hadn't been seen here yet." She had begun to feel that her mission was drawing to a close in Paris.

> You see, we had started in Europe by showing things that nobody would touch there. Then these artists became well known and I felt that the work was done for them. But there was work to be done in reverse. I knew of European artists whom I thought were wonderful, and I could not obtain a show for them in New York in the sixties. So, when we opened, we really opened with the intention of breaking up that resistance to European art that there was here—the same resistance we had found in Europe toward the Americans. A few years after we started here, John Weber started showing Europeans and Leo started showing Europeans, and then the work was really done. Nowadays, everybody is showing everything that they feel is good, without thinking about where it comes from or of what ethnic group the artists may be a part.

Thus, Sonnabend successfully completed two self-initiated missions; namely, to bring American avant-garde art to Europe and to reverse this process. She had every right to be satisfied with her work, particularly in view of resultant attention Europeans have received here and specifically in terms of the "waves" of European art that flooded the market after 1979.

Beyond introductions of art work from one continent to the other, Sonnabend chose the even more difficult task of showing art of a highly experimental nature.

> We showed art that was difficult for people. But you see, I think that was the most interesting art, because accessible art you could go through quite fast. It really had to do with my personal taste. I liked difficult things, and I decided I only wanted to show what I was interested in.

Granted that she preferred art that was highly innovative and that went beyond the poles of established norms, but how did she recognize this "difficult" art?

> I found that things I didn't like very much made me think, while things that I liked, I accepted and that was that. The things I didn't like always made me think, "Now why didn't I like this?" And I would spend more time thinking about and trying to find the meaning of this work. Ultimately, I became interested in the meaning of the work rather than only in the look of the work.

Her choices, then, were not based upon pleasing visual impressions. Rather, she was concerned with the idea or content of the work. Her judgments were more conceptual in nature. She also had a more objective criteria that she used in picking work by various artists. "It should not remind me of anything that I already know, at least not in the immediate past. Work could remind me of things from other centuries, but not in the immediate past."

When Sonnabend moved to her present location in Soho, she was not alone. Castelli, Weber, and André Emmerich also moved into a structure that The Hague Warehouse Company had found for Castelli. They inaugurated this building with simultaneous openings. Judging from a report in the *New York Times,* it was Sonnabend's particular opening that attracted most attention. In keeping with her intent to show avant-garde work by people outside America, her first show consisted of *The Singing Sculpture* by Gilbert and George. According to the *Times* reporter, Sonnabend was "a Paris dealer," who wanted an open space for showing art of a more experimental nature.[2] After nine months in operation, another critic wrote that the Sonnabend Gallery was perhaps the "...closest thing in town right now to a top avant-garde gallery, that is in an old-fashioned way at once sensation-seeking and doctrinaire."[3] This position has been retained by Sonnabend.

In addition to shows of "live" sculpture by Gilbert and George, she gave a first exhibition to Italian artist, Piero Manzoni, known for the conceptual orientation of outrageous pieces, such as his cans of "shit." Sonnabend also exhibited important work by several Americans. A notable example was Vito Acconci who, in 1971, set up his notorious *Seedbed* piece in Sonnabend's space. For an established number of hours each business day, Acconci masturbated under a ramp that had been constructed at one end of the gallery. Sonnabend also exhibited what had been termed "body" or "performance" art by Dennis Oppenheim (1971), as well as the antiformalist "scatter" pieces of Barry LeVa (1973). In addition, she showed work by Jim Dine for a time, and put up the first shows of photography by Laszlo Moholy-Nagy (1973), Kenneth Snelson, and Bernd and Hilla Becher. Mel Bochner premiered with Sonnabend in 1973, and she has cohosted exhibits by Robert Morris with Castelli beginning in 1974. In general, the work she selected was ahead of its time. That is, it was at first greeted with shock, disbelief, and disapproval and later granted a considerable degree of approval, even applause. Her contribution has been the exhibition of work that went beyond the then current definitions of art, thereby establishing new parameters and criteria. By making this work public and subject to the eventual positive judgment of the rest of the art world, she undoubtedly changed the nature of contemporary art.

Avant-garde art, of course, is not particularly or immediately sale-

able, a factor that causes her to run her business in a somewhat different manner. In some cases, Sonnabend has established a stipend guaranteed to an artist regardless of sales. Sonnabend observes, "Sometimes this is a very heavy burden for the gallery because an artist doesn't sell for two, three, four or five years." When the artist does begin selling, these advance payments are recouped by the gallery. In other instances, Sonnabend utilizes a flexible type of contract system that may on the one hand allow her to represent one artist exclusively, but also to show another in agreement with another gallery. This does not mean that an artist might have only a single show with her because "...I do like continuity. I don't think the artist profits by just one show—commercially perhaps, but we're not that kind of gallery." In fact, Sonnabend is quite firm in her position on the possibly contradictory allegiances of the dealer to monetary matters and to aesthetics. "One is caught in between, and that is exactly where one cannot afford to make concessions to money." She believes in the capabilities of others to appreciate untraditional work. "I believe the public is always capable of being as responsive and as sensitive and as intelligent as I am. I don't think that I'm terrific. I think that everyone can appreciate the work that I like."

Sonnabend is quite explicit about her view of the gallery's function. She feels that the gallery performs a great many services that cost money, such as slides, photographs, and other materials which must be assembled and disseminated for the sake of public relations and for archival purposes. In addition, the gallery performs an educational role. She compares the situation in America, "...a tremendous interest, people who come to look, like in a museum," with similar circumstances in Europe that are more "intimate" and "closed." In other countries, she recalls, "Few people come to galleries to just look. They think that there is a demand made on them if they step into the gallery. They feel they have to buy something. So, they just don't come, and that's very sad." In contrast, she points to the tours led through her New York space, "...children's classes sent to write about whatever they see, and every Saturday it's mobbed. It's wonderful! Absolutely wonderful! I feel that it's one of the functions of the gallery."

Regarding the larger circle of art affairs, she is somewhat discontented with recent art criticism. "The critics should be guides, and if they have lost that function with the public, and we are picking it up, it's not because of the public being corrupt or that we are corrupt. It's because the critics don't do their job." She complains of a lack of substantial and meaningful reviews and articles on the shows mounted in her gallery and counters the claim that critics' writings are tied to gallery advertising.

Critics feel that they want to be independent and that there must not be a tie between the publicity that the galleries make and the editorials

and, I guess, that is right, too. They are freer that way. They are less
corrupt. But they are corrupt in another way. I think that a lot is writ-
ten about really bad art because somebody is a friend of someone else,
and a lot is not written about important art because it's powerful and
the gallery is powerful.... I'm afraid that all this is not going to make
a lot of friends for me among the critics.

On the subject of her own peers, she expresses her opinion that they are
"more generous," "more loyal," than persons in other occupations, and
adds "...but we are no saints." Again, she compares American dealers
with Europeans in terms of an open bookkeeping system. "We have
good relations with the other dealers. There is an esprit de corps. We
try to help each other whenever we can, and that is really quite won-
derful."

A difficulty she cites regarding her profession is sexual in origin.
Sometimes she feels that she is taken as a "mother figure" and must ap-
propriate some artists to her assistant, Antonio Homen. Speaking on the
feminist issue of shows for women artists, she says quickly and firmly,
"I make a point of showing what's good." In spite of her spoken in-
difference to possible sexual biases, her record speaks for itself. Out of
her stable of approximately 20 artists, about a quarter are women. On
another matter involving women's concerns, she expresses disbelief in
a discernable female imagery . "I think those are prejudices. It's often
a way of putting the work down. So it's 'women's art'." Yet, in keep-
ing with her own mission, Sonnabend does feel that women are sup-
posed to be in touch with the "finer things of life," that women are the
"...civilizers and preservers who have brought culture, beauty and
civilization to the world." Indeed, Sonnabend herself has devoted most
of her life to art. At the time of our interview, she said to me, "I'm sixty-
nine. I'm so thrilled! I never thought I'd make it."

She has a number of friends in art whom she speaks of as influences,
including her ex-husband, Castelli, Pontius Hulten, Rauschenberg (a
friend since the 1950s), Alan Solomon, and Warhol. She speaks ingenu-
ously about a "sweet portrait" Warhol did of her as a surprise. She says,
"I was very touched." She herself has never wanted to be an artist be-
cause such a situation might be competitive. "Also, I have too much re-
spect for art to try anything." She has, however, formed a collection that
originated with a Matisse watercolor purchased by her and Castelli as
a wedding gift. Subsequently, she has acquired work by Johns, Fernand
Léger, Roy Lichtenstein, Bruce Nauman, Pollock, Rauschenberg, Kurt
Schwitters, and Cy Twombly, among others. She is enthusiastic about
her career and invovlement in art. "It's really a wonderful life to lead,
the life in art. It's exciting, interesting, very human and satisfying."

Sonnabend appears to be quite gentle, moderate, and benevolent.
She does have a kind of maternal appearance in opposition to the type

of person one expects to be showing avant-garde work. However, her comments on the personal inclinations of herself and Castelli are illuminating.

> I think it's a matter of character. Not only, but also. I think that Leo's personality is very extroverted, and he's a public person. I'm rather a private person. I'm basically shy and more introverted. That is rather difficult in a gallery.

However, she adds, "I don't think that being shy necessarily means being yielding." Indeed, she certainly has never acquiesced in matters of taste and quality in art.

In a look at art for the 1980s, Sonnabend put forward her theory of ten-year cycles. Accordingly, the 1960s was the Pop era, the 1970s was intellectual in view of the Minimal and Conceptual Art created then and, for the 1980s, she foresaw a greater "intimacy" in art, meaning art that is "...small, less intellectual, of more immediate impact and making fewer demands."

Sonnabend has occupied a somewhat shadowy role in comparison to the great notoriety of some of the artists she has shown over the years. This is her manner of working. Nevertheless, at the end of our interview, she said, "I was afraid I was going to be forgotten."

11
Grace Glueck

Photo: Courtesy of *The New York Times.*

A popular "hair splitter" in critical circles is the determination of whether or not a particular individual or a given piece of writing is journalism or criticism. This question does come up in considering the work of Grace Glueck for the *New York Times*. Her employer of 20 years, the *Times* has recently dubbed her a "critic" (1982). Previously she was described as an "arts reporter and critic." Over the years, this newspaper also labeled her "a cultural reporter and art columnist" (1972) and an "art news reporter" (1966). In 1981, Glueck called herself "an art reporter and reviewer."[1] Clearly, she considered herself a journalist involved with art. "As a reporter, I'm simply there to write about the sociological underpinnings—to observe the art scene." In actuality, however, Glueck often entered those judgmental areas reserved for the art critic. She often makes selections of topics that represent her opinion and, on a regular basis, she writes reviews or critical articles on exhibitions. Glueck has occupied a somewhat ambivalent position as both journalist and critic for a powerful and influential newspaper that seemed to consider her a valuable asset precisely because she can write effectively in either area. Unfortunately, the duality of her situation slowed her progress to full status as a "critic," and perhaps prevented her from becoming the chief critic for the *Times*, a position reserved for men who are frequently allowed to write critical essays as well as reviews. On the other hand, the fact that she has occupied a secondary rank at this newspaper has undoubtedly contributed to her greater breadth and range in terms of subjects in comparison to her colleagues.

Working for this paper has presented advantages and disadvantages for Glueck. "On my job, I carry the authority of the *Times* with me, and many people don't want to mess with that. I've never really had to deal with people's impatience, unwillingness or whatever." There are obvious benefits in terms of gaining access to people, places, and information. On the other hand, Glueck notes a negative factor. "...I haven't had to learn the devices and stratagems that other people have had to devise in dealing with situations." Undoubtedly, the reputation of the *Times* acts as a factor above and beyond the efforts or abilities of its employees easing their tasks but causing them to become dependent upon the prestige of their employer. Glueck also cites *Times* stylistic practices as a limiting factor.

> The *Times* is rigid about a style of writing even though they claim they are not. There are certain conventions and forms that must be adhered to, and newspaper writing is in itself a convention. There is a kind of formalism to the way one organizes a story. I've been trained that way.

In particular, she specifies writing in the third person, which she says, "...is intended to convey a kind of objectivity, whether it's real or not."

She points out that everything written for the *Times*, "...has to be put through a copy desk and the *Times* style imposed upon it." Specifically, she says this means "...a grammatical style. It's the tone in which the paper likes to address its readers. It's a formal, non-intimate, public kind of tone." Given these conditions of a third-person address and the impression of objective indifference, *Times* articles appear factual, and an opinion or judgment becomes quite omnipotent in effect. A writer like Glueck then is faced with the prospect of expressing not only her own but the "voice" of an authoritative newspaper. The influences and consequences of such a role are unquestionably enormous.

The *Times* art writer does not simply choose to write on exhibitions or some other art topic. Glueck and other members of the art writers staff meet to divide up assignments.

> It's taken for granted that we review all museum exhibitions and that we try to review the shows at the good, working galleries. I try to do off-beat things sometimes, like a group of artists having a show in the windows of a parking garage on Eighth Avenue. I attempt to cover that kind of thing from time to time and to make my beat "off-off Broadway" as much as I can, but you have to understand that the *Times* is not the kind of newspaper that the *Village Voice* is. There's a certain kind of establishment component, and so there are things that have to be covered, brought to the reader's awareness.

She is not forced to write on a show should she find it lacking in some way. "If I come back and say I don't care who the exhibit is by, it's not a good show, or I don't think we ought to give much space to that, they'll do it. They tend to pretty much rely on what their critics and reporters tell them." Before he left the paper, Hilton Kramer was her colleague for several years. She found him to be flexible in terms of writing allocations.

> If he asked me to cover such and such a show, and I said I really didn't want to, there's no question that I wouldn't do it. He never insisted that I write about something that I didn't want to, nor did he refuse me when I wanted to cover something toward which he might not be particularly sympathetic.

Although Glueck's position has entailed restrictions as well as power and prestige, the *Times'* decorum demands not only a certain style of writing, but also an employee organization or hierarchy that constitutes a formality quite different from that experienced by a free-lancer. Being "with the *Times*" can open doors, but also limit possibilities and opportunities. In terms of social as well as cultural issues its stance is quite prudential. Glueck tested that conservatism in 1974 when she became

one of a group of women who brought a class-action suit against the newspaper because of its reticence in hiring women.

> When I first came to the *Times*, nobody—no women were encouraged to be anything but secretaries, and I remember many times my immediate boss, the assistant editor, saying, "Why don't you go home and get married"—statements like that, the usual absurd things. So I was not encouraged to do anything at the paper until they needed somebody to write on art, and they realized that I had experience and some writing ability. I can't say they steered me in any direction except fulfilling the needs of the executives.

She, along with a few other women, came to feel that the *Times'* refusal to promote women to influential positions was more than simply a matter connected with their individual qualifications.

> It was pointed out in terms of very telling statistics that the *Times* was not hiring women. There were few women reporters, no women in management, no women photographers, and women got considerably lower salaries in comparison to men. Things were just not very good for women on this liberal (!—her emphasis) newspaper.

Finally in 1978, the suit was settled in favor of Glueck's group. The *Times* agreed to institute an affirmative action program and promised that women would be hired at equal salaries to those of men. Glueck was not certain whether or not the *Times* had lived up to these promises and asserted that such acquiescences would only last for four years. She said, "I just have to keep pushing." A recent problem she noted was that of younger women coming into the newspaper who were ". . . not willing to take a stand on feminist issues."

Glueck's own sensitivity to the plight of women was nurtured not only by her own employment circumstances but by what she saw as factors preventing her mother from developing herself to full capacity.

> I've always been aware of it (prejudice against women) all my life—for personal reasons, family reasons. My mother was a dynamic woman, not that she knew what feminism was, because one didn't in those days. I felt that had there been a different set of circumstances, my mother would have had a very good career.

Like her daughter, Glueck's mother was interested in journalism, admired the writing of Dorothy Thompson, and worked intermittently for newspapers.

> She really didn't have much opportunity to develop herself as a writer in terms of achieving a professional name. She was always an "auteur

amateur." There were special family circumstances that helped to make a feminist of me. I saw many women in subordinate roles, a circumstance that I wasn't prepared to accept. I always had resentment as a child. I was always conscious of resenting the perogatives that men had vis-à-vis women. Maybe I sensed some of that in my mother.

As a writer on art, Glueck has been conscious of furthering the development of women's art. "I think the best thing a critic can do is to review as much women's art as possible. When I write reviews I have been conscious of including at least one woman. I consciously try hard to do it." In general, she felt that circumstances for women have improved, making it less necessary for her to deliberately choose female artists' shows. She referred specifically to the outdoor exhibitions of sculpture held annually at Wards Island where she found a great deal of work by women and "...all the pieces I found most interesting seemed to have been done by women. The men's work seemed to me to be still at a kind of Minimalist object stage, whereas I think the women tended to react environmentally or to work more with natural surroundings." Glueck's personal experiences and observations undoubtedly spurred by the women's movement of the 1970s caused her to consciously consider women's art up to the point at which the question of gender was no longer a crucial factor. She did not feel that there was a specifically female type of imagery; however, she reflected, "I think it's a question of attitude that women have toward work. Women are much more relaxed about art categories, about where art can go.... Maybe they've brung a little bit of wildness into it." In summary of her feelings, she remarked, "There's no question about it. More women are doing better work."

One of the first large *New York Times* magazine articles Glueck wrote was on a woman, Marisol Escobar. "It's Not Pop, It's Not Op, It's Marisol" appeared in 1965. In this piece based upon extended interviews with this prolific and highly talented artist, Glueck examined the artist and her way of life as well as her work. The article was essentially a descriptive and highly informative one considering the verbal reticence of the subject. Another of Glueck's magazine pieces, "Paintings Descending A Ramp," printed in 1969, was concerned with the art collection of a woman, Peggy Guggenheim. This article called attention to Guggenheim's tremendous influence on twentieth-century art in terms of her choice of work by young artists involved in creative activity unprecedented at that time. Thus, as early as the 1960s, Glueck's work reflected an interest in women's achievements in the art world.

In 1970, she opened a piece entitled "Women at the Whitney" with these words:

> Out of 3,000 artists represented in the permanent collection of the Whitney Museum of American Art, 450 are women, a showing of 15 percent.

Since the current population of this country contains a majority female representation of 53 percent, we are entitled to one of several assumptions: a) that women's work is not or has not been deemed as worthy of inclusion in the Whitney's collection as that of men; b) that given male (and female) prejudices, women's art has unconsciously been overlooked in favor of men's and/or c) that for repressive societal reasons, women have simply not produced art in the qualitative quantity that men have.[2]

She went on to point out that this exhibition was prompted by demonstrations conducted at the museum by Women Arts in Revolution. It surely seemed a token gesture in the face of the larger issue of continued inequality of representation between men and women in the Whitney's Biennial and other exhibitions. Glueck expressed her view that "Women at the Whitney" was a "silly show" that to her reflected a kind of superiority position the Whitney attempted to take with regard to its stance on women's art. In conclusion, she write, "A show of this sort will really turn me on, however, when male artists demand equal time."[3] As a rather ironic note, the article was accompanied by a reproduction of *Mother and Child*, a maternity symbol and marble statute by Gertrude Whitney, the female founder of the museum.

Although she did not and could not by any means take a radically supportive stance within the context of her employer, Glueck did follow and write on feminist art events in the 1970s. It was news and Glueck did consider herself a reporter, but it must be noted that other reporters chose to ignore these issues while she extended some support. In 1971, she suggested a women's art exhibition organized by Lucy Lippard at the Aldrich Museum was worth a trip to Ridgefield, Connecticut.[4] However, within the next year, she published a piece, "No More Raw Eggs at the Whitney," in which she expressed disapproval of a women's demonstration at the museum.[5] In a more affirmative vein, she began a 1972 review of women's work on the West Coast with "The 'woman thing' as a semi-scornful male chauvinist puts it, is going strong out here, with women artists and their works recognized at least as much as in the Emancipated (ha!) East."[6] Writing in *Craft Horizons* the same year, she attempted to analyze a sexual bias in the art world. She noted that over a 26-week period this magazine had received the highest rating in consideration of their coverage of women's art, and that the *New York Times* showed up as best in the area of exhibit reviews devoting 82 percent to men and 18 percent to women. In terms of space, she found that 87 percent was given over to men causing her to conclude that coverage of women's exhibits was handled in fewer lines. She suggested that these statistics were reflective of gallery and museum prejudices working to prevent women from the very possibility of having an exhibition.[7] Significantly, her article was not published in the *Times*, but in a

forum associated with art forms historically connected with women. In her study, Glueck graphically demonstrated that art writers were excluding women artists from public attention.

In addition to her specific concerns with women artists and their activities, Glueck attempted to take a broader view including women in a broader context. In a special issue of *Arts in Society* of 1974, devoted to "Women and the Arts," she wrote "Making Cultural Institutions More Responsive to Social Needs," an article relevant to and concurrent with the class-action suit she had initiated against the *Times.* In this piece she insisted that a woman's point of view made a valuable contribution to established professions and women hired as executives bring to their positions certain positive traits. She contended that these factors included: a greater insight into human interrelationships; more willingness to expose and exhibit a humanitarian response; better sensitivity to problems of morals; less fear of unconventional ideas; a less formal, more approachable demeanor; greater interest in the views of others and a better ability to deal with people because of less societal pressure for firm and authoritarian behavior.[8] In a piece written for *Art News* in 1975, on the one hundredth birthday of the Art Students League, she observed that there had been "very few" female instructors,[9] and a year later, she wrote an extensive profile on Betty Parsons, "The Art Dealer's Art Dealer," for *Ms* magazine.[10]

As the decade progressed, Glueck continued to comment on women's concerns. In 1977, for the Sunday *Times* magazine section she wrote an extensive article, "The Woman as Artist," based on "the first major historical survey of painting by women;" namely, "Women Artists: 1550–1950," curated by Ann Sutherland Harris and Linda Nochlin. In her piece, Glueck observed:

> Because women artists have been generally ignored or underrated in art historical surveys (one of the most authoritative "survey" books, H.W. Janson's "History of Art," does not mention a single woman artist in its 570 page course from the prehistoric to the contemporary), many of the artists in the show, though celebrated in their own time, were unknown even to present-day scholars.[11]

In further praise of this exhibition, she stated that,

> It is a milestone on the long path to women's full liberation, because the repeated examples it presents of high-level production would lay to rest the pernicious myth that women are by nature limited in their creative abilities. Further, its cumulative evidence of the existence of large numbers of gifted women gives further affirmation to women's emergent sense of their own history—a knowledge that is crucial to their development and that till now has been concealed.

In one stroke, a marvelous galaxy of inspirational examples has been revealed that can only change for the better the collective image that present-day women artists hold of themselves.

Of equal importance is that, for the first time ever, the show and its catalogue provide documentary evidence that the strictures of a society dominated by men—with all their fears and prejudices about the female sex—have kept women from functioning at their full creative capacities; that the "problem" of women artists has in fact been a problem created by men. As Simone de Beauvoir wrote in "The Second Sex," to tell the truth, one is not born a genius, one becomes a genius, and the feminine situation has up to the present, rendered the becoming practically impossible.[12]

In subsequent paragraphs, she discussed problems overcome in organizing the exhibition and commented on the repressive conditions under which women worked as revealed in the exhibition catalogue. Glueck called it "...a fascinating study of how they (women artists) were systematically prevented from equaling the accomplishments of their male peers."[13] Glueck held that there had been progress made in the area of women's status in the art world, but that problems still existed, such as who was going to be responsible for keeping homes and raising children.

Women are still wrestling, too, with the myths of male superiority—a myth that keeps museum and gallery doors half-closed to them, since the art world clings to the myth as much as the rest of the universe. And then there is a basic question with which some younger women artists are coming to grips: Do they really want to make it in the highly political male art world, with its competitive "star system," its ideas of "mainstream" painting, and its rigidly structured exhibition scene. Are there not alternative ways of getting art out to the public?[14]

The title of her lead article, "Where are the Great Men Artists?" published in an *Art News* issue of 1980, seemed almost to challenge Linda Nochlin's seminal essay, "Why Have There Been No Great Women Artists?" However, Glueck's neutrally couched, reporter-like piece consisted primarily of an outline of historical events involving women in art over the past decade and her view of a supportive network as a major accomplishment of the 1970s.[15] Shortly thereafter, her interview with Germaine Greer on the occasion of the publication of Greer's book on women painters, consisted of questions that presupposed her advocacy of advancement for women in art.[16]

Thus, in spite of her position as a writer for an established conservative news vehicle, she managed to devote time and energy to writing on affairs concerning women artists. Glueck was certainly not as aggressive or assertive as Kingsley, Lippard, and Nemser, for example, nor could she be considered a thoroughgoing or extreme feminist. In short,

it could be simply said that Glueck did what she could and that it was fortunate that a person like her working for an important media-vehicle was more than sympathetic toward and at times outspoken about her pro-women leanings.

Beyond reportings on the women's movement, over the years Glueck wrote a number of critiques of work by a number of young artists working in experimental manners, such as Jennifer Bartlett, Susan Hall, Judy Pfaff, Deborah Remington, Ursula von Rydingsvaard, Betye Saar, Alexis Smith, Ann Sperry, and a collaborative project by Joyce Kozloff and Betty Woodman. As a part of contemporary interest, Glueck wrote a review of an exhibit of Sonia Delaunay's work in which she emphasized the unfortunate designation of this woman's role as at best a secondary one in relationship to that of her husband.[17]

As a woman journalist, Glueck was definitely part of a minority, and as a woman working for the *Times*, she was a member of an even more select group. Basically, Glueck's journalistic ambitions account for her interest in working for this newspaper, the dream of many of her peers. "I've been interested in writing from the time I was a kid. I was encouraged by my Mother; in fact, I was pushed by her into journalism. I was almost told that was what was expected of me." Born and raised in New York City, Glueck received a B.A. from New York University and then attended Columbia University School of Journalism. When she left college, she tried writing advertising copy and "hated it." Her next two years were spent in California working at MGM and in advertising. In 1949, she moved back to New York where she "started out very small as a temporary copy girl on the *Times*." After two years of performing this task for the Sunday magazine, she was given a job with the Sunday book review section. At that point her career began to include art.

> At that time, the book reviewer used to illustrate with pictures of works of art, and I was made a researcher. I had never taken classes in art in college, but during the course of that job, I studied architectural history for a couple of years. During that time, I was writing free lance things for the Sunday magazine and for other parts of the newspaper. Finally, during the sixties, when the whole Pop explosion began, it became apparent that art was reaching a much larger market. The then Sunday editor felt that we weren't giving enough coverage to this art movement. He decided that he wanted something in the Sunday paper called "Art People." It was to be a kind of sociology of the art scene. Several people tried out for it, and they asked me to try my hand at it. I did and it worked, so they threw me to the wolves as a reporter and art columnist in one full swoop.

As Glueck observed, "I became interested in art through my job," and she was able to build on her experience as an art researcher in order to handle greater responsibility.

Glueck did indeed work her way up through the ranks and into the art area at this newspaper. Among her first feature stories for the Sunday magazine were those on black bears in 1953, betel nuts a year later, and in 1959 on giraffes and "ombourzhay" or the French version of hamburger. Between 1960 and 1961, she wrote a series of food articles, and two years later she took her place as an art reporter. In addition to contemporary and women's art, other aspects of the art world that concerned her were: people; namely, artists and others involved in art; places, particularly museums where art is shown; shows, especially reviews of exhibitions; and art in public places. Subsequent to her extensive piece on Marisol, she did another "portrait of the artist" article on Larry Rivers in 1966 for the Sunday magazine, followed within three years by "Soft Sculptures or Hard, They're Oldenburgers." It was not without significance that these major articles appearing during the early part of Glueck's career had to do with artists who were associated with the Pop movement. These stories seemed appropriate for a wide readership and Glueck's manner of writing was suited to a new sociability and "familiarity" in art subject and style. The tone of her writing was friendly, almost conversational in tone, and the demeanor she projected was an informal, relaxed one. Such a style was ideal for stories on a popular art form that was touted as being available to everyone. In 1966, she served as assistant editor on the *Times* Sunday arts section and wrote a weekly column, "Art Notes." About this time she also contributed "Gallery Notes" to *Art in America*, an established and important "art" magazine, for which she also wrote a piece on "Primary Structure" that exemplified her affable mode applied to avant-garde efforts.

> Ditching pedestals, the structures depend less on old-fashioned "shape" than on positioning for their effect: they are apt to climb the walls, swoop from the ceiling, sprawl on the floor and rudely muscle in on the spectator's space.[18]

Overall, Glueck aimed her articles and reviews at a more general audience in keeping with her training as a journalist. She attempted to make her subject as palatable as possible for her readers.

A specialty Glueck developed was coverage of museums, particularly their administration. Her extensive article, "Total Involvement of Thomas Hoving," was published in the *Times* Sunday magazine in 1968, and three years later she compared Hoving with his counterpart in Cleveland, Ohio, in "Ivory Tower Versus the Discotheque; Sherman E. Lee and Thomas P.F. Hoving: Their Conceptions of a Museum's Role." The latter story, directed toward an art audience, was published in *Art in America*. Of an even more technical nature, but still presented in a reporterlike style, was "Power and Esthetics: The Trustee" which appeared in another issue of *Art in America* in 1971. In a quite tough journalistic

manner she specifically examined museum board structures, the power of trustees and predicted that in the future trustees would have to "earn" their place rather than receiving it through family or acquaintances.[19] An *Art News* magazine of 1977 contained "Annenberg Controversy," Glueck's report on Walter H. Annenberg's ill-fated proposal to contribute $40 million to finance a kind of media center for the dissemination of information on art. As usual, Glueck presented a balance of points of view on her subject before briefly submitting her own conclusion.[20] In 1982, she reported on the furor created by a "60 Minutes" program on a painting by Georges de La Tour, and the political ramifications of an exhibit of contemporary art in Poland. "A Spectacular New Wing" of the same year in the *Times* Sunday magazine considered an architectural environment of and installation of primitive art in the newly completed Michael Rockefeller wing at the Metropolitan Museum.

In addition to museum issues, Glueck wrote on other matters pertaining to support for the arts and specific aspects of art world machinations and personalities. The "Rockefeller Gift to Asia House" was the subject of her 1974 article in *Art News*. One year later in the *Times* Sunday magazine there appeared "Man the Art World Loves to Hate," an article about Frank Lloyd, head of Marlborough galleries. During the next year, she surveyed connoisseurs' opinions of one another for *Art News* in her article, "Experts Guide to the Experts," and in *Art in America* for 1979, she did an approving piece on the federal challenge grants available to the arts. The Metropolitan Museum's finances were the subject of her 1981 *Times* contribution entitled "Gala Days for the Met—Despite Money Woes."

In the 1970s, she also continued to write on art people and their views, exemplified by her interview with Saul Steinberg for *Art in America* in 1970. She began this piece in a manner exemplary of her fluent, vivacious style. "Saul Steinberg, the Delacroix of doodle, the visual Voltaire, the most inventive penman/punman alive...."[21] Within the same year, her article on Maxfield Parrish was published in *American Heritage*, and of 1973 was her thorough story on Red Grooms and his work appearing in *Art News*. A place for art, namely, "Spoleto USA," was the topic of a Sunday *Times* magazine piece in 1977. The same year for *Art News*, she edited "20th Century Artists Most Admired by Other Artists: Views of Nearly 100 Artists," that surveyed artists about whom they had admired over the past 75 years. "Winners" were Picasso, Matisse, Pollock, and Brancusi.[22] Somewhat surprising results were that Duchamp did not appear among the front runners, and the most influential art works cited by artists surveyed were all by Picasso: *Guernica, Les Demoiselles de Avignon*, and *Girl Before a Mirror*. Within two years, she published another survey-type article in this magazine on the occasion of the fiftieth anniversary of the Museum of Modern Art. For "Paradigms, Watersheds and Frosting on the Cake," 50 people were

asked to choose people, objects, or events reflective of MOMA's first 50 years. Perhaps the most succinct reply was that of Brian O'Dogherty who selected "Alfred Barr's Eye" as the museum's most important asset.

In addition to her coverage of established artists and arts institutions, she reviewed shows at The Kitchen, a Soho alternative space for experimental work by young artists, and in "The New Collectives—Reaching for A Wider Audience," she discussed the motivations of pioneering spaces, such as Fashion Moda in Manhattan's South Bronx, and CoLab and Taller Boricua in Spanish Harlem.[23] Among the writers on art for the *Times*, Glueck has quite consistently covered more liberal topics, such as the women's movement in art and exhibitions and events occurring south and north of Fifty-seventh Street.

An attractive woman with a friendly but professional manner, Glueck not only wrote for the newspaper but also taught a course in cultural news reporting at the Graduate School of Journalism at New York University for a few years. Her mother advised her never to marry, and for whatever reason, she didn't do so. Instead she devoted her life to her career and became highly accomplished as a professional journalist.

According to her, a person passing judgment on art should possess two qualities; namely, "a firm taste and a lot of receptivity." As for her own taste, she claimed to be open to a variety of styles and media, preferring artists "...who work from their gut. I tend not to like cerebral artists." Although she interviewed and approved of Duchamp, she did not like the purported successor of his notions about art in the form of Conceptual Art. "What lazy nonsense that was." To her, this type of art was not "an expression of the artist," a criterion primary to her choices in art.

In assessing Glueck's position and contribution, it must be remembered that she is now a critic and for many years was an "art reporter" for a newspaper that consciously projects an aura of permanence and stability. The conventional taste of the *Times* is inherently reflected in the contents of the paper. The major portion of Glueck's career has been spent working for this paper where she moved up through the ranks to her present position. There is no question that she is a fine writer whose work contributes vivacity and liveliness to the arts sections of the newspaper. Within the context of her employment, she has reviewed individual shows and examined the larger context of the art world. All of her work, whether it be on specific artists, on museum affairs, the women's movement, or avant-garde art, is thoroughly researched, organized, and presented in an engaging manner that is both comprehensive and informative. During her twenty-odd years with the *Times* and in writing for other periodicals, she has remained fascinated by the variety of circumstances offered by her profession. She observes, "In writing for a newspaper you have to learn your trade again every day. Sto-

ries are different. Situations are different. I guess you could say that about writing in general. Everyday you have to learn it all over again.'' In spite of the general conservatism of the *Times* and Glueck's long term association with her employer, she has taken opportunities to examine more unconventional issues, people, and places. Journalism and art have offered her continuously fresh and new occasions for the exercise of her considerable talents and expertise as a writer.

12
Paula Cooper

Photo by Keri Pickett, New York.

The first gallery in Soho was one opened by Paula Cooper in 1968. Since then, of course, this Manhattan district has become a center for contemporary art. What prompted Cooper to establish a gallery in this area? "I wanted to be where artists lived. I had worked and lived uptown and I thought it was a stultifying situation. I wanted to be much more flexible. I just wanted to do what I wanted to do when I wanted to do it."[1] These are the determined words of the soft-spoken dealer who pioneered a locality since recognized as a hub for art.

Most young women of Cooper's generation probably did not think about owning a gallery as a future vocation. However, Paula Cooper said she knew at the age of 17 what it was that she wanted to do with her life. Born in Springfield, Massachusetts, in 1938, she was the daughter of a navy man and a housewife who aspired to being a painter. Her father was head of the USO in the Eastern Mediterranean, and as a result, Cooper grew up in various geographic locations. She attended college in Athens, Greece, for a year and then a University of Maryland extension in Munich, Germany. At 16, she went to the Sorbonne to study art history from 1957 through 1958. The following year was spent at Goucher College in Baltimore, Maryland. Subsequently, she decided to pursue her already determined career goal.

At the age of 20, she moved to New York City. Although she never really wanted to be an artist, she did study at the Art Students League for a time, "because I thought I should have an idea of what it was like to be an artist." In 1959, she was hired as an assistant at World House Galleries, where she remained for two years before deciding to continue her study of art history at New York University's Institute of Fine Arts. Here she audited courses with Donald Posner on sixteenth-century Roman painting, Robert Goldwater on American art, and fifteenth-century central Italian painting from Colin Eisler. Referring to the latter course, she said, "I adored it! He was fabulous!" In spite of her enthusiasm for art history, Cooper's real concern was for contemporary art.

Even as a young student in Paris, Cooper knew she wanted to deal with young artists. "I spent all my time looking at art. I went to galleries and totally focused on art. It was very concentrated and this experience had an enormous influence on me. I thought art was so important that I wanted to help living artists." Indeed, within a few years, this was exactly what she set about doing and has been successful in accomplishing her aim. A pervasive theme running through Cooper's entire career was her support for experimental ideas in contemporaneous art.

In 1964, she opened an uptown gallery using her maiden name,

Paula Johnson. It was in this space located on Sixty-ninth Street across from Hunter College that she gave Walter de Maria his first New York showing. Subsequently, she married Neil Cooper, and bore a child, Nicholas in 1967, followed by Lucas two years later.

A turning point for Cooper was her appointment as director of the Park Place Gallery in 1966. This influential downtown space was originated by a number of artists who either were already or would become influential, including Mark di Suvero, Robert Grosvenor, Forrest Myers, and Edward Ruda. Here she found an agreeable atmosphere that included close associations with living artists, working with innovative art forms, and a downtown location more approximate to artists' lofts. She remained there until this cooperative broke up, and then decided to start her own downtown establishment.

When she moved to her own quarters on Soho's Prince Street, she brought with her Ruda who stayed for only a short time, and Grosvenor who was to remain with the Paula Cooper Gallery. Subsequently, she garnered a stable of exceptionally talented artists. In 1969, she gave first shows to Lynda Benglis, Joel Shapiro, and Alan Shields. Jackie Winsor was added in 1972, and Jennifer Bartlett and Elizabeth Murray in 1974. A year later she invited Jonathan Borofsky to join her group, Jeremy Gilbert-Rolfe in 1977, and Carl Andre two years later. Excepting Bartlett and Andre, all of these artists initially showed their work to New York audiences in her gallery; and all of them stayed with her. Prior to taking on Andre, she had often shown his work and also that of Donald Judd and Sol LeWitt. She was also the first to show the work of Christopher Wilmarth (1970), Kes Zapkus (1971), and Keith Hollingworth (1972). However, they did not remain associated with her gallery.

The atmosphere of the Cooper Gallery was a fomentive one, not only because of the art shown there, but because there were also performances, film programs, poetry readings, and dance. Cooper explained that this was a result of the fact that during the first few years there was no other place in Soho (or very few) where people could go to see or hear one another's work. There was an informal, spontaneous atmosphere surrounding impromptu, as well as planned, gallery events. For instance, Cooper recalled that during one film program, Richard Serra came in and said he'd like to show a film, ran home, brought it back, and screened it.

Some of this tradition has persisted at the present gallery site at 155 Wooster. The Chamber Music Society of Lincoln Center presents a series of "cushion concerts" called "Saturdays in Soho," and on New Year's Eve, in a tradition continued over a past decade, 100 actors, scholars, dancers, musicians, artists, lawyers, and others gather for a 50-hour marathon reading of Gertrude Stein's novel *The Making of Americans*. Perhaps some of the earlier improvisational feeling is gone, but a sense of vitality still exists at the Cooper Gallery.

An important factor in considering the work of Paula Cooper is not only her pioneering enterprise in Soho, but her strong belief and interest in the artists she represents. Her stable is a small one of 11 artists, and she says, "I think that's enough." For the most part these people live in New York City because Cooper likes to ". . .work very closely with the artists. I like to see what they're doing, and I like to see work in progress. I frequently visit the artists. It's important for me to have access to the work so that I understand it better. This allows me to have a much greater knowledge of the work." She feels that seeing a show by an artist every two years is not enough to truly know the work.

> God, all the work that one misses and sometimes very interesting developments. Say someone like Joel Shapiro. . .there's been an enormous amount of work that was scrapped or never been shown, but then it crops up again. Those ideas will emerge again, maybe three or four years later. I know exactly where those things come from or what they related to four or ten years ago, and that's important to me.

Cooper emphasized this point about her concern and contact with artists that allows her to observe the progress of an individual's creative process. Because of her keen and continuing involvement with artists' work, she has never been particularly concerned with building a personal collection. She said, "I never have been too acquisitive really, because it's almost like once something is in my mind's eye, I own it." One might also speculate that her interest in following an artist's development might bear some relationship to her previous involvement in art history.

A pertinent sidelight with regard to her connection with artists is Cooper's tendency to dress informally and stay out of the limelight. Her manner is quiet and can be quite ingenuous. In general, she's not in the outer gallery spaces, but occupied in the back office rooms. She is surprised by the recent attention being paid to dealers. "This is amazing because up to now dealers have always been the pits! We were really considered the slime of the art world. All of a sudden, dealers are stars. I don't know if we're considered respectable, but we've become more famous." In this connection, she expresses her personal disapproval of dealers receiving more attention than artists. In a sense, Cooper seems to sustain the idealism and feeling of promise that permeated the 1960s. Like an artist who creates a work of art and then steps aside, she also operates behind the scenes. Another factor that adds to an impression of modesty is the appearance of her gallery. Its facade is one of the most unpretentious in Manhattan. It appears more like a cooperative than a commercial gallery. A sign painted on the window announces the gallery. There are no flags, banners, or sleekly designed exterior and foyer. To Cooper, it's not the outer trappings, the dressing that is important, but the art itself, an inner substance. In keeping with this scenario,

Cooper usually does not go in for big advertisements in the arts magazines or newspapers. Her overall approach is low-key rather than hard sell; she seems to emphasize the art work rather than the art product and an exhibiting environment instead of a store. However, the first rather benevolent impression one gets cannot obscure the fact of Cooper's business ability and function.

She has seen a manifold role for her gallery.

> Number one, we're a public space where people, the public, can come in and see the work—so we function as an exhibition space. Number two, we take care of all of the artist's business. Number three, we document their work very carefully. We also work with the artist on museum exhibitions. I consider this a gallery, agent and archives all in one.

To her there is a distinction between dealer and agent. The former individual buys and sells work while the agent works on the artist's career. In the latter category she places activities, such as organizing shows for museums, placing work in appropriate collections, and loaning individual pieces to gallery exhibitions or museum shows. "You try to guide things a bit in the best interest of the artist." Cooper feels that a dealer should have both "a very good eye and a very good sense of business. There have been a lot of dealers who have either one or the other. I think it should be 100 percent of each."

With regard to showing work by women, Cooper says, "I've always looked at women's work." At present, among the 11 artists with her gallery, 4 are women, or better than a third. She maintains that within the last 10 to 15 years, the situation has changed "enormously" in terms of the number of women showing work. "Oh my God, yes! When I first started there were hardly any women artists, at least that you knew about. They rarely took their work around or asked you to look at it or invited you to their studio."

Her own experience with instances of chauvinism have been more in connection with age. "When I was younger—I'm so glad I'm older now—male dealers and even collectors were rude to me. Some men just can't deal with women. Now that I'm older, people can't say, 'Oh, she's just a little, fluffy girl' ". This link of sex with age has been a problem often mentioned by young female gallery owners. Some feel that in many cases youth is an even greater inducement for prejudice than gender. On the other hand, Cooper has not felt slighted by artists because of her sex. "I think that artists are interested in anyone who is interested in them. I don't mean that in a derogatory manner. I think it's just a fact." Cooper does not distinguish between a male and female imagery because it is her feeling that "most people have so much of both in them anyway." Although she feels that "the depths of the artist's psycholog-

ical persona comes out in their work," she has observed no distinguishing, sexually-biased traits.

As for political associations, Cooper has not been particularly active in the context of groups or organizations. However, in the late 1960s, she did originate exhibitions to raise money for those who were fighting against the Vietnam War, and she has also mounted benefit exhibits in support of The Kitchen, an alternative space for experimental work in Soho. "It's a very important place. I think it's one of the few places that is truly artist-oriented. It's very vital. If places like that don't continue, the whole vitality of the art scene dries up and disappears. It greatly harms individual artists." Again, her interest in "artist-oriented" spaces and an alive, creative environment surfaces as a primary motivation for activities beyond normal gallery operations.

When she sponsors a benefit show, the beneficiary receives her 40 percent commission. Today, most galleries work on a 50 percent basis, but Cooper says, "I think that the artist should get more. It's just a principle. I think the artist should get more than the dealer or gallery." Her interest in artists, and particularly the development of their work, is not only an ideology but a premise than she adheres to within the context of the gallery as a business.

Style, Cooper says, has never been a concern in choosing the artist she wishes to be a part of her gallery operation. "I'm interested in the individual artist." Her taste as it might be manifested in terms of the work she shows is difficult to categorize in any specific way. She exhibits a variety of media: paintings, sculpture, drawings, and photographs. The imagery concerning most of "her" artists is abstract; however, notable exceptions are Jennifer Bartlett and Jonathan Borofsky. One unifying factor is that the artists she represents seem to constantly push beyond previous boundaries. A sense of the "cutting edge" seems omnipresent in Cooper's choices and in her shows. Perhaps, one might say that in general the work is object-oriented, not in a Minimalist sense, but in terms of physical presence and impact.

Her importance to the course of contemporary art may be attributed to the manner in which her choices have proved to be sustained and effective ones. She has chosen to exhibit work by artists who have emerged as important influences on the history of modernist art. Although she has mentioned her admiration for the "eye" of Ileana Sonnabend in selecting innovative art, many other dealers, including Sonnabend, appreciate Paula Cooper's sensitive vision in recognizing high-quality art work that has continued to be vital and has increased in consequence over the years. Twenty years ago when Cooper began to make selections she was willing to take risks and to follow her own inclinations and thereby to operate at the outer edges of and beyond accepted aesthetics.

Beginning in the late 1960s, she has given artists shows of work that set new directions for them as individuals and for the rest of the art world. For example, she exhibited the polyurethane foam pieces of Lynda Benglis that heaved off the wall and sprawled across the floor. This novel material and Benglis's use of color in sculptural contexts broke certain sculptural conventions. Cooper also supported Benglis and her then shocking advertisements featuring provocative and erotic nude photographs of herself as a seductive Betty Grable and as a "male" macho type. Later, Benglis began to use glitter and metallic paint to ornament her knots and bows that challenged traditions in terms of subject and media. Alan Shields first showed his sewn-and-beaded-fabric constructions in Cooper's gallery, demonstrating his early use of formerly unacceptable materials and techniques. In the 1970s, Borofsky's obsessively personal ruminations and gargantuan figures have placed him at the forefront of art dubbed "Expressionist" in a reversion to more personal and subjective modes in art.

It is difficult to label Cooper's stable as being part of Minimalism, Expressionism, decorative art, or some other category, although in certain instances these words do apply to specific works. If anything, one might see a leaning toward what has been loosely termed a post-Minimalist aesthetic of eccentricity combined with reduction of form. However, in a more comprehensive sense, she is respected for her support of art that has forged new paths in terms of imagery, materials, or ideas.

She has both gambled and trusted her own feelings and instincts based on her knowledge and perception of what art can be beyond established strictures. Her acute sensibilities are in part a product of a deliberately acquired knowledge of historical and modern art as well as her direct experiences with new art forms. A strong factor behind what appears to be an uncanny sympathy toward and understanding of innovation in art is her determined character, or confidence in her own perceptions. Cooper has not been interested in accepted modes or other people's judgments; she proceeds according to her own predilections. In so doing, she has been remarkably successful in terms of introducing art forms that have helped steer the course of modernism and artists who have continued to make significant contributions in extending the boundaries of art. Paula Cooper is important because of her "eye" for quality and power in art. This may be largely attributed to her personal courage, confidence, and independence.

In taking a look at the art world as a whole, Cooper expresses her own disapproval of movements "unless they're really important philosophically." She feels that there are some artists who are underrated because their work is simply "too difficult." A person she places in this category is Richard Artschwager.

He really influenced, in a funny way, a lot of people. He was kind of an odd figure. He always had—not an eccentric vision, but it's been difficult for people, I think, to understand his work or to accept it in a general way. I think he is totally underrated.

She is reproachful of critics with regard to a manufacturing of movements and trends and their dependence upon the weekly show-review syndrome. "That facilitates their writing, doesn't it? For most newspaper and magazine critics, it's a one-shot thing. They look at a show. Oftentimes, they don't know the artist's previous work or really anything about them. It's news."

When Cooper opened her own gallery it was with a $3,000 bank loan and a $1,300 commission she had earned on a piece of sculpture she sold for an artist. "That's how I started. I would never have wanted a backer because they try to tell you what to do, and then it's not your own business." Evident was her vigorous independence from any sort of controlling element. Her career generally gravitated and was highlighted by directions apart from the norm. When she first opened her gallery she decided not to stage shows in the accepted manner but "to have continuously changing works in the space. My idea was that I would show a piece, sell it eventually and then change it." This practice lasted about three months before she realized the necessity for individual shows so that artists could see a body of work together. However, a type of changing show has persisted on Cooper's calendar for two and a half months each year from December to February. New artists have been introduced within this format. The contents of the exhibit were continually shifted. "And when I say changing, I really mean changing, because we might replace one piece and leave the others, or change the installation. You have to come every week to see it." At one time, this kind of evolutionary show was distinctive from the practices of other dealers. Now it is more commonplace. In 1976, she went to Los Angeles, took the space of Riko Mizuno, an established West Coast dealer, and showed her Eastern stable in this location. She felt it was a valuable experience and observed, "It's good to get out of your own environment." She must have believed her own observation, because in 1980 she exchanged spaces with Yvon Lambert in Paris. Each dealer did a show in one another's spaces.

In reference to her disinterest in joining groups, particularly women's organizations, she felt that her support was given "...by the way I conduct my life or what I do—that's very important to me. I want to be free...." This desire for freedom combined with deliberatively taken actions pervades Cooper's approach to her career as it is manifested in the way she runs her gallery, her approach toward the artists whose work she shows and her continuing support for a type of environment con-

ducive and appropriate to creative activity. Her manner of conducting her affairs is somewhat different from her peers, but it is uniquely identifiable with her. Perhaps Cooper's own words best summarize her attitude toward and feelings about her profession when she says, "I would never not want to be independent."

13
Rosalind Krauss

Photo by Keri Pickett, New York.

The distinctive contribution of Rosalind Krauss derives from her early beginnings and dogged persistence as a critic concerned with a theoretical approach to twentieth-century art. Essentially, her thoughts on art have evolved from a realization of the reciprocal relationship between viewer and object in modern art. In the course of establishing her ideas and perceptions, Krauss has examined various art forms, namely, sculpture, film, and photography as well as painting. Her particular interest in sculpture separates her work from that of many critics who have been concerned primarily with painting or two-dimensional forms. She has chosen to examine a less popular medium in art from an intellectual position involving two basic factors that are the art work as object and its visual apprehension by the viewer. The resolution and independence of her stance has evoked admirers and provoked detractors. She has unwaveringly charted her own course without concession to ephemerally fashionable trends or to changes in the political or social fortunes of art world stratagems or strategists. Her self-defined role as critic-theorist has allowed her to maintain a position aloof from the daily ebbs and flows of art styles and fashions.

Even though it's located just off the noisy bustle of Canal Street, a major east-west artery across Manhattan, her apartment exudes a sense of cool serenity. In her full voice, Krauss, petite and attractive, traces her interest in art back to her childhood in Washington, D.C., where her father, Matthew Epstein, a lawyer employed by the Department of Justice, took her to galleries and museums.[1] The location of her childhood home relatively approximate to the Phillips collection allowed her to frequent the "child-size" galleries that had once been bedrooms in a large, old mansion. She remembered two rooms in particular that held "...fantastically beautiful Klees and wonderful Braques. There were no guards, and I would just go there and sit on the floor and look at the paintings." Another recollection involved the panelled, shuttered and "very, very dark" music room where Renoir's spotlit *Luncheon of the Boating Party* hung over a piano. This experience allowed her an insight into the impact of Impressionist paintings on contemporary viewers.

> Basically, these paintings were hung in very dark rooms, and they provided the illumination. It was as though light came into the room from the painting. When Impressionist work is placed in brightly lit rooms, the viewer cannot understand what kind of shock and what kind of pleasure it must have been to see these paintings within Victorian interiors.

Her father approved of and encouraged the early interests of his daughter via trips to museums, as she became more intrigued by and involved with art.

As a student at Wellesley College, she was particularly attracted to a certain professor, John McAndrew, who had at one time been a curator of architecture at the Museum of Modern Art. In retrospect, she felt that his teaching prepared her for a discovery that was to profoundly affect her choice of career and the course she was to follow in her profession as critic. While at work on a "senior thesis" on the painting of Willem de Kooning during the winter of 1961, she accidentally came across an author who provided some answers to questions she had about this artist's work. At Wellesley, the art books and *Art Index* were segregated in a library separate from the main library which housed volumes on other fields and the *Readers' Guide.* Thus, her research had been largely confined to the resources of the art library. "The whole world outside of the art materials had been closed off to me, but somehow this book called *Art and Culture* floated into the art library, and I was thereby introduced to the work of Clement Greenberg." At that particular point in her research on de Kooning, she had done a great deal of thinking and reading, and,

> I felt this enormous frustration at what I thought was a tremendous dopiness of the literature. I had read Rosenberg, Hess and Goldwater, and they just seemed to talk around the issue, never to the issue, never really cutting through to the empirical field of the work from which one could derive aesthetic conditions, effects or feelings.

On the other hand, Greenberg's essays, particularly one on collage were "absolutely revelatory" to her.

As a graduate student at Harvard, she became acquainted with other students who were familiar with the ideas of Greenberg. Michael Fried, in particular, was not only interested in Greenberg, but had begun to write criticism. At Fried's suggestion and with his help, Krauss contacted James Fitzsimmons at *Art International* and started writing for that magazine. After Fried went to *Artforum*, Krauss began publishing in the latter periodical. According to Krauss, Greenberg was aware of his student following.

> He was very flattered by the presence of these people at Harvard who really knew his work, understood and admired him. All through the fifties, he had been eclipsed by Rosenberg and others. The scene had been taken over by a kind of art hustle, by dealers, collectors and critics writing in "magazine speak" about developments in New York. So when suddenly there appeared in the early sixties this group of young people who could quote his work at him like they were reciting scripture,

he was, of course, extremely receptive. He was on to the whole "Post-Painterly Abstraction" thing, and we were all wide-eyed about that. So whenever we went to New York, we would always go and have a drink with Clem.

Certainly her own work of the 1960s reflected a type of thought about art that paralleled that of Greenberg. An important example was in the form of an article, "Manet's Nymph Surprised" appearing in *Burlington Magazine* in 1967, based on material presented at a Frick Museum symposium two years earlier. In this piece she argued that the nude's gaze engaged the viewer in a manner that not only completed the painting, but caused the viewer to be conscious of their visual experience.

> The subject of the "Nymph Surprised" is voyeurism; the subject of the new consciousness—the object focused on in the experience with the "Nymph Surprised"—is the viewer's own act of looking, what it means to look at, to read, to perceive, a work of art.[2]

Furthermore, because of the title composed as an afterthought by the artist and his insertion of a male figure, Krauss concluded that Manet himself was aware of placing "...consciousness itself between the viewer and the work of art...."[3] Thus, early on in her career, Krauss presented a merger of a traditional art historical approach or that of iconographical study with the objective stance of Greenberg regarding the physical appearance of the art object to produce her own assertion of the importance of an individual viewer's experience of a work of art.

During her graduate years, she married Richard Krauss. Toward the end of this period, she had begun to think about a dissertation topic when another chance circumstance led her to the work of David Smith.

> I was in fact thinking of a topic in nineteenth-century European art that would have been much more palatable to my professors at Harvard, but it was going to be difficult for me to go to France for a year or so in the middle of this marriage. I didn't know what to do until one morning I woke up to an announcement on my clock radio that a sculptor had been killed in Vermont. I thought it was Tony Caro, because they said "Bennington, Vermont," where he was teaching. I thought, "Oh, how terrible," because I knew Tony. Then, after a couple of sentences, they repeated the name and I realized that it was Smith. I thought, "Um, I now have a thesis topic." I knew they would never allow me to do a dissertation of somebody who was still alive, but he had just died. I went rushing to Harvard to announce this as my topic.

Krauss credited Greenberg with having caused her to be receptive to the work of Smith, but felt that her treatment of the artist's work was largely the result of her own thinking and conclusions. In 1969, the completion

of her dissertation consisting of a *catalogue raisonne* coincided with the publication of a two-part series of articles entitled, "The Essential David Smith," that she had written for *Artforum*. In these articles, Krauss both employed Greenberg's ideas to suit her own purposes and presented her particular insistence upon the presence of content in Smith's work. In this vein was her Greenbergian-inspired emphasis on the importance of surface to Smith's oeuvre combined with her stress upon the perceptual experience of the art object.

> By the late '50's and early '60's, Smith understood the imperatives for grafting onto sculpture the kind of surface which derived in modern art from Cubism's acknowledgment of the picture plane. By making sculp-ture which would register in terms of extended and interconnected sur-faces, Smith could force the viewer to recognize that the sculpture spread before him was unlike other objects in the world. To see the work as entirely open and visible from a fixed point of view is to pro-voke the illusion that a sculptural object, like a picture, can be known all at once. When surface becomes that thing beyond which there is nothing to see, then the sculpture is wholly unlike objects in the world.[4]

Independently, Krauss recognized the totem idea as an important con-cept constituting content in Smith's work.

> For Smith, the task of sculpture had nothing to do with knowledge of the object, but with self-knowledge. Sculpture had therefore to uncover one's desire to possess the object and simultaneously to establish the work within a set of formal restrictions against possession. In Smith's hands the idea of totem became the thematic bridge between these two conditions. For the totem image combines in a single body the desired object, and the prohibition against grasping it.[5]

Krauss's more complete analysis of the artist's work was manifested in *Terminal Iron Works: The Sculpture of David Smith* published in 1971. In this context, she pointed to the artist's "... insistence on surface discon-nected from an underlying structure," that Krauss termed Smith's "initial insight."[6] She did not view his oeuvre in the context of histor-ical evolution dependent upon European influences, but as a break from tradition. In her dialectical manner based upon an in-depth discussion of exemplary objects, she developed a case for three-dimensional art based upon periphery factors in opposition to what she saw as a tradi-tional sculptural dependence upon a core or internal necessity. Typically, she concentrated upon single pieces to build her arguments.

> *Zig IV* projects eight feet high out toward and over the viewer. It can be described as a collection of fragments—huge cylindrical tubes split

into shallow arcs—projecting off a sloping plane balanced delicately on one point near the viewer's feet. The presence of this plane and the way it seems to be a ground for the other elements in the sculpture suggest that the work can be read within the normal conventions of sculptural relief. The viewer expects that the surface will operate like the plane of a picture: it will be the matrix of a traditional illusionistic field. But the plane contradicts this function by appearing to truncate the sculpture, so that the spectator feels that half the work is shielded from view. He can experience parts of *Zig IV* as fragments of a whole entity extending beyond the boundary of his vision.

Why would Smith do this? Why would he build into a sculpture the idea of a relief space and then deny it by simultaneously suggesting that the sculpture is composed of two intersecting elements, one of which obscures half the other?

We can move closer to explaining the apparent paradox embodied in *Zig IV* if we realize that Smith is dealing in this work with two alternative ways of organizing the visual data that surround everyone. On the one hand, he alludes to the patterns of intelligibility that are the heart of pictorial thought in, for example, perspective systems or narrative relief. On the other hand, he recalls the palpable objects that are the substance of physical experience. But it has been shown that *both* the pictorial and literal modes of perceiving are aborted in *Zig IV*. For *Zig IV* is a new kind of object, whose main characteristic is that it can be grasped neither literally nor figuratively.

The physical presence of *Zig IV* eludes us. Unlike a man-made or natural object, the sculpture does not appear whole and complete. We cannot run our fingers around it to trace its contours and define its shape. The startling fact is that although *Zig IV* is all boundaries, made completely of curving walls and angled planes, these contours bound nothing, not even a comprehensible volume of air. We have only a visual display of surfaces slipping past one another, throwing each other into relief even as they slide past the sight of the spectator moving in front of the aloof construction. Given the ambivalent character of *Zig IV*, we cannot grasp it imaginatively.

Intellectually, the work is equally elusive. The plane against which we see the curving walls of *Zig IV*, the plane that, opening out to us guarantees their visibility in the first place, does not organize the elements into a comprehensible pattern. In fact, our sense that the piece is somehow truncated and that half of it is hidden derives most strongly from the absence of a way to relate the elements in the work to some familiar convention. The continuous flat plane of *Zig IV* signals the presence of the other planes but does not organize them, making them present to vision alone.

Insofar as *Zig IV* is all boundary and all skin, it appears to us as surfaceness itself, stripped from the object that would normally function as its support, *Zig IV* involves a kind of visual paradox, for its apparent availability to the viewer is contradicted by the absence of a possessable object.[7]

An ensuing discussion evolved around the distinction of Smith's work from that of previous examples.

As early as 1933, Smith had focussed his energies on the notion of an elusive object. His primary insight grew out of an instinctive refusal to erect his sculpture around a central spine. By rejecting the idea of the spine or inner core he had freed his own work from the formal conservatism that persisted even to the most open of the European constructed sculptures of the 1930's.[8]

Characteristically, the experience of Smith's work concerned her. "To force the work to appear open and *visible* from a fixed point of view is to provoke the illusion that a sculptural object, like a picture surface, can be known all at once."[9] Here, Krauss emphasizes the lack of complete visual data in keeping with her thesis that Smith's work evaded such a total and immediate comprehension. She compared his work with the totem of other cultures as an object that combined "...the desire for contact (as the overture to violation) and the prohibition against possession."[10] In summary, Krauss considers Smith's work as visible and invisible, as a series of surfaces that may be only partially comprehended on objective or subjective levels, unlike Cubist paintings in which a series of shifting planes can all be understood on one surface. Thus, Smith's sculpture exists as a kind of enigma, attracting the viewer but eluding his full grasp of its properties. The object can be known visually from a particular point of view, but parts hidden from viewers prevent them from grasping the sculpture as an entity, from knowing the whole sculpture at once. In this manner, she deftly associates and separates a knowledge of Smith's sculpture from that of modernist painters.

Prior to its publication, the manuscript for her book was read by Greenberg, and according to Krauss, he told her that it was a treatise that he wished he'd written. However, by the late 1960s, she had begun to note conflicts between them, particularly in terms of political and social issues. In retrospect, she said,

He is enormously misogynist and very horrible to women, but that was not so difficult as his hawkish position about Viet Nam. Particularly in the late sixties, it was difficult to sit around having drinks and listen to him hold forth about Viet Nam and Southeast Asia. You weren't supposed to argue with him, but we had several fights about Viet Nam. Around 1970, he turned quite hostile toward me. I felt that people should be allowed their own political positions and by this time I was thirty years old and felt that I should be treated as an adult. I found his hostility to be part of what I thought of as a really not-so-great character.

In addition, Krauss began to have trouble with Greenberg's aesthetical position, specifically that regarding work by young artists.

> A group of artists were emerging that I found to be extraordinary, but that were taboo for Greenberg. They included Richard Serra and Robert Smithson, but mainly Serra. I looked at Serra's work and knew I was in the presence of great sculpture, but as far as Greenberg was concerned, Serra was like nowhere, and I found this coersive atmosphere unacceptable. On the tenth anniversary of *Artforum*, I wrote "A View of Modernism" and at that point officially severed my ties with Greenberg, Fried and their hard-nosed position.

Thus, as a result of both personal and professional disagreements, Krauss terminated her relationship with Greenberg. "A View of Modernism" appeared in 1972, and in this piece, Krauss defined her own position as a "modernist" critic rather than a formalist and asserted that, "Whatever power the modernist history of painting has had to convince comes mainly from the fact that it was able to explain as a comprehensible progression the most important pictorial evidence of the last 100 years."[11] However, she extended the modernist context to include work by Serra and concluded that, "One's own perspective, like one's own age, is the only orientation one will ever have."[12] At this point, then, Krauss was unwilling to stay within the strict boundaries set by other critics of similar concerns such as Greenberg and Fried, and she declared her intention to extend "modernist" theories along her own lines of thought. As one might expect, this article was no secessionist manifesto, but rather Krauss's own controlled statement of position.

Likewise, in approaching the extremely touchy issue of alleged changes made in the work of David Smith, after his death, Krauss wrote about the problem of color in his work and not about the potentially scandalous situation. Greenberg was one of the executors of the Smith estate and at least partially as a result of Krauss's article, a great deal of media attention was paid to the possibility of unauthorized changes to the artist's work made in order to better market the sculpture. Krauss's story of the events leading up to this situation was as follows:

> Dan Budnik had photographed Smith and his work over the years. Around 1973, he went to visit the fields at Bolton Landing and was horrified by the condition of the work. He photographed it and then went around New York for six months trying to interest someone in his findings. First he went to Hilton Kramer because Kramer had published a special issue of *Arts* magazine devoted to Smith. Budnik thought, "Surely Kramer will want to publish this information." Not a bit. Hilton did not want to publish it. He went to *Time,* he went everywhere, and nobody wanted to print this story. I don't think they even knew

what he was showing them. Then, he happened to be at a party with Betsy Baker (editor, *Art in America*) and showed her his pictures. She thought, "Oh, my God!" and called me the next day. She asked me if I wanted to do an article, and I said "Yes," because the issue of color had been unresolved, and I had access to almost every statement Smith made about color.

In keeping with her character and her concerns as a critic, Krauss did not jump at this opportunity to denounce and deride the Smith estate executors; instead she chose to concentrate on a formal issue. In "Changing the Work of David Smith," published in *Art in America* in 1974, she only mentioned Greenberg in a footnote. Other writers, choosing to find an innuendo of difference between Krauss and Greenberg, considered this piece a denouncement of him when in actuality the thrust was a consideration of the problem of color in sculpture, particularly Smith's own problems with it. According to Krauss, she resisted any kind of direct attack on Greenberg, even though she had in her possession evidence against him.

In a footnote, I said that the executors of the estate had allowed this to be done, in spite of the fact that I have letters from people at Marlborough saying, "Clem told us to take the paint off of this piece. Can you tell us its name?" The records of the estate were a disaster, so they were constantly writing to me. I really didn't conceive of this article as an attack on Clem at all, but as a discussion of this issue of color.

In the late 1960s and particularly in the 1970s, then, Krauss attempted to steer her own course apart from the direct influence of Greenberg. Although her primary interest continued to be sculpture, she wrote on the paintings of Ronald Davis and Frank Stella. Her pieces could not be classified as "reviews," but as treatises prompted by work that interested her. A typical example of her critical orientation appeared in *Artforum* in 1971 and referred to work by Stella among others. "What the specific range of intentions were of these painters, I cannot say. I can however talk about the effect of looking at the pictures themselves."[13] The notion of the completed art work as an object that takes on a separate existence apart from its creator remained at the heart of Krauss's critical thinking about painting and sculpture. During the following year in a piece called "Léger, Le Corbusier and Purism," she not unexpectedly traced the sources of "modernism" to late Cubist factors present in these artists' works, particularly the frontal circumstance of pictorial space viewed from a distance. Her emphasis upon the viewer's perception of object in space also appeared in a discussion of Serra's Pulitzer sculptures published in a 1972 issue of *Artforum*. Important to a consideration of Krauss's approach is a recognition of her objective and carefully couched

arguments for a consideration of the art work as a separate entity that does not exclude the intuitive factors inherent in a given viewer's apprehension of a work of art. She excludes the artist and his motivations from what basically amounts to the confrontation between art object and viewer.

In an *Artforum* of 1973, she published an important article entitled, "Sense and Sensibility, Reflection on Post '60's Sculpture," in which she discussed Stella's stripe paintings as a product of their external qualities, rather than according to the artist's prior intention or purpose. Her critical thesis was based on a consideration of art object as an independent identity to be examined without attention to the artist's a priori aims. The materialist factor in her thinking did not admit the detractive connotations of such terms as "post-Minimalism" or "dematerialization" which she criticized in "Sense and Sensibility" for their lack of positive implications. In this piece, she also argued for the separation of work by Stella and Serra from the recent historical past. To her, "post-modernist" art existed physically as matter in the "here and now" of the viewer's experience of a body in space.[14] Basically, then, Krauss extended her enquiry into art experienced and known via the viewer's direct encounter with the object.

During and since the 1970s, her primary inspiration has been "post-structuralist" writers, such as Roland Barthes and Louis Mirand. She has also admired the thought and writings of Frederick Jameson in the area of comparative literature and has based her own use of the term "post-modernism" upon that of Jameson. She acknowledges the misunderstandings and misappropriations of terms such as "structuralist" and "formalist" and prefers to think of herself as one who examines the unconditional bases of our knowledge of art.

> I don't think that most people understand what formalism is. In the art world, where ignorance is utterly rampant, formalism is thought of as describing a taste for decoration or empty abstraction. That doesn't seem to me to characterize either my writing or formalism. I have consistently written about the content of work whether it happens to be abstract or not. Some of the most brilliant theoretical work of the century is formalist in the positive sense of the term. It is about understanding the abstract logic that operates beneath things. Structuralism in that sense, is a formalism. Structuralist linguistics is a type of formalism, and I'm perfectly proud to be identified with that.

Thus, Krauss thinks of herself as a formalist who goes beyond mere analysis of surface features to an underlying principle or set of principles that could indeed be thought of as the content or basic meaning of a work of art. She prefers to think of herself as an analyst plumbing the depths for a primary property or condition of art.

As for the term "post-modernism," she has expanded it to include what she terms the "surfacing or the photographic in all aesthetic fields." By that she means that art has come to exist as a kind of record of its own processes. Her conception of photography involves its existence as a kind of "mirage of reality" or optical phenomenon. She feels that photography has "...reshaped the terms of art and aesthetic response and that then heralds an entirely new set of conditions that I wanted to call 'post-modernism' and that paralleled what Jameson was calling 'post-modernism'." However, Krauss came to feel that the term had become synonymous with the word "pluralism" used to describe art of the 1970s, and that thereby it was to her "corrupted" and "unusable." Her concept of "post-modernism" was specifically associated with her thinking about the basic meeting of viewer with object in space.

Throughout her association with *Artforum* in the early to mid-1970s there was among editors, according to Krauss, "...a sort of an agreement to disagree."

> Basically, Max Kozloff and Lawrence Alloway never agreed with or even particularly respected Annette Michaelson and myself. Robert Pincus-Witten formed a third point of view, and as far as I was concerned, Joe Masheck's view was unclear. We were all associate editors who contributed in different ways to the magazine. It was basically a kind of amicable feud. Board meetings could be pleasant or really disagreeable.

This condition existed as long as John Coplans, the editor-in-chief, was able to maintain a balance. When he hired Kozloff as a regularly salaried staff member, the schism became an intolerable situation for Krauss and her colleague, Michaelson.

> Max rejected an article of mine. Although we were never paid for editorial work we did for the magazine, we were paid for our articles, and they were certainly to publish our material. Max began to make it impossible for Annette and me to publish. It just became really ugly, so we left.

In the spring of 1976, Krauss and Michaelson produced the first issue of their magazine, *October*, published by MIT Press. Within a six-year period, this periodical boasted a circulation of 3,500 and was able to "break even" in terms of a cost-return investment. Michaelson was a film critic, and by the mid-1970s, Krauss had become interested in film. Therefore, it was appropriate that the magazine's title be derived from Sergei Eisenstein's film, *October*. Since Krauss did not expect the periodical to survive publication of more than a couple of issues, she thought of the title and the magazine as a kind of manifesto.

John Coplans said to the *Village Voice* that we had been purged from the magazine (*Artforum*) because we were formalists, and this notion that formalists had to be purged was exactly what happened to Eisenstein. *October* was the first film in which Stalinist aesthetics intervened. Trotsky had been expelled, and there was a tension between Stalinist artistic theory and the vision held by Russian artists in the twenties of a natural marriage between formal experimentation and politics in sort of a utopian and forward-looking view. In the thirties, Eisenstein had to make a public confession of his sins as a formalist. He had to make a kind of public self-criticism. The repressive nature of Stalinist aesthetics employed in the name of politics paralleled what was going on at *Artforum*. The ironies of all of that seemed to be condensed in an interesting way in the name *October*.

However, unlike the subsequent history of the filmmaker, Krauss made no compromises and never hesitated to continue developing her own line of aesthetic thinking and writing.

To her, the experience of film coincided with her articulation of the viewer-object encounter in understanding painting and sculpture. Basically, her conception of film involved a recognition of time as well as space as factors relevant to the viewer's knowledge. She emphasized the art object's existence as the manifestation of a particular medium. In 1974 she wrote, "A modernist sensibility pushes a medium to its limits, creating an image of itself in them."[15] The next year in an interview published in *Studio* magazine, she reiterated her interest in ". . .the methodology of a kind of empirical description" and emphasized her concern for

an investigation of the phenomenological situation; that is, the space between the viewer and the work of art, and the time that space implies. It wants to make an account of the way that temporality gives rise to meanings, instead of simply legislating that time and space out of the aesthetic experience.[16]

She contrasted her position with that of Fried whom she felt transcended considerations of space and moment while continuing to maintain a "positivist-trained taste for sculpture" grounded in what was basically a Greenbergian notion of "sculpture-as-furniture-as-paradigm for modern sensibility."[17] To Krauss, sculpture was not merely object, but evocative of ". . .a form of consciousness that is skewered on facts." Her thinking was based on ". . .an extraordinary sense of the autonomy of the visual," particularly in terms of the modernist art object's independence from an historical past and association with the artist's intent.[18] Krauss thought of the authentic content as that embodied in the material itself.

The medium of painting, sculpture or film has much more to do with the objective, material factors specific to a particular form: pigment—heaving surfaces; matter extended through space; light projected through a moving strip of celluloid. That is, the notion of a medium contains the concept of an object-state, separate from the artist's own being through which his intentions must pass.[19]

The art object, its medium, and the experience of its viewer were factors central to Krauss's ideas. In an exhibiton catalogue essay on work by Donald Judd, Richard Artschwager, and Joel Shapiro written in 1976, she summarized her view of the relationship of viewer to art work.

The literalized object—in the work of Judd, Artschwager, Shapiro—is used, then, to establish a certain kind of reciprocity that exists between the viewer and his world. Whether the nature of that reciprocity is described as perceptual or psychological, its time is the present and its space is here.[20]

Her premise that space and time were inseparable from and concomitant to an analysis of sculpture formed a major theme in her book; *Passages in Modern Sculpture*, published in 1977. Typically, her approach consisted of a "case study" format or in-depth analysis of selected examples of nineteenth and twentieth-century sculpture. In this volume she developed her theory of modernist sculpture that disdained the notion that something "...wells up from within the personality of the sculptor and, by extension, from within the body of the sculptural form...." To her, the "ordering system" was dependent upon externals or something that came "from outside the work."[21] Krauss characterized the modernist bent in sculpture as that which revealed an object in terms of a space-time continuum. In particular, she pointed to Robert Smithson's *Spiral Jetty* as an attempt to "...supplant historical formulas with the experience of a moment-to-moment passage through space and time."[22] Her notion of the direct apprehension of sculpture in an accumulative manner is expressed in her own words.

Contemporary sculpture is indeed obsessed with this idea of passage. We find it in Nauman's "Corridor," in Morris's "Labyrinth," and in Serra's "Shift," in Smithson's "Jetty," and with these images of passage, the transformation of sculpture—from a static, idealized medium to a temporal and material one—that had begun with Rodin is fully achieved. In every case the image of passage serves to place both viewer and artist before the work, and the world, in an attitude of primary humility in order to encounter the deep reciprocity between himself and it.[23]

Krauss's choice of words imply a kind of spiritual essence that does seem to encounter popularly-held notions of "formalist" criticism but, as she has stated, her interests lie not in superficial or surface analysis but in the more profound areas of meeting between art work and observer.

In 1979, in an article entitled, "Sculpture in the Expanded Field," Krauss elaborated upon the inherent autonomy of the art object "...through the representation of its own materials or the process of its construction."[24] She pointed to a "loss of site" that contributed to modernist sculpture as "...functionally placeless and largely self-referential."[25] To her, this was not a limiting factor, but actually opened an "expanded field," or a broadened realm of possibilities. She explored these potentialities in an article on "John Mason and Post-Modernist Sculpture: New Experiences, New Words" in an issue of *Art in America* in 1979. During the same year in *October*, Krauss published an article on "Grids" which she saw "...as a paradigm or model for the antidevelopmental, the antinarrative, the antihistorical," or all the factors she considered detracting from the real nature of sculpture.[26] A year later in *Art in America*, Krauss took issue with an "expressionist" view of work by Pablo Picasso on the basis of what she saw as an "...ahistorical, formal self-presence of the object," meaning the work of Picasso.[27] Thus, as Krauss moved into the 1980s, she continued to develop her theory of the independent, material existence of the art object as it was apprehended by a viewer within the context of space and time.

In part, her point of view was influenced by what she saw as a "...pervasiveness of the photograph as a means of representation in the seventies."[28] In articles on a series of photographs called "Equivalents" by Alfred Stieglitz, published in *October* (1979) and in *Arts* (1980), she pointed to the manner in which Stieglitz had transformed clouds or natural phenomenon into the abstract realm of the photograph.

> And what there is to see in the "Equivalents" is photography understanding itself as essentially possessing the conditions of a symbolic field—a field of dislocation with its own system of traces, its own way of marking absence.[29]

In her analysis of photography, she distinguished between an historical mode of defining an art work in relationship to artist and her critical concern with "achievement" or the evidence present as the art object itself. The self-referential factor she discerned in photography was delineated in an article entitled "Nightwalkers" on work by Brassai published in the *Art Journal* in 1981. In this context, she wrote that, "Through this deliberate conflation of levels of 'reality' Brassai establishes the surface of the photograph as a representational field capable of representing its own process of representation."[30] Inherent in the photographic image, Krauss found a record of its own materialization. Consequently,

she viewed photography as objects embodying space-time factors. Photography's ability to assimilate reality while existing as a separate object interested her. In *October* (1980) she published a piece prompted by an exhibit, "Avant-Garde Photography in Germany 1919–1939." In this article and in another on photographs by Irving Penn that appeared in *Arts* (1980), she set forth her argument for the photograph as a singular phenomenon that nevertheless reminded the viewer of another reality. About the photographic process and its perception by the viewer, she wrote:

> Part of the camera's power is its capacity to sharpen and intensify attention by tearing something out of the context of reality and presenting it in isolation. This is the power of framing; and framing is surely a central element in the photographic aesthetic, as the viewer of the image experiences the resultant visual evidence of the cutting edges, as it were, of the camera's lens.[31]

Concerning the end result or photograph, she concluded:

> Thus, at the very center of its representational power is its message of the absence (of the real) that is the precondition of representation itself. The pleasure of photography cannot be separated from this distillation of absence.[32]

Krauss's interest in photography has evolved into plans for a book the content of which will range over the history of this field. As is her manner, Krauss plans to consider "different issues plucked from the moving stream." Sculpture continues to be a concern, and Krauss will be involved with a catalogue for an exhibit of work by Richard Serra at the Museum of Modern Art. Although sculpture and photography might seem quite disparate in form and intent, Krauss sees them as various and intersecting manifestations of modernism. To her, these are the "neglected children," generally ignored, offering the opportunity for pioneering work and totally consistent with her concept of art as object experienced by the viewer in a temporal and spatial context.

At present, Krauss is divorced, has no offspring, and has been preoccupied with the development of her career. Only recently, she has realized the reality of social and political threats to the independence and status of women.

> I have come to see that all of our thinking has been deeply affected by the feminist movement simply saying certain things out loud. These things were always in a way unthinkable and unsayable. Now, because they've been stated, I think a lot of women when faced with circumstances they find inexplicable and weird...suddenly the nickel drops and they think, "Oh, it's because I'm a woman." To use the horrible

word "consciousness," I would say that my consciousness about how I am perceived and the limitations of the possibilities of my operations because of how I'm perceived as a woman...that's all been put in place for me over the last three years. I now deeply understand, in a way that I never did before, the kind of war that's going on, that it's really serious and mean.

Krauss speaks of Linda Nochlin, a colleague at the City University of New York Graduate Center as a "model" in terms of her own ideals as a professional woman concerned with art.

Currently, Krauss teaches art theory at the Graduate Center, and she is a professor of art history at Hunter College. She has also taught at Wellesley, Massachusetts Institute of Technology, and Princeton. Her awards include a Guggenheim fellowship in 1971, the Mather Award for Art Criticism (1972), election to the presidency of the International Critics Association—American Section for 1976–77, and her appointment as a Resident Scholar at the Center for Advanced Study in the Visual Arts at the National Gallery in Washington, D.C.

As for today's art scene, Krauss predicts the end of "modernism" and its "splintering into endless replication." She maintains an allegiance to the work of Serra and others of his generation.

This kind of hysteria about the last moment in aesthetic production is, I think, very destructive. It seems crazy to me, and at this point I feel that if we care about art, we can't get involved in this notion of obsolescence.

Regarding a recent enthusiasm, she professes disinterest in what she terms a "pathetic return to painting." She is also critical of the new corporate patrons who are "...interested in something they can understand" and prefer paintings for the walls of the boardroom over sculpture. "The bourgeoisie client feels very reassured by oil and precious materials. It's not very interesting, and it's certainly not rising to the challenge of any kind of difficult art."

Krauss feels that the audience for which she writes, particularly in October, consists of students in art schools who are searching, as she once was, for answers to questions that have not been considered by other authors. Certainly her particular position, involving a reciprocal concept of aesthetic experience has distinguished her contribution to thought on modern art. Both the strength and resolution of her position have been and will continue to depend upon her own dogged belief in and development of a train of thought based upon what, from her point of view, consists of the actual circumstances of recognition engendered by the art object. After approximately 15 years of work in this direction, she is well established and up to the task.

14
Cindy Nemser

Photo by Charles Nemser, New York.

At the height of a successful career as an art critic, Cindy Nemser left the profession to begin working as an independent author writing autobiographical fiction. In 1977, she severed contact with people, places, and events in the art world because she had become disillusioned with and tired from her work in support of women artists; her magazine, *Feminist Art Journal*; and a particular viewpoint of contemporary art.

> I had started out writing about art seriously around 1969, and I didn't realize it but within the space of a very short time, I guess I had built up a reputation for myself and that took a tremendous amount of energy which I was very eager to put in. There was a tremendous momentum in that period. It was a very exciting time, but by 1977, I was really at a point of exhaustion. I just felt I couldn't do it anymore. There were a lot of factors involved. One was that I stopped believing in the art to a large degree. Contemporary art. That is, it was very hard for me to continue to write about it, whether it was done by men or women. I felt disappointed in the women artists' movement. I started out thinking it would accomplish such tremendous things. I was so idealistic, so hopeful, and it didn't happen. I didn't see it happening, and I didn't find that there was all that much support from the women themselves, and that was disappointing. The magazine was not making much money. It never did, and it was difficult to keep on doing something that didn't make an income.[1]

As a critic, she had been interested in a contemporary form of realism, in art by women, and in establishing a new critical vocabulary. Eventually, however, she despaired of the hope that the art world would ever change in the way she thought it should. She found that her own aims as a feminist writer opposed established interests in art, and in time, she came to believe that her goals were generally unachievable and basically unrewarding ones.

> It was an impossible position for me, because if you must work within the art system and yet believe it's nonsense then you're a hypocrite. That really distressed me. If you don't believe in the system and say so, then you're outside, and it doesn't matter what you say in another context. Yes, there'll be people who'll say, "Here, here, you're right, Cindy. On with it, expose 'em, tell 'em off." But it doesn't matter, because the people who endorse the machinations of the art world are entrenched from what I have seen. There is no way to dislodge them. They're very powerful.

As a critic, she began to see members of her profession as Janus-faced figures who wrote one thing but actually believed in another.

> I think in order to be an art critic today, you have to be able to practice what George Orwell called "double think," which is being able to say one thing and absolutely being able to convince yourself you believe it all that time knowing that it's nonsense or that it's not true. I think that's the only way you can succeed in the art world as a critic.

Nemser did feel that in part her cynicism had developed in retrospect or after having made the decision to leave her career as critic. However, given her initial idealism and the course of her career, it was undoubtedly part of an underlying and increasing problem.

More specifically, Nemser also became increasingly disillusioned with the women's movement. Prior to the establishment of the *Feminist Art Journal*, or in 1971, she had written a piece called "Forum: Women in Art," for *Arts* magazine which consisted of responses to questions posed by her to a number of women artists. Many of their answers were rather negative in tone in terms of a feminist viewpoint. The resultant article, ("Forum: Women in Art") was rather incongruously placed in the context of her book, *Art Talk*, after the introduction. It was in the course of gathering reactions for this article that she began to realize that some women themselves were not particularly concerned about their status as artists. Indeed, Nemser felt that many of them were downright "hostile" toward the nature of her inquiries. Years afterward, she concluded that, "It was always that way. Doing the *Journal* was an uphill battle all of the time." She did, however, acknowledge endorsement from "the little people" outside of New York City, or those whom she felt were supportive of her and the magazine. When she stopped publishing it in the spring of 1977, this periodical had not lived up to her expectations in terms of what she had envisioned as its potential for influence and power, nor was it providing any earnings. Ceasing its publication represented the end of Nemser's expectations and hopes for change in the art world.

Other reasons for her shift to another career involved her skeptical attitude toward the narrative art that she saw in the 1970s, her feeling that she could write better stories and most importantly, the discovery that she did have something to write about.

> It must have been around 1974–75 when they started doing narratives in avant-garde galleries. That annoyed me. I thought they were so inane. I said to myself, "Gee, I can do better than that." Also, I saw a film that was very important to me. It was called, "Nana, Mom and me." Amalie Rothschild was the filmmaker. Yvonne Rainer was doing films which sort of hinted at autobiography, but it was hidden under an ab-

stract approach. Amalie, who was not an artist but a filmmaker, did this film dealing with the relationship between herself, her mother and her grandmother. I was astonished, because I thought a filmmaker—I associated film with Hollywood movies—made romances. Who makes films about their relationship with their mother? She put herself in it, and I gave her a lot of credit for that. I was very moved by it, and it touched a lot of chords in me, because the reality was that the greatest drama of my life was not my romance with my husband as much as my conflict with my mother. All of a sudden, I realized that I had content.

Nemser said that years prior to the experience of seeing this film, she had wanted to write novels, but that she thought she couldn't do so because she hadn't "lived" in the manner of someone like George Sand. When she was in her mid-twenties, she wanted to become a writer, but felt that she couldn't without additional formal preparation and life experience.

After making the decision to leave criticism, Nemser wrote short stories and two novels. Her first unpublished manuscript, "Heroica,"was based directly upon people she knew and events that took place in the art milieu of the 1970s. Her second book, *Eve's Delight*, was completed in 1982 and published by Pinnacle Press within the next year. Both longer manuscripts were based in part on her past.

A pervasive thread woven into the fabric of her background involved an idealistic view of artist or author and the circumstances surrounding their creativity. In 1937, she was born in Brooklyn, where she married and continued to live with her husband, a salesman she married in 1956, and a daughter, Cathy. As a high-school student, she wanted to become an artist but felt that she didn't have enough talent. During her years at Brooklyn College she made few future vocational plans.

> I really didn't know what I wanted when I was a kid. I concentrated more on being popular. I spent my college years in a dream world focused on making my personal life more secure. I got married when I was very young. No one in my family ever encouraged me to have a career.

After graduation or in 1958, she was employed as an elementary school teacher in the notoriously malevolent Bedford-Stuyvesant school system until 1964. During the course of this job, she returned to college for a master's degree in English literature received in 1963.

> I had wanted to become an artist. Giving it up and becoming a teacher seemed very ordinary to me. I wanted out of a boring middle, less than middle class. Teaching in Bedford-Stuyvesant was a rough experience. I was there for six and a half years, and I did well. They were going

to make me the art specialist. However, I did have my ups and downs. I joined the teachers' union and got involved in strikes. I have a history of that sort of thing. . . . But in this case, it was because I was bored and very frustrated.

For the graduate degree, Nemser wrote her thesis on "Sensibility in Jane Austen's Novels." Her desire to bring the artist's life into her paper caused her problems with the head of the department who was more interested in structural criticism. These difficulties were quite prophetic of conflicts she was to have later on as an art critic.

After completing the degree, Nemser "left teaching completely. I gave up the license and the money and began to study art history." Nevertheless, she did feel guilty about leaving her position.

> But Emerson said that we had a right to develop ourselves, and nothing or no one had a right to stop us. He believed that we're part of the whole divine process or spirit or whatever, and that we have to flower as individuals. This type of thinking meant a great deal to me and gave me the courage to leave teaching and pursue the study of art history.

Thus, disappointed in the strictures of English literature, she embarked upon a study of art history. At this point, she remembered being "passionate" about art when she left teaching to study art history.

> I just thought it would tell me everything. Art was about communication and beauty, and I wanted to give myself to this subject. I admired people who knew about it. It was a fantasy associated with a high strata of people, the upper class. Everything that was beautiful and desirable, I associated with art.

In spite of being pregnant with her child, she enrolled at New York University's Institute of Fine Arts. She also had a vision of this place that proved to be a false expectation.

> I went in with a great admiration for academia. I really worshipped academia. I put these people on pedestals. They were the experts. They were scholars. I thought the Institute would be a community of scholars, and it turned out to be a community of vipers. Jockeying for position and career mattered too much. . .getting the better of your fellow students and jumping on one another. The seminars were hell. I really did come in with the idea that these were learned people and that they knew everything. They knew so much, and I wanted to know, too. I never wanted to be a journalist, I wanted to be a scholar. In a way, leaving the Institute was a come-down from the Ivory Tower, the rarefied atmosphere. The Institute was considered a super school, and there I was in this magnificent mansion. We used to have tea every Friday in

the library and sherry on great occasions. I liked the trappings, and I was willing to do anything to pay for them. The price was you had to write this dry, esoteric stuff. One of the reasons I didn't pursue the doctorate was that I couldn't see myself spending five years in the 42nd Street Library writing about some subject that was long past. I wanted to get out and be with people.

She also reflected that she did not fit in at NYU because of her personal circumstances.

At the time, I didn't get much encouragement from them. I really got the message that if you were married and pregnant you were not exactly wanted, sort of a persona non grata. I was told by Colin Eisler that I shouldn't think about working full-time since I had a child, and that I should look for some kind of volunteer work. I got my master's in two and a half years, and I guess I could have gone on for the Ph.D. They weren't cheering me on. They just said, "If you want to continue we'll let you come back and take more courses and then we'll decide." By that time, I wanted to get out. I wasn't so sure it was art history I wanted anymore. I thought I wanted to join the contemporary world.

At that point, Nemser felt that an historical background was a supportive and necessary basis for contemporary art. Eventually, however, she came to feel that the use of art historical references when writing about contemporary art was more a matter of "subverting art history" or using it in a foreign context without a justifiable basis. After completing a "crash course" at the Whitney Museum on contemporary art, she decided that, "It was another world. Art history didn't prepare me for this at all."

Her entry into art criticism was coincidental in nature. Through an artist friend she met an advertising saleswoman for *Arts* magazine. She inquired about writing for an art magazine and was told they needed reviewers. Subsequently, she wrote a review and showed it to the editor, Gordon Brown, who told her to try more. "So with a lot of fear and trepidation, I went out and started doing it, taking it very seriously. It was very thrilling, because I had never published anything." Her initial expectation was again colored by her romantic impressions of the field.

One of the fantasies I always had was being in a Salon. . . not like Gertrude Stein's salon, but like an earlier, nineteenth-century salon. The people were very cultured and spoke beautifully about art and music. The equivalent of that for me in the twentieth century was an opening at the Museum of Modern Art, or a place where all these cultured people would come together. They would be creating the taste of the time, and I wanted to be part of that.

Another admittedly inherent factor in her aspirations over the years was her ambition to be in a controlling position. She said, "I like power. I like where power is. It interests me." So with her aspirations of reaching a position of influence and authority, Nemser entered a career as critic.

To a large extent, her candid thoughts about her ambitions, experiences, and decisions were based upon her reflections of the past. She did not paint a rosy picture of memories as one might tend to do when talking about one's own history, nor did she spare herself in terms of delineating personal motivations or goals. In general, what might be termed naive or relatively ambitious in Nemser's case could be easily identified with similar inducements governing the lives of many people. In particular, Nemser's story entailed somewhat unconventional choices made to alleviate certain sets of circumstances only to encounter new difficulties.

In 1965, or before graduating from New York University with a master's degree in art history, Nemser served as a curatorial intern at the Museum of Modern Art where she had an opportunity to become more familiar with twentieth-century art and the people involved in it. Nonetheless, her first extensive article for *Arts* magazine published in 1968 was "Paintings for the Many, the American Vision: 1825–1875," focusing on American art of the nineteenth century. Noteworthy was her slant toward a kind of populist position. Within a year, she began to concentrate on contemporary art, but two elements found in this early piece persisted in her work. One was an interest in realism and a second involved her support of an art that was intelligible and accessible to more people. Other topics considered within the next three years concerned the part perception played in creativity and the position of women in art.

Her early and continuing interest in the accessibility of art to a wide audience appeared again in "Revolution of Artists" (*Art Journal*, 1969) in which she wrote about artists' attempts to make more universal statements and their reaction against the "stifling materialism of modern society."[2] Her attention to realism was extended in a piece on "Max Weber" appearing in the galleries section of *Arts* in 1970. A year later she wrote on perceptual factors involved in the environmental sculpture of Lila Katzen. Also of 1970 was "Interview with Chuck Close," published in *Artforum* simultaneously with "Presenting Charles Close" in *Art in America*.[3] In connection with her choices of subjects, she said that it was in part a "sort of psyching out of who's really up and coming. And for a magazine like *Arts*, I have to say it was also a question of who's going to buy advertising space." Her selection of Close, of course, was a highly significant one in that she was at the forefront of writers who initiated a consideration of his particular manner of working. Nemser's recognition of his talents were later verified by a large show of work at

the Whitney Museum, and in general, he became one of the most highly acclaimed of the "new realist" artists. Nemser was also interested in the "narrative realism" of Gabriel Laderman and the more expressionist representations of Alice Neel.

In 1970, for *Arts* magazine, she surveyed the realist trend in three-dimensional art in her piece, "Sculpture and the New Realism." Part of the thrust of this article was concerned with the perceptual or psychological possibilities of art. During the same year, "Art Criticism and Perceptual Research" was published in the *Art Journal*. This piece dealt with her investigation into the realm of our apprehension of art or the manner in which viewers understand visual forms.[4] In a further attempt to advance her study and theories, she wrote on the phenomenology or circumstances of realist art ("Representational Painting in 1971: A New Synthesis," *Arts*, 1971) and presented classifications of artists in terms of their frontal or oblique views of subject matter,as well as their respective uses of apparent brush strokes, large or small scale, the relative flatness of the painted image, serializations of a given theme, and influences from or interests in the work of old masters.[5] In two pieces of 1971, "Alchemist and the Phenomenologist," comparing work by Gordon Matta and Alan Sonfist, and "Subject—Object: Body Art," (*Arts*) that referred to psychologist-writer, James J. Gibson, she pursued her initial explorations into the ways in which artists perceive the world and their respective expressions of that knowledge.[6]

Thus, within the first four years of her career as a critic, Nemser chose to write about realist art not only in terms of particular artists, but in relation to a more general and theoretical viewpoint. In general, she was fascinated with the question of how we recognize and react to artistic form. Her mode of inquiry accommodated not only realist paintings and sculpture, both traditional and experimental, but also avant-garde performances and abstract art. Within the latter categories were her early interviews with Stephen Kaltenbach (*Artforum*, 1970) and with Vito Acconci (*Arts*, 1971). There might appear to be a discrepancy between her concerns for more traditional styles of realism as opposed to the more unconventional art of performance. In actuality, these two approaches simply represented various levels of realism from the metaphorical to the highly literal. In recalling this period, Nemser at first attributed her choices to a kind of opportunism. "It all seemed so haphazard. We were looking for the newest thing, the latest movement. We tried to keep up with everything that was going on in the art world." Nevertheless, she did point to a unifying factor.

The work of someone like Vito or Dennis Oppenheim in body art was very human. It was involved with people. I never really found myself particularly interested in someone like Donald Judd. That type of art is

remote. I don't care much for total abstraction. I like the concrete, the human experience.

Without question, Nemser was primarily concerned with the reality of art, whether that consisted of recognizable imagery or personal encounter. Underlying her bent as a critic was a singular inclination toward tangibility and relevance. She considered content more important than form, reality more significant than abstraction, and social import over aesthetic esotericism. In the process, she occasionally succumbed to an inherent elitism or a consideration of herself at the forefront of a few initiates. That she was an "insider," a member of a special circle, was important to her but at cross purposes with her aims as an egalitarian. However, the socialization of the unquestionable exclusiveness of the contemporary art world was and is a hazardous preoccupation, one that is fraught with pitfalls and entrapments. Although she did, at times, assume a rather particular stance, in general she was indeed a leader in pushing the belligerently sluggish art denizens toward a recognition of broader, more reciprocal aims.

Rounding out a period dominated by realist and experiential concerns, was her article, "The Close Up Vision—Representational Art," appearing in an *Arts* issue of 1972, in which she wrote about the "spiritual unity of all things," a belief she later referred to as an ongoing "strain" in her thinking—a part of which was indebted to the ideas and writings of Emerson. At this point, it might also be noted that her personal collection of art consisted in part of realist works by artists such as Laderman, Audrey Flack, and Roy Lichtenstein. Gradually, Nemser's concern with realism and human experience evolved into an overriding commitment to women's art.

As early as 1970, she had been attentive to developments in art by women. Undoubtedly, part of the reason for her direction was the fact that she entered the profession at a time when women's movement forces were struggling for momentum. As a matter of fact, she wrote on work by women several years prior to the time when their fame was to reach a point of full fruition, and she continued to be one of women artists' staunchest advocates. In fact, her greatest contribution was made in the area of women's art. In 1970, she did "An Interview with Eva Hesse" for *Artforum*. Unquestionably, this was a seminal piece. After Hesse's death, a retrospective at the Guggenheim and a book by Lippard, this artist's reputation rose to a pinnacle of postmortem success in 1976, and she has retained an influential position in contemporary art. Lippard's book relied upon the published interview, and she acknowledged her source. However, according to Nemser, the exhibition and catalogue essay were at least partially based upon her interview transcript that she inadvertently gave to the artist to read while she was in

the hospital and that was subsequently incorporated into Hesse's estate by its trustees.[7] Whatever the circumstances were surrounding other writings about Hesse, the most significant factor was Nemser's initial contact with and appreciation of this artist's work. Other women she wrote on were Marian Beerman (*Arts*, 1971) and Dorothy Heller (*Arts*, 1972). The title of her piece on the latter artist was "Symbols of Consciousness: the Paintings of Dorothy Heller." In this context, she once again stressed universal aspects she found in this artist's work. She maintained that Heller sought "...unity with the cosmic rhythm."[8] This kind of psycho-philosophical tendency distinguished her work from those critics more concerned with a stylistic or formalist approach.

There were also other women to whom she devoted attention. "Interview with Helen Frankenthaler" appeared in a 1971 issue of *Arts* and in 1973, "Lee Krasner's Paintings 1946–49," was published in *Artforum*. Certainly, she was not the first to discuss Frankenthaler's work since this artist had been accorded some recognition in terms of her influence on the Washington, D.C. school of male, "Color Field" painters. However, Nemser did treat Frankenthaler as an artist whose work was independently worthy of consideration and recognition. In the course of this interview, Nemser quoted herself as having said, "I have always been concerned as to how the artist's life intersects with his work."[9] (The reference to artist as a male was later to become a critical issue to Nemser.) Her statement is reflective of the wider social context that she considered important to art and, to a lesser extent, the actual surrounding circumstances involved in the artist's creative activity. In the case of Krasner, Nemser was the first to call attention to the early achievements of this artist via her "little image" paintings. Nemser pointed out that Krasner had worked in an abstract manner since 1943 and had reached that point simultaneously with other artists of her generation. Nemser also discussed the fact that other critics had not referred to this artist within her rightful context as a pioneer of Abstract Expressionism. In Nemser's words, a "major body of work" has thereby been "...obscured by sexist discrimination."[10] At a later date she commented,

> It was a terrible heresy to say that Krasner might have been as important as Pollock. Do you know all the money that's invested in Pollock? And now we're going to come up with a wife!—who might even have influenced him.... They do not like boats being rocked. I mean that's big, big money. I came to realize that's what it's all about.

In her article, Nemser called for a reevaluation of Krasner's work, but that was not to happen until seven years later when Barbara Rose examined the Pollock-Krasner connection.[11]

Increasingly, Nemser's focus became a call for equality and social

responsibility in art. By 1972, she had established the interview format, or actual conversation with the living artist, as a specialty. Already, she had published interviews with Acconci, Close, Hesse, Frankenthaler, Kaltenbach, and Krasner within a two-year period. She went on to talk with several other artists, publishing the results in the journal she established and in her book, *Art Talk*. This tack to the job of writing on art was somewhat involved with her romantic idealism regarding the art world.

> I finally got to meet these wonderful creatures. Again, they were also on my pedestals. When I was a kid, I read *Lust for Life* and I identified with Van Gogh. Meeting these fantastic people was a bit of a thrill, sort of like a groupie encountering movie stars.

A more substantial reason for her pursuit of the interview form was that it offered a means to circumvent a certain type of writing that she believed was dominant in art writing of that time.

> I felt that even when I wrote for *Arts* I wasn't quite esoteric enough, that my sentences weren't long enough, that I was too clear. *Artforum* had this incredible stylistic demand, and I really couldn't write like that if I stood on my head. I felt with *Arts* I had a little more freedom, but I still had to watch myself. I could certainly not come out too strongly with any of the skepticism I began to feel. No humor—they didn't believe in humor and also very little human content. It's very dry writing.

One of the reasons she started the *Feminist Art Journal* in 1972 was to establish a forum for a more personal, informal type of writing. In her own journal she could publish what she considered to be clear, intelligible writing as opposed to an exclusive, unintelligible type of criticism. In keeping with her own development as a critic, she was much less concerned with style than with content or meaning. As the first magazine devoted to women's art, the *Journal* was certainly a pioneering enterprise. It was particularly respected within the wider range of women's art circles outside of the New York City establishment. Where the system was less clearly delineated, Nemser's journal was more easily accepted. A periodical devoted to women was certainly a significant development to thousands of women artists across the country who were encouraged to learn that someone, somewhere, was actually focusing a magazine on their efforts. In a 1982 issue of *Woman's Art Journal*, a progeny of the *Feminist Art Journal*, there appeared an article that consisted of a kind of balance sheet delineating the relative successes and failures of *Feminist Art Journal* in terms of the author's view of its contribution or lack thereof. The general conclusion was that Nemser had used the *Journal* as a vehicle for the promotion of her own viewpoint.[12] In her defense, one might

ask what publication did not reflect or has not reflected the views of its publisher and editors. At the time, Nemser felt her aims were in the direction of the greater good of a larger number of artists. Regardless of her motivations, she was the first to start a women's magazine devoted to art and in so doing, she gave hope and courage to many women and created a niche in art history and possibly in social chronicles to be written about our time.

In 1972, or during the same year that she started the *Journal* and within the next five years, she wrote and published a number of influential and important articles on women's art. "Art Criticism and the Gender Prejudice" (*Arts*, 1972) was one of these. She began this piece with a reference to John Canaday's review of a show of work by Paula Modersohn-Becker and continued with a discussion of whether or not there was a feminist art. Following her already established course of consulting psychological sources, she referred to experimental psychologists for information and asserted that gender prejudice was a product of cultural conditioning, not biological differences. She went on to separate feminist art from feminine art in terms of political associations. In conclusion, she offered her advocacy of an egalitarian circumstance or "human art" that is what "...men and women are producing and have always produced."[13]

In the course of this piece, she also complained of critical language loaded with prejudicial phrases. This was the subject of a specific article entitled, "Stereotypes and Women Artists" which she finally printed in the first issue of the *Feminist Art Journal* after the editor who commissioned it for *Art in America* failed to accept it for publication. (Later it was published in the *Journal of Aesthetic Criticism* and in Judy Loeb's book, *Feminist Collage*.) The piece was inspired by Mary Ellinan's book, *Thinking About Women*, and based on the results of a questionnaire she had sent to a number of contemporary critics. In specific reference to certain of their reviews, she pointed to descriptive terminology and phrases as reflective of a prejudicial attitude against the work of women. Indeed, the use of innocent words, such as "light" can be associated with light-minded and "soft" can be related to a subordinate status. As critics used such terms, they consciously or unconsciously supported a patriarchal superiority in art. In retrospect, Nemser felt that this was the most significant article she had done in terms of research and "original thinking." Both "Art Criticism and the Gender Prejudice" and "Stereotypes and Women Artists" made primary contributions to the feminist position in art. Their strength is dependent upon Nemser's own thoughtful and pointed analysis of her own field of writing on art.

In addition to using the *Journal* as a vehicle for important articles that would otherwise not have surfaced in a public forum, Nemser also utilized this format as a rostrum for her direct attacks on individuals whom

she felt were chauvinists. During the magazine's formative stages, she intended to write a series of articles under the general rubric, "Male Chauvinist Exposé." The first of these was devoted to the critic, David L. Shirey. Other single pieces called "I've Got A Little List" (*FAJ*, 1973) and "Blowing the Whistle on the Art World" (*FAJ*, 1975) seemed to occupy ground somewhere between an enumeration of Nemser's pet peeves and her stated desire to oppose and attack art factions hostile to her feminist aims. These bitter forays were balanced by a more positive approach taken in several articles on women artists. Among these were: "Interview with Members of AIR" (*Arts*, 1972); "A Conversation with Lee Krasner"(*Arts*, 1973); "Women's Conference at the Corcoran" (*Art in America*, 1973); "Conversation with Audrey Flack" on this artist's paintings of women (*Arts*, 1974); "Grace Hartigan: Abstract Artist, Concrete Woman" excerpted from her book (*Ms*, 1975); "Audrey Flack: Photorealist Artist" (*FAJ*, 1975); and "Conversation with Betye Saar" (*FAJ*, 1975–76).

Among pieces of the early 1970s were several interviews continuing a format she had established that culminated in the book, *Art Talk: Conversations with Women Artists*, begun in 1972 and published in 1975. Some of these had been featured in individual issues of the *Journal*, others were published in other contexts and some appeared only in the book. This volume was important within the context of Nemser's years as a critic because it represented not only a kind of culmination of her work on women in the form of a series of "conversations" or more informal, personal presentations, but because it was one of the first volumes to be devoted solely to women's art. Again, the latter reason would be most likely to gain historical recognition for this author.

Nemser seemed to ride a crest of enthusiasm in the 1970s for women's art. She was named a contributing editor of *Arts* magazine in 1973; became a founding member of an organization called Women in the Arts; coordinated three sessions on women artists (1972–73) for the College Art Association; curated two exhibitions, "In Her Own Image," for the Philadelphia Civic Center (1974); served on the advisory board of the Women's Caucus for Art from 1975 to 1978; and received a National Endowment for the Arts, Art Critics Fellowship in 1975.

In addition to and complementing her work on issues affecting women's art, she wrote several pieces representing and calling for a more personal and human approach to art. A moving example in this vein was "My Memories of Eva Hesse" written in 1973 (*FAJ*) after the tragic death of the artist and "Four Artists of Sensuality" published in *Arts* in 1975 that presented work by Eleanor Antin, Lynda Benglis, Judith Bernstein, and Hannah Wilke within an intimate and provocative context. This year was also the time of her encounter with EST therapy. She said she was never a devotee, but that it "...started me on an inward path." After

that point, she felt embarked upon an orientation that was essentially "psychological and internal—self-exploration." However, considering her earlier interest in perceptual aspects of art, this diversion would seem to represent a continuation of her former focus.

At a later date, Nemser claimed, "What I saw as the contribution of women was the content," meaning a relevance to societal or human circumstances in general. In the mid-1970s, she participated in a panel, "Role of the Artist in Today's Society," sponsored by Oberlin College. Her contribution along with that of the other panelists was printed in the *Art Journal*. Here, she argued for a social function for art as opposed to the art-for-art's sake tradition and an art that was "accessible to all."[14] The latter position confirmed her early advocacy of greater availability of art to a wider audience. A social interpretation of art was also posited in "The Artist in Today's Society" (*FAJ*, 1973), in "Humanizing the Art World" (*FAJ*, 1975–76) in which she criticized "...a system that does not encourage humanity or attention to human concerns,"[15] and "On Humanizing the Arts" appearing in *American Artist* in 1976. In the latter essay, she criticized the "mystique" surrounding the one-of-a-kind art available to a few, wealthy elite and expressed her view that "Art that focuses only on art problems, concentrates essentially on formalist matters, only parallels in the most superficial manner the scientific and technological preoccupations which devoid of human warmth, have created the inhuman state we are now forced to endure."[16] In order to halt the system which she viewed as destructive of human values, she called upon artists to stop thinking of themselves in the singular.

> Artists must stop scorning the middle class and denying that they wish to sell their work. By playing the antibourgeois game, artists are playing into the hands of the super-rich. This is the game of the lone male genius, a game whose rules state that if the work of a few is valid, the rest of the artists are losers. There is no place for them. This makes a few geniuses rare commodities and wealthy collectors (very often the same people who are on the boards of prestigious museums) profit from this game, along with a few dealers.[17]

She went on to denounce the "mystique" surrounding art and bewildering an uninitiated public. Her feeling was that, "...only an art that addresses itself directly to immediate human concerns in the real world can be effective in the area of radical change."[18]

In view of Nemser's support of art related to social issues, her scorn for stylistic criticism by Clement Greenberg and others was perfectly in character. Speaking of Greenberg, she said, "Personally, I couldn't see his point of view, but it was very easy to buy. He convinced a lot of collectors, and they put their money where his mouth was." Nemser felt that Greenberg and others were not sufficiently concerned with the content of art.

Little attempt has been made to deal with the social context of contemporary art. Those who call themselves critics have avoided dealing with this content at all cost, whether they condemn the work as rubbish; for example, Hilton Kramer and John Canaday writing for *The New York Times* or discuss only its formal aspects, as if the work had no social content; for example, Greenberg, Michael Fried, et al. If this art has an importance it also has social significance and this societal factor must be made clear to the public. Critics and art historians must be willing to stand up and deal truthfully with all aspects of the work and not only with its stylistic characteristics.

Nemser's view of formalist criticism was that it promoted art as investment.

Collectors, at whom these writings are aimed, must be convinced that they are being sold great and meaningful works of art. Therefore, enterprising editors encourage their writers to make up esoteric theories about the most simplistic images and to present their theses to the readership in the most confused jargon-ridden, unreadable prose. The idea behind these strategies being that most people are completely intimidated by writings they cannot comprehend, believing that it is all too deep.

During the course of her relatively short career—not even ten years—as an art critic, Nemser fought several battles; namely, that with the highly respected formalist critics, that in support of women artists, and that in favor of a social context for art. In evaluating her past, she said, "I like challenging conventions." She did feel, however, that she became somewhat pigeon-holed in a certain role. Referring to her work on panels, she remarked,

It's always good to have a controversial person around. I really began to feel like I was playing a role, because I was type cast. Somebody once said, "Oh, we expected you to be at the panel, and when you weren't there, we were waiting for you to throw a bomb." After a while, always being up there throwing bombs is exhausting and if everybody expects it, at a certain point, it doesn't mean anything.

Part of her motivation for these struggles was her disappointment with the reality of a situation that didn't live up to her dreams. Perhaps she best summarized her actions in leaving art behind her when she commented, "The more I go over it, the more I realize that there was nothing else I could do."

15
April Kingsley

Photo: Courtesy of April Kingsley.

The approach and contributions of April Kingsley can best be attributed to what she calls her "innate pluralism" or willingness to consider a variety of art styles and media and her attentiveness to art created by minority groups. Rather than writing on the latest product offered to the art market, Kingsley prides herself on keeping an open eye and mind in considering new as well as accepted art and in consciously keeping her focus apart from any fashionable "mainstream" grouping. Her stance is not the result or conclusion of an evolved aesthetic theory, but it has existed as a continuous modus operandi characterizing her career. Her expansive and catholic attitude has been most noticeably manifested in the attention she has paid to art by black and women artists.

In addition to factors associated with her choices or the subjects of her articles and essays, Kingsley's work can be recognized by certain stylistic factors; namely, a bright, lively, emphatic manner of writing that presents art and artist in approving, positive, and clearly stated terms. Her pieces concisely express and reflect their author's belief in her subject. Her writing is engaging, it catches the reader and sweeps her or him into its flow. One is convinced not only by her words and their meaning, but by the total thrust and impact of her vigorous and spirited literary style.

Born in 1941 in New York City, the daughter of Grace Haddock, a housewife, and printer, Kingdon Edward Kingsley, she remembered being particularly fascinated by her father's box of art reproductions.[1] However, in college, she pursued training to become a nurse. After completing a two-year program, she began work at New York University Hospital and switched to a general program to complete a bachelor's degree. Undertaking course work while holding down a full-time job enabled her to take advantage of a free tuition program allowed university employees. She became interested in history and decided to take courses in the historical backgrounds of a number of subjects. "I wanted to learn about all the different fields, not just one area." After a general course in art history with H. W. Janson, she concluded that it was art history that she wanted to major in for her degree. The special areas of interest she pursued were modern and medieval, patterning her course in part after that of her advisor, Irving Lavin, and that of Meyer Schapiro whom she continued to view as a model. During her last year, she received an upper-class fellowship that allowed her to reduce nursing duties, and she obtained another part-time job at Park Place Gallery where she worked from 1965 to 1966 as an assistant to John Gibson, the founder-director. (It was in 1966 that Paula Cooper began to direct this gallery.)

After graduation, she enrolled in NYU's Institute of Fine Arts for a master's degree in art history which she received in 1968 along with a certificate in museum training and 21 credits toward a doctorate. At this level, her majors were modern and oriental art history. "I wanted to learn about the world's art, not just one subject, and that's really why I liked the oriental area." A Ford Foundation Fellowship in Museum Training facilitated internships at the Cloisters and at the Museum of Modern Art where she was assigned to assist William Rubin on an exhibition called, "The New American Painting and Sculpture, the First Generation." When this apprenticeship had been completed, Rubin hired her in order to complete work on this show, and she continued there as a curatorial assistant from 1969 to 1971. During this period, she was involved with a number of other major shows; such as an exhibition of work by Frank Stella, an "Information" exhibit and a "Spaces" show. Subsequently, she went to the Pasadena Art Museum as an associate curator from 1971 to 1972. Here, she organized a Rafael Ferrer exhibit and worked on the Galka Scheyer Collection of German Expressionist art. By the time she finished her work on the collection, the museum had been purchased by a new owner, and she had met painter Budd Hopkins whom she married in 1972. Kingsley credited her husband with a continual influence in terms of conversations they had over the years on art. A year later, or in 1973, she began teaching at New York City's School for Visual Arts two weeks before giving birth to a daughter, Grace.

While she was in California, she began writing for *Art Gallery* magazine and in the early 1970s she wrote reviews and articles for *Art News* (1971–73), *Artforum* (1972–73), and *Art International* (1973–74). A brief sampling of people she chose to write on during these years is indicative of her broad and quite independent interests, a tendency established at the outset of her career as a writer. For example, her reviews in *Art News* ranged from commentary on work by Joseph Raffael to that of Arshile Gorky. She wrote on Conceptualists, On Arakawa and Bruce Nauman, and on a show by Italo Scanga at the Whitney. Scanga's work achieved widespread critical attention about ten years later as a part of 1980's enthusiasm for "European" art. Also of 1972, were two pieces on another Conceptualist, Douglas Huebler and an article on James Brooks that emphasized this artist's ". . . highly personal color and the form language he has brought into being."[2] Thus, from the start and perhaps because of her background in art history, Kingsley considered art prior to as well as that of her own time. In a quite catholic manner, she was attentive to work of an intellectual bent and that appealing to the emotions. In addition, she could not be linked with any particular medium or form. For *Artforum*, she wrote on Willem de Kooning in 1972 and about the work of Yvonne Jacquette, Sylvia Mangold, Tal Streeter, Hannah Wilke, and

Jack Youngerman. In so doing, she covered painting, sculptures, and performance—not to mention artists who had been categorized as Abstract Expressionist, Color Field, Hard Edge, and Neo-Realist.

Approximately coincidental with her beginnings as an art critic was her recognition of the importance of women's art. In addition to those reviews already mentioned, she published "Mary Frank: 'A Sense of Timelessness' " in *Art News* in 1973 and in the same year, "Women Choose Women" appeared in *Artforum*. Her position on the subject of women's art was made clear in the latter piece. "On the whole what the show (an exhibition of work by women that had been chosen by women) did prove was that women made art in a wide variety of distinctly idiosyncratic, underivative ways and that they make art that is as strong both conceptually and perceptually as men's art."[3] She continued to support women's art with her piece on "Nora Speyer" in *Art International* (1974). Throughout her career and in spite of a reduction in media enthusiasm for women's concerns, Kingsley continued to support and write about the art of women.

For *Art International*, she discussed the seemingly disparate work of Ronald Bladen and Jack Tworkov. However, she found a common ground in terms of temperament. About Bladen, she observed that he had been able to "...subvert the implications of a 'Minimal' formal vocabulary with a Romantic temperament," and she astutely commented on Tworkov's "...lifelong dependence on the stroked line...."[4] She pointed to the more obvious use of line by both artists and the less apparent romanticism governing the work of each artist. From 1973 through 1974, she authored the "New York Letter" for *Art International*, which became a forum for her all-encompassing aesthetic expansive enough to include: video art by Joan Jonas, Minimalist work by Donald Judd, the affluent canvases of de Kooning, the conceptual creations of Agnes Denes, an Impressionist-Post-Impressionist show at Wildenstein's, exhibitions of work by Louise Nevelson and Charles Ross, a women's exhibit at the 55 Mercer artists' cooperative gallery, and shows by John Cacere, Colette, Hans Hoffman, and George Segal. Rounding out these New York "letters" for 1973, were reviews of work by such contrasting figures as Peter Agostini and Jackie Ferrara; Ree Morton and Mel Bochner; Richard Anuszkiewicz and Nancy Spero; and Ellsworth Kelly or Al Held and Chaim Soutine. And in 1974, she continued to look at and write about several disparate artists' works, such as that by Carl Andre, Ilya Bolotowsky, Paul Brach, and Joan Mitchell.

Kingsley's diffuse interests were always at odds with established market preference for mainstream art, criticism that served as a seal of approval for the prospective consumer and with the concentrated tendency toward specialization, particularly among critics writing during and since the 1960s. In fact, entire magazines were geared to reflect a

particular critical bent. Kingsley's independent position caused her to lose one position, that of reviewer for *Artforum*. Then editor, Robert Pincus-Witten, released her from this endeavor in a delicately but precisely phrased letter. He appeared to truly appreciate Kingsley's abilities but felt that the magazine could not accept her pluralist tendencies on a regular basis.

> Because I was long struck by your breadth of awareness of the scene and by your natural literary gifts, I had wanted you to join the reviewing staff. But the intention of this experience was to create at the same time a sense of team, of sober commitment to the ideas of the rich and precious dialogue germane to *Artforum*. I guess you'd say my vision was vertical. I think your vision of critical responsibilities is horizontal. I don't take issue with the position, but in all honesty, I am struck by the diffusion of your talents. Because of this experience I am no longer going to press you with regard to monthly New York coverage. Do not view this, however, as a rejection as both John and I would welcome any substantive essay on any contemporary subject that would engage your admirable talents.[5]

In consideration of Pincus-Witten's directional comparison that is analogous to masculine-feminine symbolism, one might note the disparity between critical approaches emphasizing singular, in-depth concentration and those concerned with a broad view of the scene. Certainly Kingsley was not among those who embraced and developed a singular type of art and theory. She was not interested in concentrating on a certain type of art that matched her ideas, rather she was supportive of a variety of thoughts and forms in art. If anything, it could be said that she favored art by minority groups, but that was never a completely consuming inclination.

The content of her articles of this period reveal a probing and perceptive mind. For instance, on a show by the enigmatic Marisol, she commented:

> Throughout her work, there runs a deep thread of necessity, a surreal and meaningless but essential content which prevents it from seeming merely chic. Narcissism has always been one of the primary constituents of this content; her off-beat humor is another. Both of these factors were in full operation in the fish where her face replaced their heads and in the fishheaded man. She is a cagey artist. She offers the viewer a handle on her work, but when it is grasped, its attachment to anything substantial disappears.[6]

Her unique and astute observations were also exemplified in lines from a review of a show by Robert Morris.

> Throughout Robert Morris' career he has seemed to swing back and forth between two extremes in art—dance and object making—that is between the ungraspable (impermanent, fleeting, never exactly repeatable performance) and the unavoidable present.[7]

These excerpts illustrate the manner in which Kingsley could swiftly and deftly get at the crux of the matter, whether it be specific works or an entire oeuvre.

Having completed the requisite experience as a reviewer, Kingsley was prepared for positions of greater authority and responsibility and these were forthcoming in the form of her employment as regular critic for the *Soho Weekly News* from 1975 to 1977, the *Village Voice* between 1977 and 1979, and *Newsweek* in 1979. She felt that her experience as a reviewer was a necessary background enabling her or any critic to discern innovation from imitation and in order to sensitively assess the large bulk of visual, written, and spoken information that is the purview of the art critic. Her resolute belief in the value of a training period caused her to suggest a revision in later developments in this system wherein inexperienced persons were assigned as reviewers. "*Artforum* should go back and hire John Perreault, Carter Ratcliff, me, all of us to write reviews...."

On an individual level, she felt that her own involvement with reviews for several magazines over a period of years augmented by the impact of the women's movement in terms of removing sexist language had contributed to a more immediate and direct manner of writing. During the 1970s, her particular style crystalized and became recognizable for its clarity, liveliness, and incisiveness. She never studied writing in the sense of formal school courses and said, "I never really learned how to write, so I never think of myself as a real writer. I don't write other things either like short stories." In the course of her indenture, she evolved a particular technique in which she set up a first paragraph that would determine the subsequent arrangement of her review, article or essay. "Flow" is a key word to describe Kingsley's manner of writing because of a sense of connectedness, or the interrelationships of word to word, sentence to sentence, and paragraph with previous and successive paragraphs. The fluidity of her style discouraged editing and prohibited quoting from her work. She could recall only one statement lifted for advertising purposes from a piece in which she described an exhibition at the Museum of Modern Art of work by Paul Cézanne as "sensational." Her choice of words was a clever play on her opinion of the show and the artist's description of his own "little sensation" transcribed to canvas from nature. Her own statement about her profession accurately summarized both her intent in writing and its particular appeal to her. "Writing is a challenge. To write well, informatively and interest-

ingly and to keep people reading whatever you're writing about is a nice challenge."

In general, Kingsley felt that most of her writing had been directed toward a largely uninformed public and that her function was partly one of "information spreading." As for the status of art criticism on the whole, Kingsley expressed a need for "more markets for writers" and decried the lack of "newspapers with any serious criticism." She pointed to the "broad, expanded cultural phenomenon" that could result from regular critics being hired at good salaries to write for the New York *Daily News*, the *Post*, and local papers everywhere. According to Kingsley, the fact that critics were offered a pittance for their work leads to offers from dealers who could offer money above and beyond the rate of art magazines for articles and essays on the artists shown in their establishments. She also worried about the pressure from newspapers to review current exhibitions which she termed journalism or "a graphing of the scene," instead of writing on more encompassing, less current issues that might be both more profound and timely.

In the mid to late 1970s, Kingsley's long-standing commitment to her own choices rather than those of the mainstream and to the relatively unknown artist rather than the popular individual caused her to explore the work of a variety of people in the pages of the *Soho Weekly News*, the *Village Voice*, and various art magazines. Her tendency to "set up" the first paragraph as an organizational keystone and as an attractive inroad into subsequent content appeared in many versions. For example, a piece on James Brooks for *Arts* magazine in 1975 that combined essay and interview formats began with both a statement and a question. "Problem #1: James Brooks' paintings are obviously beautiful; they are 'mood paintings'. Can such pictures withstand thoroughgoing, serious critical attention?"[8] By way of contrast to this discursive approach, another piece, "Reality in Abstraction" on work by Rudolf Baranik appearing in the *Soho Weekly News* in 1976, was introduced in a highly poetic or subjective manner.

> Black. Black. Gray, Black. Phosphorescent whites silenced on all sides by absorbent darkness. Midnight blues glowing dimly. The flap of winding sheets. Bandages. Death. Putrification and decay. The world seen blurred through incompletely closed eyelids. Absence. Death. Sleep without end. The Wasteland. Suppressed violence.[9]

Matching her multifarious selections were the approaches she took in terms of style in discussing disparate works of art.

Typically, Kingsley's articles are reflective of her keen interest in the work expressed in a clear, incisive, and vigorous manner. Her lively style of writing never becomes a superficial overlay; rather her words are to

the point and reflective of an extensive background in and depth of understanding about the nature of art. Certain artists, such as de Kooning, continued to attract her attention and again in 1976 she wrote a piece indicative of her continuing admiration for his Expressionist work. During the same year, she wrote a trenchantly phrased piece on the Hard Edge pieces of Frank Stella.

> Stella's new paintings look like gigantic still lifes of stencils, draughtsman's equipment and templates on heaving Cezannesque table tops which have been affixed to the wall. They literalize Cubist collage, while being made of all the same material—painted honeycomb—core aluminum sheets. The rectilinear borders of each painting, which are essential here to control the imminent chaos of thrusting forms and bristling painterliness within seem like a departure for Stella, but aren't. He has repeatedly returned to the normal outline of his pre-shaped canvases in the past, especially when he wanted to explore new coloristic approaches.[10]

Characteristically, Kingsley's tack was a positive one, but when provoked she could also unleash her command of the language in a terse and trenchant comment. She did just this when angered about John Elderfield's concentration on formalist, inconographical, and technical factors in his essay for the Museum of Modern Art's "The Wild Beasts" show. In her piece, she emphasized the emotional basis and approach of Fauvist work and sharply criticized her colleague. "Playing down the emotionality of Fauvism as he does, Elderfield does a disservice to the meaning of the work. He should be grateful that the work is so exciting since it blinds us to his pedantic installation and prosaic prose style."[11]

Among her publications within the next year were essays on art by two women, Brenda Miller and Helene Valentin for *Arts* magazine, a call for more public art in her piece "Art for All" appearing in the *Village Voice*, and an extensive catalogue essay on "Cape Cod as an Art Colony" written with Fritz Bultman. Typically, her contributions to the *Voice* for 1977 were varied fare including articles prompted by shows of work by Mary Miss, Mark Rothko, and an exhibition of figurative sculpture. Partly because of her formal education in art history and partially because of her own sense of a personal position, she did not hesitate to write about a fine historical show or a new development in art. Kingsley was not swayed by media "hype"; she made her own decisions whether they entailed extolling an old master or climbing out on the limb to introduce new talent. For example, "Flesh Was the Reason Oil Paint Was Invented" was the title of her review of shows by de Kooning and Pierre Bonnard. Certainly, Bonnard, and with few problems de Kooning, could be placed in the "master" category, and Kingsley chose to write about the conventional medium; namely, oil paint. On the subject of de Kooning's paintings, she recreated a sense of their physical appeal.

Now he's not necessarily painting the figure, but his robust paint han-
dling, and the bursts of warm pink, sultry yellow, and soft, blood red
seem full-bodied like flesh. De Kooning's swaths and squiggles of oily,
wet-looking pigment form a palpitating, breathing skin on the picture's
surface.[12]

And further on in her inimitably vivid manner, she wrote, "Viewing
these frenzied abstractions is an exhilarating experience. You are swept
into his struggle as your eye risks passage along the maze of discontinu-
ous pathways and plateaus he's created out of an endless series of recon-
sidered decisions."[13] Exemplary of her coverage of the latest develop-
ments in art was her important piece, "Opulent Optimism" concerned
with a "Pattern Painting" exhibit organized by critic John Perreault at
P.S. 1. In this instance she emphasized the visual richness of the show
as a whole. "Each work is densely loaded with detail in which to im-
merse yourself," and "They (work in the exhibit) offer the problem-free
pleasures of artificial experience."[14] And in a crossover between past
and present, she saw Ira Joel Haber's art as "eccentric" in a nineteenth-
century manner (*Arts*, 1980).[15]

The year 1978 was particularly important to Kingsley because it was
then that she began to write about work by black artists. This move was
certainly in keeping with her interest in supporting and willingness to
write about art that had not already been promoted or even exhibited
to any extent. The first of these essays was "Black Artists: Up Against
the Wall" appearing in an issue of the *Village Voice*. Kingsley emphasized
that the publication of this piece and a second called "Overcoming the
Double Whammy" of 1979 was highly unusual, because the *Voice* like
other newspapers preferred articles geared to particular exhibits. As
Kingsley observed in "Up Against the Wall," shows of work by black
artists had disappeared after the late 1960s and early 1970s. In both arti-
cles she emphasized the emotional richness of black art expressed
through abstract means. These writings led to an exhibition that she cu-
rated at P.S. 1. In a piece on the "evolution" of the show, she delineated
a factor unifying this show of contemporary work by blacks. This fea-
ture was "...a reference, however indirect, to African art or ex-
perience."[16] In her essay for the exhibit entitled, "Afro-American Ab-
straction," she wrote that this was "...the first important survey of its
kind since the spate of shows devoted to Black artists around 1970,"[17]
and delineated each artist's African connections.

Kingsley's exhibition received extraordinary critical attention. Robert
Hughes writing in *Time* magazine called it a "modest sort of land-
mark";[18] in *Soho Weekly News*, John Perreault maintained that "Very
few all-white shows—and most art exhibitions as such—are as good";[19]
Carrie Rickey reviewing the exhibit for the *Voice* was generally suppor-
tive though skeptical of African ties; and for the *New York Times*, critic

John Russell judged that ". . . in range, in energy and in level of achievement. . . ," this exhibit compared ". . . very favorably with most of the other mixed media exhibitions of painting, sculpture and environmental art that we get to see in New York."[20]

Among spin-offs from Kingsley's articles and exhibit were a catalogue essay dealing with work by Richard Hunt and two pieces on the art of Melvin Edwards. In "Steelyard Blues" published in *Encore* in 1981, she emphasized that, "For Edwards and other aware and committed Black artists it has never been enough to simply make good, white-Art-World, mainstream art; they also want to make art that will mean something more to their people than its mere acceptance by the establishment."[21] One might interpolate that it has also never been enough for Kingsley to write about mainstream art, that she wanted to express her ideas about more meaningful issues. In a catalogue essay written for Edwards's exhibition at the New Jersey State Museum, she pointed to the manner in which the artist's ". . . own experiences fuel his art. . ." and the way in which ". . . he poured his life as an African—American into the specific kinds of space-shaping and movement."[22] Her central point in this essay and in other work was that "abstract" need not mean without content. Kingsley was not ever a formalist in the sense of art form referring and relating solely to itself. In Edwards's case, she felt that he complicated ". . . the purity of the Constructivist geometrical mode by imbuing it with the spirit and history of his people."[23]

Indeed, much of Kingsley's work was directed toward abstract art in which she found content. In particular, this position was especially appropriate to her writings on art by women. A case in point was the eloquently phrased observations found in another important and original article she did for *Arts* in 1978, called "Six Women at Work in the Landscape." In this piece, she described work by Cecile Abish, Alice Aycock, Nancy Holt, Mary Miss, Mary Shaffer, and Michelle Stuart as "meaningful, intensely human statements" and differentiated their work on the land from that done by men.

> Women seem to want to build the kinds of places they'd like to be in themselves, and to build them with their own hands whenever possible. They exhibit no split between marking and making. The underlying obsessions which fuel their artworks seem to be both deeper and more directly expressed than they tend to be in men's "earthworks." Women tap the unconscious in their audience because their works are self-referential. One senses a rapport with their site and their materials, rather than a victory over them. Finally, whereas most of the well-known "earthworks" by men spring from a minimalist aesthetic, those by the women do not. If anything, they lean toward an Expressionist or Surrealist aesthetic instead, for some part of the work's content at least. Rarely do they pit the man-made against nature in a simplistic

way. Their relationship to their site is so complex that the irrationality of nature, the irrationality of humankind and the rationality of the architectonic are often enjoined at one and the same time. Their sites aren't neutral, nor are their works about materials, scale or internal structure per se in the old minimalist tautalogical manner. Their works are multi-temporal as well as multireferential to an unprecedented degree.[24]

In general, Kingsley tended to take the artist into consideration when writing about his or her work. This might include factors of sex, race, life style, or even personality. Exemplary of the latter element was her piece on H. C. Westermann for the *Voice* in 1978. The title itself, "Narrating Life's Existential Fuck-Up," indicated a content intertwining the artist's personality, life style, and work.

Kingsley's spirited and intelligible writing style enabled her to publish work in a variety of specialized art magazines and others with a less elite readership. For *Horizon* (1979), she wrote "Sacred and Erotic Vision of Balthus" in which she encapsulated his style as "...an uneasy mix of three ingredients: an idolatry of the great art of the past, an immediately obsessive sexual content and an acute awareness of the structures of modernism."[25] During 1979, she was appointed critic for *Newsweek*, a post she held for a relatively short time because of what she thought was an editor's unwillingness to tolerate a woman in that position, due to the heavy editing of her copy and because of her disinterest in spending hours on production decisions regarding use of appropriate color reproductions. In this connection, Kingsley pointed out that part of the commitment of magazines or newspapers to articles on art was due to the fact that they wanted to have a certain number of color pages in any given issue to visually attract viewers to their publication. In spite of the problems she had, her style of writing and interests were certainly appropriate for a general readership and she was interested in the challenge of writing informatively and clearly on art for a large audience. During the short period of her association with *Newsweek*, she did write several articles for them, including a piece on Michelangelo called "Drawings of a Titan" and another on work by Rufino Tamayo entitled "Magic from Mexico." For *Horizon* magazine, she wrote in 1981 on Camille Pissarro, an artist whom she found "viable for us today,"[26] and in 1980, appeared her piece "Philip Guston's Endgame," beautifully illustrated and designed for this issue.

Her interest in the art of minorities has persisted into the present. Of 1979 in *Ms* magazine was, "I-Hate-to-Cook Dinner," on Judy Chicago's *Dinner Party*, and of the next year was "Cynthia Carlson: The Subversive Intent of the Decorative Impulse" (*Arts*), in which she asserted the artist's intention to use traditional feminine techniques toward purposes other than "propaganda and beauty," or to "challenge the in-

tegrity of the picture plane,'' and Carlson's ability to use ornament as subject rather than as decoration.[27] Among articles on art by women between 1981 and 1983 were those concerned with the abstract paintings of Carol Haerer (*Arts*, 1983), the plant forms of Buffie Johnson (*Art International*, 1981), and the content of work by Pat Lasch (*Arts*, 1981). A decade of development was the subject of her article on William T. Williams appearing in *Arts* in 1981. To Kingsley, the subjects of women's or black art was not an ephemeral, journalistic enthusiasm; instead, she has shown a real and continuing commitment to supporting these important areas of creativity.

In 1980, she was appointed codirector of the Sculpture Center, a nonprofit school and gallery in Manhattan, and she began to expand and renew her work as a curator. ''Islamic Allusions'' shown at the Alternative Museum, represented her choice of artists whose work referred to three aspects of Near Eastern Art; namely, ''. . . architecture and its embellishment, geometrically generated patterning, and calligraphy—but direct quotation is the exception rather than the norm.''[28] Her show and accompanying essay, ''The New Spiritualism: Transcendent Images in Painting and Sculpture,'' opened at Oscarsson Hood Gallery in 1981. The focus of this show was ''transcendent images'' created by a number of artists who went beyond formal concerns.

> Not merely making ''art for art's sake,'' not solving problems nor wringing variations on formalist themes—these artists are making emotionally charged, reference-heavy contemplative abstractions that seem to have welled-up inexorably from within, out of internal need.[29]

In this piece and via the show, Kingsley reiterated her continued interest in the content of abstraction. For the Sculpture Center in 1982 was an important exhibit of ceramic work entitled ''East Coast Clay'' that constituted one of the rare attempts of a nonprofit institution to exhibit a medium usually relegated to a status lesser than that of the traditional ''high'' art forms of painting and sculpture. In 1983 she embarked on yet another phase of her career, namely a Ph.D. in art history from New York University.

In summary, the factors that distinguish Kingsley's work as a critic are: 1) her attraction to a variety of styles and media; 2) her strong, vivacious style of writing suited to large as well as smaller art audiences; 3) her interest in and willingness to write about our art historical past as well as young artists not yet established in the art world; and 4) her unwavering support of the art of minority groups, particularly women and blacks. She feels that her greatest contribution may be the latter element, and says that ''My thing has always been to raise things up that aren't in their appropriate place.'' She submits that this inclination might

relate back to her earlier choice of nursing as a profession, or possibly to her "aquarian nature." A desire to be free from the entanglements of any prevailing current persists in her expressed interest in curating a show of "...artists that I think are great, who have no galleries and aren't getting any attention. That's me, you know." She also points out that rather than writing negative things about fashionable art, she feels that paying attention to other art and artists is a more effective device. "Functioning in terms of choice, writing about things that are not necessarily mainstream...that's your basic, effective weapon."

16
Holly Solomon

Courtesy of Holly Solomon Gallery, New York.
Photo by D. James Dee, New York.

Hollis Benna Dworken was born in Bridgeport, Connecticut, in 1934, on February 12. " 'Benna' means 'good' in Latin, and I was born on Abraham Lincoln's birthday."[1] Was she then meant to be both good and honest? "Oh, Jesus, the whole pile." Among members of her family, she admired most her grandmother who owned a hotel in New Jersey. "She created a large business and became a very influential woman. She was important during the war because she harbored European war victims—a very charitable woman." Hollis Dworken kept a diary when she was a child, and in it she wrote that she wanted to be a "...very great actress and collect real oil paintings." The second of these childhood aspirations was eventually realized, at least in intent, when as Holly Solomon, she became a provocative and charming dealer and collector of new art forms.

Hollis Dworken graduated with a theater major from Sarah Lawrence, but she also spent two formative years at Vassar.

> I had a very fine teacher named Linda Nochlin—it was her first year there. Also, the head of my dorm had Calders and Arps in her apartment. She lived with contemporary art, and she was the first person that I'd ever really knew who really lived with art. I realized that we mortals could also live with contemporary work.

The link stage with art during her school years is prophetic in terms of the taste she developed for quite theatrical forms of art. After graduation, she married Horace Solomon, a manufacturer of women's hair accessories and small plastic items. They had two sons, one of whom is involved with filmmaking. The other is involved with gallery work, currently as codirector of an alternative space. After her sons had grown, she did some work in avant-garde theater and acted in a few television commercials and movies. In 1973, Solomon received the Edinburgh Film Festival Award for a film, and during the next two years she taught art history at the Fashion Institute of America. Solomon emphasized that she taught only modern art history. "Oh, God, yes! I don't pretend to be an expert. Somebody said to me, 'You don't know anything before 1959.' My expertise was limited to a certain period of art."

By the late 1960s, she and her husband had begun to collect contemporary art. Their collection spanned a two-decade period beginning with art from the 1960s. To some people, the manner in which it was displayed was controversial.[2] They lived with objects around their home and were criticized for not treating their art work with more reverence. Her taste for richness and abundance was combined with easy informal-

ity and an attitude of rather playful indifference to conventions. Criticism aside, and Solomon certainly wasn't fazed by it, she fulfilled her early dream of making art a part of her home environment and life. The Solomon's collection consisted of work by Christo Javacheff, Robert Kushner, Thomas Lannigan-Schmidt, Roy Lichtenstein, Kim MacConnel, Gordon Matta-Clark, Claes Oldenburg, Alexis Smith, Ned Smyth, and Andy Warhol. In addition to a potpourri of Minimal, Pop, Conceptual, performance, earth, narrative, and pattern or decorative art, Holly Solomon also acquired through commissions a number of portraits of herself from leading artists, such as: Richard Artschwager, Christo (she and Horace were wrapped in plastic and tied with rope for this piece), Neil Jenny, Joseph Kosuth (a conceptual piece based on her nickname Holly), Roy Lichtenstein, Andy Warhol, and William Wegman. Perhaps one of the most revealing in terms of character definition was a picture by Max Kozloff, photographer and art critic. For this piece, Solomon took a kind of provocative, odalisque pose. The resultant art work revealed something about a personality and an attitude or approach to life and work.

Solomon is in reality both saucy and piquant. For a moment her voice may be low, throaty, well-modulated, and in the next instant it can become commanding and authoritative. Her highly expressive face can melt into a warm smile for a friend or a glare directed at an antagonist. She is gamin-like in appearance, a petite woman who smokes and actively gestures with her small hands. Her blondeness is often complemented by clothes in beige tones or she may dress in mixed patterns and hues. At times, she seems to "costume" herself in an inimitably smart manner. For example, one outfit she assembled consisted of pink sweater, green skirt, a jacket with a multicolored, large plaid design, dark green knee-highs, green suede shoes, and two yellow barrettes. She conveys an impression of impertinence or impudence, a pleasure in breaking rules or thumbing her nose at convention. She is quite a fascinating person because of the manner in which she consciously combines a kind of girlish charm with professional acumen. She successfully makes informality seem chic. Her own colorful personality is quite at home within an avant-garde world, with art that is lively, unusual, and conventional.

For a time, she tried her hand at writing "concept plays," and she and her husband opened a place called 98 Greene Street where they sponsored exhibitions, poetry readings, and video and film programs. Two and one half years after closing this place, she opened a Soho gallery space in 1975. Two years later, her husband sold his business and joined her. The Holly Solomon Gallery quickly became known as a harbinger of experimental work, and her large stable of artists reflected her taste for art that was exceptional, decorative, untraditional, and at times humorous or satirical. She was not attracted by work in bronze, marble, or oil paint. Instead, she chose artists who used fabric, sequins, card-

board, wire, and all sorts of relatively untraditional materials. Mostly, the work is colorful, lively, brazen, and often cocky rather than grand. It's art that often prompts delight rather than awe, a sense of visual richness more than compositional reserve. Some of the approximately 30 artists she chose to represent are: Nicholas Africano, Laurie Anderson, Donna Dennis, Valerie Jaudon, Robert Kushner, Kim MacConnel, Gordon Matta-Clark, Judy Pfaff, Rodney Ripps, Thomas Lannigan-Schmidt, George Schneeman, Ed Shostak, Alexis Smith, Ned Smyth, William Wegman, and Joe Zucker.

Her choices have been quite varied, but possessive of a common sense of vitality, theatricality, and audacity. Anderson is known primarily for her performances that have attracted the large audiences of the Brooklyn Academy of Music and Carnegie Hall. Wegman has created photographs and videotapes starring his dog, Man Ray. Truncated architectural structures possessing romantic overtones are Dennis's forte, while Pfaff constructs whole and dramatic environments from diverse manmade and often colorful materials. Jaudon, Kushner, MacConnel, and Lannigan-Schmidt are usually related to the "Patterning and Decoration" category coined in the late 1970s. Repeatedly, Solomon's medium-sized Soho gallery was the site of environmentally-scaled installations. Her artists seemed to think of the open space as a kind of challenge, as though each was trying to outdo the other in dealing with this interior. Artist Robert Morris has probably provided the best characterization for this phenomenon. In his words, "The Holly Solomon Gallery often seems like one large Cornell box that changes every three weeks."[3] Morris accurately identifies the three-dimensional collagelike effect of these shows and the untraditional humble materials that have been transformed into precious lode. Solomon's preferences tend toward striking, often colorful and decorative imagery in art which exhibits a kind of Dadaist disregard for traditional Western conventions.

Solomon described her selections as "eclectic."

> I have no taste. Taste is dictated by the artists, and that frees me from getting involved in one style. I would hate to have a gallery in which every artist was so involved in one aesthetic. It would be so boring and so awful for me.

She was, however, quick to claim the "patterning and decoration" movement.

> I was the first person—Horace and myself—in the art world to recognize those ideas and to approve of them. I think I have a natural love of them. They're so impudent, Those artists did a great deal to allow other things to happen. They freed up everything, and they really created great controversy, so that people looked again at contemporary

work. I guess I feel rather motherly toward that area, because it is still so volatile and so disapproved of. There must be something extremely important about it since so many people are rattled and passionately opposed to it.

She felt that perhaps resistance to pattern painting and decorative art was based on its inherent attractiveness. "Curators and established people find it too pretty, too fey." With calculated candor, Solomon added, "I always thought art was supposed to be beautiful. I never thought ugly for ugly's sake was any good at all."

Perhaps it is Solomon's background in theater that causes her to readily accept new and less expensive materials. Whatever the reason, she has expressed some disgust with public hesitancy about art made from unconventional materials. She says, "I don't give a damn whether somebody uses a pebble or a sequin. I think modernism allows freedom in the use of materials." With undisguised sarcasm, she admits, "I guess there's still nothing like a real oil painting, and people really do love marble." As for imagery, Solomon emphasizes the variety of sources used by artists represented by her gallery.

Something quite interesting is the bastardization. They steal from the Renaissance, and they steal from the cafeteria—I mean the aesthetic of the cafeteria. They steal from the subway. This is part and parcel of being a human being and getting your material from anywhere you want. It's so available.

Quite in keeping with her early interest in the theater, she defends her own disinterest in realism. "Nobody cares about a mirror. I'll put on my television set and that'll be a mirror." Nevertheless, she expresses an adamant belief in her artists as a part of, or as a reflection of, their time. Certainly work by Africano, Anderson, and Wegman, though not in a naturalistic style, does possess an innate commentary on humanity and social situations. Finally, Solomon is pleased with the independency of her choices.

I must say, I'm proud of the fact that I never took what was easy. I never sold out. I've shown what I thought right to show, and I've done what I thought was the right thing for me. I've also not bothered to disapprove of what other people wanted to do. I really feel that the world is large enough and open enough so that many voices can be heard.

One of her own unilateral choices was a "Young Italian Wave" show in 1980. Her success in this venture seemed to lead to a "New Italian Art" show at the Guggenheim Museum in 1982 and to subsequent "waves" of German and French art shows by other galleries for the next three years.

I showed a French artist whom I thought was pretty good and I got no reviews. I couldn't get any kind of backing, no peer backing. So, I reasoned that to show somebody outside of New York—I'd rather introduce three young artists than one, because that way perhaps I could get people more interested in what's happening. So my notion of introducing the Italians and then the Germans was at least people are going to look at work. If you brought one German over here, forget it. No one would concentrate on it. This way there's energy and people say, "Oh, I like this," or "Oh, I hate that." Out of it all you give people some context to look at work. So, it was me who really basically decided that this was the best way to do it—out of my mistake.

The Solomon Gallery was also included in the later French "Statements" show directed by Castelli and André Emmerich. Her strategy did prove effective, at least in terms of notice, because all of these European waves received considerable critical attention. Another part of her rationale had to do with the development of "new blood" and "a new language" to talk and write about recent work. "We need young people and a vital situation."

Solomon's astute assessment of the art scene was based upon more than one encounter. She recalled that when she first opened her gallery, there was a need for a new space to show art that was not being noticed at that time.

> The art market was very poor. I thought that one of the reasons was that we needed new critics, new collectors, a whole new group of people. Because there's always rich people—thank God! The collectors of the sixties had their walls and commitments filled. We really needed a whole new audience—an explosion. The talent was certainly available. It was just not being explored or looked at. Somehow people were not concentrating in areas that I thought were extremely important. Some were deeply involved with certain aesthetics, and therefore the other aesthetic was not given a chance.

Her first experiences were not all encouraging. She opened the gallery on her own with money from some bonds her mother had given her. An initial problem was acquiring a checking account. Since she had not had one before, the bank would not give it to her without the approval of her husband and his bank. Then she had problems acquiring credit cards as a self-employed female. Also, early response to the work she showed was not particularly favorable. To illustrate this fact, she told this story.

> When I first opened the gallery, we were as poor as church mice. I mean really! To make a hundred dollar sale, we were dancing. And I learned a big lesson. Somebody had done me a very large favor, and I wanted

to repay it, so I got a piece of art, wrapped it and put a beautiful card in it. The woman called me and said, "Holly, please come and get this. I hate it." I thought to myself, "My God, I can't even give it away!"

Since then, Solomon has built up a successful and vital operation. In choosing artists, she attempts to "...make judgments that I feel will hold up over a long period of time. I look at the work and I try to determine whether that artist has ambition to be a great artist—this means stamina, concentration, strength of character, an obsession." She talks about the necessity of endurance.

It's one thing to make remarkable or interesting work when you're in the dark, when nobody likes you, your mother and father hate your work, one collector may like it, but generally people don't give a damn. Some people do important work that way. But what happens when people are really looking at you? How strong is that real commitment to work and to something important in you that has to be said?

Indeed her criteria are important for selection of individuals who will persist and evolve in their careers. In searching for new talent, Solomon estimates that she looks at 25 sets of slides per day and visits studios whenever time permits. It certainly is in keeping with her interest in turnover of new people and images to be on the lookout for young artists and work. As for those artists she has chosen, she feels that each has to be dealt with differently regarding shows and sales. She maintains that a market place influence can be negative. "The pressure on them to produce is too severe. However, it is a business, and I would never consider taking an artist on whom I didn't believe in for commercial reasons. I won't do that."

In response to negative criticism of dealers, she emphasizes the dependence of artists on their respective galleries.

I feel the only power a dealer really does have is to put up what she believes in on her walls. She also helps her artists as best she knows how—through the good times and the bad times, and the good times can be just as hard as the bad times. A dealer has the ability to make sure that there is enough money being made so that he can run his business. It's very serious. I have a great many people who depend on this situation for food! Never mind a swimming pool! We're not talking about luxury. When I opened the gallery, I only had two artists who could make a living as artists. Everybody else had other jobs. I'm rather proud that my artists are able to find support for what they do. I don't think it's possible for me to die the richest woman in the cemetery, It doesn't happen to be one of my goals. It's not that I'm against it. . . .

She points out that museums do not show work by unknown artists; therefore, dealers must do it.

> If that's where we get our power, well, hell, I can't show every artist in the world. I don't have the energy. I don't have the ability. I have to make certain choices, whether they be right or wrong, and I have to be able to support my artists and myself. I have to eat. Every penny I get goes back into this bloody gallery. Sure, I'm not suffering. I don't want to suffer.

Particularly relevant to the Solomon enterprise is the use her artists have made of available materials. She notes that, "Most of the artists in this gallery came out of poverty. One reason for the use of unusual media is that they had no money for canvas. They used whatever was possible." Solomon takes a 50 percent commission, although at times, she says, she gives money to her artists. In connection with the business aspect of a gallery, she notes the dealer's necessity to keep abreast of "...Wall Street, gold or diamonds, appliances or the housing industry. What happens to collectors is part of my life."

Among Solomon's twenty-odd artists, almost half are women, but her verbal support of women artists is less conclusive. She says, "Women in business and the professions have to understand that they have to pay a price and the price is dear. Maybe some women aren't willing to pay the price." One of her central complaints is a lack of women collectors. "If you're going to have men buy art, they're going to support stud art." In the world of commerce, she feels that the respective difficulties for men and women are relatively equal. "It's hard for men! New York is a very tough place. If you're not really working, thinking and doing all the time, there's always somebody else that'll take over." From her own personal experience, she feels that she can accomplish some things easier than the opposite sex.

> I don't have any rule book. I've made up my own rules. I mean, I'm not afraid of banks. Most men are...men...grown up men! I don't care how big or important. I know I'm not going to be given anything that I'm not willing to put up, so I don't think anyone's doing me a big favor.

Also, Solomon mentions certain women who have been influential upon her as a professional. These people are: Lillian Nassau, an Art Nouveau dealer, Ileana Sonnabend, and Paula Cooper.

Among the many facets of her business, Solomon cites selling as her "most onerous duty." Less burdensome is her pedagogical function or "giving information," and she maintains that she makes every effort to educate clients. "I like my collectors to buy out of knowledge, not out of ignorance," and for that reason she sends them to other places to look at work. One of the pleasures of her occupation is the "theme" show that she curated for the smaller of two galleries in her Soho space. "It

concentrates me and makes me and the people in the gallery think about certain issues that we feel are important."

Solomon travels a great deal, both to see what is going on in art elsewhere and to sell the art of her people. The satisfaction she gets from her position lies in working with contemporary art and artists. "It's really a joy. You put up a show, and you can feel it in the gallery. It's like a charge. You know something's happening."

As for the present and future, Solomon recently moved to an uptown location off of Fifty-seventh Street on Fifth Avenue. Her "neighbors" in the building are Grace Borgenicht, Antoinette Kraushaar, and Virginia Zabriskie. She has high hopes for the future. "I do feel that Americans are extremely visually oriented. Art suits them like television suits them. America is at the baby stage of art development, as far as collectors are concerned. It's just the beginning. That's why I opened the gallery." Regarding the relative historical importance of certain art and artists, she says of the 1980s, "We're going to see who are the footnotes, and who are the real pages." As for her own contribution, she remembers her difficulties as a young, struggling actress. "I hope that I have helped people in some small way. That somehow the tradition of courage, you know—bravery, impudence, humor, dignity—that those things will be possible. If I stand for anything that's what I would like to stand for."

17
Monique Knowlton

Courtesy of Monique Knowlton.

More often than not at the Monique Knowlton Gallery, the proprietress herself is seated at the outer desk. Contrary to the practice of most gallery owners, female or male, who stay in their back office rooms, Knowlton is frequently found close to her exhibition space. From this vantage point, of course, she can observe gallery visitors and make herself immediately available to critic or prospective client. Also, she can judge the amount and flow of traffic and assess public response to her shows. In other galleries, this position is filled by a young woman or man who reads a book or magazine or is preoccupied with records or documentation. Knowlton assumes this post from which she can inconspicuously view her gallery while making phone calls and attending to other business. Whatever her preoccupation, one senses that this dealer is completely aware of everything happening in the immediate area and that she wishes to be at the pulse of her operation.

Knowlton is a beautiful woman who at one time was a successful model. Born Monique Graevener, in Karlsruhe, Germany, in 1937, she set about becoming a French citizen at the age of 18 because ''...when the Nuremberg trials took place, I had this feeling of not wanting to be German. I was full of ideals at that time and couldn't wait not to be German.[1] Since then, she has been indifferent to nationalistic loyalties and never bothered to change her citizenship. During the course of her childhood, her mother moved the family several times to escape the dangers of war and disease. As a girl, Graevener attended a number of schools after passing a qualifying test required of new entrants. She remembered being in the first grade when ''there was very little school because there were always bombs falling and alarms. Some days you didn't go at all, or if the alarm was sounding at noon, you couldn't get back to school.'' Her parents divorced when she was nine, and for a time she lived with her father. However, ''...when you are nine and you don't have a mother in a big house with servants, you tend to do what you want and I must have become unruly because by the time I was nine and a half, I was sent off to boarding school.'' At 12 or 13 years, she developed an interest in art. ''My parents had lots of art books, so I was exposed to many artists. For instance, at this time, I was crazy about Daumier. That tough, satirical stuff appealed to me more than did reproductions of paintings by Renoir.'' Thus, at an early age, Knowlton's taste in art had begun to materialize. Later, she enrolled at the Ecole Polyglotte in Switzerland, earning an interpreter's diploma in English, French, and German. At 17, she found employment as an interpreter in France and held this job for about a year. Shortly thereafter there was a marriage, and

at 18, she had her first child followed by a second at 21. In the interim, or at 19 years, she obtained work as a model in France. Subsequently, she remarried (Hugh Knowlton) and moved to the United States in 1961. Her reasons for becoming a model were primarily financial and practical in nature.

> I never considered modeling a career—it was just a way to make money and still have time to spend with the children. To make the same amount in another job, I would have worked night and day. At that time, women didn't get jobs easily, and I didn't have any real professional training. Certainly, as an interpreter, I wouldn't have made any money at all and wouldn't have been able to take care of the children—not in the city anyway. Also, my eldest daughter, then a baby, developed meningitis. The doctors had given up her case. She recovered, but I was very concerned about her. Modeling helped to keep my mind off of her when she was ill and in the hospital.

In France, her pictures appeared in French *Vogue* and various journals. In this country, she worked for other magazines and did some television commercials. She was so successful and in demand that she was forced to limit the amount of time spent posing for "editorials" or noncommercial pictures for magazine covers. "I had so much work that I was barely able to accept one day a week of editorial which was just enough to keep my pictures on the covers of *Vogue, Harpers*, or other magazines at all times." Understandably, there were also movie offers, undoubtedly resulting from Knowlton's blonde, northern European beauty. However, she turned down these opportunities because becoming an actress was not a financially secure venture for a single parent. "I didn't think for two seconds that I had any talent anyway and, basically, I didn't want a career. I just wanted to take care of my children and myself and pay for the nurse, the rent, the doctor, and the school." Knowlton's children have played a continuously important role in her life. She had a third daughter after moving to America, however her second daughter, with whom she was particularly close, was tragically killed in an automobile accident in 1977. Three years later she gave birth to a son named Willy after her third husband, Bill Sterns, and another son in 1982. She points with pride to her eldest daughter's career as an independent producer in Hollywood and her youngest daughter's enrollment at Harvard University.

After giving up her work as a model in about 1963, she became more keenly interested in art. As early as the mid-1960s she had wanted a gallery, but her children were small and there was the problem of Saturdays ("as silly as it sounds") when the family was accustomed to drive to their house in the Massachusetts countryside. "It was really out of the question for me not to go up there. The nurse was off on Saturday and

Sunday, and at that time I had the three girls, the dog, the cat, the tur-
tles...and I couldn't just leave them." During these years, however, she
spent hours in galleries while her children were at school. One gallery
that she frequently visited was that of Antoinette Kraushaar, and
Knowlton is effusive in her praise for this prototypical businesswoman.
"She's a fascinating woman, full of knowledge, and one of the few la-
dies!" Knowlton was interested in American paintings from 1913 to 1930,
and Kraushaar's was a place where she could find this work after con-
ducting her own research on art and artists of interest to her. She
perused and studied books, old catalogues, and gallery exhibitions in or-
der to find "...whom I could still afford to buy among these people.
At the time there were plenty of them. In the sixties, almost no one was
interested in American paintings from 1913 to 1930. You could find really
major works for a few thousand dollars."

Thus, she started her collection in a manner that seemed to combine
market savvy with practical necessity. For paintings done after 1945, she
would have had to pay top dollar prices, whereas by buying out of fash-
ion or demand, she was able to pick up some real bargains. Unfor-
tunately, because of her husband's reluctance, she was not able to buy
some things that suited her taste.

> When you're in your twenties, you don't have the same nerve to do
> what you want to because it feels right to you. If someone in the family
> doesn't approve, you'll say, "Oh, well...." It took me a long time, but
> by the time I was twenty-eight or twenty-nine, I did buy several Ameri-
> can pieces because they were so reasonable that I didn't discuss it with
> him. Sometimes I was able to just buy them from leftover household
> money.

As an example, she referred to a drawing by Morris Kantor that she
bought at the Zabriskie Gallerie for $225 and was later to sell to the
Museum of Modern Art for a much larger sum. Knowlton described her-
self as possessive, and her extensive collection evolved to include work
by: Gregory Amenoff, Balthus, Robert Beauchamp, Oscar Bluemner,
Phyllis Bramson, Alexander Calder, Willem de Kooning, Alexandra Ex-
eter, Frank Faulkner, Keith Haring, Gaylen Hansen, Edward Kienholz,
Robert Lostutter, Joseph Piccillo, Betye Saar, Cindy Sherman, Robert
Smithson, and Tom Wesselman.

Another project of the 1960s was attending classes in the decorative
arts at New York University from 1965 to 1969. She received A's in
courses there with the exception of the "beginners" course which she
and a few friends avoided until they had to take it in order to receive
the certificate. According to Knowlton, the professor was a "nincom-
poop" who wrongly identified slide illustrations during the course of a
lecture. She and her friends would correct him, "...and the man really

took vengeance on us." He gave her an average grade, and when she appealed his decision, the school upheld the professor's grade. Her course work in the decorative arts did not have a direct bearing upon her eventual taste or career, but it did affect her manner of entry into the gallery business.

She began to do some interior design work and became friendly with a dealer, Serge Sabarsky, who at one time had been a designer and general contractor. Perhaps based on his own personal experience, he outlined a course for her.

> He said to me, "Listen, I know what you really like to do. You really like to spend your time in galleries and find things—discover people that nobody else knows about, shows that took place in some obscure spot, the artist that was the best one in that show—and you feel good about having found that out. Then you want to pursue it and see if his family still exists somewhere in the country and buy the work. Why don't you do it professionally?" I said, "Oh, God, no! I couldn't!" How could I? I mean, I can't tell you how difficult it seems to an outsider to be a dealer. It just seems an impossible thing to do. I'd never really sold anything, and I thought that people would laugh at me if I came and offered them things, particularly after I'd been buying from them for years.

Nevertheless, she did ease herself into a dealership. Sabarsky asked her to find things that he could sell in his gallery, and she began a private dealership later in 1973. One of her first ventures was the purchase of a drawing by Paul Klee from Knoedlers who "had nothing to do with Klee" and the sale of it through Sabarsky to some Japanese collectors. ("At the time the Japanese were buying as if there were no tomorrow.")

> It was astonishingly reasonably priced at Knoedlers because they didn't deal in Klee drawings. They didn't have any idea. So the principle was simple; first of all, choose two or three people and study them as much in depth as you can. As Serge was always saying, "If you spend six months and really delve into one artist, you'll know more about him than most dealers do in town because nobody has the time to do that kind of research."

During the course of her two years as a private dealer, another of the artists Knowlton chose was Oscar Bluemner and, as Sabarsky advised, she became an expert in his work. Her almost immediate success brought with it self-confidence. "Although I had basically no experience, I was seeing immense possibilities after six months. It was a very heady thing, because every deal that I tried really worked out." According to her, only modest financial means were necessary to undertake such an operation. "It wasn't expensive. A good Klee drawing of about 1925—an ink drawing, let's say, good size, maybe ten by fifteen, was $4,000 at auction. I

don't have time for private dealing now, but I would say the same drawing, more than fifty years later, is probably worth at least $15,000–$20,000."

When she opened a gallery in 1975, she quit dealing on a private basis because she felt that the demands of running a gallery did not allow other activity.

> You have to be on top of all the things happening for contemporary artists which means being aware of shows that are being planned or knowing that a curator is planning a show that perhaps your artist would fit into. You've got to put a lot of yourself into it. A curator may not come and say, "Who do you have that I might include in my show?" Maybe that person is new and doesn't know your artists. So you've got to do research. You can't do that if your mind isn't on it all the time.

Family concerns were not the only reason behind Knowlton's decision not to open a gallery until the mid-1970s. As she stated, the previous decade "...was not the right period for me because my taste did not coincide with that of the sixties. It was much too intellectual, much too sparse and unemotional." She found her own convictions somewhat verified by Tom Wolfe's book, *The Painted Word*.

> I just laughed, but most of the people in the art world who read it were outraged, particularly dealers who were showing the kind of work he was talking about. I said at the time, "You don't realize how much of an impact this is going to have on the average collector—particularly those who are not that knowledgeable—because they're going to feel that this is exactly what they've been thinking all along, and when they go to auction they're not going to buy these things." Almost immediately, within months after the book came out, every spare and intellectual work brought to auction did not sell, at all! I mean it was surprising how much of the work that had to be explained didn't sell anymore. I think it was the beginning of the decline of that era.

Knowlton's preference in art is for what she terms a "bizarre" kind of imagery based on comic books and American culture. She has also termed it "seductive, personal and seemingly naive." Figurative themes and a narrative suggestiveness dominates the work of artists in her stable; such as Robert Beauchamp, Phyllis Bramson, and Gaylen Hansen. Edward Larson's quilts and sculpture bear a kind of relationship to traditional American crafts and the startled, rearing, pawing horse drawings of Joseph Piccillo are Fuseli-like in their nightmarish drams. The collages and boxes of Betye Saar often convey a kind of fetish stasis within the context of modern means. The strange, bound figures of Robert Lostutter possess a content of psychological discomfort. In general, work by Knowlton's artists often does have a cartoon quality, and the imagery

and content is often disposed toward the violent aspect of comic content. Exceptional materials and techniques are utilized in the quilts of Larson and rugs by Shari Urquhart, but rare or peculiar imagery best describes most work shown at Knowlton's gallery. A recent addition to her group is Jay Coogan whose form installations have humorous connotations. Coogan and Frank Faulkner are exceptional in working with nonobjective images, but even their abstract forms suggest content. Many of these artists reside in the Mid- or Northwest. For example, Hansen lives and teaches in Washington state and Bramson is in Chicago. Regardless of subject, the work she has chosen possesses a content that is strange, peculiar, and at times, eccentric.

For a time, Knowlton felt unsure of her instinctive choices.

> I did not have complete faith in my own judgment. It takes a long time. You have to have a certain amount of success before you can say, "Well, to hell with so-and-so's critique. I really think this is good. I always felt, well, they must know better than I." If the critics are not writing about it, it must not be worth showing. Then I would simply buy work for myself. As the years went by more imagery came back, and these people really started catching on.

As critics began to pay more attention to her, artists were also attracted to her gallery. "It was like a snowball." She stressed, however, that her taste had not changed and that the same work that first drew her interest remained attractive to her. "Also, I was a little bit inexperienced and stubborn. I wanted to show what appealed to me, and if other people didn't like it, as long as the gallery survived, it was alright."

In spite of and because of her determined vision, she was able to quite rapidly establish her gallery. She said she lost a "small" amount of money ($10–$15,000) the first year, which to her was a "minor" setback. At that time, her space was a former machine shop in Soho for which she paid $200–250,000 rent each year. Soon after opening, in what she attributed to "dumb luck," critics were attracted to her shows. She decided to do a show called "Art in Boxes" in order to feature work by Betye Saar. This Los Angeles-based artist had recently agreed to show with Knowlton. In a typical example of her practical know-how, she thought of this show not only in terms of a valid theme, but as a means to promote her artist.

> I thought the way to get people to find her work as interesting as the work of Samaras, let's say, and other work that had been done in boxes, was to put her into a kind of prestigious show—prestigious because the other artists were already established. I got reviews right away.

Undoubtedly, more than good fortune beckoned a *New York Times* critic to see and write on this show twice. "Uptown collectors went down to

that tiny space. It was packed!'' Eventually, she lost her shyness about calling critics to see shows that she felt might interest them. However, she maintained that in general, ''Critics are just as independent, more so, than the artists I deal with. Critics don't write to please a dealer, but they might be attracted to certain artists attached to a gallery.''

Knowlton moved her business uptown to east Seventy-first Street where she remained until the early 1980s when she began to think about a return to Soho, in part because she wanted enough space for an adjacent home and business. (As circumstances would have it, she moved her business to Soho and her home to upstate Westchester county.) At first she had thought of buying her east side building, but the price jumped from $700,000 to $850,000 and, since space on Fifty-seventh Street was not available to her, she bought 5,800 square feet in a downtown structure. To her, the shift did not mean a loss of collectors because she felt they were in general quite knowledgeable and mobile. In this connection, she spoke of ten collectors in New York, ''...that see every show. They see every alternative space. They see every new talent show. They see everything, and they know exactly what's going on.'' In addition to mortgage, Knowlton has several other costs. She adopted a 50 percent contract basis in order to cover expenses, such as $4,000–$5,000 a month for advertising, $5,500 a year for insurance, and telephone bills of $9,000–$10,000. ''It's unbelievable. We do have to sell things.''

To Knowlton, the most enjoyable part of her occupation is ''...the time spent on finding artists and hanging their shows. When you see the artist getting established, it's equally exciting. The rest is just office work. It's promotional work.'' In this regard, Knowlton insists upon showing artists who will have a sustained career and not just attract momentary critical attention.

> Critics don't go to the studio to see whether there's several years of work behind the artist or whether the current work is an advancement over what's been shown before. A dealer has to do that. We have to find those people whom we think have staying power—and not simply assemble currently ''hot'' artists. Dealers who have done that will drop them just as quickly as the critics stop writing about them.

Knowlton prefers to show those artists who are ''very young and look promising,'' and those who have ''...a minimum of five to ten years of interesting work behind them.'' Another factor that figures into her choices is her insistence upon a singular direction. ''I totally avoid people who have ten different styles.'' She has been known to advise young artists who seem to be heading in several diverse directions to get rid of all of them except those reflecting one point of view. What she looks for in an artist is ''...not only a future, but a little bit of past, too.''

Knowlton does not feel that sex or race are issues affecting her choices of artists. Out of about twenty people, eight are women and one is black. In particular, she feels that race isn't an issue because of the fact that where she grew up there were no racial problems and she has no feelings of guilt. She considers deliberately adding a minority person to a show is also a form of discrimination. In general, she finds that she gets along better with women and that it is easier for her to work with female artists. Among people in her field, she particularly admires Kraushaar and Paula Cooper. Her theory about the large number of women art dealers has to do with the possibility of being able to individually establish an enterprise. "It's a business that women could start on their own. It is not part of a corporation where you have all the males competing for the same job. You don't have to work yourself up the corporate ladder."

Perhaps on the basis of her prior knowledge as a private dealer as well as experiences gained as a gallery owner, she gives this advice to collectors:

> The last thing to do is to follow a trend because whenever you do—it's true of anything—you always pay a maximum and you get a minimum. Unless you are the trend, unless you're the one who makes the trend, you're paying an increased price for somebody else's taste.

In her opinion, styles periodically change in the art world.

> It's a matter of things going in and out of fashion. The pendulum swings back and forth, just the way it does with conservatism and liberalism in this country. It's the same thing. A few years ago, parents were overindulging their children, and now there's a backlash. People are always overdoing things. With all the energetic work being done right now, it has to eventually go back to cooler, more reflective, more intellectual work.

Knowlton sees the present situation for art as one approaching other forms of commerce. "It's become big business. Within the last couple of years there's a trend to look at art the way people look at real estate and the stock market." She points to newsletters that list the number of shows an artist has had, how many reviews an individual has received, and what price one can expect to pay for his work presently and in the future.

Her response to intermittent but continuing accusations that dealers are interested only in profits is based not only on her experience in and appraisal of her profession, but also on her own personal motivations.

> I think they've missed the point because having a contemporary art gallery is one thing and one thing only. It's an ego trip. It isn't anything

else, because any of the dealers, no matter how pushy they are would be making ten times as much money if they dealt privately. It's infinitely easier to deal with things that are established. You have to have an eye, and you have to have studied an artist's work to know what a good piece is from a good period at a good price and, of course, you have to be careful that it is the real thing. Once you know these things, you need nothing other than time and persistence to make heaps and heaps of money compared to contemporary dealers. Do you know how difficult it is to sell something by a young artist for $500 or $1,000? People would much rather buy something for $5,000 or for $10,000. They don't know! The critics don't have a clue, and most of them would falter miserably if tomorrow they had to open a gallery. It's a liberal attitude behind thinking that all you need is good will to open a gallery. It's the ego of the person involved to see their choice confirmed by the art world. There's no question. Because I can't tell you what a "high" it gives you.

18
Pam Adler

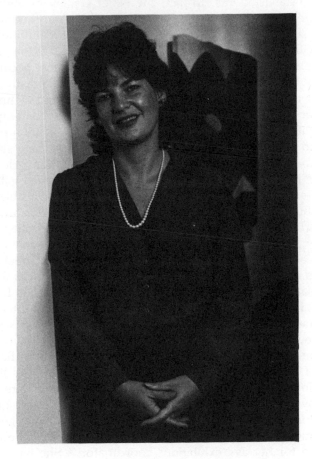

Photo by Joan Harrison, New York.

The Pam Adler Gallery is one of the most avant-garde of mid-Manhattan establishments. In fact, the Adler Gallery exhibitions have been described as a "foreign exchange" from Soho to the more recognized Fifty-seventh Street gallery area. In spite of the identification of her business with new art forms, Pam Adler has not at all followed fashionable trends in the sense of showing the season's most popular work. Rather, she has followed the dictates of her own quite distinctive taste for art that is original and fresh in form, medium, and technique.

The story of how she became a reputable dealer in contemporary art is somewhat unusual because formal training in art is not a part of her background. As a matter of fact, at one point, the last thing she wanted was to become a dealer because of their poor reputation.[1] However, in September 1978 she and Kathryn Markel opened a small gallery at 50 West Fifty-seventh Street. An architect manipulated available space so that they could share an office and have separate exhibition areas. In this location, Adler quickly attracted critics' attention to work she was showing, and by 1980, she had become successful enough to move to her own larger space across the street at 37 West Fifty-seventh Street.

Adler's initial interest in art materialized while she was working as a secretary at the Whitney Museum of American Art. Born in Larchmont, New York, in 1947, she had no childhood background or interest in art. After graduating from Hunter College with a bachelor's degree in anthropology, she was not able to find work in this field, and although she had "no real interest in art," she accepted a secretarial job at the Whitney Museum of American Art. At this time, Marcia Tucker and Jim Monte were employed there as curators, and she was both inspired and encouraged by them. In a real sense, her passion for and interest in art was kindled while working at the Whitney. Gradually, she was given an increasing amount of responsibility to the point at which a new position was created for her as "exhibitions coordinator." She termed the experience of this multifarious appointment a "great education" and held it over a two-and-a-half year period or until a new director dismissed the entire curatorial staff. By that time, however, Adler had been "...bitten by the bug of contemporary art" and was faced with the clear impossibility of working in another museum because she lacked a degree in art history. Bleak prospects aside, she decided that she did want to continue her involvement with young artists and new art in some capacity and eventually came to the realization that the only course open to her was to become a dealer, which she did, entering the profession on a private basis.

Adler called Marcia Tucker a "mentor" in terms of activating and developing her interest in unfamiliar art forms. Interestingly enough, among the staff who were discharged from the Whitney, three people went on to assume other positions of authority. Tucker, of course, distinguished herself in terms of accomplishing the monumental task of establishing her own organization; namely, the New Museum, that continues to attract considerable and well-deserved critical attention. Another Whitney secretary, Patricia Hamilton, instituted her own gallery on West Fifty-seventh Street. All three women, Adler, Hamilton, and Tucker, were concerned with contemporary art, and Tucker lead the way in terms of knowledge, experience and accomplishments. She continued in an amplified and concentrated manner to emphasize new art by young artists in her museum, while Adler and Hamilton established commercial galleries.

After leaving the Whitney, Adler used the interim of private dealing to ascertain what work and which artists she would like to handle.

When I started out, I went to a lot of studios. I saw work by hundreds of artists and put together a portfolio of work based on gut-level reaction. I used that time to see what kinds of relationships I developed with these artists, to see how the work held up for me over a period of time and to assess the reactions I was getting from other people, not only in terms of sales but verbal responses.

Adler worked out of her apartment for two years until she felt a need for a "public" space. By the time she actually opened a gallery, she had in mind 13 artists with whom she could work and whose art had attracted her and seemed to stimulate other people.

Assembling some family money, she chose to open with Markel on Fifty-seventh Street after looking at property in Soho. She found that she preferred the aura of Fifty-seventh Street and has continued to be content with her uptown location.

I didn't like the feel of Soho. I didn't like the circus atmosphere of it, the street activities that go on down there and the crowds of people. I thought that 57th Street was more stable. I liked the atmosphere better and felt more comfortable here.

Adler's father had established his own business and was excited about his daughter's enterprise; however, he couldn't understand the necessity of an initial cash outlay for space since he hadn't even rented a place until he had a contract. In spite of his objections, Adler forged ahead and managed to initiate a business that almost immediately became known for its attention to quality art.

In Adler's own words, "I am very interested in work that has tex-

ture and dimension." During the 1980 season, she put on an exhibition that she called "Between Painting and Sculpture," and much of the work she exhibits fits into this broad arena. She does show paintings on stretched canvas and some figurative work, but most of the artists associated with her gallery are involved with abstract, relieflike forms. Cynthia Carlson, one of the best artists represented by Adler, has used pigment to make designs directly on the wall in all-over designs that have been described as "wallpaper." The patterns are three-dimensional and project at least one quarter inch from the wall. Another artist who works directly on the wall is Don Dudley, but his imagery is angular and geometric in comparison to the organic, curvilinear forms of Carlson. Jeff Way's painted subjects are often adapted from popular subjects, such as Elvis Presley, while Jack Chevalier's constructions evolve from the influence of American Indian art. Small, figurative vignettes that project from the wall describes work by Ira Joel Haber, and Brenda Goodman uses wire and gauze to create her stagelike boxes. Subsequent additions to the Adler Gallery have been Charles Clough who utilizes both painting and photographic processes to create large abstractions from paintings of past periods in art history. Barbara Zucker's painted constructions demonstrate her early and consistent advocacy of color in sculpture. Considering Adler's bent toward work that exists between painting and sculpture categories, Zucker's work is a logical choice. Before opening her gallery, Adler represented Bill Jensen, and she regrets his decision to exhibit elsewhere. According to her, "He's one of the best painters around." In general, the work she does exhibit is reflective of her particular taste for innovative forms and methods of creating art. Although she feels her current stable is complete at 13 people, she does introduce new talent via a spring invitational show and at times accepts work on consignment so that she can have some time to formulate her feelings about it. Her own collection consists in part of: an early drawing by Dennis Ashbaugh, a Cynthia Carlson ceiling installation, another installation by Don Dudley, a piece by Rodney Ripps, and paintings by Bill Jensen and Judith Murray.

In opening a gallery, Adler felt that she could, "bring something fresh to it, because I had not studied art or worked in a gallery. I wanted to bring some new things to people's attention. Certainly the fact that I have no formal training in art has some bearing on the type of art shown in my gallery. As a dealer, she feels that her function is to provide an exhibition space for art that she perceives to be important and to dispense information on and promote the careers of the artists she represents and exhibits in her gallery. In general, her exhibits have attracted critical favor, and she is pleased with the amount of coverage her artists have received in arts magazines and weekly newspapers. At times, she also initiates magazine articles.

Usually when I do that it's with critics who are just starting out, and they're looking for things to review. Often I've gotten their first full-page article in *Arts* magazine, for example. It's also very satisfying to start a young critic on his or her career.

Adler has resisted showing market fads in favor of her commitment to the artists she has agreed to represent. She feels that within the last couple of years, there has been too much concern with promoting artists. "Lately, there seems to be a tremendous amount of hype, and that's very discouraging to me. There are real publicity pushes to get artists into the limelight. A lot of that comes from dealers, but in many cases it also comes from the artist," Part of the dilemma is the necessity for sales to remain in business. Adler points to the present-day situation as it contrasts with that of the past when some dealers were wealthy enough not to have to depend upon gallery income. She feels that the more recent conception of a dealership as a business venture has lead to dealers' greater concerns with art as a commodity.

You have to pay the bills, and I think that a lot of galleries, with that in mind, are leaning toward art that has a modish appeal. It's unfortunate. The art world has really become very much like the fashion world. So, if somebody is doing work that is very high quality, but it's not in style, it's difficult for that artist to find some place to show it.

She notes that in some cases artists are influenced to direct their work to suit a certain trend or that dealers may attempt to influence artists to do so. In some cases an artist may decide to do a different type of work that may not suit the dealer. Adler does not want to intervene in her artist's development. A case in point was Cynthia Carlson's 1983 exhibit that consisted entirely of paintings of insects—certainly a change from her overall wall designs. Adler has no contract with artists; she feels that as an artist's style changes to the point of diverging from her particular preferences that the artist's best course is to leave the gallery. As she sees it, in order to market the work, she has to believe in it. No matter how high the quality of a given type of art, if it doesn't suit her taste, she cannot sell it. Her own solution to the problem of artists being influenced by sales or market trends is to advise them to seek another income.

Artists have an idea that they'll get in a gallery, that their work will sell and that they can live off their work. It doesn't happen very often. I try to tell the artists they should not make their work with the idea that this is going to be their living, but that they should somehow work out a way to make money other than creating art. They should make art without any influences on them in terms of what they think will sell, because often they don't really know what's going to be marketable.

On the whole, Adler is comfortable in and pleased with her profession and the people in it. She speaks of a "wonderful camaraderie" within a profession that might appear to be and undoubtedly is highly competitive. Another facet of this vocation is the personal relationship that exists between dealer and client. Adler says "It's a very social world; there are many social activities. It's more personal than other kinds of businesses."

Without hesitation, Adler admits that there have been times when art sales have been down, adding that most dealers will maintain to the contrary in order to keep business from getting worse. Her assessment of the situation centers around a criticism of too much promotion in some cases and resultant feelings of bewilderment among collectors.

> The best way to sell art is to have a show that's sold out. If work isn't selling, then people feel that there's something wrong. There are very few people who buy art just because they like it. They buy it for investment purposes. They buy for status. They follow the crowd. The collectors become confused, because they feel that there is a lot of hype going on, and they don't know where to turn. They don't know who to believe. They don't trust themselves, so they don't buy.

Adler feels that time will determine whether or not certain vogues will prove to be lasting influences.

> If the Italians and the Germans hold up in the eighties, or whether they're a "flash in the pan" will determine to a large degree the influence of galleries and critics. If they do persist, then those people will continue to set the trends. If they don't remain popular, it will create an incredible amount of uncertainty, but hopefully people will go back to themselves and decide what they want based on their own instincts.

Adler is a young, soft-spoken dealer who is relatively new to the business, but she like all the others, male or female, is dependent upon her own taste and ability to distinguish important work. "I think the best way to learn about art is to look at a lot of work, and eventually you develop an eye not only for what you like, but also for quality." She wants to see her choices verified in time. Undoubtedly, she speaks for every gallery owner when she says, "I would like to be remembered for being the dealer who was first to present these artists, because I believe that they are all important. Also, I would like to have a reputation for having a good eye for new work, which I think I do."

19

Barbara Gladstone

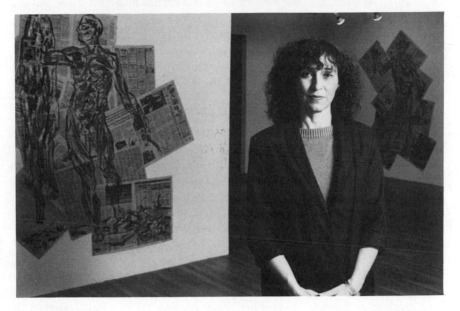

Photo by Jozee Oppee.

Barbara Gladstone entered the gallery business relatively recently, or in 1978. At the time, she was in her early forties and had three grown sons, so she was a woman who began a career in early mid-life. Like others of her peers, Gladstone's primary interest became adventurous work by young artists. Part of her motivation in becoming a dealer was a desire to proselytize and educate people on the topic of contemporary art. Within an amazingly short period of time, her business became a highly successful venture.

Born Barbara Levitt in Philadelphia in 1935, she remembered no particular family interest in art. However, at a later date, after she had become involved in art, her parents began to buy paintings for their new retirement home in Florida. Gladstone offered to advise them on their purchases, but her mother chose things on her own. Gladstone pointed with pride to the fact that the first thing her mother had acquired by herself was "the most incredible Joan Mitchell painting."[1] Barbara Levitt left college to marry Elliot Regen and raise three sons, but by the time her youngest was five, she was beginning to take classes again. She had moved to Long Island from Manhattan and began to visit museums as a part of a kind of syndrome involving the suburban housewife's day in Manhattan. These excursions whetted her appetite, and she began to buy catalogues in order to pursue the topic. At 18, she had traveled in Europe visiting Florence and the Uffizi Museum. She recalled being "astounded," and knowing "...that I was in the presence of something that was incredible, but it didn't really touch my life enough to make me inquire about it."

In college her major was political science, but when she began to think about returning to school, she "...no longer cared about changing the world or thinking it was possible or even caring very much. At that point, I began to feel that personal knowledge and personal satisfaction were the only things that were really going to be important to me." She did not, however reenroll in college with the intention of studying art.

> I took art completely by accident, because it was given at the right time. My son was in a car pool. It was one of those things that women did at that time—everyone else's needs came first. I had two hours on Tuesday and Thursday, and when I went to school to enroll, there was an art course given at that time, so I took it. I remember within two weeks, everybody in the house could be half dead with some rare disease, but I was getting to class no matter what else happened. It began to satisfy me in a way that I never thought was possible.

At that time, she attended nearby C. W. Post Center Long Island University, supplementing her class work with reading at home. Within a short period, one of her professors advised her to go to Hofstra University where she could choose from a greater number of art history courses. Later, she described her feelings about art and about reentering college as an older, more mature student.

> I felt I was almost self-educated. My reading extended far beyond whatever courses I took because I had this thirst. Later, when I was teaching, I discovered that when many women go back to school, it's the one thing they've done for themselves after ten or fifteen years of never committing a selfish act. As a result, you become so possessive of it. It's like being a junkie. You can't get enough, you can't do enough. I couldn't buy enough books. I couldn't see enough. When I was at college before, I had a social life. I had all kinds of things that diverted me. Later, I was very single-minded. I mean, there was nothing on my mind except learning as much as I could. I had found this thing that I could study for my entire life and never finish, never feel that it was over, that there wasn't more to learn, that there wasn't more that was exciting. There was so much that was unexplainable because words could only go so far. I would look at something and it was magic. There was nothing anyone could do to make it less.

Barbara Regen earned first a B.A. (1968) at Hofstra and then a master's degree (1970) in art history, specializing in architectural history. Subsequently, she was made an instructor of art history and modern architecture, a post she held at Hofstra from 1971 to 1975 when a variety of factors caused a cutback in staff. She left her position with regret for what she considered a fulfilling experience. "I loved teaching! I loved it! I loved turning somebody on, introducing them to something. I liked that part much better than I did the endless hours of research. To me, that was tedious and difficult." So when she found herself out of work, Gladstone decided that something "more actively involved" would be better for her. Contemporary art seemed a possibility, but her knowledge was limited to prints. These were affordable to her, so she bought a large inventory of prints by recognized artists and began to deal on a private basis. It wasn't long, however, before she became dissatisfied with this endeavor.

> People who wanted to buy them knew all about them. They wanted a particular Hockney, a particular Johns. It was like selling meat to me. What mattered in dealing with blue chip things that were readily saleable was whether or not you could find buyers. That's the skill in it, not picking the art. It's already been decided which are the best images. I found it wasn't very interesting, and that it didn't have much to do with art. Often the people who were buying never even looked at them.

They had seen it already and knew they wanted it. So you put it in a tube and sent it to them. It wasn't getting a chance to teach!

At that point, she decided to take on work by younger artists. Within a short time, she and the artists realized that no one was able to see the work that she sold from her home. Her experiences as a private dealer led her to the discovery of what it was that she wanted to do with her life. "I realized that I enjoyed working with living artists, especially younger ones, and bringing the message to other people, convincing them to see what I saw in this new work." In general, then, her motivation was prompted by two interrelated factors; namely, an urge to educate and, second, a wish to be a harbinger of culture. Both incentives were a part of the accepted norm of women's place within a patriarchal scheme of things. However, in realizing her aims, she challenged the restrictions of this traditional female role.

In October of 1978, Barbara Gladstone (she had recently remarried) opened her first retail space at 38 East Fifty-seventh Street in a tiny area of the building that she devoted to works on paper. Her choice of medium and correspondingly smaller size was a venture that appeared quite innovative among other galleries dealing in media geared to large-scale works. But at the time, there was considerable enthusiasm for paper works on the part of artists and collectors. Of course, there had been other galleries that sold prints, but mostly these had been associated with bookstores or their offerings were historical in nature. A bona fide gallery devoted to prints and drawings encouraged artists who had worked in these areas for years and stamped the medium with a kind of commercial seal of approval. Heretofore, printmaking and drawing had suffered from neglect and a stigma of secondary or even incomplete status. The notion of drawing, for example, as a preliminary and not a finished product persists to the present.

A part of her concern involved commissioning prints from artists, and Gladstone particularly liked the "collaboration" aspect inherent in publishing a print.

> Often it was my idea to choose a particular artist, to propose they do this print, to commission it and to find a printer and bring the two of them together. It's almost like giving birth to something that didn't exist before. Whereas a painting delivered to the gallery by an artist—it's wonderful, but it's less participatory for me.

After two years in this operation, she realized that the artists who appealed to her also made paintings or other objects that could not be shown in her small space. "So, at a certain point, I realized that what I really wanted in addition to publishing prints—which I still liked—was

to be able to show and represent a group of artists—a classical gallery situation."

Thus, a second Barbara Gladstone appeared in a larger space across the street at 41 West Fifty-seventh Street in 1980. Originally, she purchased her first print inventory with money from an insurance settlement on a fire in her house. The prints she sold from the collection enabled her to open a gallery. Sales at this place allowed her to establish a larger space and to take on a comprehensive dealership. Eventually, she moved her enterprise to even larger quarters in Soho. As she put it, "The business brought on the changes." She noted that even when she started, "I didn't want to have backers. I didn't want a big financial burden. I didn't want to be responsible to anyone." In a relatively short period of time, her business grew in proportion and reputation. Of course, her choice of artists and the critical acclaim their work received had much to do with her almost immediate success.

Today, her medium-sized stable of 15 artists consists of people who are doing avant-garde work in a variety of media and styles. She shows huge figurative paintings by Bernd Zimmer, an artist who has been associated with the German Neo-Expressionist grouping, along with the tiny, intricate machines fashioned by Kathleen Thomas. Vernon Fisher's large-scale pieces occupy a position somewhere between narrative painting and installation. Fisher's work is satirical and somewhat hermetic in content, in contrast to the more politically assertive images of Mike Glier. Hollis Sigler's subliminal and vulnerable women's stories seem in opposition to Miriam Schapiro's colorful affirmations of imagery and materials associated with women. Certainly, the patterned designs of Joyce Kozloff manifested in the form of ceramic tile are different from the more expressionist aura of painted reliefs by Annette Messager, who was at one time a part of her stable. Many of her artists—Zimmer, Fisher, Sigler, Thomas, and David Middaugh—had their first New York shows in her gallery. Others, such as Schapiro, Grossman, and Kozloff came to her with well-established reputations. In an overview, diversity is a distinguishing feature characterizing the Gladstone Gallery offerings, along with a somewhat audacious sense of individual course or aspiration.

In particular, Schapiro has been a friend and mentor to Gladstone. Gladstone credits this artist with having been an "inspiration" to her when she first opened her works-on-paper gallery with a show of Decorative art.

> I was very nervous about opening the gallery because I didn't know what was involved. I went to Miriam's and had a conversation with her. She gave me great confidence because she said, "You're going to be very good. I can tell. I have a lot of faith in you, and I'm very seldom wrong." When I left there, I was three feet off the ground! I thought, "Well, if

she sees it, maybe there's something there, maybe I can live up to this image she has of me.'' I felt elated and that maybe I would be more effective than I had dared think.

Although Schapiro is mature in terms of her work and her age, Gladstone quite rightly considers her ''. . . one of the young ones because she underwent a renaissance and because she's changed so radically. To me she's very young.'' It is Schapiro and other artists who often recommend new work to her. ''I really think it's the artists who know the good work and who are exposed to it. It's very easy for dealers to become isolated because of the nature of doing business that keeps you out of artists' studios unless you specifically set aside time to go.''

When she does take on the work of an artist, she does not place them under contract. Her terms are a 50 percent commission that she uses to achieve wider exposure for the artist. ''It means a more beautiful announcement, a certain kind of lavishness in ordering slides, transparencies, and having all kinds of press material available for scholars.'' The prices she places on artists' works are dependent upon other factors than simply gallery sales.

> Prices of work don't come from out of the blue. An example might be Hollis Sigler whose first show I had in 1979. She was making drawings that were selling for $450. Then she was in the Whitney Biennial, a large show at the Walker Art Center in Minneapolis, a survey of American painting in Jacksonville, Florida, and she had a one-person show in Florida. She had a lot of curatorial support, and a number of articles were written about her. In 1980, her paintings and drawings rose in price to $1,500. The fact that later her paintings sold for $5,000 was supported by a broadly-based interest.

In 1980, business was ''booming'' for Gladstone, and she was in the enviable position of having to turn people down rather than seeking clients. In actuality, some artists were not terribly prolific; for example, that year Sigler produced only nine paintings. But this was not the primary reason behind Gladstone's favorable status in the art market. ''Her'' artists were appealing to the public on several levels, including critical, curatorial, and patronage bases. The print business was also successful; however, she incurred complex financial and archival work as well as monetary profits. She explained, ''If you have an edition of fifty or sixty prints, it meant keeping track of fifty records, packing, shipping and selling them all.'' At some point, she would like to have additional employees to complete these bookkeeping tasks. In 1980, she hired Alan Schwartzman to direct the gallery and eventually involved him in aesthetic decisions on what work was to be shown in the gallery. Three years later, she engaged Richard Flood to fill this position.

In assessing her own taste, Gladstone, like many of her peers, judged it to be eclectic.

> I never responded particularly well to the kind of didacticism that I thought was dominant in the early part of the seventies when Minimalism pervaded, when there was one established mode and most of the serious criticism and so-called serious art followed in that same vein. I don't like that kind of situation. I like it when there are more choices.

In generalizing about the style of all her artists, she felt they were all "anti-Minimal."

> This kind of work (Minimal) attested to a type of mental or intellectual superiority that intimidated everybody. It was a kind of control. It almost told you how to live, and I'm not willing for that to happen. I'm in favor of a much more personal, subjective kind of existence for everybody. I like eclecticism or a situation in which collectors don't feel that they're wrong if they buy what they like.

For herself, Gladstone has purchased work in a variety of styles. The first work she bought after she "woke up" to contemporary art was one by Nancy Grossman. Since then her collection has grown and continued to attest to her broad taste as it consisted of a photograph by Cindy Sherman, a painting by Chicago artist Russell Warren, and work by Nicholas Africano, Steve Kiester, Rodney Ripps, and Robert Zakanitch.

Gladstone's selections of work for her collection and for her gallery has included people living outside New York City. Zimmer resides in Germany, Fisher is from Texas, Sigler lives outside of Chicago, and Anish Kapoor is from India. She feels that "...out-of-town artists need to be represented in New York," but laments the fact that she cannot be with these artists more on a friendly basis and professionally to see work in progress.

Among the artists represented by her gallery, Miriam Schapiro and Joyce Kozloff have been staunch advocates of feminist concerns. Gladstone, however, had her own opinions on the course of feminism.

> I think that part of the movement is individual responsibility, that once certain things have been opened up, one has to take care of one's self and that that's a realization everybody has to have. Certain inroads having been made, I think it's time for people to move on to a more personal kind of achievement. I think that's the end result of feminism. I don't think it's necessary to be militant forever.

She did, however, recall instances of chauvinism in the course of her former career as a teacher.

Once I was passed over for a full-time position by the chairman of the department because there was a young man whom he thought needed the money more because he had just gotten married. That just killed me. And at one time, I had two adjunct positions. I was teaching at Hofstra and at another Nassau County facility where I had to be observed once every semester by members of the faculty. The first line of their evaluation was "Mrs. Regen is a very attractive and intelligent professor."

At first she was "infuriated," but she has since decided to use her sex and its stereotypic attributes to her own advantage.

There's a foreign dealer who comes to New York about twice a year and he's absolutely frightening. He must be sixty-five, he's very northern, and he always tries to strike an unfair bargain from my point of view. So I always get sort of delicate and weepy in front of him, which isn't me at all, but he always falls for it.

Gladstone is an attractive, vivacious woman in her late forties who looks younger than her age. Her image in terms of hair style and clothing matches a vibrant personality. In her husky, throaty voice, she readily reveals her age because "I have these enormous children which sort of gives the story away. They're all six feet tall." One of her sons is a graduate of Skidmore in art history and may enter the art field. In answer to a question of whether or not she might want him to join her in the gallery, she replies,

Never, never! It's very easy really to become a dealer. All you have to do is want to be one, and I think that every gallery bears the stamp of one person's taste. There really isn't room to advance very far within someone else's gallery. I think if that's what he wants to do, he should do it by himself.

Reflected in these words is her own independent spirit that sustains her support for contemporary work that evades the market as well as categorization. For example, she is enthusiastic about artists like Christov Kohlhofer.

He's an incredible artist. Incredible! It's an almost impossible proposition to show his work in a commercial gallery because the nature of the objects he makes are difficult to sell to all but the most adventurous collectors. He had a show in Pennsylvania at the Philadelphia College of Art entitled *Ali Baba and the Forty Thieves*. It consists of portraits of the forty presidents of the United States done on towels that were taken from hotels throughout the country on a bicentennial trip he took in 1976. He had this show on his mind. It's fabulous, but I mean for some-

one to buy a portrait of a president that's painted on a Howard Johnson's bathmat (laughter) or from some motel in Tijuana is almost unthinkable. It's extraordinary work! Extraordinary!

She is fascinated by art of this type and feels that,

> The only reason to be in this business with living artists is to make something possible that might not otherwise be possible. There are lots easier ways to make money. I'm sure of it. To present young artists whom we believe in and no one else really knows about is difficult, chancy and really in the nature of gambling.

Obviously, Gladstone enjoys and is thriving on such risks. Another pleasure for her is curatorial work that allows her to show work by artists other than those associated with her gallery. "I love to do idea shows. It's great fun for me." Exhibitions that would come under that category were "Parafunction" which she did in 1982 and "The Crucifix Show" of 1982. Both exhibits included work by artists from other galleries.

> There are not fifteen artists in the world who are the epitomy of all creative output. It's as if every gallery dealer is only supposed to recognize those artists whom they represent. As if you couldn't for a moment acknowledge that there were other good artists. I think that's foolish.

Gladstone, like several of her colleagues, has come to realize the advantages of showing artists associated with other galleries.

She does, however, expect a return from her faith in the artists she chooses to represent and exhibit in her gallery.

> I think most people, given today's world, are not going to put so much energy into something if they're not going to be successful at it. One's self-respect is at stake. I think most people expect that their efforts are going to pay off. I do expect to have a successful business, otherwise I wouldn't do it. I simply wouldn't. It's too much energy, too much time. It's almost seven days a week and many nights. It's not a nine-to-five job.

Gladstone counts on her artists to "fulfill the promise" that she saw in them and wants them to attain critical and curatorial attention that will create a support system. She would like their reputations and the prices of their work to rise gradually, based on more than retail values. "I believe that certain dealers can make anybody buy anything, but if it isn't supported by people who are not profiting from it, then it means nothing." To her, the gallery system requires a broad base in order to function at a high level. Generally, she is confident that galleries do fulfill needs felt by artists as well as the larger art world.

I think it's a very effective filtering system. If every dealer takes some-one on and supports their work, it's because the artist is good enough to merit this effort on their behalf. It's a good screening system. There are so many galleries that clearly there's much to choose from. I do feel that the system works. I believe that all the good work finds a home. If someone is not represented year after year, then it's probably because aesthetically they are not up to somebody else's standards. There are too many good galleries for an important artist not to be represented by one of them.

Of course, it can be argued that the proportion of galleries in rela-tion to numbers of artists is small and that new art may not necessarily suit the taste of a gallery owner already comfortable in an established business. Nevertheless, this does not deter Gladstone's enthusiasm for her profession. It has and will probably continue to satisfy her. Her vigor in sustaining a position in agreement with her interest in "unthinkable" art or that which eludes dogma shows no signs of abatement. As she remarked, "Things have happened. Wonderful things!" And undoubt-edly she will continue to make them happen along the subjective lines of her personal assessment of aesthetical values.

NOTES

1. EMILY GENAUER

1. Unless otherwise indicated quoted statements were made by Emily Genauer during the course of interviews conducted by the author on December 12, 1981, and October 12, 1983.

2. Emily Genauer, "New Horizons in American Art," *Parnassus* 9 (October 1936):207.

3. Emily Genauer, "Young Painters in the East," *Parnassus* 9 (April 1937):16–19.

4. Emily Genauer, "Paris Comes to Main Street," *Independent Woman* 16 (October 1937):318–19.

5. Emily Genauer, *Modern Interiors Today and Tomorrow; A Critical Analysis of Trends in Contemporary Decoration as Seen at the Paris Exposition of Arts and Techniques and Reflected at the New York World's Fair* (New York: Illustrated Editions, 1939).

6. Emily Genauer, "Questioning the Met? Hearn Fund Purchases," *Art Digest* 14 (September 1, 1940):8–9.

7. Emily Genauer, "Fur-Lined Museum," *Harper's* 189 (July 1944):133.

8. Emily Genauer, "Public Be Damned; Art Popularity Polls, *Art Digest* 20 (September 15, 1946):7.

9. Emily Genauer, "Your Children and Art," *House and Garden* 110 (September 1956):38–40.

10. Emily Genauer, "H. R. 452: Federal Sponsorship," *Art Digest* 27 (July 1953):22.

11. Emily Genauer, *School and the Fine Arts: What Should Be Taught in Art, Music and Literature?* (Washington, D.C.: Council for Basic Education, 1966).

12. Emily Genauer, "Coming to Terms with the New Art," *House Beautiful* 109 (April 1967):183, 209.

13. Emily Genauer, *Best of Art* (Garden City, N.Y.: Doubleday, 1948).

14. Emily Genauer, "Is There an American Style in Art?" *House Beautiful* 93 (June 1951):92–93, 161–63.

15. Emily Genauer, "Purpose of Art in Our Time," *Art in America* 49 (1961):27.

16. Emily Genauer, "The Night the Bubble Burst," *New York Herald Tribune Magazine*, February 14, 1965, pp. 7, 31.

17. Emily Genauer, "Painter Enters the Poets' Wasteland," *New York Herald Tribune Book Review*, November 28, 1954, p 20.

18. Emily Genauer, "A Visit with Marin, Celebrating 81st Birthday with New Exhibition," *New York Herald Tribune*, January 6, 1952, p. 6.

19. Emily Genauer, "Reviewer Says 'Yes' for Cézanne," *New York Herald Tribune*, August 16, 1953, p. 5.

20. Albert M. Frankfurter, "Is There a Gentleman in the House? Dondero's Attack on Artists," *Art News* 48 (September 1949):13.

21. Emily Genauer, "Still Life with Red Herring," *Harper's Magazine* 199 (September 1949):88–91.

22. Emily Genauer, "Art and Artists: New Galleries," *New York Herald Tribune*, October 11, 1953, p. 5.

23. Emily Genauer, "The Myth of American Provincialism," *New York Herald Tribune Magazine*, October 24, 1965, p. 51.

24. Emily Genauer, "Three Centuries of American Painting," *New York Herald Tribune Magazine*, April 4, 1965, p. 30.

25. Emily Genauer, "Isms and Schisms—A Survey of Seven Decades," *New York Herald Tribune Magazine*, April 24, 1966, p. 38.

26. Emily Genauer, "Duchamp—Pop's Granddada," *New York Herald Tribune Magazine*, January 24, 1965, p. 32.

27. Emily Genauer, "Chicago Art Story," *Theatre Arts* 35 (July 1951):28.

28. Emily Genauer, "Soup Cans Going Back on the Shelf," *New York Herald Tribune Magazine*, September 12, 1965, p. 39.

29. Emily Genauer, "Now It's Pubism," *New York Herald Tribune Magazine*, May 2, 1965, p. 37.

30. Emily Genauer, "Leonardo and the Stain," *Newsweek* 90 (December 12, 1977):27.

31. As quoted by John Wesley English in *Criticizing the Critics* (New York: Hastings House, 1979), p. 187.

32. Emily Genauer, "Critical Look at the Art Critic," *House and Garden* 111 (April 1957):60.

33. Emily Genauer, "Critics' Anxieties," *New York Herald Tribune Magazine*, January 3, 1963, p. 25.

34. Emily Genauer, "The 10 Greatest—It Says Here," *New York Herald Tribune Magazine*, July 25, 1965, p. 27.

35. Genauer, *Best of Art*, p. 81.

2. MARIAN WILLARD

1. Unless otherwise indicated quoted statements were made by Marian Willard during the course of interviews with the author on October 22, 1981, and September 10, 1982.

2. Will Grohmann, *Paul Klee* (New York, Abrams, 1967), p. 2.

3. Stuart Preston, "Art: A Gallery's Review: Willard Exhibits Works of Artists It Introduced in Its First Twelve Years," *New York Times*, January 6, 1962, p. 41.

3. KATHARINE KUH

1. Unless otherwise indicated quoted statements were made by Katharine Kuh during the course of interviews conducted by the author on October 24, 1981, and October 19, 1983.

2. Katharine Kuh, "Seeing is Believing," *Chicago Art Institute Bulletin* 39 (April 1945):53.

3. "Interpreter Kuh," *Newsweek* 39 (February 25, 1952):60.

4. Katharine Kuh, *Art Has Many Faces, The Nature of Art Presented Visually* (New York: Harper, 1951), p. 335.

5. Katharine Kuh, "Four Versions of Nude Descending a Staircase," *Magazine of Art* 42 (November 1949):265.

6. Katharine Kuh, "Chicago's New Collectors," *Art Digest* 26 (May 15, 1952):5.

7. Katharine Kuh, "The Midwest—Spearhead Chicago," *Art in America* 42 (Winter 1954):32–39.

8. Katharine Kuh, "Fernand Léger," *Arts and Architecture* 70 (May 1953):29.

9. Katharine Kuh, "Grandma Moses," *Saturday Review* 43 (September 10, 1960):45.

10. Katharine Kuh, "Why Wyeth," *Saturday Review* 51 (October 26, 1968):26–29.

11. Katherine Kuh, "The Painter Meets the Critic," *Saturday Review* 43 (July 2, 1960):31–32, and Kuh, "Conclusions from an Old Cubist," *Art News* 60 (November 1961):48–49.

12. Katharine Kuh, *The Artist's Voice; Talks with Seventeen Artists* (New York: Harper and Row, 1962).

13. Katharine Kuh, "Art in America in 1962, A Balance Sheet," *Saturday Review* 45 (September 8, 1962):30A, D.

14. W. McQuade, "First National of Chicago Banks on Art," *Fortune* 90 (July 1974):106.

15. Katharine Kuh, "Mystifying Maya," *Saturday Review* 52 (June 28, 1969):17.

16. Katharine Kuh, "Circuitous Odyssey of Irish Art," *Saturday Review* 51 (March 23, 1968):25–31, 60.

17. Katharine Kuh, "Art That History Shaped," *Saturday Review* 49 (January 29, 1966):17–24.

18. Katharine Kuh, "Alaska's Vanishing Art," *Saturday Review* 49 (October 22, 1966):25–31.

19. Katharine Kuh, "An American Critic Reports on Art in the Soviet Union," *Saturday Review* 46 (August 24, 1963):17–26.

20. Katharine Kuh, *Art in New York State, The River: Places and People* (Buffalo, N.Y.: Albright-Knox Art Gallery, 1964).

21. Ibid.

22. Katharine Kuh, *Break-up; the Core of Modern Art* (Greenwich, Conn.: New York Graphic Society, 1965), p. 11.

23. Katharine Kuh, "Still, the Enigma," *Vogue* 155 (February 1, 1970):218–19.

24. Katharine Kuh, *The Open Eye; In Pursuit of Art* (New York: Harper and Row, 1971), p. 233.

25. Ibid., pp. 221–22.

26. Katharine Kuh, "The Vision of Hilla Rebay," *New York Times*, May 7, 1972, p. 21.

27. Katharine Kuh, "Beyond Function and Form," *Saturday Review World* 2 (November 16, 1974):38–39.

28. Katharine Kuh, "Guide for the Guileless Bidder," *Saturday Review World* 1 (April 6, 1974):45.

29. Katharine Kuh, "Degas: 'The Reluctant Impressionist,' " *Saturday Review World* 2 (October 5, 1974):46.

30. Katharine Kuh, "The New Art and Its Collectors," *Saturday Review World* 1 (December 4, 1973):38.

31. Ibid.

32. Katharine Kuh, "Can Modern Art Survive Its Friends?," *Saturday Review* 43 (March 12, 1960):16.

33. Ibid.

34. Katharine Kuh, "A Note on Art Criticism," *Saturday Review* 43 (December 24, 1960):33.

35. Ibid.

4. ANTOINETTE KRAUSHAAR

1. Unless otherwise indicated quoted statements were made by Antoinette Kraushaar during the course of interviews with the author on September 25, 1981, and October 18, 1983.

5. BETTY PARSONS

1. Unless otherwise indicated quoted statements were made by Betty Parsons during the course of an interview conducted by the author on October 9, 1981.

2. Lawrence Campbell, "The Ray Johnson History of the Betty Parsons Gallery," *Art News* 72 (January 1973):56.

3. Ibid.

4. Calvin Tomkins, "Profiles, A Keeper of the Treasure," *New Yorker* 51 (June 9, 1975):60.

5. Grace Glueck, "Art Notes: Last of the Big-Time Internationals," *New York Times*, March 23, 1975, p. 31.

6. Ken Kelly, "Betty Parsons Taught America to Appreciate What It Once Called 'Trash' Abstract Art," *People* 9 (February 27, 1978):83.

7. Ibid., 85.

6. DORE ASHTON

1. Unless otherwise indicated quoted statements were made by Dore Ashton during the course of interviews conducted by the author on October 22, 1981, and October 25, 1983.

2. Dore Ashton, "Afro," *Art Digest* 29 (May 1, 1955):10.

3. Dore Ashton, "Notes from France and Spain," *Arts and Architecture* 74 (November 1957):4.

4. Dore Ashton, "Mark Rothko," *Arts and Architecture* 74 (August 1957):8.

5. Ibid., p. 31.

6. Dore Ashton, "Oranges and Lemons, An Adjustment," *Arts* 51 (February 1977):142.

7. *Ibid.*

8. *Ibid.*

9. *Ibid.*

10. Dore Ashton, "Rothko's Passion," *Art International* 22 (February 1979):6.

11. *Ibid.*

12. Dore Ashton, "Miró/Artigas—Their New Ceramics," *Craft Horizons* 24 (January 1964):26.

13. Dore Ashton, "Marcel Duchamp, Bricoleur de Génie," *XXᵉ Siècle* 26 (June 1965):97.

14. Dore Ashton, "Willem de Kooning," *Arts and Architecture* 76 (July 1959):5.

15. Dore Ashton, "Willem de Kooning," *Arts* 50 (January 1976):60, 61.

16. *Ibid.*, p. 61.

17. Dore Ashton, *Philip Guston* (New York: Grove Press, 1960), p. 60.

18. Ibid., p. 57.

19. Dore Ashton, "Philip Guston, the Painter as Metaphysician," *Studio* 169 (February 1965):64.

20. Ibid., p. 66.

21. Dore Ashton, "Quality in Art," *Arts and Architecture* 78 (October 1961):30.

22. Dore Ashton, "Contemporary Art Critic," *Arts and Architecture* 76 (March 1959):8.

23. Dore Ashton, "Young Abstract Painters: Right On!" *Arts* 44 (February 1970):31.

24. Dore Ashton, *Abstract Art Before Columbus* (New York: Andre Emmerich Gallery, 1957), p. 38.

25. Dore Ashton, *The Unknown Shore: A View of Contemporary Art* (Boston: Little, Brown, 1962), p. 251.

26. Graham Reynolds, "American Art Comes of Age" (review of *The Unknown Shore*), *Apollo* 81 (June 1965):505–6.

27. Dore Ashton, "Richard Diebenkorn's Paintings," *Arts* 46 (December 1971):36.

28. Dore Ashton, *Yes But . . . : A Critical Study of Philip Guston,* (New York: Viking Press, 1976), pp. 108–9.

29. Dore Ashton, "A Closed, Infinitely Open Universe," *Studio* 184 (November 1972):190.

30. Dore Ashton, "Dubuffet and Anticulture," *Arts* 44 (December 1969):36–38.
31. Dore Ashton, "Sculptures de Picasso," *XXᵉ Siècle* 30 (June 1968):25.
32. Dore Ashton, "Art; the New Realism," *Arts and Architecture* 76 (October 1959):8.
33. Dore Ashton, "Yellow Fever," *The Soho News*, February 9, 1982, p. 18, and "Moma's Papa," *The Soho News*, September 1, 1981, p. 52.
34. Dore Ashton, "Recent Book by Harold Rosenberg," *Arts and Architecture* 79 (November 1962):33.
35. Interview, October 22, 1981.
36. Dore Ashton, "Beyond Literalism, But Not Beyond the Pale," *Arts* 43 (November 1968):50.
37. Dore Ashton, "Dry Season Notes," *Arts and Architecture* 75 (February 1958):31.
38. Dore Ashton, "Canadian Art in Review; Marlborough Gallery, New York," *Artscanada* 31 (December 1974):106.
39. Dore Ashton, *A Reading of Modern Art*, (Cleveland: Press of Case Western Reserve University, 1969), p. v.
40. Dore Ashton, *American Art Since 1945*, (New York: Oxford University Press, 1982), p. 34.
41. Ibid., p. 149.
42. Ibid., p. 155.
43. Ibid., p. 211.

7. GRACE BORGENICHT

1. Grace Borgenicht, unpublished statement.
2. Unless otherwise indicated quoted statements were made by Grace Borgenicht during the course of interviews conducted by the author on September 22, 1981, and October 25, 1983.
3. Judith Kaye Reed, "Debut at Laurel Gallery," *Art Digest* 21 (1947):21.
4. "Reviews and Previews: Grace Borgenicht," *Art News* 46 (December 1947):58.
5. Amy Robinson, "Reviews and Previews: Grace Borgenicht," *Art News* 49 (March 1950):50.
6. Martica Sawin, "Fortnight in Review: Grace Borgenicht," *Art Digest* 29 (May 1, 1955):21.
7. Parker Tyler, "Exhibition of Watercolors at Jackson Gallery," *Art News* 54 (1955):48.
8. Barnaby Conrad, "Stroll Down Fifty-seventh Street," *Horizon* 24 (April 1981):26–35.
9. Grace Glueck, "Art People," *New York Times*, June 12, 1981, p. 21.

8. VIRGINIA ZABRISKIE

1. Unless otherwise indicated quoted statements were made by Virginia Zabriskie during the course of an interview conducted by the author on November 18, 1981.

9. LUCY LIPPARD

1. Unless otherwise indicated quoted statements were made by Lucy Lippard during the course of interviews conducted by the author on December 15, 1981, and on November 15, 1983.
2. Lucy Lippard, *Pop Art*, (New York: Praeger, 1966), p. 82.
3. Lucy Lippard, *American Sculpture of the Sixties*, (Los Angeles: Los Angeles County

Museum, 1967); reprinted in Barbara Rose, *Readings in American Art 1900–1975*, (New York: Praeger, 1975), p. 184.

4. Lucy Lippard, "Cult of the Direct and the Difficult," *Two Decades of American Painting*, (New York: Museum of Modern Art, 1966); reprinted in *Changing, Essays in Art Criticism*, (New York: Dutton, 1971).

5. Lucy Lippard, "Eccentric Abstraction," *Art International* 10 (November 1966):28.

6. Ibid., p. 28–40.

7. Ibid., p. 39.

8. Ibid.

9. Lucy Lippard, "Eros Presumptive," *The Hudson Review* 20 (Spring 1967):91.

10. Lucy Lippard, "After a Fashion—The Group Show," *The Hudson Review* 19 (Winter 1966–67):625.

11. Lucy Lippard, "Activity of Criticism," *Studio* 189 (May 1975):186.

12. Lucy Lippard, "The Dilemma," *Arts* 45 (November 1970):28.

13. Ibid., p. 29.

14. Lucy Lippard, *Changing, Essays in Art Criticism*, (New York: Dutton, 1971), p. 31.

15. Lucy Lippard, "Douglas Huebler: Everything about Everything," *Art News* 71 (December 1972):31.

16. Carter Ratcliff, "Art Criticism: Other Minds, Other Eyes," *Art International* 19 (January 1975):53.

17. Lucy Lippard, "Sexual Politics, Art Style," *Art in America* 59 (September 1971):19.

18. Lucy Lippard, "Why Separate Women's Art?" *Art and Artists* 8 (October 1973):9.

19. Lucy Lippard, "Projecting a Feminist Criticism," *Art Journal* 35 (Summer 1976):338.

20. Lucy Lippard, "Two Proposals; Lucy Lippard Presents the Ideas of Adrian Piper and Eleanor Antin," *Art and Artists* 6 (March 1972):44.

21. Ibid.

22. Lucy Lippard, "New Landscape Art," *Ms* 5 (April 1977):73.

23. Lucy Lippard, *Overlay: Contemporary Art and the Art of Prehistory*, (New York: Pantheon, 1983), p. 1.

24. Ibid., p. 5.

25. Ibid., pp. 214, 238.

26. Lucy Lippard, "Vancouver," *Art News* 67 (September 1968):70.

27. Lucy Lippard, "Pulsa," *Artscanada* 25 (December 1968):60.

28. Lucy Lippard, "Notes in Review of 'Canadian Artists '68' Art Gallery of Ontario," *Artscanada* 26 (February 1969):27.

29. Lucy Lippard, "One," *Studio* 186 (September 1973):102.

30. Lucy Lippard and Eva Cockroft, "The Death of a Mural Movement," *Art in America* 62 (January 1974):35.

31. Lucy Lippard, "The Pink Glass Swan: Upward and Downward Mobility in the Art World," *Heresies* 1 (1977), p. 85.

32. Ibid., p. 83.

33. Lucy Lippard, "Making Something Out of Nothing," *Heresies* 1 (Winter 1977–78):65.

34. Lucy Lippard, "Some Propaganda for Propaganda," *Heresies* 3 (1980):36.

35. Ibid., p. 38.

36. Lucy Lippard, "Open Season," *Village Voice*, October 7–13, 1981, p. 91.

37. Lucy Lippard, "Don't Bank On It," *Village Voice*, March 2, 1982, p. 77.

38. Lucy Lippard, "Making Manifest," *Village Voice*, January 27–February 2, 1982, p. 72.

39. Lucy Lippard, "Sex and Death and Schock and Schlock; A Long Review of the Times Square Show," *Artforum* 19 (October 1980):51.

40. Lucy Lippard, "Real Estate and Real Art," *Seven Days* (April 1980):32.

41. Lucy Lippard, "Hot Potatoes: Art and Politics in 1980," original manuscript, p. 17; published in *Block* 4 (1981).

42. Lucy Lippard, "Ad Reinhardt, One Art," *Art in America* 62 (September 1974):74.

10. ILEANA SONNABEND

1. Unless otherwise indicated quoted statements were made by Ileana Sonnabend during the course of interviews conducted by the author on October 8, 1981, and October 28, 1983.

2. Grace Glueck, ''4 Uptown Art Dealers Set Up in SoHo,'' *New York Times*, September 27, 1971, p. 40.

3. Peter Schjeldahl, ''The Malaise that Afflicts SoHo's Avant-Garde Galleries,'' *New York Times*, June 11, 1972, p. 21.

11. GRACE GLUECK

1. Unless otherwise indicated quoted statements were made by Grace Glueck during the course of interviews conducted by the author on August 6, 1981, and October 21, 1983.

2. Grace Glueck, ''Women at the Whitney,'' *New York Times*, December 19, 1970, p. 23.

3. Ibid.

4. Grace Glueck, ''26 Contemporary Women Artists,'' *New York Times*, May 30, 1971, p. 20.

5. Grace Glueck, ''No More Raw Eggs at the Whitney?'' *New York Times*, February 13, 1972, p. 21.

6. Grace Glueck, ''21 Artists 'Invisible/Visible,' '' *New York Times*, April 16, 1972, p. 19.

7. Grace Glueck, ''Art Press Blames Sex Bias on Museums, Galleries,'' *Craft Horizons* 32 (August 1972):5.

8. Grace Glueck, ''Making Cultural Institutions More Responsive to Social Needs,'' *Arts in Society* 11 (Spring/Summer 1974):53.

9. Grace Glueck, ''100 Years at the Art Students League,'' *Art News* 74 (May 1975):41.

10. Grace Glueck, ''Betty Parsons: the Art Dealer's Art Dealer,'' *Ms* 4 (February 1976):109–12.

11. Grace Glueck, ''The Woman as Artist,'' *New York Times Magazine*, September 25, 1977, p. 50.

12. Ibid.

13. Ibid.

14. Ibid.

15. Grace Glueck, ''Where are the Great Men Artists,'' *Art News* 79 (October 1980):58–63.

16. Grace Glueck, ''Women Painters and Germaine Greer,'' *New York Times Book Review*, October 28, 1979, p. 3.

17. Grace Glueck, ''Art: Sonia Delaunay and 'Pure' Color,'' *New York Times*, November 21, 1980, p. 25.

18. Grace Glueck, ''New York Gallery Notes,'' *Art in America* 54 (September 1966):105.

19. Grace Glueck, ''Power and Aesthetics: The Trustee,'' *Art in America* 59 (July 1971):78–83.

20. Grace Glueck, ''Annenberg Controversy, *Art News* 76 (May 1977):63–64.

21. Grace Glueck, ''Artist Speaks: Saul Steinberg,'' *Art in America* 58 (November 1970):110–11.

22. Grace Glueck, ''20th-Century Artists Most Admired by Other Artists; Views of Nearly 100 Artists,'' *Art News* 76 (November 1977):78–103.

23. Grace Glueck, ''The New Collectives—Reaching for a Wider Audience,'' *New York Times*, February 1, 1981, p. 23.

12. PAULA COOPER

1. Unless otherwise indicated quoted statements were made by Paula Cooper during the course of an interview conducted by the author on October 21, 1981.

13. ROSALIND KRAUSS

1. Unless otherwise indicated quoted statements were made by Rosalind Krauss during the course of an interview conducted by the author on May 21, 1982.

2. Rosalind Krauss, "Manet's Nymph Surprised," *Burlington Magazine* 109 (November 1967):624.

3. Ibid., p. 627.

4. Rosalind Krauss, "The Essential David Smith," *Artforum* 7 (February 1969):47–48.

5. Ibid., p. 48.

6. Rosalind Krauss, *Terminal Iron Works; the Sculpture of David Smith* (Cambridge: MIT Press, 1971), p. 36.

7. Ibid., pp. 12–13, 16.

8. Ibid., p. 16.

9. Ibid., p. 37.

10. Ibid., p. 91.

11. Rosalind Krauss, "View of Modernism," *Artforum* 11 (September 1972):50.

12. Ibid., p. 51.

13. Rosalind Krauss, "Problems of Criticism, Pictorial Space and the Question of Documentary," *Artforum* 10 (November 1971):68.

14. Rosalind Krauss, "Sense and Sensibility, Reflection on Post '60's Sculpture," *Artforum* 12 (November 1973):43–53.

15. Rosalind Krauss, "Dark Glasses and Bifocals, A Book Review," *Artforum* 12 (May 1974):61.

16. Rosalind Krauss and C. F. Walker, "Activity of Criticism," *Studio* 189 (March 1975):85–86.

17. Rosalind Krauss, "How Paradigmatic is Anthony Caro?" *Art in America* 63 (September 1975):80.

18. Ibid.

19. Rosalind Krauss, "Video: The Aesthetics of Narcissism," *October* 1 (Spring 1976):52.

20. Rosalind Krauss, Sam Hunter, and Marcia Tucker, *Critical Perspectives in American Art* (Amherst: University of Amherst, 1976), p. 27.

21. Rosalind Krauss, *Passages in Modern Sculpture* (New York: Viking, 1977), p. 270.

22. Ibid., p. 282.

23. Ibid.

24. Rosalind Krauss, "Sculpture in the Expanded Field," *October* 8 (Spring 1979):34.

25. Ibid.

26. Rosalind Krauss, "Grids," *October* 9 (Summer 1979):64.

27. Rosalind Krauss, "Re-Presenting Picasso," *Art in America* 68 (December 1980):93.

28. Rosalind Krauss, "Notes on the Index: Seventies Art in America," *October* 3 (Spring 1977):78.

29. Rosalind Krauss, "Alfred Stieglitz's Equivalents," *Arts* 54 (February 1980):137.

30. Rosalind Krauss, "Nightwalkers," *Art Journal* 41 (Spring 1981):37.

31. Rosalind Krauss, "Jump Over the Bauhaus," *October* 15 (Winter 1980):106.

32. Rosalind Krauss, "Irving Penn: Earthly Bodies," *Arts* 55 (September 1980):86.

14. CINDY NEMSER

1. Unless otherwise indicated quoted statements were made by Cindy Nemser during the course of interviews conducted by the author on September 10, 1981, and October 25, 1983.

2. Cindy Nemser, "Revolution of Artists," *Art Journal* 29 (Fall 1969):44.

3. Cindy Nemser, "An Interview with Chuck Close," *Artforum* 8 (January 1970):51-55. Cindy Nemser, "Presenting Charles Close," *Art in America* 58 (January 1970):98-101.

4. Cindy Nemser, "Art Criticism and Perceptual Research," *Art Journal* 29 (Spring 1970):326-29.

5. Cindy Nemser, "Representational Painting in 1971: A New Synthesis," *Arts* 46 (December 1971):41-46.

6. Cindy Nemser, "Alchemist and the Phenomenologist," *Art in America* 59 (March 1971):100-3.

Cindy Nemser, "Subject—Object: Body Art," *Arts* 46 (September 1971):38-42.

7. Also, part of this transcript was quoted in Ellen H. Johnson, "Order and Chaos: From the Diaries of Eva Hesse," *Art in America*, Vol. 71 (Summer 1983):118.

8. Cindy Nemser, "Symbols of Consciousness; the Paintings of Dorothy Heller," *Arts* 47 (September 1972):33.

9. Cindy Nemser, "Interview with Helen Frankenthaler," *Arts* 46 (November 1971):53.

10. Cindy Nemser, "Lee Krasner's Paintings 1946-49," *Artforum* 12 (December 1973):65.

11. Barbara Rose, *Krasner/Pollock, A Working Relationship* (East Hampton, New York: Guild Hall Museum, 1981), pp. 6-9.

12. Cristine C. Rom, "One View: The Feminist Art Journal," *Woman's Art Journal* 21 (Fall 1981/Winter 1982):19-24.

13. Cindy Nemser, "Art Criticism and the Gender Prejudice," *Arts* 46 (March 1972):46.

14. Cindy Nemser, "Role of the Artist in Today's Society," *Art Journal* 34 (Summer 1975):331.

15. Cindy Nemser, "Humanizing the Art World," *Feminist Art Journal* 4 (Winter 1975-76):36.

16. Cindy Nemser, "On Humanizing the Arts," *American Artist* 40 (June 1976):52.

17. Ibid.

18. Ibid.

15. APRIL KINGSLEY

1. Unless otherwise indicated quoted statements were made by April Kingsley during an interview conducted by the author on December 10, 1981, and November 8, 1983.

2. April Kingsley, "James Brooks: Stain Into Image," *Art News* 71 (December 1972):48.

3. April Kingsley, "Women Choose Women," *Artforum* 11 (March 1973):73.

4. April Kingsley, "Ronald Bladen—Romantic Formalist," *Art International* 18 (September 20, 1974):44, and Kingsley, "Jack Tworkov," *Art International* 18 (March 1974):26.

5. Robert Pincus-Witten, letter to April Kingsley, March 15, 1973.

6. April Kingsley, "New York Letter," *Art International* 17 (October 1973):53.

7. April Kingsley, "New York Letter," *Art International* 18 (Summer 1974):45.

8. April Kingsley, "James Brooks: Critique and Conversation," *Arts* 49 (April 1975):54.

9. April Kingsley, "Reality in Abstraction," *Soho Weekly News*, March 18, 1976, p. 30.

10. April Kingsley, "This Time Last Year," *Soho Weekly News*, October 21, 1976, p. 17.

11. April Kingsley, "The Wild Beasts are Still Roaring," *Soho Weekly News,* April 15, 1976.

12. April Kingsley, "Flesh Was the Reason Oil Paint Was Invented," *Village Voice,* November 14, 1977 p. 101.

13. Ibid.

14. April Kingsley, "Opulent Optimism," *Village Voice,* November 28, 1977, p. 76.

15. April Kingsley, "Bigness of Small: Ira Joel Haber's Art," *Arts* 55 (September 1980):154.

16. April Kingsley, "Afro-American Abstraction at P. S. 1: The Evolution of an Exhibition," *The New Art Examiner,* June 1980, p. 3.

17. April Kingsley, *Afro-American Abstraction* (New York: P. S. 1, 1981), p. 3.

18. Robert Hughes, "Going Back to Africa—as Visitors," *Time* 115 (March 31, 1980):72.

19. John Perreault, "Positively Black," *Soho Weekly News,* February 27, 1980, p. 49.

20. Carrie Rickey, "Singular Work, Double Bind, Triple Threat," *Village Voice,* March 3, 1960, p. 71.

21. April Kingsley, "Steelyard Blues," *Encore* 9 (November 1981):43.

22. April Kingsley, *Sculpture by Mel Edwards* (Trenton: New Jersey State Museum, 1981).

23. Ibid.

24. April Kingsley, "Six Women at Work in the Landscape," *Arts* 52 (April 1978):108.

25. April Kingsley, "Sacred and Erotic Vision of Balthus," *Horizon* 22 (December 1979):30.

26. April Kingsley, "Camille Pissarro," *Horizon* 24 (May 1981):50.

27. April Kingsley, "Cynthia Carlson: The Subversive Intent of the Decorative Impulse," *Arts* 54 (March 1980):90.

28. April Kingsley, *Islamic Allusions* (New York: Alternative Museum, 1981):7.

29. April Kingsley, *The New Spiritualism: Transcendent Images in Painting and Sculpture* (New York: Oscarsson Hood Gallery, 1981), p. 3.

16. HOLLY SOLOMON

1. Unless otherwise indicated, quoted statements were made by Holly Solomon during the course of an interview with the author on November 25, 1981, and October 12, 1983.

2. Martin Filler, "Good Golly Miss Holly!," *House and Garden* 153 (March 1981):135.

3. Robert Morris, "American Quartet," *Art in America* (December 1981):96.

17. MONIQUE KNOWLTON

1. Unless otherwise indicated quoted statements were made by Monique Knowlton during the course of interviews conducted by the author on October 22, 1981, and October 18, 1983.

18. PAM ADLER

1. Unless otherwise indicated quoted statements were made by Pam Adler during the course of interviews with the author on November 20, 1981, and October, 25, 1983.

19. BARBARA GLADSTONE

1. Unless otherwise indicated quoted statements were made by Barbara Gladstone during the course of interviews conducted by the author on November 18, 1981, and October 12, 1983.

Selected Bibliography

Books

Guggenheim, Peggy. *Confessions of an Art Addict*. New York: Macmillan, 1960.

Harris, Barbara J. *Beyond Her Sphere, Women and the Professions in American History*. Westport, Connecticut: Greenwood Press, 1978.

Loeb, Judy, ed. *Feminist Collage, Educating Women in the Visual Arts*. New York: Teachers College Press, 1979.

Longley, Marjorie, Louis Silverstein, and Samuel A. Tower, eds. *America's Taste 1851-1959*. New York: Simon and Schuster, 1960.

Lynes, Russell. *The Tastemakers*. New York: Harper and Bros., 1954.

Saarinen, Aline B. *The Proud Possessors*. New York: Random House, 1958.

Articles

Cochrane, Diane G. "Women in Art, A Progress Report." *American Artist* 36 (December 1972):52-56.

Conrad, B. "Stroll Down Fifty-seventh Street." *Horizon* 24 (April 1981):26-34.

Dean, Clarence. "Art Galleries Enjoy Boom Here, But Artists Are Not Prospering." *New York Times*, February 27, 1957, p. 26.

"In Los Angeles, a Woman's Place May Be in the Art Gallery," *New York Times*, June 26, 1971, p. 16.

Russell, John. "Is SoHo Going Up, Down, Nowhere." *New York Times*, March 12, 1976, p. 35.

Wayne, June. "The Male Artist as a Stereotypical Female." *Art Journal* 32 (Summer 1973):132. (reprinted in *Feminist Collage*).

"Women's Liberation, Women Artists and Art History." *Art News* 69 (January 1971): entire issue.

Bibliography by Author in Order of Text

EMILY GENAUER

Books

Genauer, Emily. *Best of Art*. Garden City, New York: Doubleday, 1948.

———. *Modern Interiors Today and Tomorrow; A Critical Analysis of Trends in Contemporary Decoration as Seen at the Paris Exposition of Arts and Techniques and Reflected at the New York World's Fair*. New York: Illustrated Editions, 1939.

———. *Rufino Tamayo*. New York: Harry N. Abrams, 1974.

Articles and Essays

Genauer, Emily. "Adventures in Moscow." *New York Herald Tribune Magazine*, June 20, 1965, p. 31.

———. "Albright's 'Victims in a World of Shadow' ". *New York Herald Tribune*, January 31, 1965, p. 31.

———. "All Star Cast." *Parnassus* 9 (October 1937):9–12.

———. "Amateurs,. Those Who Paint as a Pastime." *Art Digest* 24 (January 15, 1950):13.

———. "Antidote for Nature." *House and Garden* 110 (July 1956):107–8.

———. "L'arc-en-ciel de Chagall à Chicago." *XXᵉ Siècle* 44 (June 1975):24–31.

———. "Are Artists Normal?" *New York Herald Tribune Magazine*, October 20, 1963, p. 35.

———. "Armory 1945; Critics' Choice." *Art News* 44 (October 1, 1945):21.

———. "Armory Show in Retrospect." *New York Herald Tribune Book Review*, March 2, 1958, p. 13.

——. "Art and the Artist." *New York Post,* December 16, 1972, p. 36.

——. "The Art Film." *Theatre Arts* 35 (August 1951):20–21, 101–2.

——. "Art for All to See." *Ladies Home Journal* 63 (November 1946):100–3.

——. "Art on the Road." *House and Garden* 109 (April 1956):181–83, 200.

——. "Automobile Exhibit at Modern Museum Kicks Up a Big Cloud of Verbal Dust." *New York Herald Tribune,* September 2, 1951, p. 6.

——. "Bérard." *Theatre Arts* 35 (June 1951):31–33, 101.

——. "Blowtorch Cellinis." *House and Garden* 109 (May 1956):205–6, 208.

——. "Chicago Art Story." *Theatre Arts* 35 (July 1951):26–29, 86–87.

——. "Coming to Terms with the New Art." *House Beautiful* 109 (April 1967):183, 209.

——. "A Common Denominator in 4 Exhibitions." *New York Herald Tribune Magazine,* February 7, 1965, p. 31.

——. "Critical Look at the Art Critic." *House and Garden* 111 (April 1957):60–62.

——. "Critics' Anxieties." *New York Herald Tribune Magazine,* January 3, 1963, p. 25.

——. "Directors' Choices." *New York Herald Tribune Magazine,* October 17, 1981, p. 10.

——. "Doom Deferred—Despite Ionesco." *New York Herald Tribune Magazine,* March 6, 1966, p. 25.

——. "Duchamp—Pop's Granddada." *New York Herald Tribune Magazine,* January 24, 1965, pp. 31–32.

——. "Everyday Objects Can Be Fine Art." *House Beautiful* 92 (December 1950):156–61, 196–98, 201–3, 208.

——. "Footnote to a Tour of Art Shows Abroad." *New York Herald Tribune Book Review,* September 2, 1956, p. 11.

——. "Fur-Lined Museum." *Harper's* 189 (July 1944):128–38.

——. "The Good-Will Show at Home." *New York Herald Tribune Magazine,* March 28, 1965, p. 39.

——. "H. R. 452: Federal Sponsorship." *Art Digest* 27 (July 1953):22.

——. "Homage to the School of Paris." Introduction to *Hommage A L'Ecole De Paris*, by Arbit Blatas. New York: Graphophile Associates, 1962.

——. "Imogene Coca Goes to the Gallery," *Theatre Arts* 35 (December 1951):28–29.

——. "In Provincetown Art Begins with Breakfast Coffee." *New York Herald Tribune Book Review*, August 11, 1957, p. 10.

——. Introduction to *Labor Sculpture*, by Max Kalish. New York: The Plant of the Comet Press, 1938.

——. " 'Involuntary' Giacometti." *New York Herald Tribune Magazine*, June 13, 1965, pp. 31–32.

——. "Is There An American Style in Art?" *House Beautiful* 93 (June 1951):92–93, 161–63.

——. "Isms and Schisms—A Survey of 7 Decades." *New York Herald Tribune Magazine*, April 24, 1966, pp. 34–35, 38.

——. "It Doesn't *Have* to be a Masterpiece." *House Beautiful* 92 (February 1950):60–61, 147–48, 150.

——. "It's What's Happening, So Don't Fight It, Baby." *New York Herald Tribune Magazine*, November 28, 1965, pp. 42, 44.

——. "Leonardo and the Stain." *Newsweek* 90 (December 12, 1977):27.

——. "The Living Wasteland." *New York Herald Tribune Magazine*, April 17, 1966.

——. "Mad Hatters, Inc." *Art Digest* 24 (October 15, 1949):10, 30.

——. "Mauer Memorial—Reminiscence, Controversy, and Applause." *Art Digest* 24 (November 15, 1949):7.

——. "Mielziner." *Theatre Arts* 35 (September 1951):34–37, 86–87.

——. "Modern Art and the Ballet." *Theatre Arts* 35 (October 1951):16–17, 75–77.

——. "Museum Shows Art in Private Collections." *New York Herald Tribune Book Review*, June 5, 1955, p. 10.

——. "The Myth of American Provincialism." *New York Herald Tribune Magazine*, October 24, 1965, p. 51.

——. "New Galleries." *New York Herald Tribune*, October 11, 1953, p. 5.

——. "New Horizons in American Art." *Parnassus* 8 (October 1936):2–7.

———. "The Night the Bubble Burst." *New York Herald Tribune Magazine*, February 14, 1965, pp. 7, 31.

———. "No Future in Dirty Pictures." *New York Herald Tribune Magazine*, January 10, 1965, p. 25.

———. "Now It's Pubism." *New York Herald Tribune Magazine*, May 2, 1965, p. 37.

———. "Painter Enters the Poets' Wasteland." *New York Herald Tribune Book Review*, November 28, 1954, p. 20.

———. "Paris Comes to Main Street." *Independent Woman* 16 (October 1937):318–19, 334.

———. "Pity the Poor Museum Director!" *Carnegie Magazine* 29 (April 1955): 134–35; excerpted from "Pity the Poor Museum Director!" *New York Herald Tribune Book Review*, January 2, 1955, p. 10.

———. "Portrait of the Artist as a Social Lion." *New York Herald Tribune Magazine*, January 17, 1965, pp. 33–34.

———. "The Private World of Abstract Art." *House and Garden* 111 (March 1957):20, 33, 98.

———. "Public Be Damned; Art Popularity Polls." *Art Digest* 20 (September 15, 1946):7.

———. "Purpose of Art in Our Time." *Art in America* 49 (1961):26–29.

———. "Questioning the Met? Hearn Fund Purchases." *Art Digest* 14 (September 1, 1940):8–9.

———. "Rebuttal for the Critics." *Art Digest* 22 (May 15, 1948):17.

———. "Restaged, Remounted and Redressed." *Theatre Arts* 35 (November 1951):28–29, 90–91.

———. "Reviewer Says 'Yes' for Cézanne." *New York Herald Tribune*, August 16, 1953, p. 5.

———. "Rhode Island Museum: Isms in Art Since 1800." *Art Digest* 23 (February 15, 1949):18.

———. "Rouault as Mirror and Prophet." *New York Herald Tribune Magazine*, November 22, 1964, p. 37.

———. "Rufino Tamayo." *Horizon* 22 (June 1979):38–47.

———. *Rufino Tamayo; Oil Paintings*. New York: Perls Galleries, 1973.

————. "Scenic Design's Men of Distinction." *Theatre Arts* 41 (July 1957):74–75, 83–84.

————. *School and the Fine Arts: What Should Be Taught in Art, Music and Literature?* Washington, D.C.: Council for Basic Education, 1966.

————. "Season in Spoleto." *Theatre Arts* 42 (September 1958):71–74.

————. "Selections All Set for Russian Show." *New York Herald Tribune*, March 1, 1959, p. 8.

————. "Sensation and Sensibility." *New York Herald Tribune Magazine*, March 21, 1965, p. 49.

————. "Soup Cans Going Back on the Shelf." *New York Herald Tribune Magazine*, September 12, 1965, pp. 38–39.

————. "Still Life with Red Herring." *Harper's* 199 (September 1949):88–91.

————. "Strident Non-Objective Paintings Dominate Whitney Museum Annual." *New York Herald Tribune*, November 11, 1951, p. 5.

————. " 'The 10 Greatest'—It Says Here." *New York Herald Tribune Magazine*, July 25, 1965, pp. 26–27.

————. "A Thoughtful Buffalo Show Redefines Expressionism as a Healthy Art Force." *New York Herald Tribune*, May 25, 1952, p. 5.

————. "Three Centuries of American Painting." *New York Herald Tribune Magazine*, April 4, 1965, p. 30.

————. "Timeless Aspects of Modern Art." *Art Digest* 23 (December 1, 1948):11.

————. "To a Collector-Dealer-with Love." *New York Herald Tribune Magazine*, April 25, 1981, pp. 32, 34, 35.

————. "Two Worlds—Léger, Chagall—and Two Little Words." *New York Herald Tribune Magazine*, April 11, 1965.

————. "Value Beyond Price." *New York Herald Tribune Magazine*, August 1, 1965, p. 41.

————. "Van Gogh and the T-Men." *Life* 29 (October 9, 1950):17–18, 20.

————. "The Van Gogh Portrait Mystery: Fraud-Detection Methods on Trial." *New York Herald Tribune*, December 4, 1949, p. 6.

————. "Velazquez Madrid Show." *New York Herald Tribune Book Review*, December 18, 1960, p. 20.

——. "A Visit with Marin, Celebrating 81st Birthday with New Exhibition." *New York Herald Tribune*, January 6, 1952, p. 6.

——. "The Wizards of Op." *New York Herald Tribune Magazine*, February 21, 1965, pp. 30, 32, 58.

——. "Young Painters in the East." *Parnassus* 9 (April 1937):16–19.

——. "Your Children and Art," *House and Garden* 110 (September 1956):38–40.

About Emily Genauer

"Art and Its Critics." *America* 94 (March 24, 1956):681.

"Emily Genauer Acclaims Farnsworth Portrait." *Art Digest* 14 (October 15, 1939):11.

Frankfurter, Albert M. "Is There a Gentleman in the House? Dondero's Attack on Artists." *Art News* 48 (September 1949):13.

Reed, Judith Kaye. "Critic Genauer Climbs Out On That Limb; Best of Art at the Riverside Museum." *Art Digest* 22 (February 15, 1948):12.

MARIAN WILLARD

Articles

Preston, Stuart. "Art: A Gallery's Review." *New York Times*, January 6, 1962, p. 41.

Willard, Marian: "David Smith: First Meeting." *Art in America* 54 (January 1966):22.

KATHARINE KUH

Books

Kuh, Katharine. *Art Has Many Faces, The Nature of Art Presented Visually*. New York: Harper, 1951.

——. *Art in New York State, The River: Places and People*, Buffalo, N.Y.: Albright-Knov Art Gallery, 1964.

———. *The Artist's Voice: Talks With Seventeen Artists.* New York: Harper and Row, 1962.

———. *Break-up; the Core of Modern Art.* Greenwich, Conn.: New York Graphic Society, 1965.

———. *Léger.* Chicago: Chicago Art Institute, 1953.

———. *The Open Eye; In Pursuit of Art.* New York: Harper and Row, 1971.

Articles

Kuh, Katharine. "About Museums and the National Gallery." *Saturday Review World* 4 (April 16, 1977):55–56, 58.

———. "Abstract and Real." *Art in America* 46 (Winter 1958–59):16–17.

———. "Alaska's Vanishing Art." *Saturday Review* 49 (October 22, 1966):25–31.

———. "An American Critic Reports on Art in the Soviet Union." *Saturday Review* 46 (August 24, 1963):17–26.

———. "American Drawings: A Salute." *Saturday Review World* 4 (March 5, 1977):43–45.

———. "Art." *Saturday Review World* 4 (August 6, 1977):52–54, 75.

———. "Art in America in 1962, A Balance Sheet." *Saturday Review* 45 (September 8, 1962):30A–30P.

———. "Art of Collecting." *Saturday Review* 47 (January 18, 1964):37–52.

———. "Art: Some Causes for Kudos." *Saturday Review World* 2 (March 22, 1975):30–32.

———. "Art That History Shaped." *Saturday Review* 49 (January 29, 1966):17–24.

———. "Art of Sicily." *Saturday Review* 53 (October 3, 1970):16–23.

———. "The Artist Looks at Children." *Saturday Review* 46 (December 14, 1963):35–38.

———. "Art's Voyage of Discovery." *Saturday Review* 47 (August 29, 1964):149–51, 187.

———. "Beware of Sculpture." *Vogue* 141 (March 1, 1963):26.

——. "Beyond Function and Form." *Saturday Review World* 2 (November 16, 1974):38–39, 41.

——. "A Brazilian Enigma." *Saturday Review World* 3 (May 29, 1976):43–45.

——. "Can Modern Art Survive Its Friends?" *Saturday Review* 43 (March 12, 1960):15–17, 75.

——. "Causes for Complaint." *Saturday Review World* 2 (July 26, 1975):35–37.

——. "Chicago's New Collectors." *Art Digest* 26 (May 15, 1952):5.

——. "Chinese Windfall." *Saturday Review World* 1 (January 26, 1974):58–60.

——. "Circuitous Odyssey of Irish Art." *Saturday Review* 51 (March 23, 1968):25–31, 60.

——. "Conclusions from an Old Cubist." *Art News* 60 (November 1961):48–49.

——. "David Hare: American Surrealist." *Saturday Review World* 5 (October 1, 1977):38–40.

——. "The Day Pop Art Died." *Saturday Review* 47 (May 23, 1964):24–25.

——. "Dedicated to Excellence; Asia House Gallery." *Saturday Review* 51 (November 30, 1968):67–68.

——. "Degas: 'The Reluctant Impressionist.' " *Saturday Review World* 2 (October 5, 1974):44–46.

——. "Delacroix: Prophet in Paint." *Saturday Review* 46 (June 22, 1963):21–23.

——. "Dreams as Reality." *Saturday Review World* 1 (August 10, 1974):107–9.

——. "An Educational Explosion: The Museum of African Art." *Saturday Review World* 4 (May 28, 1977):34–36.

——. "Elie Nadelman Rediscovered." *Saturday Review World* 3 (November 29, 1975):34–36.

——. "FDR Memorial Competition; Must Monuments Be Monumental." *American Institute Architectural Journal* 37 (March 1962):30–31.

——. "Felix Ruvolo." *Magazine of Art* 40 (April 1947):136–37.

——. "Fernand Lèger." *Arts and Architecture* 70 (May 1953):28–29.

——. "First Look at the Chase Manhattan Bank Collection." *Art in America* 48 (Winter 1960):68–75.

——. "Florence: Mending Damaged Treasures." *Saturday Review* 50 (July 22, 1967):11–21.

——. "Four Versions of Nude Descending a Staircase." *Magazine of Art* 42 (November 1949):264–65.

——. "Georgia O'Keefe by Georgia O'Keefe." *Saturday Review World* 4 (January 22, 1977):44–46.

——. "A Golden Anniversary for Chicago Art." *Chicago Art Institute Art Bulletin* 40 (April 1946):39–46.

——. "Golden Loans for a Silver Anniversary." *Saturday Review* 49 (March 19, 1966):45–51.

——. "Grandma Moses." *Saturday Review* 43 (September 10, 1960):16–17, 45.

——. "Great Sculpture." *Saturday Review* 45 (June 23, 1962):14–21.

——. "The Greening of a Collector." *Saturday Review World* 4 (July 9, 1977): 44, 46.

——. "The Guggenheim: A Rarefied Pantheon." *Saturday Review World* 3 (April 17, 1976):37–39.

——. "Guide for the Guileless Bidder." *Saturday Review World* 1 (April 6, 1974):44–45.

——. "Gyorgy Kepes." *Arts and Architecture* 69 (June 1952):18–19.

——. "If I Were a Collector." *Saturday Review World* 3 (August 7, 1976):41–43.

——. "Intimate Annals from India." *Saturday Review World* 3 (March 6, 1976):33–35.

——. "Ironies of Art." *Saturday Review* 48 (September 25, 1965):49.

——. "Italy's New Renaissance." *Saturday Review* 44 (February 11, 1961):32–35.

——. "J.M.W. Turner: An Enigma." *Saturday Review World* 2 (February 8, 1975):34–35.

——. "Joseph Cornell: In Pursuit of Poetry." *Saturday Review World* 2 (September 6, 1975):37–39.

——. "Lachaise: Sculptor of Maturity." *Chicago Art Institute Bulletin* 40 (March 1946):30–32.

——. "Los Angeles: Salute to a New Museum," *Saturday Review* 48 (April 3, 1965):29–35.

——. "Many Sides of Cubism." *Saturday Review* (August 28, 1965):24–25.

——. "Marc Chagall." *Chicago Art Institute Bulletin* 40 (December 1946):85–92.

——. "The Midwest—Spearhead Chicago." *Art in America* 42 (Winter 1954):32–39.

——. "Mies Van Der Rohe: Modern Classicist (interview)." *Saturday Review* 48 (January 23, 1965):22–23.

——. "Modern Sculpture—Additions and Plans." *Chicago Art Institute Quarterly* 52 (April 1958):22–23.

——. "Must Monuments Be Monumental?" *Saturday Review* 44 (September 30, 1961):26–27.

——. "Mystifying Maya." *Saturday Review* 52 (June 28, 1969):11–17.

——. "The New Art and Its Collectors." *Saturday Review World* 1 (December 4, 1973):38–40.

——. "New Sculpture at the Art Institute." *Chicago Art Institute Quarterly* 47 (November 1953):62–66.

——. "New Talent in the U.S.A." *Art in America* 44 (February 1956):10–11.

——. "New Year's Resolutions." *Saturday Review* 47 (December 26, 1964):32–33.

——. "A Note on Art Criticism." *Saturday Review* 43 (December 24, 1960):33.

——. "The Painter Meets the Critic; Interview." *Saturday Review* 43 (July 2, 1960):31–32.

——. "The Painter's Paintings." *Saturday Review* 44 (October 28, 1961):44.

——. "Patterns of Paris in South America." *Saturday Review World* 1 (June 1, 1974):46–48.

——. "Plus and Minus of the Building Boom." *Art in America* 49 (1961):40–45.

——. "Posada of Mexico." *Chicago Art Institute Bulletin* 38 (March 1944):42–44.

——. "Preservation of the Avant-Garde." *Saturday Review World* 4 (October 30, 1976):55–57.

——. "Reassessments in Baltimore." *Saturday Review World* 2 (May 3, 1975):29–31.

——. "Rembrandt, the Unrealistic Realist." *Saturday Review* 53 (January 10, 1970):46–48.

——. "The River: Places and People." *Art in America* 52 (April 1964):25–35.

——. "Riviera as a Studio." *Saturday Review* 44 (October 14, 1961):62–66.

——. "Roots of Turkish Art." *Saturday Review* 54 (November 20, 1971):20–26, 64.

——. "The Rosenwald Collection." *Saturday Review* 44 (September 23, 1961):33–34.

——. "St. Louis Spreads Its Wings." *Saturday Review* 45 (April 28, 1962):33–34.

——. "Seeing is Believing." *Chicago Art Institute Bulletin* 39 (April 1945):53–56.

——. "Selective Window." *Saturday Review* 52 (October 18, 1969):29–31.

——. "Shinto: A Secret World." *Saturday Review World* 4 (December 11, 1976):74–76.

——. "Space as Form." *Saturday Review* 43 (November 12, 1960):30.

——. "Still, the Engima." *Vogue* 155 (February 1, 1970):180–83, 218–20.

——. "Through the Eyes of Mark Tobey." *Saturday Review World* 1 (September 11, 1974):84–85.

——. "Tiffany and the Good Life." *Saturday Review World* 2 (June 14, 1975):43–45.

——. "Titan of the Renaissance." *Saturday Review* 43 (May 21, 1960):19–20.

——. "To Lend or Not to Lend?" *Art in America* 51 (June 1963):24.

——. "Turner in New York." *Art in America* 48 (Fall 1960):98–99.

——. "Twenty Overlooked Museums." *Saturday Review World* 1 (January 12, 1974):26–27.

——. "Twentieth Century Art from the Louise and Walter Arensberg Collection." *Chicago Art Institute Bulletin* 43 (September 1949):52–57.

——. "Two 'Modern' Portraits." *Chicago Art Institute Quarterly* 53 (April 1959):35–37.

———. "The Two Vincent van Goghs." *Saturday Review World* 1 (February 23, 1974):44–45.

———. "UNESCO and the Jerusalem Digs." *Saturday Review World* 3 (January 24, 1976):40–42.

———. "The Vision of Hilla Rebay." *New York Times*, May 7, 1972, p. 21.

———. "When I Think of Rome, I Think of Caravaggio." *Saturday Review World* 1 (October 23, 1973):62–64.

———. "Worcester Gift." *Chicago Art Institute Bulletin* 41 (September 1947):58–59.

About Katharine Kuh

"Appointed Curator of Painting and Sculpture, Art Institute of Chicago." *Arts* 32 (November 1957):12.

"Interpreter Kuh." *Newsweek* 39 (February 25, 1952):60.

McQuade, W. "First National of Chicago Banks on Art." *Fortune* 90 (July 1974):104–11.

BETTY PARSONS

Articles

Alloway, Lawrence. "Art." *Nation* 218 (May 4, 1974):572–73.

———. "Betty Parsons, Diary of an Art Dealer; Excerpts From An American Gallery with Editorial Comment." *Vogue* 142 (October 1, 1963):156–57.

———. "Ray Johnson's History of Betty Parsons Gallery." *Nation* 216 (February 5, 1973):189–90.

Aylon, Helen. "Interview with Betty Parsons." *Womanart* (September 1977).

Block, Jean Liliman. "The Hamptons, New York." *Craft Horizons* 35 (October 1975):42.

Boswell, Helen. "Betty Parsons at Midtown." *Art Digest* 16 (December 1, 1941):23.

Burrey, Suzanne. "Fortnight in Review, Betty Parsons," *Arts Digest* 29 (April 1, 1955):22.

Campbell, Lawrence. "The Ray Johnson History of the Betty Parsons Gallery." *Art News* 72 (January 1973):56–57.

——. "Reviews and Previews." *Art News* 54 (April 1955):46–47.

——. "Reviews and Previews, Grand Central Moderns." *Art News* 66 (May 1967):17.

——. "Reviews and Previews." *Art News* 71 (November 1972):75.

Constable, Rosalind. "The Betty Parsons Collection." *Art News* 67 (March 1968):48–49, 58–60.

Crosman, Christopher B. and Nancy E. Miller. "Speaking of Tomlin." *Art Journal* 39 (Winter 1979–80):114–16.

Devree, Howard. "By Contemporaries." *New York Times*, December 2, 1951, p. 11.

——. "Other Events." *New York Times*, October 6, 1946, p. 8.

Ellenzweig, Allen. "Arts Reviews." *Arts* 51 (March 1977):25.

Ffrench-Frazier, Nina. "New York Reviews." *Art News* 76 (March 1977):136.

"Fifty-Seventh Street in Review, Betty Parsons, Artist-Dealer." *Art Digest* 23 (December 1948):18.

Fitzsimmons, James. "57th Street in Review." *Art Digest* 26 (December 15, 1951):18.

Glueck, Grace. "Art Notes: Last of the Big-Time Internationals." *New York Times*, March 23, 1975, p. 31.

——. "Betty Parsons: the Art Dealer's Art Dealer." *Ms* 4 (February 1976):109–12.

Jones, R.W. "For Designers 'In the Know': Betty Parsons." *Residential Interiors* 3 (September 1978):22.

Kelly, Ken. "Bio, Betty Parsons Taught America to Appreciate What It Once Called 'Trash' Abstract Art." *People* 9 (February 27, 1978):76–78, 83–85.

Kennedy, R.C. "London Letter." *Art International* 13 (January 1969):51.

Lichtenstein, Grace. "Parsons: Still Trying to Find the Creative World in Everything." *Art News* 78 (March 1979):52–56.

"Montclair Art Museum; Exhibit." *Connoisseur* 187 (September 1974):60.

"New Exhibitions of the Week." *Art News* 36 (December 25, 1937):21.

"New Exhibitions of the Week: Betty Pierson-Parsons: Houses and Landscapes." *Art News* 35 (December 19, 1936):18.

"New York Galleries: Betty Parsons." *Arts* 45 (April 1971):54.

Perreault, John. "Betty Parsons at Montclair Art Museum." *Art in America* 62 (September/October 1974):115–16.

Porter, Fairfield. "Reviews and Previews." *Art News* 50 (December 1951):47–48.

"Reviews and Previews." *Art News* 47 (December 1948):51.

Rubinfien, Leo. "Betty Parsons, Truman and Kornblee Galleries, New York Exhibits." *Artforum* 17 (January 1979):62–63.

Russell, John. "Art: Betty Parsons 30th Year." *New York Times*, April 3, 1976, p. 20.

———. "Art: Choice Landscapes; New Sculptures by Betty Parsons." *New York Times*, November 10, 1978, p. 23.

———. "Betty Parsons—An Artist Both in Life and Art." *New York Times*, August 15, 1982, p. 23.

Sawin, Martica. "In the Galleries." *Arts* 32 (December 1957):58.

"Studio By the Sea." *House and Garden* 131 (June 1967):86–89.

"Ten Years." *Art News* 54 (January 1956):54.

"Tenth Anniversary Exhibit, 1946–1956." *Arts* 30 (December 1955):9.

Tillim, Sidney. "In the Galleries, Betty Parsons." *Arts* 35 (December 1960):56.

Tomkins, Calvin. "Profiles; Betty Parsons." *New Yorker* 51 (June 9, 1975):44–48, 51–52, 54, 59–60, 62, 66.

"Who Was Jackson Pollock?" *Art in America* 55 (May 1967):55.

Wolf, Ben. "Gouaches by Betty Parsons." *Art Digest* 19 (April 15, 1945):10.

Yau, John. "Betty Parsons at Kornblee and Truman." *Art in America* 67 (January 1979):142.

DORE ASHTON

Books

Ashton, Dore. *Abstract Art Before Columbus.* New York: André Emmerich Gallery, 1957.

———. *About Rothko.* New York: Oxford University Press, 1983.

———. *American Art Since 1945.* New York: Oxford University Press, 1982.

———. *A Fable of Modern Art.* New York: Thames and Hudson, 1980.

———. *A Joseph Cornell Album.* New York: Viking Press, 1974.

———. *Modern American Sculpture.* New York: Abrams, 1968.

———. *The Mosaics of Jeanne Reynal.* New York: G. Wittenhorn, 1964.

———. *The New York School: A Cultural Reckoning.* New York: Viking Press, 1973.

———. *Philip Guston.* New York: Grove Press, 1960.

———. *Picasso on Art: A Selection of Views.* The Documents of 20th Century Art series. New York: Viking Press, 1972.

———. *Poets and the Past.* New York: André Emmerich Gallery, 1959.

———. *Pol Bury.* Paris: Maeght, 1971.

———. *Rauschenburg's Dante.* New York: Abrams, 1964.

———. *A Reading of Modern Art.* Cleveland: Press of Case Western Reserve University, 1969.

———. *Richard Lindner.* New York: Abrams, 1969.

———. *Rosa Bonheur: A Life and A Legend.* New York: Viking Press, 1981.

———. *The Unknown Shore: A View of Contemporary Art.* Boston: Little, Brown, 1962.

———. *Yes But . . . : A Critical Study of Philip Guston.* New York: Viking Press, 1976.

Journal Articles

Ashton, Dore. "A to B: Dore Ashton Answers Leonard Baskin on the Question of Originality in Art." *Studio* 166 (November 1963):194–97.

——. "About-Face in Poland." *Horizon* 3 (May 1961):20–23.

——. "Afro." *Art Digest* 29 (May 1, 1955):10–11.

——. "Al Held, New Spatial Experiences." *Studio* 168 (November 1964):210–13.

——. "Alechinsky at Large." *Art International* 22 (March 1978):22–29.

——. "All Painting is Initiated in Paradox: The New Paintings of Paul Rotterdam." *Arts* 56 (May 1982):77–79.

——. "American Sculpture in Paris." *Studio* 170 (November 1965):184–87.

——. " 'Americans 1963' at the Museum of Modern Art." *Arts and Architecture* 80 (July 1963):4–5.

——. "Antonio Gaudi." *Craft Horizons* 17 (November 1957):35–41.

——. "Arshile Gorky Peintre Romantique." *XX^e Siècle* 24 (June 1962):76–80.

——. "Arshile Gorky Peintre Romantique." *XX^e Siècle* 40 (June 1973):87–91.

——. "Art and Literature in America." *Arts* 52 (March 1978):140–41.

——. "Art as Spectacle." *Arts* 41 (March 1967):44–46.

——. "Art of Architectural Drawings." *Artisan* 35 (February-March 1978):34–37.

——. "Art of Perpetual Crisis: Is Abstraction A School"? *Arts* 42 (February 1968):39–41.

——. "Art; the New Realism." *Arts and Architecture* 76 (October 1959):8–10.

——. "Art USA 1962." *Studio* 163 (March 1962):84–95.

——. "Avantgardia." *Arts Digest* 29 (March 15, 1955):16–17.

——. "Beyond Literalism, But Not Beyond the Pale." *Arts* 43 (November 1968):48–50.

——. "Beyond Max Ernst." *Arts* 49 (April 1975):50–51.

——. "Brooklyn Reviews Today's American Print Techniques." *Arts Digest* 26 (Summer 1952):6–8.

———. "Canadian Art in Review: Marlborough Gallery, New York." *Artscanada* 31 (December 1974):104–6.

———. "A Chambered Nautilus of Modern Art." *Arts* 40 (March 1966):37–39.

———. "A Closed, Infinitely Open Universe." *Studio* 184 (November 1972):189–91.

———. "Christopher Wilmarth's Gnomic Sculpture." *Arts* 55 (December 1980):93–95.

———. "Clothes Do But Cheat and Cousen Us." *Arts* 42 (December 1967):40–42.

———. "Cobra in Context." *Arts* 52 (February 1978):106–9.

———. "Commentary for Houston and New York." *Studio* 171 (January 1966):40–42.

———. "Contemporary American Drawing." *Arts* 39 (April 1965):26–31.

———. "Contemporary Art Critic." *Arts and Architecture* 76 (March 1959):8–29.

———. "Dallo Studio di Isamu Noguchi." *Domus* 415 (June 1964):52–55.

———. "Distance from 1926 to 1966." *Arts* 41 (December 1966):28–33.

———. "Drawings: An Intimate Obligato to the Paintings and Sculpture." *Art News* 78 (October 1979):92–95.

———. "Dry Season Notes." *Arts and Architecture* 75 (February 1958):4, 31.

———. "Dubuffet and Anticulture." *Arts* 44 (December 1969):36–38.

———. "El Greco of Toledo: the 1982–1983 Exhibition." *Arts* 56 (June 1982):88–91.

———. "The End and the Beginning of an Age: Epoch Making Shows at MOMA and the Brooklyn Museum." *Arts* 43 (December 1968):46–50.

———. "The European Art Press on American Art." *Arts and Architecture* 75 (August 1958):7.

———. "Everything Should Be As Simple As It Is But Not Simpler." *Studio* 184 (Summer 1972):86–88.

———. "Exercises in Anti-Style: Six Ways of Regarding Un, In and Anti-Form." *Arts* 43 (April 1969):45–47.

———. "L'exposition du futurismé á New York." *XX^e Siècle* 23 (December 1961):4–6.

——. "Forces in New York Painting 1950–1970." *Artscanada* 36 (December 1979–January 1980):23–25.

——. "French Malaise: The State of French Polemics." *Arts and Architecture* 72 (July 1955):10, 33.

——. "French 19th Century Painting and Literature with Special Reference to the Relevance of Literary S-M to French Painting." *Art Bulletin* 55 (Summer 1973):469–70.

——. "From Symbol to Symbolism." *Arts* 55 (February 1981):168–71.

——. "Giuseppe Capogrossi." *Arts Digest* 29 (March 1, 1955):10–11.

——. "Good and the Civilized; Problem of English Painting." *Art and Architecture* 72 (November 1955):12, 35, 36.

——. "La Grande Retrospective de Kandinsky." *XXᵉ Siècle* 25 (May 1963):1–5.

——. "Gustave Moreau and the Questions of Abstraction." *Marsyas* 20 (1979–80):71–77.

——. "Helen Frankenthaler." *Studio* 170 (August 1965):52–55.

——. "Holland, Belgium and Switzerland." *Arts Digest* 29 (November 15, 1954):20–21.

——. "A Home-Made Process for Unravelling Meanings." *Studio* 185 (March 1973):134–35.

——. "Hourlouping It on Wall Street." *Studio* 185 (January 1973):41–42.

——. "In the Last Analysis." *Studio* 176 (October 1968):122–23.

——. "Intercultural Gaps on the Cote d'Azur; Maeght Foundation Shows American." *Art* 45 (Summer 1970):38–41.

——. "Interview of Marcel Duchamp." *Studio* 171 (June 1966):171, 244–47.

——. "Isamu Noguchi." *Arts and Architecture* 76 (August 59):14–15.

——. "Jackson Pollock's Arabesque." *Arts* 53 (March 1979):142–43.

——. "Jacques Villon; Father of Modern Printmaking." *Art Digest* 27 (Summer 1953):8–9.

——. "Jake Berthot's Order." *Arts* 56 (March 1982):97–99.

———. "Jake Berthot Paints Quietness." *Arts* 46 (November 1971):32–35.

———. "James Ensor's Re-Entries." *Arts* 51 (March 1977):136–38.

———. "James Rosati: World of Inner Rhythms." *Studio* 167 (May 1964):196–97.

———. "Japanese Avantgardism at the Martha Jackson Gallery." *Arts and Architecture* 75 (November 1958):4–5.

———. "Jean Xcéron." *XXᵉ Siècle* 23 (May 1961):5–7.

———. "Jeunes Talents de la Sculpture Américaine." *Aujourd'hui* 10 (January 1967):158–60.

———. "John Walker." *Flash Art* 104 (October/November 1981):44–45.

———. "José de Rivera." *Arts and Architecture* 69 (November 1952):22–23, 34.

———. "Joseph Goto: Hawaiian Sculptor in Steel." *Studio* 165 (August 1964):74–77.

———. "Kant and Cant." *Arts* 41 (May 1967):11.

———. "Lester Johnson's Strolling Players." *Arts* 56 (April 1982):66–67.

———. "Letter from New York." *Canadian Art* 20 & 21 (November 1963-July 1964):48, 104, 174, 242, 358–59.

———. "London; An Insular Psychology." *Arts Digest* 28 (Summer 1954):16–17.

———. "Making Art Pay." *Arts* 41 (Summer 1967):41–49.

———. "Marcel Duchamp, Bricoleur de Génie; with English Text." *XXᵉ Siècle* 26 (June 65):97–99.

———. "Mark Rothko." *Arts and Architecture* 74 (August 1957):8, 31.

———. "Mark Tobey et la Rondeur Parfaite." *XXᵉ Siècle* 21 (May 1959):66–69.

———. "Matisse and Symbolism." *Arts* 49 (May 1975):70–71.

———. "Mexican Art World." *Arts and Architecture* 75 (October 1958):4.

———. "Milton Avery: A Painter's Painter at Borgenicht." *Arts* 42 (May 1968):34–35.

———. "Miró/Artigas Ceramics." *Craft Horizons* 17 (Fall 1957):16–20.

———. "Miró/Artagas—Their New Ceramics." *Craft Horizons* 24 (January 1964):24–33.

———. "Mondrian: Notes on an Exhibition at the Guggenheim Museum." *Artscanada* 36 (May-June 1979):57–59.

———. "Museums, Paris—New York and Other Things." *Arts* 52 (October 1977):120–21.

———. "Naissance d'un grand musée Guggenheim." *XXᵉ Siècle* 31 (December 1968):137.

———. "New Images of Man." *Arts and Archeticture* 76 (November 1959):14–15.

———. "New York Commentary: 'Software—Everywhere.' " *Studio* 180 (November 1970):200–2.

———. "New York Commentary: "Uptown, Downtown, All Around Town.' " *Studio* 179–180 (June 1970-January 1971).

———. "New York Gallery Notes." *Art in America* 55 (January 1967):90–95.

———. "New York Museums Stage Summer Shows." *Art Digest* 25 (June 1951):25–29.

———. "New York Times and Controversy." *Art News* 60 (April 1961):8.

———. "News from the Castle Behind the Iron Curtain." *Art News* 59 (November 1960):31.

———. "IX Bienal de São Paulo: Notes from an Innocent Abroad." *Arts* 42 (November 1967):24–29.

———. "Noguchi's Recent Marbles." *Art International* 16 (October 1972):38–41.

———. "Notes from France and Spain." *Arts and Architecture* 74 (November 1957):4.

———. "Open and Shut Case." *Arts* 42 (April 1968):28–30.

———. "Oranges and Lemons, An Adjustment." *Arts* 51 (February 1977):142.

———. "Outmoderned." *Studio* 186 (October 1973):118–19.

———. "Painting Toward: The Art of John McLaughlin." *Arts* 54 (November 1979):120–21.

———. "Paris; An Esthetic Behemoth: Thesis and Antithesis." *Arts Digest* 29 (October 15, 1954):14–15.

———. "Paris—Berlin: Rapports and Contrasts from 1900 to 1933." *Arts* 53 (December 1978):106–7.

———. "Pastel Anthology." *Arts* 40 (Fall 1966):29–32.

———. "La Peinture Optique A New York," *XXᵉ Siècle* 27 (June 1965):1–3, 26–27.

———. "Perceiving the Clay Figure." *American Craft* 41 (April/May 1981):24–31.

———. "Perspective de la Peinture Americanine." *Cahiers d'Art* (1960) 33–35, 203–20.

———. "Philip Guston." *Aujour d'Hui* 6 (June 1962):28–29.

———. "Philip Guston: Different Subjects." *Flash Art* 105 (December 1981-January 1982):20–25.

———. "Philip Guston, the Painter as Metaphysician." *Studio* 169 (February 1965):64–67.

———. "Philosopher or Dog? A Consideration of David Hare." *Arts* 50 (May 1976):80–81.

———. "Picasso and Frenhofer: The Idea of Modern Art." *Artscanada* 37 (September/October 1980):1–16.

———. "A Planned Coincidence." *Art in America* 57 (Summer 1969):36–47.

———. "Pollock: le nouvel espace." *XXᵉ Siècle* 23 (December 1961):75–80.

———. "Post-War Abstract Art in England." *Arts and Architecture* 74 (October 1957):4.

———. "Power Boothe's Gait." *Arts* (June 1981):118–19.

———. "Principles of Transitoriness." *Studio* 186 (Summer 1973):91–92.

———. "Prologue and Log." *Arts and Architecture* 77 (May 1960):18–19.

———. "Quality in Art." *Arts and Architecture* 78 (October 1961):14–15, 19, 30.

———. "Quid est?... For an Answer, Only Enigma." *Arts* 42 (March 1968):42, 46.

———. "The Quest for Impressions." *Saturday Review* 43 (December 31, 1960):17–18.

———. "Radiance and Reserve: The Sculpture of Christopher Wilmarth." *Arts* 45 (March 1971):31–33.

———. "Recent Book by Harold Rosenberg." *Arts and Architecture* 79 (November 1962):4–5, 33,

———. "Report for Rome." *Arts Digest* 29 (Fall 1955):14–15.

———. "Response to Crisis in American Art." *Art in America* 57 (January 1969):24–35.

———. "Response to Philip Guston's New Paintings." *Arts* 54 (December 1979):130–31.

———. "Retrospective/Perspective 1961–1974." *Arts* 49 (Summer 1974):34–39.

———. "Richard Diebenkorn." *Flash Art* 102 (March/April 1981):8–13.

———. "Richard Diebenkorn's Paintings." *Arts* 46 (December 1971):35–37.

———. "Richard Lindner's Eternal Return." *Arts* 43 (May 1969):48–50.

———. "Richard Lindner, the Secret of the Inner Voice." *Studio* 167 (January 1964):12–17.

———. "Robert Motherwell." *Flash Art* 100 (November 1980):4–8.

———. "Robert Motherwell, Passion and Transfiguration." *Studio* 167 (March 1964):100–5.

———. "Robert Natkin." *Studio* 164 (November 1962):190–92.

———. "Romare Bearden: Projections." *Quadrum* (no. 17 1964):99–110.

———. "The Rothko Chapel in Houston." *Studio* 181 (June 1971):272–75.

———. "Rothko's Passion." *Art International* 22 (February 1979):6–13.

———. "Say Uncle: The Opening of the National Collection of Fine Arts." *Arts* 42 (June/Summer 1968):48–50.

———. "Sculptor-Reformers of the Twentieth Century." *Arts and Architecture* 76 (June 1959):10–11.

———. "Sculpture of José de Rivera." *Arts* 30 (April 1956):38–41.

———. "Sculptures de Picasso." (English) *XXe Siècle* 30 (June 1968):25–40.

———. "Search for Whom?" *Arts* 55 (November 1980):96–97.

———. "Die Seltsame Maschine des Monsieur Tinguely." *Bau and Werk* 14 (Fall 1961):90–92.

——. "Seven American Decades." *Studio* 165 (April 1963):148–53.

——. "Shape's the Thing: Paintings by John Walker." *Studio* 181 (April 1971):170–72.

——. "The Situation in Printmaking: 1955." *Arts* 30 (October 1955):15–17.

——. "Stephen Posen and the Mixed Metaphor." *Arts* 53 (October 1978):134–37.

——. "Sweeney Revisited." *Studio* 166 (Summer 1963):110–13.

——. "Symbolist Legacy." *Arts and Architecture* (Summer 1964):10.

——. "Synoptic Loft: U.S. Commentary." *Studio* (November 1971):199–201.

——. "Synthesists; Modern Italian Art." *Art and Architecture* (Summer 1955): 6, 8.

——. "U.S.A.: Nouvelles Explorations de l'espale." *XX*e *Siècle* 28 (May 1966):7–10.

——. "Variyan Boghosian: Portrait of the Artist as Litterateur." *Studio* 169 (April 1965):168–71.

——. "The Vatican's Exhibition of Fra Angelico." *Arts Digest* 29 (August 1955):24–25.

——. "La Voix du Tourbillon Dans L'Amerique de Kafka." *XX*e *Siècle* 26 (May 1964):92–96.

——. "Warning: The Road to Culture is Paved with Profits." *Arts* 51 (Summer 1976):126.

——. "What is Avant Garde?" *Arts Digest* 29 (Summer 1955):6–8.

——. "What's New (and What's Old) in Mexico." *Arts* 54 (April 1980):136–38.

——. "Willem de Kooning." *Arts and Architecture* 76 (July 1959):5.

——. "Willem de Kooning: Home Faber." *Arts* 50 (January 1976):58–61.

——. "William Tucker's Gyre." *Arts* 128 (June 1979):128–29.

——. "Young Abstract Painters: Right On!" *Arts* 44 (Fall 1970):31–35.

——. "Young Painters in Rome." *Arts Digest* 29 (June 1955):6–7.

GRACE BORGENICHT

Articles

Borgenicht, Grace. Statement. "The Encyclopedia of the American Woman."

Glueck, Grace. "Art People." *New York Times,* June 12, 1981, p. 21.

Reed, Judith Kaye. "Debut at Laurel Gallery." *Art Digest* 21 (1947):21.

"Reviews and Previews: Grace Borgenicht." *Art News* 46 (December 1947):58.

Robinson, Amy. "Reviews and Previews: Grace Borgenicht." *Art News* 49 (March 1950):50.

Sawin, Martica. "Fortnight in Review: Grace Borgenicht." *Art Digest* 29 (May 1, 1955):21.

Tyler, Parker. "Exhibition of Watercolors at Jackson Gallery," *Art News* 54 (1955):48.

VIRGINIA ZABRISKIE

Articles

Trusco, Terry. "Virginia Zabriskie: a Dollar , a Dream and a Passion for Art." *Art News* 78 (February 1979):62–63.

LUCY LIPPARD

Books

Lippard, Lucy. *Ad Reinhardt.* New York: Abrams, 1981.

——. *Changing, Essays in Art Criticism.* New York: Dutton, 1971.

——. *Dadas on Art.* Englewood Cliffs, New Jersey: Prentice-Hall, 1971.

——. *Eva Hesse.* New York: New York University Press, 1976.

——. *From the Center: Feminist Essays on Women's Art.* New York: Dutton, 1976.

——. *The Graphic Work of Philip Evergood; Selected Drawings and Complete Prints.* New York: Crown, 1966.

——. *I See/You Mean.* Hermosa, California: Chrysalis, 1979.

——. *Overlay: Contemporary Art and the Art of Prehistory.* New York: Pantheon, 1983.

——. *Pop Art.* New York: Praeger, 1966.

——. *The School of Paris: Paintings from the Florene May Schoenborn and Samuel A. Marx Collection.* (Preface by Alfred H. Barr, Jr., Introduction by James Thrall Soby, Notes by Lucy R. Lippard.) Garden City, New York: Doubleday, 1965.

——. *Surrealists on Art.* Englewood Cliffs, New Jersey: Prentice-Hall, 1970.

——. *Tony Smith.* New York: Abrams, 1972.

Articles and Catalogue Essays

Lippard, Lucy. "A is for Artpark." *Art in America* 62 (November 1974):32, 37–39.

——. "Abstract Realism of Alice Adams." *Art in America* 67 (September 1979):72–76.

——. "Activity of Criticism." *Studio* 189 (May 1975):185–86.

——. "Ad Reinhardt: One Art." *Art in America* 62 (September 1974):65–75.

——. "All Fired Up." *Village Voice*, December 208, 1981, p. 100.

——. "Art Outdoors, In and Out of the Public Domain: A Slide Lecture." *Studio* 193 (March 1977):83–90.

——. "Art Tranquil, Art Defiant: Kes Zapkus." *Art in America* 70 (Summer 1982):132–38.

——. "Art Worker's Coalition: Not a History." *Studio* 180 (November 1970):171–74.

——. "Artists' Book Goes Public." *Art in America* 65 (January 1977):40–41.

——. "Beauty and the Bureaucracy." *The Hudson Review* 20 (Winter 1967–68): 650–56.

——. "Binding/Bonding (Harmony Hammond's Sculptures)." *Art in America* 70 (April 1982):112–18.

———. "Blind Leading the Blind." *Detroit Institute Bulletin* (1981):24–29.

———. "Brenda Miller: Woven, Stamped." *Art in America* 64 (May 1976):96–97.

———. "Calling the Shots." *Village Voice*, October 4, 1983, p. 116.

———. "Caring: Five Political Artists." *Studio* 193 (May-June 1977):197–207.

———. "Cashing in a Wolf Ticket (Activist Art and Fort Apache, the Bronx)." *Artforum* 20 (October 1981):64–73.

———. "Color at the Edge." *Art News* 71 (May 1972):24–25, 64–66.

———. "Complexes: Architectural Sculpture in Nature." *Art in America* 67 (January 1979):86–97.

———. "Cult of the Direct and the Difficult," *Two Decades of American Painting.* New York: Museum of Modern Art, 1966.

———. "Dada in Berlin: Unfortunately Still Timely," *Art in America* 66 (March 1978):107–11.

———. "Dear Ray (Johnson)...Love, Lucy." *Art Journal* 36 (Spring 1977):240.

Lippard, Lucy, and Eva Cockroft. "The Death of a Mural Movement." *Art in America* 62 (January 1974):35–37.

Lippard, Lucy, and John Chandler. "The Dematerialization of Art," *Art International* 12 (February 1968):31–36.

Lippard, Lucy. "The Dilemma." *Arts* 45 (November 1970):27–29.

———. "Distancing; the Films of Nancy Graves." *Art in America* 63 (November 1975):78–82.

———. "Don't Bank On It." *Village Voice*, March 2, 1982, p. 77.

———. "Douglas Huebler: Everything About Everything." *Art News* 71 (December 1972):29–31.

———. "Eccentric Abstraction." *Art International* 10 (November 1966):28, 34–40.

———. "Ernst and Dubuffet, A Study in Like and Unlike." *Art Journal* 21 (Summer 1962):240–45.

———. "Eros Presumptive." *The Hudson Review* 20 (Spring 1967):91–99.

———. "Eva Hesse." *Kunstwerk* 25 (March 1972):31–36.

———. "Eva Hesse: the Circle." *Art in America* 59 (May 1971):68–73.

———. "Faith Ringgold Flying Her Own Flag (interview)." *Ms* 5 (July 1976):34, 36–37, 39.

———. "Five." *Studio* 187 (January 1974):48.

———. "Flagged Down: the Judson Three and Friends." *Art in America* 60 (May 1972):48–53.

Lippard, Lucy, Richard Bellamy, and Leah P. Sloshberg. *Focus on Light*. Trenton: The New Jersey State Museum Cultural Center, 1967.

Lippard, Lucy. "Gardens: Some Metaphors for a Public Art." *Art in America* 69 (November 1981):136–50.

———. "Getting Hers: Judy Chicago's 'Through the Flower.' " *Ms* August 1975, p. 42.

———. "Groups." *Studio* 179 (March 1970):93–99.

———. "Hanne Darboven: Deep in Numbers." *Artforum* 12 (October 1973):35–39.

———. "Homage to the Square." *Art in America* 55 (July 1967):50–57.

———. "Home Economics." *Heresies* 4 (1981):50–55.

———. "How Good is the Freeze?" *Village Voice*, June 15, 1982, p. 95.

———. "Hot Potatoes: Art and Politics in 1980," original manuscript, p. 17. Published in *Block* 4 (1981).

———. "Iain Baxter: New Spaces." *Artscanada* 26 (June 1969):3–7.

———. "Icons of Need and Greed." *Village Voice*, May 25, 1982, p. 87.

———. "Jackie Winsor." *Artforum* 12 (February 1974):56–58.

———. "Jonathon Borofsky at 2,096, 974." *Artforum* 13 (November 1974):62–63.

———. "Judy Chicago, Talking to Lucy R. Lippard." *Artforum* 13 (September 1974):60–65.

———. "Judy Chicago's Dinner Party." *Art in America* 68 (April 1980):114–26.

———. "June Leaf: Life Out of Life." *Art in America* 66 (March 1978):112–17.

———. "Louise Bourgeois: From the Inside Out." *Artforum* 13 (March 1975):26–33.

——. "Making Manifest." *Village Voice,* January 27-February 2, 1982, p. 72.

——. "Making Something Out of Nothing." *Heresies* 1 (Winter 1977–78):62–65.

——. "Mary Miss: An Extremely Clear Situation." *Art in America* 62 (March 1974):75–77.

——. "Max Ernst: Passed and Pressing Tensions." *Art Journal* 33 (Fall 1973):12–17.

——. "More Alternate Spaces: the L. A. Woman's Building." *Art in America* 62 (May 1974):85–86.

——. "New Landscape Art." *Ms* 5 (April 1977):68–73.

——. "Northwest Passage: A Critics Diary of a Trip through the Upper-Left-Hand Corner of America." *Art in America* 64 (July 1976):59–63.

——. "One." *Studio* 186 (September 1973):102–3.

——. "Open Season." *Village Voice,* October 7–13, 1981, p. 91.

——. "The Pains and Pleasures of Rebirth: Women's Body Art." *Art in America* 64 (May 1976):73–81.

——. "Passion Plays." *Village Voice,* May 4, 1982, p. 95.

——. "The Pink Glass Swan: Upward and Downward Mobility in the Art World." *Heresies* 1 (1977):82–87. (Reprinted in Loeb, Judy. *Feminist Collage.* New York: Teachers College Press, 1979.)

——. "Projecting a Feminist Criticism." *Art Journal* 35 (Summer 1976):337–39.

——. "Pulsa." *Artscanada* 25 (December 1968):59–60.

——. "Questions to Stella and Judd (interview)." *Art News* 65 (September 1966):55–61.

——. "Real Estate and Real Art," *Seven Days.* (April 1980):32.

——. "Ree Morton: At the Still Point of the Turning World." *Artforum* 12 (December 1973):48–50.

——. "Report from Colorado; Women's Art Festival." *Art in America* 67 (October 1979):29.

——. "Report from Houston: Texas Red Hots." *Art in America* 67 (July 1979):30–31.

———. "Report from New Orleans; You Can Go Home Again: Five From Louisiana." *Art in America* 65 (1977):22–23.

———. "Representations of Nature in Art." *Studio* 186 (December 1973):254.

———. "Richard Pousette-Dart; Toward an Invisible Center." *Artforum* 13 (January 1975):51–53.

———. "Rosemarie Castoro: Working Out." *Artforum* 13 (Summer 1975):60–62.

———. "Rudy Burckhardt: Moviemaker, Photographer, Painter." *Art in America* 63 (March 1975):75–81.

———. "RX Art." *Village Voice*, August 19–25, 1981, p. 66.

———. " 'Sculpture Sited' at the Nassau County Museum." *Art in America* 65 (March 1977):120.

———. "Seven." *Studio* 187 (March 1974):142–43.

———. "Sex and Death and Shock and Schlock: A Long Review of the Times Square Show." *Artforum* 19 (October 1980):50–55.

———. "Sexual Politics, Art Style." *Art in America* 59 (September 1971):19–20.

———. "The Silent Art." *Art in America* 55 (January 1967):58–63.

———. "Six." *Studio* 187 (February 1974):96.

———. "A Small Slice of Whose Pie?" *Village Voice*, June 8, 1982, p. 82.

———. "Software Battle." *Artforum* 9 (December 1970):37.

———. "Some of 1968 (Excerpts from 6 Years—Dematerialization of the Art Object)." *Arts* 47 (December 1973):45–47.

———. "Some Propaganda for Propaganda." *Heresies* 3 (1980):35–39.

———. "Space Embraced: Tom Doyle's Recent Sculpture." *Arts* 40 (April 1966):38–43.

———. "Stonesprings." *Heresies* 2 (Spring 1978):28–31.

———. "The Structures, The Strictures and the Wall Drawings, the Structures and the Wall Drawings and the Books," *Sol LeWitt.* New York: Museum of Modern Art, 1978.

———. "Taking Pictures, Silent Words, Yvonne Rainer's Recent Movies." *Art in America* 65 (May 1977):86–90.

——. "They've Got FBEyes for You." *Village Voice*, November 4–10, 1981, p. 114.

——. "Three." *Studio* 186 (November 1973):202.

——. "Three Short Fictions." *Heresies* 1 (May 1977):22–24.

——. "Time: A Panel Discussion." *Art International* 13 (November 1969):20–23, 39.

——. "Tony Smith: Talk About Sculpture." *Art News* 70 (April 1971):48–49, 68, 71–72.

——. "Transformation Art: Conceptual Art." *Ms* 4 (October 1975):33–34, 36–38.

——. "True Confessions." *Heresies* 2 (Spring 1979):96.

——. *26 Contemporary Women Artists.* Ridgefield, Connecticut: Aldrich Museum, 1971.

——. "Two." *Studio* 186 (October 1973):162.

——. "Two Proposals; Lucy Lippard Presents the Ideas of Adrian Piper and Eleanor Antin." *Art and Artists* 6 (March 1972):44.

——. " 'Unmanly Art' at the Suffolk Museum, Stonybrook, New York." *Art News* 72 (January 1973):77.

——. "Vancouver." *Art News* 67 (September 1968):26, 69–71.

——. "Why Separate Women's Art?" *Art and Artists* 8 (October 1973):8–9.

——. "The World of Dadamax Ernst." *Art News* 74 (April 1975):27–30.

——. "Yvonne Rainer on Feminism and Her Film." *The Feminist Art Journal* 4 (Summer 1975):5–11.

Articles on Lucy Lippard

Ratcliff, Carter. "Art Criticism: Other Minds, Other Eyes." *Art International* 19 (June 1975):52–54.

ILEANA SONNABEND

Articles

Claus, Jürgen. "Die Kunst and Ihr Publikum, Ein Gespräch Mit Der Kunsthänd-lerin." *Kunstwerk* 19 (November 1965):56.

Glueck, Grace. "4 Uptown Art Dealers Set Up in SoHo." *New York Times*, September 27, 1971, p. 40.

"Ileana Sonnabend Suing Frank Stella." *New York Times*, October 27, 1971, p. 44.

Schjeldahl, Peter. "The Malaise that Afflicts SoHo's Avant-Garde Galleries," *New York Times*, June 11, 1972, p. 21.

GRACE GLUECK

Articles

Glueck, Grace. "About Bears on a Rampage." *New York Times Magazine*, November 15, 1953, p. 37.

——. "About Betel Nuts." *New York Times Magazine*, August 29, 1954, pp. 54–55.

——. "About: Grade A." *New York Times Magazine*, February 18, 1962, pp. 35–36.

——. "Ale Shoes and Scrimshaw." *New York Times Magazine*, September 25, 1960, p. 18.

——. "And Now, Ombourzhay." *New York Times Magazine*, November 19, 1959, p. 52.

——. "Annenberg Controversy." *Art News* 76 (May 1977):63–64.

——. "An Art Blackout in Poland." *New York Times*, January 24, 1982, p. 15.

——. "Art in Public Places Stirs Widening Debate." *New York Times*, May 23, 1982, p. 1.

——. "Art Press Blames Sex Bias on Museums, Galleries." *Craft Horizons* 32 (August 1972):5, 60.

———. "Art Rite, Opening Night." *New York Times Magazine,* December 13, 1964, pp. 44–45.

———. "Artist Speaks: Saul Steinberg (interview)." *Art in America* 58 (November 1970):110–17.

———. "Betty Parsons: the Art Dealer's Art Dealer." *Ms* 4 (February 1976):109–12.

———. "Betye Saar Gives Spirits Form." *New York Times.* April 18, 1980, p. 22.

———. "Big Day for the Handmade." *New York Times Magazine,* March 19, 1961, p. 11.

———. "Childhood in Comfort." *New Republican* 134 (March 26, 1956):20.

———. "Circa 1825–2000." *Art in America* 56 (September/October 1968):108–12.

———. "The Cityscapes of Wayne Thiebaud" (including a review of *12 Women* at The Sarah Institute). *New York Times,* April 11, 1980, p. 18.

———. "The Clay Figure' At the Craft Museum" (including a review of work by Joyce Kozloff). *New York Times,* February 20, 1981, p. 21.

———. "Clubs, Clubs and More Clubs." *New York Times Magazine,* April 7, 1963, p. 44.

———. "Deborah Remington." *New York Times,* April 29, 1977, p. 19.

———. "Design." *New York Times Magazine,* September 21, 1975, pp. 62–63.

———. "Dissidence as a Way of Art." *New York Times Magazine,* May 8, 1977, pp. 33–35.

———. "Dotty Attie." *New York Times,* November 21, 1980, p. 25.

———. "A Downtown Scene." *New York Times,* November 18, 1970, p. 15.

———. "Experts Guide to the Experts." *Art News* 77 (November 1978):52–59.

———. "Federal Challenge Grants: Money to Make Money." *Art in America* 67 (January 1979):10–12.

———. "Fine Art of Fasting." *New York Times Magazine,* October 8, 1961, p. 106.

———. "Food Yes! Meals, No." *New York Times Magazine,* April 10, 1960, p. 10.

———. "Fresh Talent and New Buyers Brighten the Art World." *New York Times,* October 18, 1981, p. 1.

——. "Furrier to the Art World." *New York Times Magazine*, October 2, 1966, pp. 38–39.

——. "Gala Days for the Met—Despite Money Woes." *New York Times*, December 13, 1981, p. 32.

——. "Garden Drawings by Jennifer Bartlett." *New York Times*, January 23, 1981, p. 19.

——. "A Happy New Year." *Art in America* 59 (January/February 1971):22–27.

——. "Home, Risky Home." *New York Times Magazine*, December 11, 1960, p. 42.

——. "Image and Object." *New York Times*, January 11, 1980, p. 17.

——. "It's Not Pop, It's Not Op, It's Marisol." *New York Times Magazine*, March 7, 1965, pp. 34–35.

——. "It's the Thought That Counts?" *New York Times Magazine*, November 25, 1962, pp. 59–60.

——. "Ivory Tower Versus the Discothéque; Sherman E. Lee and Thomas P. F. Hoving: Their Conceptions of a Museum's Role." *Art in America* 59 (May 1971):80–85.

——. "Jo Baer and Bruce Robbins at 112 Workshop." *New York Times*, March 21, 1980, p. 20.

——. "Juan Hamilton: Sculpture." *New York Times*, April 17, 1981, p. 20.

——. "The Kinetic Eye: Environmental Art." *House Beautiful* 110 (October 1968):136–37.

——. "Making Cultural Institutions More Responsive to Social Needs." *Arts in Society* 11 (Spring/Summer 1974):53–56.

——. "Man the Art World Loves to Hate." *New York Times Magazine*, June 15, 1975, pp. 12–13.

——. "Maxfield Parrish." *American Heritage* 22 (December 1970):17–18.

——. "Moving in on the Met." *New York Times Magazine*, February 27, 1977, pp. 20–22.

——. "Museum of Modern Art at 50." *Interior Design* 51 (January 1980):262–69.

——. "Museum Summit in Britain." *Art in America* 64 (January 1976):19.

———. "The New Collectives—Reaching for a Wider Audience." *New York Times,* February 1, 1981, p. 23.

———. "A 'New Realism' in Sculpture." *Art in America* 59 (November/December 1971):150–55.

———. "New Twist in an Old Biscuit." *New York Times Magazine,* June 25, 1961, p. 52.

———. "New York: Visual Riches and Recessionary Blues." *Art in America* 59 (March/April 1971):42.

———. "No More Raw Eggs at the Whitney?" *New York Times,* February 13, 1972, p. 21.

———. "The Non-Gallery of No Art." *New York Times,* January 24, 1971, p. 24.

———. "Now His *Is* Hers." *New York Times Magazine,* September 20, 1964, p. 45.

———. "Odd Man Out: Red Grooms, the Ruckus Kid." *Art News* 72 (December 1973):23–27.

———. "Oldenburg's Soft Sculpture." *New York Times,* September 21, 1969, p. 26.

———. "100 Years at the Art Students League." *Art News* 74 (May 1975):40–42.

———. "Painting Attribution Sparks an Uproar." *New York Times,* April 4, 1982, p. 1.

———. "Paintings Descending a Ramp." *New York Times Magazine,* January 19, 1969, pp. 36–38.

———. "Paradigms, Watersheds and Frosting on the Cake." *Art News* 78 (October 1979):186–88, 202.

———. "Pasadena Take-Over." *Art News* 73 (September 1974):36–37.

———. "Pictures and Promises." *New York Times,* January 30, 1981, p. 19.

———. "Power and Esthetics: The Trustee." *Art in America* 59 (July 1971):78–83. (Reprinted in *Museums in Crisis,* edited by Brian O'Doherty. New York: Braziller, 1972.)

———. "Rivers Paints Himself Into the Canvas." *New York Times Magazine,* February 13, 1966, pp. 34–35.

———. "Rockefeller Gift to Asia House." *Art News* 73 (April 1974):73–74.

———. "Rome's Many Voices." *New York Times Magazine,* February 12, 1961, pp. 56–57.

———. "The Scene from Soho to Tribeca." *New York Times,* January 30, 1981, p. 19.

———. "Sculptors on Paper and a Gallery on the Move." *New York Times,* September 25, 1983, p. 29.

———. "Sculpture in the 70's: The Figure at Pratt Manhattan Center Gallery." *New York Times,* November 7, 1980, p. 19.

———. "Sculptured Figures of 70's at Pratt Gallery" (including review of work by Ann Sperry). *New York Times,* November 7, 1980, p. 19.

———. "Short Circuit for Summer." *Art in America* 54 (May 1966):114–15.

———. "Soft Sculptures or Hard, They're Oldenburgers." *New York Times Magazine,* September 21, 1969, pp. 28–29.

———. "Sonia Delaunay and 'Pure' Color." *New York Times,* November 21, 1980, p. 25.

———. "A Spectacular New Wing." *New York Times Magazine,* January 24, 1982, pp. 20–68.

———. "Spoleto U.S.A." *New York Times Magazine,* May 22, 1977, pp. 20–22.

———. "Statistics, N.Y." *New York Times Magazine,* June 23, 1963, p. 29.

———. "Summer Art Scene: From 42nd St. South." *New York Times,* August 8, 1980, p. 25.

———. "Susan Hall: Works at Patricia Hamilton Gallery." *New York Times,* April 17, 1970, p. 30.

———. "Thoughts that Count." *New York Times Magazine,* December 13, 1964, pp. 121–22.

———. "Total Involvement of Thomas Hoving." *New York Times Magazine,* December 8, 1968, pp. 45–47.

———. "20th-Century Artists Most Admired by Other Artists; Views of Nearly 100 Artists." *Art News* 76 (November 1977):78–103.

———. "21 Artists, 'Invisible/Visible.' " *New York Times,* April 16, 1972, p. 19.

——. "26 Contemporary Women Artists at Aldrich Chosen by Lippard." *New York Times*, May 30, 1971, p. 20.

——. "Ursula von Rydingsvard at 55 Mercer." *New York Times*, April 18, 1980, p. 22.

——. "Virtuosity in Neo-Plasticism" (including review of work by Barbara Zucker). *New York Times*, March 3, 1978, p. 19.

——. "Wall Pieces by Alexis Smith and Mary Heilmann at Holly Solomon." *New York Times*, January 23, 1981, p. 19.

——. "Walter Gay, a Searcher for the Spirit of Empty Rooms" (including a review of work by Judy Pfaff). *New York Times*, September 26, 1980, p. 17.

——. "Where are the Great Men Artists?" *Art News* 79 (October 1980):58–83.

——. "Who's Minding the Easel." *Art in America* 56 (January/February 1968):110–13.

——. "The Woman as Artist." *New York Times Magazine*, September 25, 1977, pp. 48–50.

——. "Woman's Work at Whitney South." *New York Times*, March 21, 1980, p. 20.

——. "Women Artists '80: A Matter of Redefining the Whole Relationship Between Art and Society." *Art News* 79 (October 1980):58–63.

——. "Women at the Whitney." *New York Times*, December 19, 1970, p. 23.

——. "Women Painters and Germaine Greer (interview)." *New York Times Book Review*, October 18, 1979, p. 3.

——. "The Working Process at City Gallery." *New York Times*, April 17, 1970, p. 20.

Articles on Grace Glueck

"Russell Is Named Chief Critic." *New York Times*, February 22, 1982.

PAULA COOPER

Articles

"New York Galleries: Paula Cooper." *Arts* 45 (April 1971):62.

Rose, Barbara. "Eight Gamblers on Young Artists: Art Dealers in New York." *Vogue* 155 (February 1, 1970):176–77.

Russell, John. "Art People: A Paris-SoHo Gallery Swap." *New York Times,* February 22, 1980, p. 23.

ROSALIND KRAUSS

Books

Krauss, Rosalind. *Passages in Modern Sculpture.* New York: Viking Press, 1977.

——. *Terminal Iron Works; the Sculpture of David Smith.* Cambridge: MIT Press, 1971.

Krauss, Rosalind, Sam Hunter, and Marcia Tucker. *Critical Perspectives in American Art.* Amherst: University of Amherst, 1976.

Articles and Catalogue Essays

Krauss, Rosalind, and C.F. Walker. "Activity of Criticism." *Studio* 189 (March 1975):85–86.

"Alfred Stieglitz's Equivalents." *Arts* 54 (February 1980):134–37.

Krauss, Rosalind. "Brancusi and the Myth of Ideal Form." *Artforum* 8 (January 1970):35–39.

——. "Changing the Work of David Smith." *Art in America* 62 (September 1974):30–34.

——. "Contra Carmean: The Abstract Pollock." *Art in America* 70 (Summer 1982):123–31.

——. "Cubism in Los Angeles." *Artforum* 9 (February 1971): 32–38.

——. "Dark Glasses and Bifocals, a Book Review." *Artforum* 12 (May 1974):59–62.

——. "The Essential David Smith." *Artforum* 7 (February 1969):43–49.

——. "The Essential David Smith, Part II." *Artforum* 7 (April 1969):34–41.

——. "Grids." *October* 9 (Summer 1979):51–64.

——. "How Paradigmatic is Anthony Caro"? *Art in America* 63 (September 1975):80–83.

——. "In the Name of Picasso." *October* 16 (Spring 1981):5–22.

——. "Irving Penn: Earthly Bodies." *Arts* 55 (September 1980):84–86.

——. "Jackson Pollock's Drawings." *Artforum* 9 (January 1971):58–61.

——. "Jasper Johns: The Functions of Irony." *October* 2 (Summer 1976):91–99.

——. "John Mason and Post-Modernist Sculpture: New Experiences, New Words." *Art in America* 67 (May 1979):120–27.

——. "Joseph Beuys at the Guggenheim." *October* 12 (Spring 1980):3–21.

——. "Jump Over the Bauhaus." *October* 15 (Winter 1980):103–10.

——. "Léger, Le Corbusier, and Purism." *Artforum* 10 (April 1972):50–53.

——. "LeWitt in Progress." *October* 6 (Fall 1978):47–60.

——. "Manet's Nymph Surprised," *Burlington Magazine* 109 (November 1967):622–27.

——. "Max Ernst: Speculations Provoked by an Exhibition." *Artforum* 11 (May 1973):37–40.

——. "Montage *October:* Dialectic of the Shot." *Artforum* 11 (January 1973):61–65.

——. "New York." *Artforum* 8 (December 1969):69–71.

——. "Nightwalkers." *Art Journal* 41 (Spring 1981):33–38.

——. "Notes on the Index: Seventies Art in America." *October* 3 (Spring 1977):68–81.

——. "The Originality of the Avant-Garde: A Postmodernist Repetition." *October* 18 (Fall 1981):47–66.

——. "Painting Becomes Cyclorama." *Artforum* 12 (June 1974):50–52.

——. "Paul Sharits." *Film Culture* no. 65–66 (1978):89–102.

——. "Paul Sharits: Stop Time." *Artforum* 11 (April 1973):60–61.

——. "Photography's Discursive Spaces: Landscape/View." *Art Journal* 42 (Winter 1982):311–19.

———. "Poststructuralism and the Paraliterary." *October* 13 (Summer 1980):36–40.

———. "Problems of Criticism, Pictorial Space and the Question of Documentary." *Artforum* 10 (November 1971):68–71.

———. "Rauschenberg and the Materialized Image." *Artforum* 13 (December 1974):36–43.

———. "Re-Presenting Picasso." *Art in America* 68 (December 1980):90–96.

———. "Richard Serra: Sculpture Redrawn." *Artforum* 10 (May 1972):38–43.

———. "Robert Mangold; An Interview." *Artforum* 12 (March 1974):36–38.

———. "Robert Motherwell's New Paintings." *Artforum* 7 (May 1969):26–28.

———. "Sculpture in the Expanded Field." *October* 8 (Spring 1979):31–44.

———. "Sense and Sensibility, Reflection on Post '60's Sculpture." *Artforum* 12 (November 1973):43–53.

———. "Seventies Art in America (Part 2)." *October* 4 (Fall 1977):58–67.

———. "Stella's New Work and the Problem of Series." *Artforum* 10 (December 1971):40–44.

———. "Stieglitz/'Equivalents.' " *October* 11 (Winter 1979):129–40.

———. "Tracing Nadar." *October* 5 (Summer 1978):29–48.

———. "Video: The Aesthetics of Narcissism." *October* 1 (Spring 1976):51–64.

———. "View of Modernism." *Artforum* 11 (September 1972):48–51.

———. "Washington." *Artforum* 9 (May 1971):83–85.

CINDY NEMSER

Books

Nemser, Cindy. *Art Talk: Conversations with 12 Women Artists.* New York: Scribner's, 1975.

Articles

Nemser, Cindy. "Alchemist and the Phenomenologist." *Art in America* 59 (March 1971):100–3.

———. "Art Criticism and the Gender Prejudice." *Arts* 46 (March 1972):44–46.

———. "Art Criticism and Perceptual Research." *Art Journal* 29 (Spring 1970):26–29.

———. "Art Mailbag: Can Women Have 'One-Man' Shows?" *New York Times*, January 9, 1972, (letter), p. 21.

———. "The Artist in Today's Society." *Feminist Art Journal* 2 (Fall 1973):20.

———. "Audrey Flack: Photorealist Rebel." *Feminist Art Journal* 3 (Fall 1975):5–11.

———. "Blowing the Whistle on the Art World." *Feminist Art Journal* 4 (Summer 1975):25–31.

———. "The Close Up Vision—Representational Art, Part II." *Arts* 46 (May 1972):44–48.

———. "Conversation with Audrey Flack." *Arts* 48 (February 1974):34–37.

———. "Conversation with Betye Saar." *Feminist Art Journal* 4 (Winter 1975–76):19–24.

———. "Conversation with Diane Burko." *Feminist Art Journal* 6 (Spring 1977):5–12.

———. "A Conversation with Lee Krasner." *Arts* 47 (April 1973):43–48.

———. "Directory of Women Artists' Activities." *Feminist Art Journal* 2 (Spring 1973):23–24.

———. "Forum: Women in Art." *Arts* 45 (February 1971):18.

———. "Four Artists of Sensuality." *Arts* 49 (March 1975):73–75.

———. "Grace Hartigan: Abstract Artist, Concrete Woman (interview excerpted from *Art Talk*)." *Ms* 3 (March 1975):31–35.

———. "Humanizing the Art World." *Feminist Art Journal* 4 (Winter 1975-76):36–37.

———. "The Indomitable Lee Krasner." *Feminist Art Journal* 4 (Spring 1975):4–9.

——. "An Interview with Chuck Close." *Artforum* 8 (January 1970):51–55.

——. "An Interview with Eva Hesse." *Artforum* 8 (May 1970):59–63.

——. "Interview with Helen Frankenthaler." *Arts* 46 (November 1971):51–55.

——. "Interview with Members of A.I.R." *Arts* 46 (December 1972):58–59.

——. "Interview with Stephen Kaltenbach." *Artforum* 9 (November 1970):47–53.

——. "Interview with Vito Acconci." *Arts* 45 (March 1971):20–23.

——. "I've Got a Little List." *Feminist Art Journal* 2 (Winter 1973):9.

——. "Lee Krasner's Paintings 1946–49." *Artforum* 12 (December 1973):61–65.

——. "Lila Katzen Defines 'Environment.' " *Arts* 45 (September 1970):44–45.

——. "Lila Katzen: A Human Approach to Public Sculpture." *Arts* 49 (January 1975):76–78.

——. "Male Chauvinist Exposé, Chapter I: David L. Shirey." *Feminist Art Journal* 1 (April 1972):17.

——. "Max Weber." *Arts* 43 (April 1969):59.

——. "Miriam Beerman at the Brooklyn Museum." *Arts* 46 (November 1971):58.

——. "My Memories of Eva Hesse." *Feminist Art Journal* 2 (Winter 1973):12–13.

——. "On Humanizing the Arts." *American Artist* 40 (June 1976):52.

——. "Paintings for the Many, the American Vision: 1825–1875." *Arts* 43 (September 1968):30–32.

——. "Presenting Charles Close." *Art in America* 58 (January 1970):98–101.

——. "Representational Painting in 1971: A New Synthesis." *Arts* 46 (December 1971):41–46.

——. "Revolution of Artists." *Art Journal* 29 (Fall 1969):44.

——. "Role of the Artist in Today's Society." *Art Journal* 34 (Summer 1975):329–31.

——. "Sculpture and the New Realism.." *Arts* 44 (April 1970):39–41.

——. "Stereotypes and Women Artists." *Feminist Art Journal* 1 (April 1972):1, 22–23.

——. "Subject—Object: Body Art." *Arts* 46 (September 1971):38–42.

——. "Symbols of Consciousness; the Paintings of Dorothy Heller." *Arts* 47 (September 1972):33–35.

——. "Why is 'Art Talk' Threatening to New York Museums." *Feminist Art Journal* 2 (Summer 1977):37–38, 42.

——. "The Women Artists' Movement." *Feminist Art Journal* 2 (Winter 1973–74):8–10.

——. "Women's Conference at the Corcoran." *Art in America* 61 (January 1973):86–90.

APRIL KINGSLEY

Selected Articles and Catalogue Essays

Kingsley, April. "Absorbing, Amping, Beaming." *Village Voice*, January 23, 1978, p. 64.

——. *Afro-American Abstraction*. New York: P. S. 1, 1981.

——. "Afro-American Abstraction at P. S. 1: The Evolution of an Exhibition." *The New Art Examiner*, June 1980, pp. 3, 4.

——. "Ah! Revisionism." *Village Voice*, September 25, 1978, p. 113.

——. "Art for All." *Village Voice*, December 12, 1977, p. 86.

——. "Art Goes Underground." *Village Voice*, October 16, 1978, p. 122.

——. "Art or Aesthetics?" *Soho Weekly News*, February 26, 1976, p. 18.

——. "Artscape." *Village Voice*, July 24, 1978, p. 61.

——. "Bigness of Small: Ira Joel Haber's Art." *Arts* 55 (September 1980):154–55.

——. "Black Artists: Up Against the Wall." *Village Voice*, September 11, 1978, p. 113.

——. "Brenda Miller." *Arts* 51 (May 1977):6.

——. "Calder's Universe: It's Not All Fun and Games." *Soho Weekly News,* November 4, 1976, pp. 20, 22.

——. "Camille Pissarro." *Horizon* 24 (May 1981):44–51.

——. "Carol Haerer: Spiraling Through Space and Time." *Arts* 58 (September 1983):126–28.

——. "Chasing the Empty Coffee Table Blues," *Village Voice,* December 18, 1978, p. 113.

——. "Concept vs. Art Object: A Conversation Between Douglas Huebler and Budd Hopkins." *Arts* 46 (May 1972):24–25.

——. "Cynthia Carlson: The Subversive Intent of the Decorative Impulse." *Arts* 54 (March 1980):90–91.

——. "De Kooning: 'The New Ones Are Good Too.' " *Soho Weekly News,* November 11, 1976, pp. 18, 23.

——. "Douglas Huebler." *Artforum* 10 (May 1972):74–78.

Kingsley, April, and Fritz Bultman. "An Embarrassment of Riches." In *Cape Cod as an Art Colony.* Sandwich, Massachusetts: Heritage Plantation at Sandwich, 1977.

Kingsley, April. "Energy and Order—the Paintings of Budd Hopkins." *Art International* 17 (April 1973):32–35.

——. "Erotic Undertow." *Soho Weekly News,* December 1, 1975, p. 18.

——. "Fall Roundup: Part Two." *Soho Weekly News,* November 25, 1976, p. 17.

——. "Flesh Was the Reason Oil Paint was Invented." *Village Voice,* November 14, 1977, p. 101.

——. "Fly-Specked Earth and Leaden Skies." *Village Voice,* April 3, 1978, p. 67.

——. "From Explosion to Implosion: the Ten Year Transition of William T. Williams." *Arts* 55 (February 1981):54–55.

——. "From Hot to Cold in One Block on West Broadway." *Soho Weekly News,* February 17, 1977, pp. 18–19.

——. "Galleries: Out-of-the-Ordinary Mixed Bags." *Village Voice,* January 2, 1978, p. 66.

——. "Gerald Samuels." *Arts* 52 (October 1977):6.

——. "Getting It Together." *Village Voice,* March 19, 1979, p. 78.

——. "The Great Body Snatcher." *Newsweek,* July 9, 1979, pp. 66–67.

——. "Have We Overcome." *Village Voice,* February 13, 1978, p. 66.

——. "Helene Valentin." *Arts* 51 (April 1977):5.

——. "The Heroic Figure." *Soho Weekly News,* March 3, 1977, pp. 19–20, 68.

——. "I-Hate-to-Cook-Dinner Party." *Ms* 7 (June 1979):30–31.

——. "The Interiorized Image." *Soho Weekly News,* February 5, 1976, pp. 21, 41.

——. *Islamic Allusions.* New York: Alternative Museum, 1981.

——. "Jack Tworkov." *Art International* 18 (March 1974):24–27.

——. "James Brooks: Critique and Conversation." *Arts* 49 (April 1975):54–57.

——. "James Brooks: Stain into Image." *Art News* 71 (December 1972):48–49.

——. "John Grillo." *Arts* 53 (October 1978):11.

——. "Looks in Paint." *Village Voice,* August 14, 1978, p. 67.

——. "Mad Logic of Georges Nöel." *Art International* 18 (February 1974):30–31.

——. "Magic from Mexico." *Newsweek* 93 (June 4, 1979):85–86.

——. "Mark Rothko: The Painful Evolution of a Radical." *Village Voice,* November 20, 1978, p. 101.

——. "Mary Frank: 'A Sense of Timelesness.' " *Art News* 72 (Summer 1973):65–67.

——. *Michael Loew.* New York: Marilyn Pearl Gallery, 1979.

——. "Motherwell, Bultman and Ross Uptown." *Soho Weekly News,* January 29, 1976, p. 19.

——. "Muddling Through." *Soho Weekly News,* March 31, 1977, pp. 19, 23.

——. "Narrating Life's Existential Fuck-Up." *Village Voice,* May 22, 1978, p. 67.

——. "New Imagery Keeps It Cool." *Village Voice,* January 1, 1979, p. 71.

——. *The New Spiritualism: Transcendent Images in Painting and Sculpture.* New York: Oscarsson Hood Gallery 1981.

———. "New York Letter." *Art International* 17 (October 1973):51–53.

———. "New York Letter." *Art International* 18 (Summer 1974):43–45.

———. "Nora Speyer." *Art International* 18 (May 1974):36–37.

———. "Opening and Closing: Fritz Bultman's Sculpture." *Arts* 50 (January 1976):82–83.

———. "Opulent Optimism." *Village Voice*, November 28, 1977, p. 76.

———. "Overcoming the Double Whammy." *Village Voice*, June 24, 1979, p. 99.

———. "Painted Portraiture Lives." *Soho Weekly News*, January 15, 1976, pp. 16, 41.

———. "Pat Lash: Death and Transfiguration." *Arts* 56 (November 1981):130–31.

———. "Philadelphia." *Artforum* 14 (February 1976):72–73.

———. "Philip Guston's Endgame." *Horizon* 23 (June 1980):34–41.

———. "Pictures and More Pictures." *Soho Weekly News*, January 6, 1977, p. 16.

———. "Planes—In Spaaace." *Village Voice*, April 16, 1979, p. 84.

———. "Primal Plants of Buffie Johnson." *Art International* 24 (January/February 1981):195–203.

———. *Rafael Ferrer.* Pasadena Art Museum, 1972.

———. "Real Alternatives: Richard Diebenkorn and Stephen Greene." *Soho Weekly News*, January 20, 1977, pp. 20, 25.

———. "Reality in Abstraction." *Soho Weekly News*, March 18, 1976, pp. 30, 34.

———. "Reviews." *Artforum* 11 (December 1972):81–84; (January 1973):88–91; (February 1973):86–89; (May 1973):87–89.

———. "Reviews and Previews." *Art News* 72 (January 1973):18–19 and (May 1973):89–90.

———. *Richard Hunt.* Tempe, Texas: Saulsbury Gallery, Cultural Activities Center, 1980.

———. "Ronald Bladen—Romantic Formalist." *Art International* 18 (September 20, 1974):42–44.

———. "Sacred and Erotic Vision of Balthus." *Horizon* 22 (December 1979):26–35.

——. *Sculpture by Mel Edwards.* Trenton: New Jersey State Museum, 1981.

——. "Sculpture Gets New Energy." *Soho Weekly News,* January 1, 1976, p. 16.

——. "Sex, Religion and the Mythic Image." *Soho Weekly News,* February 12, 1976, p. 20.

——. "Sherman Drexler." *Arts* 51 (March 1977):11.

——. "Six Women at Work in the Landscape." *Arts* 52 (April 1978):108–12.

——. "Steelyard Blues." *Encore* 9 (November 1981):42–43.

——. "Sticks and Stones." *Village Voice,* May, 28, 1979, p. 78.

——. "Suitable Subversions." *Village Voice,* March 13, 1978, p. 72.

——. "This Time Last Year." *Soho Weekly News,* October 21, 1976, p. 17.

——. "Uptown, Downtown, All Around Town." *Soho Weekly News,* March 25, 1976, pp. 25–26.

——. "Vedder's Vivid Visions." *Village Voice,* July 9, 1979, p. 65.

——. "Wave the Magic Wand." *Soho Weekly News,* May 5, 1977, p. 21.

——. "West Meets East; First Western States Biennial Exhibition." *Newsweek* 94 (August 20, 1979):79–80.

——. "The Wild Beasts are Still Roaring." *Soho Weekly News,* April 15, 1976, p. 21.

——. "Womanhood is Powerful." *Village Voice,* February 12, 1979, p. 87.

——. "Women Choose Women." *Artforum* 11 (March 1973):69–73.

HOLLY SOLOMON

Articles

Filler, Martin. "Good Golly Miss Holly!" *House and Garden* 153 (March 1981):132–35.

Glueck, Grace. "Sculptors on Paper and a Gallery on the Move." *New York Times,* September 25, 1983, p. 29.

Index

Abbot, Bernice, 96
Abish, Cecile, 190
Abstract Art, 71–72, 73
Abstract Expressionism, 2, 8, 15, 19–
 20, 26, 28, 43, 51, 54, 58, 60, 61, 78,
 86, 102, 116, 174
Acconci, Vito, 120, 172–173, 175
Ad Hoc Women Artists Committee,
 112
Adams, Alice, 102, 105
Adams, Ansel, 96
Adams, Pat, 90
Adler, Pam, 251–220
Africano, Nicholas, 198, 199, 227
Afro-American Abstraction, 240
Agostino, Peter, 85, 184
Albers, Josef, 38, 42
Albright, Ivan, 38, 42, 44
Alloway, Lawrence, 159
Amenoff, Gregory, 208
American Association for Labor Legis-
 lation, 37
American Indian Art, 40, 43
Anderson, Laurie, 198, 199
Andre, Carl, 63, 141, 185
Antin, Eleanor, 177, 236
Anuszkiewicz, Richard, 184
Arakawa, On, 183
Arbus, Diane, 96
Archipenko, Alexander, 60, 94
Arensberg, Walter, 44
Arnheim, Rudolph, 79
art criticism, 24–26, 44–45, 47, 77, 121–
 122, 179, 233
Art Deco, 16, 118–119
Art News, 15
Art of This Century Gallery, 2, 60

Art Student League, 140, 237
Art Worker's Coalition, 103, 112
Artforum, 159, 160, 175
Artschwager, Richard, 145–146, 161
Arts, 100, 170, 175
Ash Can School (See The Eight)
Ashbaugh, Dennis, 219
Ashton, Dore, 5, 6, 65–79, 234–235
Asia Society, 32
Atget, Eugene, 96
Ault, George, 94
Avery, Milton, 83
Aycock, Alice, 190

Bachelaer, Gaston, 66
Bacon, Francis, 43
Baer, Jo, 104
Baizerman, Saul, 94
Balthus, Jean, 208, 240
Baranik, Rudolf, 187
Barr, Alfred H., 17, 20, 36, 44, 74, 101
Barthes, Roland, 158
Bartlett, Jennifer, 133, 141, 144
Baskin, Leonard, 84
Batten, Karin, 110
Baudelaire, Charles, 66
Beato, Felice, 96
Beauchamp, Robert, 208, 210
Becher, Bernd and Hilla, 120
Beckett, Samuel, 74
Beckmann, Max, 84, 85
Beerman, Marian, 174
Bell, Larry, 118
Benglis, Lynda, 141, 145, 177
Bergdorf-Goodman, 15
Berman, Eugene, 18

About the Author

Judy K. Collischan Van Wagner is Director of Hillwood Art Gallery, C.W. Post Center, Long Island University, New York. Until 1982, she was Associate Professor of Art History at State University of New York.

Dr. Van Wagner has published widely in the area of art. Her articles and reviews have appeared in *Arts* magazine, *Art Express*, and the *Woman's Art Journal*.

Dr. Van Wagner holds a B.A. from Hamline University, St. Paul, Minnesota, a M.F.A. from Ohio University, and a Ph. D. from the University of Iowa in Iowa City.